A CULTURAL HISTORY
OF OBJECTS

VOLUME 3

A Cultural History of Objects
General Editors: Dan Hicks and William Whyte

Volume 1
A Cultural History of Objects in Antiquity
Edited by Robin Osborne

Volume 2
A Cultural History of Objects in the Medieval Age
Edited by Julie Lund and Sarah Semple

Volume 3
A Cultural History of Objects in the Renaissance
Edited by James Symonds

Volume 4
A Cultural History of Objects in the Age of Enlightenment
Edited by Audrey Horning

Volume 5
A Cultural History of Objects in the Age of Industry
Edited by Carolyn L. White

Volume 6
A Cultural History of Objects in the Modern Age
Edited by Laurie A. Wilkie and John M. Chenoweth

A CULTURAL HISTORY
OF OBJECTS

IN THE
RENAISSANCE

VOLUME 3

Edited by James Symonds

BLOOMSBURY ACADEMIC
LONDON • NEW YORK • OXFORD • NEW DELHI • SYDNEY

BLOOMSBURY ACADEMIC
Bloomsbury Publishing Plc
50 Bedford Square, London, WC1B 3DP, UK
1385 Broadway, New York, NY 10018, USA
29 Earlsfort Terrace, Dublin 2, Ireland

BLOOMSBURY, BLOOMSBURY ACADEMIC and the Diana logo are
trademarks of Bloomsbury Publishing Plc

First published in Great Britain 2021
This paperback edition published in 2024

Series design by Raven Design
Cover image: *The Ambassadors*, Holbein the Younger, 1533 © Bridgeman Images

A catalogue record for this book is available from the British Library.

A catalog record for this book is available from the Library of Congress.

ISBN: HB: 978-1-4742-9873-5
 PB: 978-1-3504-6336-3
 Pack: 978-1-4742-9881-0

Series: The Cultural Histories Series

Typeset by Integra Software Services Pvt. Ltd.
Printed and bound in Great Britain

To find out more about our authors and books visit www.bloomsbury.com
and sign up for our newsletters.

For Bram Kempers

CONTENTS

LIST OF ILLUSTRATIONS

SERIES PREFACE

Our lives are lived with and through and surrounded by objects. We shape them, we use them, and they shape us, too. Small wonder that scholars study them: not just those in disciplines like anthropology, archaeology, or science and technology studies that have long led the way in such research, but also—increasingly—historians, social scientists, literary theorists, and others. This six-volume *Cultural History of Objects* is a response to the growing appreciation of the subject's significance: both an authoritative summing up of the state of the art and a provocation for future work in the field.

A Cultural History of Objects explores how objects were created, the changing ways in which they have been used and understood, and their ongoing and cumulative consequences. Stretching from antiquity to the contemporary period, it is a chronologically wide-ranging but culturally specific project, one that focuses quite deliberately on the experience of the Western world.

Over the past three thousand years, Europe has seen the creation, maintenance, and development of a series of particular attitudes to the material world. These attitudes have been worked out through the creation and use of artifacts. These practices have involved expanding scales of production, commodification, industry, technology, and networks of distribution. At the center of this process is the idea of the object: a thing distinct from the subject who owns or uses it. This Western history of objects stands in contrast to non-Western and prehistoric attitudes to material culture in which distinctions between subjects and objects are often less clearly drawn.

For that reason, these volumes do not present a history of technology, a history of artifacts, or of material culture in which the geographic scope would necessarily be global and cross-cultural. Rather, the focus of the exercise is specifically the cultural history of objects.

This assumption shapes the periodization of the project, in which each volume deals with a recognizably Western epoch:

1. *A Cultural History of Objects in Antiquity* (c. 1000 BCE–500 CE)
2. *A Cultural History of Objects in the Medieval Age* (500–1400 CE)
3. *A Cultural History of Objects in the Renaissance* (1400–1600 CE)
4. *A Cultural History of Objects in the Age of Enlightenment* (1600–1760 CE)
5. *A Cultural History of Objects in the Age of Industry* (1760–1900 CE)
6. *A Cultural History of Objects in the Modern Age* (1900 CE–present)

Each volume shares the same structure. After an introduction, which places the period in a broader context, considering wider issues of cross-cultural exchanges with the non-Western world and the legacy of previous periods, the first chapter explores the critical question of how objecthood was understood and experienced. Successive chapters then uncover aspects of objecthood, tracing developments in technology, economic objects, everyday objects, art objects, architecture, and bodily objects. The final chapter goes further, opening up the volume and the subject more generally by using a particular object or class of objects to consider the "object worlds" of the period: the ways in which objects shaped human life in the past and shape scholarship in the present.

This approach enables readers to trace the story chronologically or thematically, reading each volume to explore a particular moment in time or reading the same chapter across all volumes to understand how particular types of object changed through time. Either way, *A Cultural History of Objects* offers an authoritative, provocative, and original account of this subject, whose importance can only grow.

General Editors: Dan Hicks and William Whyte

Introduction

JAMES SYMONDS

"The courageous act of history," according to Henry Glassie, "is the act of the historian who ignores most people and events while selecting a tiny number of facts and arranging them artfully and truthfully in order to speak usefully about the human condition" (Glassie 1999: 6–7). In order to construct their narratives, historians pick over a haphazard and arbitrary "mythic resource" in search of moments of change, "segmenting linear time, then linking the segments along the arc of progress that leads, inevitably, to us" (Glassie 1999: 6–7). Historical periodizations are a useful rhetorical device. They allow us to assemble information about the past in self-contained but linked units, rather like the carriages of a train. However, this way of conceptualizing history has many problems, and can lead to "train-track thinking." It can, for example, encourage us to view periods as containers of knowledge, people, and things. This form of *post hoc* compartmentalization can also encourage scholars to work within the safely demarcated boundaries of a particular period and to view that period in isolation, with little regard for what came before, or after.

What, then, should we make of the term "Renaissance?" It may seem unnecessary to provide a definition for such a familiar and well-worn term. The art historian Erwin Panofsky defined the Renaissance in two ways: first, as "a rebirth of classical antiquity following a complete, or nearly complete, breakdown of classical traditions," and second, more broadly, as a "universal efflorescence of art, literature, philosophy, science and social accomplishments after a period of decay and stagnation" (Panofsky 1944: 201). The Renaissance is often defined in a third way: as a period of European history that spanned the lives of Petrarch (1304–1374) and Descartes (1596–1650) (Burke 1998: 1).

A fourth definition, devised by the art historian Ernst Gombrich, suggests that rather than being defined as a historical period, the Renaissance may best be viewed as a cultural movement (Gombrich 1974).

The "tangible yield of human conduct" or "culture made material" (Glassie 1999: 41) of this European Renaissance (i.e. the paintings, sculpture, architecture, and literature) is a palpable presence in the contemporary world. The vital materiality of these objects provides an insistent and unequivocal testimony to a remarkable outpouring of cultural creativity. If we attempt to recover the thoughts and motivations of the people behind such creations, it is possible to see an emerging sense of self consciousness and a belief in the self as unique (Burke 2009: 20). The promotion of individualism prompted by Renaissance humanism went hand in hand with an "attachment to things" and a new interest in acquiring and owning possessions (Cohn 2012). This intense fascination with things, which extended to the natural world, led to new approaches to art and representation as artists attempted to emulate and better the work of ancient craftsmen. When viewed through the prism of presentism, this seemingly familiar past may seem to hold the origins of capitalism, consumerism, and many of the universal values that underpin the Western world (Welch 2017).

The Renaissance obsession with the voices and deeds of the dead brought early forms of literary studies and archaeology into being (Schwyzer 2007). In the early fifteenth century, the papal clerk Poggio Bracciolini scoured monastic libraries in search of manuscripts of classical works that might reveal Rome's historical topography. His use of ancient texts created a "newly historicized philology" or a form of "materialistic etymology" (Barkan 1999: 29–30). And when he chanced upon a copy of *On the Nature of Things* by the Roman poet Lucretius in the monastery of Fulda in Germany in 1417, its description of the universe as a collection of atom-like particles in perpetual motion and its reiteration of the Greek philosophical doctrine of Epicurus, which stated that humans could act freely without divine intervention, encouraged a new wave of humanist thinking (Greenblatt 2011).[1]

In the 1420s, Cyriacus of Ancona, a merchant from a small port on the Adriatic coast of Italy, took to creating drawings to accompany the textual inscriptions that he recorded on monuments from the classical world on his travels around the Mediterranean (Belozerskaya 2009). The fragmentary heads and torsos from colossal ancient sculptures that littered the open spaces of Rome were also scrutinized with a renewed curiosity at this time. More complete sculptures were also discovered, such as the serpent-entangled figure of *Laocoön*, unearthed in 1506, which was quickly acquired by Pope Julius II. The pope installed the sculpture in the Cortile Belvedere at the Vatican Palace, thereby encouraging the idea that objects from the classical past should be assembled and exhibited (Barkan 1999: 2, 119–73).

By the early seventeenth century, this fascination with human mortality and a desire to communicate with the dead had worked its way north and permeated the literary texts of Spenser's *Faerie Queene*, Shakespeare's *Romeo and Juliet* and *Hamlet*, the metaphysical poems of John Donne, and Thomas Browne's *Hydriotaphia* or *Urne-Buriall* with images of ghosts, skulls, and exhumation (Schwyzer 2007). Indeed, if two core themes can be identified running through Renaissance objects, poetry, and philosophy, it is a preoccupation with the individual human experience and "the destiny of men, caught in the inexorable process of Time" (Plumb 1982: 10).

This volume is one of six Bloomsbury books exploring the cultural history of objects. Within this collection, Renaissance objects are dated to the period 1400–1600, and this volume sits between two other volumes that cover the Medieval Age (500–1400) and the Age of Enlightenment (1600–1760). We need to approach our subject of Renaissance objects with some caution, however. The idea that the Renaissance may be best understood as a historical period neatly sandwiched between the medieval and early modern period is only one way of comprehending the phenomenon, and one that has little academic support these days. There are, however, several reasons why we should question the master narratives that have been used to shape understandings of Renaissance things.

First, the Renaissance is a cultural and historical construction, and for this reason it can be argued that "Renaissance objects" have only ever existed as retrospective categorizations. Then there is the problem that the term "Renaissance"—which is often freely employed—does not bestow any form of homogeneity upon the objects to which it is applied or indicate that they are spatially or temporally synchronous. The European Renaissance was a moving spectacle, with all of the intensity and unpredictability of a wildfire. This movement exhibited clear signs of connectivity, as ideas and objects spread through the conduits created by aristocratic marriages and allegiances, mercantile networks, and artistic commissions. However, particular material forms and durations varied across continental Europe between the fourteenth and seventeenth centuries according to time, place, artist or craftsperson, and genre. As we will see below, research by art and cultural historians has attempted to address this problem and to reframe the Renaissance as a transnational cultural exchange that generated hybrid forms of expression (Farago 1995; Burke 1998; Kaufmann and Pilliod 2005).

A third problem is the compartmentalized way in which art, architecture, objects, literature, and music have traditionally been studied. This complicates matters, as different disciplines have developed their own distinctive temporal and interpretative frameworks. The mansion of history has many windows, and each offers a slightly different perspective on the bustling Renaissance townsfolk and their things. Art historians, for example, tend to view the Renaissance as starting in Italy as early as the thirteenth century, with the paintings of Giotto,

and culminating in the late sixteenth century, with the works of Michelangelo and Leonardo da Vinci. Literary scholars, on the other hand, tend to focus on the so-called English Renaissance in the sixteenth and seventeenth centuries and the poetry and drama of Shakespeare, Milton, and Spencer. Economic and social historians, meanwhile, refer to the centuries between *c.* 1400 and 1600 as the beginning of the early modern period. Archaeologists have their own terms for the period *c.* 1400–1600, depending on where they are in the world and whether they have been trained according to British archaeological traditions, which refer to the post-medieval period (1485–1750 CE), or North American anthropological traditions, which define the post-Columbian era as the realm of study of historical archaeology.[2]

In general, however, the term "Renaissance" is notable by its absence from the titles of archaeological publications. This may be because the field of Renaissance studies is often concerned with the study of high-end elite material culture, which is highly prized by museums, galleries, and private collectors, and therefore perhaps less accessible for routine archaeological study. Archaeologists may also refrain from using the term "Renaissance" in their work as they see it as an art historical construction and prefer to make their own studies of more mundane everyday objects working with "material culture with the dirt on it" (Hüme 1978).

The perception that the Renaissance was an Italian urban phenomenon of the fifteenth and sixteenth centuries has cast a long shadow across Renaissance scholarship. Such a precise, or narrow, periodization was useful inasmuch as it created an architecture on which "the history of art constructed its imposing edifice" (Moxey 2011: 80). But close scrutiny of this edifice reveals many flaws. For one thing, the very idea of an *Italian* Renaissance carelessly conflates time and place, as the Unification of Italy started centuries after the end of the so-called Renaissance in the nineteenth century and was not completed until 1871.

The idea that the Renaissance was in some way the cradle of Modernity is also laden with teleological problems. Many accounts of the Renaissance embody Hegel's philosophy of history and his idea of a progressive human "Spirit" that emerged with the demise of the Middle Ages and the rise of a secular Modernity (Moxey 2011: 80). With the benefit of hindsight, the nineteenth century chain of reasoning that links the Italian Renaissance's rediscovery of the classical past to the emergence of modern individualism can perhaps be seen as at best an attempt to create a seamless account of social evolution and human progress, and at worst as a triumphalist fabrication that served to promote the cultural superiority and political hegemony of the West.

In the light of such concerns, it may be that the term "Renaissance" has had its day, or at least lost any credible academic utility. But I suspect that this imagined Renaissance will linger on, not least because it is linked to such a vibrant body of material culture. One way forward may be to de-essentialize the notion of the

Renaissance. The historian Peter Burke was characteristically ahead of the field when he adopted Gombrich's concept of the Renaissance as a cultural movement more than twenty years ago (Burke 1998: 1). This allowed Burke to redefine the hitherto seemingly monolithic and indivisible European Renaissance that was present in so much previous scholarship and to craft more nuanced and culturally contingent narratives of the various temporal and spatial shifts.

Burke defined three phases within the Renaissance movement: an early Renaissance in Italy, lasting from the early fourteenth century until the late fifteenth century, in which fragments of antiquity were rediscovered; a high Renaissance (c. 1490–1530), when these fragments were brought together and emulated as Italian artists and scholars came to compete with the ancients, and scholars in other countries came to compete with Italians; and finally a later Renaissance (c. 1530–1630), which, although in some ways characterized by a return to fragmentation, was also the phase in which classical and Italian styles were most widely distributed internationally, prompting cultural adaptions and hybridity as Renaissance ideas entered everyday lives and became domesticated (Burke 1998: 13–4).

The new ways of seeing and doing that emerged in the northern Italian city-states in the fourteenth century began to circulate around Europe in the late fifteenth century. However, as indicated by Burke's phrasing, this was a slow process, and only became more widespread and visible internationally in the sixteenth and early seventeenth centuries. Various metaphors have been used to describe the spread of the Renaissance movement. The process has been likened to an impact or penetration, a form of contagion, a commercially led borrowing of ideas and things, and, most commonly, to a hydraulic event involving percolation or spreading along channels and absorption.

Metaphors aside, Burke was clear that the spread of classical ideas and styles outside Italy was a "collective European enterprise of cultural exchange" and a form of cultural "reception" through "an active process of assimilation and transformation" rather than a simple process of diffusion and replication of classical or Italian ideas (Burke 1998: 5–6). Before going further into our investigation of Renaissance objects, it may therefore be helpful to take a brief foray into the historiography of the Renaissance in order to help us to understand how different receptions of the Renaissance have emerged and shaped interpretations of the phenomenon and the object worlds that the unfolding movements set in motion.

WRITING THE RENAISSANCE: HISTORIES, MYTHS, AND HUBRIS

The idea of the European Renaissance has been fashioned and gilded for more than a century and a half (Fergusson 1948; Kerrigan and Braden 1991).

It would be wrong, however, to assume that it is a relatively modern fabrication, or for that matter that it has been solely shaped by professional historians. Historians are in fact relative newcomers to a process that has for the most part been shaped since the sixteenth century by the personal investment of a series of artists, writers, patrons, and connoisseurs (Findlen 1998: 83). Looking back still further in time, from as early as the fourteenth century, northern Italian scholars were aware that they were living through a time of cultural recalibration and change. Some used the term *renovatio* (renewal) to refer to the upsurge in interest in ancient literature and art that they were experiencing, while others defined the seemingly dark abyss of time or the "long parenthesis" (Burke 1998: 2) that separated their world from the glories of the ancient world as the *Medium Aevum*, or Middle Ages (Martin 2003: 5).

In the mid-sixteenth century, the Tuscan artist Giorgio Vasari (1511–1574) used the term *rinascità* (rebirth) to refer to this cultural fluorescence in his two-volume *Lives of the Artists* (1550). Vasari's *Lives* documented almost two and a half centuries of Italian artistic output, from the late thirteenth century until the mid-sixteenth century, and sought to demonstrate how successive generations of Italian artists, from Cimabue and Giotto to Leonardo da Vinci and Michelangelo, had successfully revived classical traditions of art as a counterbalance to the Goth styles of art and architecture that had developed in northern France in the mid-twelfth century and spread across Europe. Vasari celebrated the newfound interest in the study and imitation of nature and claimed that the creative works of his contemporary Michelangelo, whose skills he admired above all others, far exceeded the abilities of ancient painters and sculptors. For Vasari, then, the *rinascità* was not only a rebirth, but also a point of departure for something new. In his view, rather than simply imitating what had gone before, the innovation and energy of Italian artists had created new ways of conceptualizing and materializing nature and the human form.

The French word *Renaissance* (rebirth) was used to refer to historical developments in the sixteenth century by Jules Michelet in his *Histoire de France* (1855). The seventh volume of Michelet's history, *La Renaissance*, defined the sixteenth century as an age of discoveries and scientific advances between Columbus's voyages to the New World and Galileo's observational astronomy. An ardent republican and nationalist, Michelet claimed that it was French advances in technology, art, and literature that had put an end to the tyranny of the Middle Ages and inspired this pan-European spirit of renewal and cultural progress. Like all histories, Michelet's *Histoire de France* is a product of its time. With the benefit of hindsight, it seems clear that, faced with the fading values of the French Revolution and the failure of the revolution of 1848 in his own century, Michelet was searching for a historical moment when the values of liberty and egalitarianism had seemingly prevailed (Brotton 2002: 22).

In 1860, the Swiss historian Jacob Burckhardt used the term "Renaissance" in his *The Civilization of the Renaissance in Italy*. Burckhardt's essay described the cultural history of the Italian states in the fourteenth and fifteenth centuries and went on to become a foundational text that underpinned many twentieth-century accounts of the Renaissance. The standout point from Burckhardt's elegantly written essay is his claim that the Renaissance in Italy was a turning point in Western history that saw the emergence of the modern idea of the individual. Put simply, Burckhardt proposed that the origins of individualism, and hence the spirit of capitalism and modernity, lay in the fourteenth- and fifteenth-century city-states of northern Italy. Burckhardt's thesis combined several strands of evidence, claiming that it was a secular conception of the state, along with a powerful code of chivalry, and a revival of classical arts from Greece and Rome that had allowed the idea of the self-conscious and dynamic modern individual to emerge. Burckhardt's vision of the Renaissance differed from previous accounts as he highlighted the fact that it was not only the revival of antiquity that prompted this momentous change in worldview, but its union, invoking Hegelian historicism, with the "spirit" of the Italian people (Burke 1998: 2). In his view, the character of the Italian city states had propelled their citizens toward modernity, making them "the first-born among the sons of modern Europe." Burckhardt likened this transformation to a moment of revelation:

> In the Middle Ages ... Man was conscious of himself as a member of a race, people, party, family, or corporation—only through some general category. In Italy this veil first melted into air; an objective treatment and consideration of the state and of all the things of this world became possible. The subjective side at the same time asserted itself with corresponding emphasis; man became a spiritual *individual* and recognized himself as such. (Burckhardt 1990: 98)

This view of the Renaissance mirrored nineteenth-century struggles for democracy and the emergence of the industrialized secular state. The idea that individual curiosity and creativity had been driven by the spirit of the age was also a feature of Walter Pater's *The Renaissance* (1873). In contrast to Michelet and Burckhardt, Pater, an Oxford don and aesthete, downplayed early modern scientific and political developments in his analysis and saw the Renaissance as a cultural spirit that extended from the twelfth to the seventeenth centuries. Pater characterized the Renaissance as a hedonistic counterculture that focused on the celebration of art and beauty and rebelled against the social constraints imposed by contemporary moral and religious conventions.

The definitions of the Renaissance offered by Michelet, Burckhardt, and Pater celebrated the human spirit and the perceived origins of individualism, but they also served a darker purpose. Here, plain to see was a Grand Narrative

that explained the origins of the modern world and provided a rationale for nineteenth-century European colonialism (Brotton 2002: 25). In this sense, the "presentism" identified by Welch is not simply a feature of twenty-first-century interpretations of the Renaissance. As Jerry Brotton has observed:

> The Renaissance Man invented by Michelet and Burckhardt was white, male, cultured, and convinced of his cultural superiority. In this respect, Renaissance Man sounds like the Victorian ideal of an imperial adventurer or colonial official. Rather than describing the world of the fifteenth and sixteenth centuries, these writers were in fact describing their own world. (Brotton 2002: 33)

A rather different interpretation of the origins of the Renaissance emerged in the early twentieth century. In *The Waning of the Middle Ages* (published in 1919 and translated in 1924), the Dutch historian Johan Huizinga studied forms of life, thought, and art in France and The Netherlands in the fourteenth and fifteenth centuries. Huizinga claimed that Burckhardt had "exaggerated the distance separating Italy from the Western countries and the Renaissance from the Middle Ages" (Huizinga 1972: 67–8). Rather than being a period of rebirth, Huizinga characterized the late Middle Ages as a period of cultural exhaustion and decline when much of value was lost. In Huizinga's view, the visual realism of fifteenth-century Flemish painters such as van Eyck was not an expression of Renaissance art, but rather "a feature of the spirit of the expiring Middle Ages," and one that was, in essence, "almost exclusively concerned with giving a finished and ornate form to a system of ideas which had long since ceased to grow" (Huizinga 1972: 262–3). A similar debate over meaning has found expression in twentieth-century poetry. Thus, while W. H. Auden famously described the fate of the falling Icarus and the apparent nonchalance shown by the onlookers in Pieter Brueghel's *The Fall of Icarus* as depicting humanity's universal indifference to human suffering (Auden 1998), Jack Gilbert took a more Huizingan line, preferring to see the falling Icarus as "not failing as he fell, but just coming to the end of his triumph" (Gilbert 2006).

 If the Renaissance worlds crafted by Michelet, Burckhardt, and Pater reflected their nineteenth-century circumstances and ideals, then the autumnal metaphor used by Huizinga would seem to reflect a Northern European pessimism following the devastation of the First World War. The rise of fascism and the Second World War had an even more profound impact upon Renaissance scholarship. In the 1930s, many Jewish intellectuals fled from fascist oppression and gained employment in American and British universities, bringing their extraordinary talents to leading Anglophone institutions (Fleming and Bailyn 1969). In the postwar years, these displaced scholars embraced Burckhardt's progressive narrative with vigor. This time around, the narrative seemed to

illustrate a victory of civilization over barbarism and was used to legitimate the triumph of the USA and the Allied powers over fascism (Martin 2003: 6–7).

The horrors of war are seldom contained within the period of active conflict. Memories of violence and atrocities blight the lives of those who endured and survived the conflict and haunt their descendants for generations to come. Many of those who fled from Europe in the 1930s had been deeply traumatized by events in their early lives, and this can be seen in their subsequent reflections on the Renaissance. The art historian Erwin Panofsky, who had fled from Hamburg to Princeton, New Jersey, took the view that the European Renaissance had been the pinnacle of human achievement. Panofsky devised a systematic approach to the analysis of Renaissance art, which he termed "iconology" (Panofsky 1939). This system analyzed and classified symbols in a similar way to that in which early twentieth-century anthropologists and ethnographers classified "human races," seeking to illustrate "when and where specific themes were visualized by which specific motifs" (Panofsky 1955: 31). Panofsky believed that the scientific study of art was a measure of humanity and that, through the systematic analysis of subject matter, images, and treatments, it was possible to reveal how social attitudes and beliefs had been channeled through individual artists to become materialized in a physical form (Brotton 2002: 27–8). A similar idea—that careful historical scholarship and the analysis of texts and contexts can recover hidden or lost systems of meanings, which may not be apparent to modern viewers—may be seen in the work of Simon Baxandall, whose study of painting in fifteenth-century Italy introduced the term "the period eye" to refer to a lost way of seeing and understanding the cultural meanings held within a piece of art (Baxandall 1972).

In the early 1950s, the work of another Jewish refugee, Roberto Lopez, who had fled to America from Mussolini's Italy, introduced the first major contribution from economic history to the debate about the origins of the Italian Renaissance. Lopez argued that the decision to invest in culture in late fourteenth-century Italy followed two devastating outbreaks of plague in 1348 and 1362–1363, and the related famine and financial turmoil. In his view, "hard times" and an uncertain future had encouraged northern Italian urban elites to invest in art and architecture in a desperate attempt to preserve their diminishing personal assets (Lopez 1953: 19–32). The Black Death has also been identified as a major factor shaping the emergence of the Renaissance in central Italy by the American historian Samuel Cohen (Cohn 1997, 2002). However, in contrast to Lopez, Cohen argued that the increased investment in art and architecture that occurred from the late fourteenth century reflected a growing optimism and a sense of triumph, as human resilience and ingenuity were seen to have overcome the horrors of the plague (Cohn 1997, 2002). Cohen's contributions have gained significance in Renaissance studies, as he implored historians to move beyond the study of the rich and their objects to

study consumption patterns in a wider section of society through the evidence contained in hitherto neglected marriage contracts, inventories, and last will and testaments.

In the 1960s and 1970s, the second wave of French Annales historiography, championed by the work of Fernand Braudel, introduced new ways of conceptualizing and writing histories of the early modern world. By questioning the value of elite-centered explanatory frameworks and focusing instead on daily life and mentalities, Braudel was able to explore the transformation of social and economic structures within different modes of historical time (Burke 1990). In his view, the Renaissance was primarily an urban phenomenon and had emerged from a comparatively small and geographically limited number of zones of creativity (Braudel 1949, II: 899–900). Following Lopez, Braudel interpreted Renaissance cultures to be the "morbid product" of an economic recession. However, in his overview of European cultural movements, he placed more emphasis on the cultural impact of the Baroque, stating: "The cultural waves that the Baroque unfurled upon Europe were probably more deep, full and uninterrupted than those even of the Renaissance" (Braudel 1949, II: 835).

The late 1970s and early 1980s saw the rise of feminism and a wider focus on identities in the social sciences, which drew attention to the process of individuation and highlighted the androcentric focus of Renaissance histories. Feminist scholars stressed that social identities are constructed and are fluid and contingent, *contra* Burkhardt's idea of the monolithic and indivisible "Renaissance Man" (Kelly-Gadol 1977). The nature of Renaissance individualism was addressed by the literary scholar Stephen Greenblatt in his *Renaissance Self-Fashioning: From More to Shakespeare* (Greenblatt 1980). Although maintaining the Burkhardtian position that the Renaissance had paved the way for the emergence of modernity, Greenblatt was interested in how cultural and political forces had worked to enable or constrain the expression of different forms of individual identity in sixteenth-century England. Drawing upon theory from cultural anthropology, psychoanalysis, and the work of Michel Foucault, Greenblatt devised the term "self-fashioning" to explain how noblemen and women had used prescribed forms of attire, behavior, and portraiture to exhibit their power and authority. Rather than allowing a greater freedom of expression, however, Greenblatt, borrowing a term from the cultural anthropologist Clifford Geertz, reached the conclusion that these nobles had been molded into "cultural artifacts" (Geertz 1973: 51). Self-fashioning in this sense was "the Renaissance version of ... control mechanisms, the cultural system of meanings that creates specific individuals by governing the passage from abstract potential to concrete historical embodiment" (Greenblatt 1980: 3–4). Within this overarching framework that governed both manners and materiality, from forms of dress to possessions, "freedom of choice was strictly delineated" (Greenblatt 1980: 256).

Scholars working on the seventeenth-century English Renaissance were keen to follow Greenblatt's lead. A new interest in Renaissance materiality, sensuality, and physicality can be seen in the influential edited volume, *Subject and Object in Renaissance Culture* (de Grazia et al. 1996). At about the same time, there was a move beyond studying human subjects as autonomous agents to studying human interactions with everyday objects in texts and theatrical performances (de Grazia et al. 1996; Fumerton and Hunt 1999; Jones and Stallybrass 2000).[3]

Research by anthropologists from the late 1970s onwards has emphasized how meanings emerge through social actions and how gifts and commodities can take on different meanings in different cultural contexts (Douglas and Isherwood 1979; Thomas 1991). The works of Arjun Appadurai on the social life of things (Appadurai 1986) and that of Igor Kopytoff in the same volume on the cultural biographies of things (Kopytoff 1986) have been particularly influential in this respect and continue to inspire work on the accumulated histories of Renaissance objects (Olson et al. 2006).

The last two decades of the twentieth century saw the publication of several seminal works by economic historians who were seeking the origins of modern consumer behavior. Within the context of the new wave of neoliberal politics that had risen to prominence in the USA and Britain, it was reasoned that modern attitudes to goods and possessions had most likely appeared in England in the eighteenth century as a consequence of the production of mass-produced goods and the emergence of the world's first "industrial revolution" (McKendrick et al. 1982; Brewer and Porter 1993).

Perhaps not wishing to be outdone, scholars of the Dutch "Golden Age" responded to this claim by insisting that new attitudes to goods and commodities had emerged not in eighteenth-century England, but rather in the prosperous towns of the seventeenth-century Dutch Republic (Schama 1987). Schama's research aimed to decenter the teleological Anglo-American interpretation of the origins of modern consumer society; however, it only served to move the supposed origin a short distance in space and time to a closely related rival trading nation. The historian Jan De Vries took a similar line, arguing that the wider availability of manufactured and exotic goods that became a material signature of the Dutch "Golden Age" created an era of "new luxuries."

> Here, for the first time—on such a scale and on so enduring a basis—was a society in which the potential to purchase luxuries extended well beyond a small, traditional elite. A substantial tranche of society was now in a position to exercise choice—to enter the market and spend money to fashion a consumer culture. (De Vries 2002: 42)

However, while this assertion accurately describes how Dutch houses filled up with new goods and possessions as a consequence of the success of the Dutch East India Company, the origins of this early form of consumerism

are ultimately still explained as being a consequence of Northern European protestant "industrious" behavior rooted in colonial expansion and overseas trade (De Vries 2008).

An alternative explanation, which focused on Southern Europe and Roman Catholic nobles and patricians, placed the origins of consumerism still further back in time. In a series of books and articles written in the 1980s and 1990s, the economic historian Richard Goldthwaite created a compelling case that a significant shift in human attitudes to things took place in Renaissance Italy:

> [A]lthough the world has become infinitely more cluttered since the Renaissance, an argument can be made that modern consumer society, with its insatiable consumption setting the pace for the production of more objects and changes in style, had its first stirrings, if not its birth, in the habits of spending that possessed the Italians in the Renaissance. (Goldthwaite 1985: 660)

At the core of Goldthwaite's argument is the observation that there was a substantial increase in expenditure in the building and furnishing of urban palaces by northern Italian nobles and patricians during the fifteenth and sixteenth centuries (Goldthwaite 1982). This dramatic upsurge of investment in architecture and material culture, which included the acquisition of tablewares, pictures, wall hangings, and all manner of possessions, had of course been noted by Lopez (1953). However, rather than seeing the increased investment in the material world as being a response to uncertainty and hard times, Goldthwaite linked this phenomenon to the growing wealth and aspirations of urban Italian elites. In his view, the objects and art that began to fill Florentine *palazzi* showed a passion for acquisition, and the new forms of urban elite domestic display that came into being were vehicles for self-expression and self-fashioning:

> The Italians worked out and defined values, attitudes, and pleasures in their possessions and goods, so that these things became the active instruments for the creation of culture, not just the embodiment of that culture. (Goldthwaite 1993: 5).

Goldthwaite's focus on high-end material culture inspired a new subfield of Renaissance studies. In her popular book *The World of Goods* (1996), the cultural historian Lisa Jardine surveyed the exquisite jewelry and sumptuous clothing and furnishings that can be seen in Renaissance paintings and reveled in their magnificence. Other scholars have subsequently used the framework of the house and home to examine interior decorations and domestic material life. Valuable contributions to this field include Patricia Fortini Brown's (2004) *Private Lives in Renaissance Venice: Art, Architecture, and the Family*, Elizabeth Currie's *Inside the Renaissance House* (2006), and *At Home in Renaissance Italy* (Ajmar-Wollheim, et al. 2006). The number of historical studies dedicated to

domestic interiors and family life in Renaissance Italy has grown exponentially in recent years and is too extensive to be summarized here. For an overview and critical commentaries, see Ajmar-Wollheim et al. (2007) and Blondé and Ryckbosch (2015).

A major research project hosted by the University of Sussex in collaboration with the Victoria & Albert Museum followed Goldthwaite's focus on material culture and produced two seminal volumes, *Shopping in the Renaissance* (Welch 2005) and *The Material Renaissance* (O'Malley and Welch 2007). Welch's *Shopping* diverted from the line taken by Burkhardt, Goldthwaite, and Jardine and stressed that, far from being a precursor to modern forms of consumption, Italian Renaissance practices involved complex and highly nuanced forms of pre-capitalist exchange. Hence, rather than being driven by the invisible hand of the market, the consumption of goods by sixteenth-century Florentine elites was still socially embedded and contingent:

> Renaissance buying practices were a multiplicity of interconnected events and acts, dependent as much on time, trust, social relations and networks as on the seemingly impersonal issues of price, production and demand. (Welch 2005: 303).

Welch's volume has been criticized by Samuel Cohen on the grounds that it makes little attempt to engage with the economics of production or the impact of luxury goods on living standards in the wider economy (Cohn 2012: 985–6). The essays in *The Material Renaissance*, in contrast, while still drawing inspiration from Goldthwaite's analysis of luxury goods, are far more concerned with the particularities of exchange and tackle the dynamic links between demand, production, and innovation head-on. The volume investigates the demand for material culture in a wide range of contexts, ranging from the design and construction of magnificent palaces to the circulation of used clothing. If a handful of useful chapters may be singled out from this volume, then Paula Hohti's study of an innkeeper's goods breaks new ground by moving beyond the traditional focus on "conspicuous consumption" in elite households (Hohti 2007).[4] Ann Manchette's chapter on the use of credit in exchanges of used clothes and household furnishings in sixteenth-century Florence serves to emphasize that trade and exchange in the Italian Renaissance were socially embedded and contingent upon the relationship between the buyer and the seller. In her words: "Economic transactions cannot be seen as freed from the myriad social commitments that linked people to each other" (Matchette 2007: 225).

Daily life was regulated by customary laws and complex sets of ideas that governed the acquisition and use of goods. Patricia Allerston's exploration of the interplay of intellectual, religious, and sociopolitical ideas in sixteenth-century Venice has shown that while citizens still observed sumptuary laws and

retained the religious belief that sumptuous material was linked to corporeal pleasure and sin, they also made use of the developing commercial facilities at their disposal and "had few difficulties in treating their material possessions as commodities" (Allerston 2007: 28).[5]

The papers in O'Malley and Welch's volume retain their value more than twelve years on. Taken together, they stimulate an interest in the workings of the market in Renaissance Italy and encourage a desire to understand how mundane as well as prestige objects were acquired and valued in everyday contexts (O'Malley and Welch 2007: 2).

Moving beyond questions of commodification and the circulation of goods, an important subfield of study has emerged examining the relationship between artisan skills, modes of production, and the emergence of scientific knowledge. Following on from Pamela H. Smith and Paula Findlen's influential *Merchants & Marvels* (2013), which highlighted how representations of nature were transformed as a result of the growth of global commerce, several studies have focused on how new manufacturing processes were devised to mimic and reproduce natural forms. Pamela H. Smith has examined how artisans experimented with materials and gained insights into the natural world as they created lifelike casts of plants or small reptiles (Smith and Beentjes 2010). Her work has demonstrated how the hitherto separate Aristotelian fields of the "making of knowledge" and the "making of objects" were brought together in Europe in the late sixteenth and early seventeenth centuries as part of the so-called "Scientific Revolution" (Smith 2004; Smith and Schmidt 2007; Smith et al. 2014).[6] The impact of artisan skills and knowledge on the emerging empirical methodologies of the "new sciences" has also been explored by Pamela Long, who has developed the concept of "trading zones" to describe the social arenas where artisans and scholars interacted and shared knowledge about materials and the natural world (Long 2011).

From this necessarily brief and far from comprehensive examination of the historiography of the Renaissance it will be clear that various explanations have been advanced to explain the explosion of creativity and the new interest in material things and possessions that have come to characterize the movement. The Renaissance has served different purposes in different times and places, but it has always provided ontological security by creating a reassuring ideological backdrop to the present, whenever that present might be. In the nineteenth century, this meant providing a narrative to support nationalist movements in many parts of Europe. In the twentieth century, or the so-called "American Century," Renaissance scholarship made a transatlantic leap and was dominated by Jewish–American scholars, many of whom had fled persecution in pre-World War II Europe. The idea that the Renaissance was a moment of unfettered creative genius and arguably the pinnacle of human achievement, unsullied by the hatred and destructive spirit of the twentieth century, seems to shine through

in their work, like a beacon of hope amid the darkness of secular modernity. In the last two decades of the twentieth century and the early twenty-first century, research into Renaissance material culture diversified and became concerned with more mundane issues. Following trends in anthropology and economic history, scholars turned their attention to the circulation and consumption of goods, issues of supply and demand, and the material manifestations of social identities as reflected or enacted through material culture.

One final major scholarly "turn" needs to be explored before we go further into our investigation of Renaissance objects. So far, our discussion has for the most part focused on historical approaches to the Italian Renaissance. But if we are to consider the properties and impact of Renaissance objects in a broad historical context, we need to ask: Was the Italian Renaissance truly as unique as has been claimed? Or was it just another, albeit dazzling, example of a pan-cultural historical phenomenon?

RENAISSANCE: THE ONE OR THE MANY?

The perception that the Italian Renaissance was a unique and, in many ways, self-fulfilling prophesy has arguably always been strongest among art historians. And while it may be the case that the Italian Renaissance should be regarded as "the Big One" by virtue of its size, duration, and long-term influence (Goody 2006: 27), its uniqueness—as a cultural movement or event—has been challenged. In the 1920s, the Harvard medieval historian Charles Homer Haskins made the case for a Renaissance in twelfth-century Europe (Haskins 1927). Other medieval historians have defined a Carolingian Renaissance in the late eighth and ninth centuries (Ullmann 1969; Contreni 1984). Meanwhile, maintaining a focus north of the Alps, art historians have identified a Northern Renaissance that commenced in the late fifteenth century, based on the realist paintings of van Eyck and the Early Netherlandish painters, as well as the work of the Bavarian painter and printmaker Albrecht Dürer, and was assisted by the spread of the printing press (Snyder 1985; Chipps Smith 2004). Focusing less on panel painting and more on tapestry, embroidery, jewelry, and music, Marina Belozerskaya has argued for the power and influence of the fifteenth-century Burgundian Court of Philip the Good, seeking "one alternative to the Italocentric perception of the era," which has tended, since Burckhardt, to see Renaissance creativity as unidirectional, spreading north out of Italy (Belozerskaya 2002: 2).

The possibility of multiple renaissances—or *renascences*—was explored by Erwin Panofsky in the 1940s. Panofsky, however, was keen to maintain the artistic preeminence of the Italian Renaissance, and while acknowledging that other revivals of literature, art, and philosophy had occurred in Europe, such as in the Carolingian twelfth century, he argued these were short-

lived, relatively localized, and far less significant in terms of their long-term cultural significance (Panofsky 1944). Taking a longer-term view of the growth and decline of world civilizations, the British historian Arnold J. Toynbee was also clear that, whereas the Renaissance in Europe was "the natural expression of the western spirit" (Toynbee 1954: 84), it was also "one particular instance of a recurrent phenomenon" (Toynbee 1954: 4). In Toynbee's view, influenced by his belief that civilizations evolved through a process of challenge and response, a renaissance occurred when elements of a former culture were rediscovered and put to cultural use; his use of the word *revenant* suggested a phoenix-like rebirth, with new cultural life arising from the ashes of a dead culture.

More recently, Peter Burke has drawn attention to fact that there were concurrent "renaissances" and that the Renaissance in Western Europe needed to be seen in a wider geographical context, as it was "one culture among others, coexisting and interacting with its neighbours, notably Byzantium and Islam, both of which had their own 'renaissances' of Greek and Roman antiquity" (Burke 1998: 3).

In the early twenty-first century, fifty or more years of postcolonial studies have encouraged more inclusive and nuanced forms of historical writing, and there is also a current trend for writing global histories. Following on from Burke's work in the 1990s, several anthropologically informed scholars have attempted to decenter, or at least to historically contextualize, the Italian Renaissance. In *The Renaissance Bazaar*, the literary historian Jerry Brotton set out to question the "myth of European cultural superiority" (Brotton 2002: 20) and in so doing stressed that the achievements of the European Christian Renaissance were both anticipated and to a large degree enabled by economic and cultural contacts with the Ottoman Islamic East. In his view, the Renaissance that emerged in the northern Italian city-states "looked to the east to define itself artistically and culturally," and eagerly embraced "precious commodities, technical, scientific, and artistic knowledge, and ways of doing business that were way beyond anything understood in what we today would call the west" (Brotton 2002: 37). A similar revisionist concern has been shown by Gerald McLean, who has argued that "the Renaissance would have been entirely different, if not impossible, had it not been for direct and regular contact with the eastern, largely Muslim world" (McLean 2005: 2).

Other scholars have looked beyond Europe to identify material expressions of *"renascences"* in earlier non-Western cultures. In *The Theft of History* (2006), the social anthropologist Jack Goody confronted the problem of "Eurocentric" or "egocentric" approaches to the Renaissance by arguing that "the European Renaissance was not as unique as is often supposed" (Goody 2006: 130). Drawing upon the work of the prehistorian V. Gordon Childe on the Bronze Age (*c.* 3000 BCE), Goody argued that "in all societies descending from the

cultures of the Urban Revolution there was a growth of artistic and 'cultural' forms along with rising standards of living in other mercantile and bourgeois communities in which they were embedded." Furthermore, "Renaissance-type developments may be seen in many parts of the world in the course of urban societies becoming more complex" (Goody 2006: 130).

This long view of renaissances as recursive phenomena is helpful for four reasons. First, it takes us well beyond the closely dated parameters of 1400–1600 CE, which have traditionally been used to argue that the European Renaissance was a unique steppingstone to modernity. Second, it demonstrates that new forms of artistic and artefactual production frequently arise in response to the desires and patronage of mercantile and other bourgeois elites. Third, and this point is amplified in a second book by Goody, which explores "renaissances" in Islam, India, and China:

> A renascence or reformation such as was experienced in Europe (which I distinguish as the Renaissance of Reformation), then, is in principle possible *in any literate society*, in other words, ever since the Urban Revolution of the Bronze Age, because writing enables one to refer back to the "visible speech" originating in earlier times, then to rebuild on that. (Goody 2010: 19, emphasis added)

And finally, a fourth point may be made that the growing academic trend that seeks to decenter the primacy of the European Renaissance occurs at a time of rapidly increasing globalization and ever more fragile international relations. In this context, the trend may be interpreted as an academically motivated form of political intervention. Reinterpreting the Renaissance in Europe as one example of a recurrent form of human behavior places the movement within a broad anthropological spectrum. In so doing, it attempts to break the enchainment that has for centuries sought to privilege Western global hegemony by linking it to a supposedly unique but largely imagined cultural history.

THE MAKING OF "THE BIG ONE"

We have seen how different versions of the Renaissance have emerged over time and how the cultural processes that shaped European art, architecture, and other forms of material culture in the fifteenth and sixteenth centuries have similarities with social and economic processes in very different times and places, arguably extending back in time as far as the Bronze Age. Having said that, we should perhaps accept Jack Goody's point that the Italian Renaissance, and its subsequent European receptions, is arguably still "the Big One." In the light of this, we may ask: What particular set of circumstances, events, or practices arose and coalesced to create the material circumstances of the Italian Renaissance?

European history in the period 1400–1600 was characterized by social and economic change and a desire to embrace new opportunities. The devastating plagues and food shortages of the later Middle Ages had passed, leading to demographic growth in many areas. In the Mediterranean, this led to increased cultural exchanges and to an upsurge in trade as goods from the East entered the ports and city-states of northern Italy. One consequence of this was the enrichment of powerful families, such as the Florentine Medici, who became famed as patrons of the arts. The wealth of such families became embodied in possessions as their homes became arenas for conspicuous consumption. Research in the last twenty years has shown that this new attachment to things and the use of objects to represent and project the image of the individual and the family were not limited to elites, however, and can be seen in different levels of society.

At the same time, the development of humanism, from Petrarch's rediscovery of the letters of Cicero in the fourteenth century to the political treatises of Machiavelli, encouraged Italian intellectuals to question religious orthodoxies. Humanists promoted the idea that man was at the center of his own universe and should embrace progress through self-belief and independent thought. This philosophy led to unprecedented advances in the arts and sciences and to the work of celebrated Renaissance artists such as Leonardo da Vinci and Michelangelo, who excelled in capturing the human form. The humanist rediscovery of classical texts and sculptures also stimulated a renewed interest in nature and the natural world as artists strived to create realistic copies of plants and animals.

In the realm of commerce, mercantile activities were encouraged by the system of double-entry bookkeeping, set down in book form by the newly introduced printing press at the end of fifteenth century by the Franciscan friar and mathematician Luca Pacioli (Galassi 1996). Pacioli's new method for accounting enabled Venetian merchants to accurately quantify their profits and losses and encouraged competition within their ranks. In Florence and other city-states, the rise of wealthy merchants and artisans created powerful *arti* or guilds, whose munificence enriched local churches and public works.

Over the course of the fifteenth and sixteenth centuries, seaborne exploration opened up new trade routes that overcame the limitations of medieval overland trade and down-the-line transshipments. The expansion of global trade, first with the Far East and then with the discovery of the New World, brought a wealth of new materials, plants, and animals to European shores. This collision of cultures, which increased in scale as time went on, led to appropriation, experimentation, and hybridity, and became one of the defining characteristics of the Renaissance. Many of the carefully crafted objects that emerged from this extraordinary interplay of events, circumstances, and skills still hold pride of place in the contemporary world. What can they tell us about their world? Is

it possible to identify specific contexts in which Renaissance objects were put to use? Let's take a trip to Florence.

THE YOUNG MARBLE GIANT: PUBLIC ART AND CIVIC PRIDE IN RENAISSANCE FLORENCE

Michelangelo's statue of David stands to a height of 17 feet and is the most famous sculpture from the Italian Renaissance, and arguably one of the most famous sculptures of all time. The sculpture has achieved an iconic status due to its smoothly contoured muscularity and elegantly proportioned masculine physique. But Michelangelo's greatest trick was his decision to use a facial expression to capture a moment of thought. So rather than depicting David in a fighting stance or in the moment of victory over Goliath, holding up the giant's severed head, Michelangelo chose to depict the shepherd boy in a relaxed pose, but with a furrowed brow. This is the moment when David has decided that he must fight and is anxiously anticipating the contest.

The sculpture has acquired many layers of meaning. It was originally commissioned to be a piece of religious art to commemorate the Old Testament hero and prophet from the Book of Samuel. A contract to create the artwork was awarded to the sculptor Agostino di Duccio in 1464, and the work was intended to be one of twelve statues to be placed on the east-end of the roof of the Cathedral di Santa Maria del Fiore in Florence.

The statue was only completed forty years later, by Michelangelo, after Agostino di Duccio and a second sculptor had both failed to complete the commission. When it was unveiled in 1504, the sculpture gained a political meaning, as its strength and sense of resolute defiance was taken to represent the Florentine Republic. Michelangelo had read his audience well. As he worked the massive lump of flawed Tuscan marble, he had taken care to flatter his biblical subject, but he had also made sure that it would appeal to the city-states' intellectual elites with their humanist beliefs. David's oversized head is said to represent his intelligence, while his disproportionately large and flexed right hand clutching a stone indicates his strength, and also perhaps puns on David's nickname, *manu fortis*, or strong hand. This David is a rational individual and embodies the humanist idea that man can shape his own destiny by using his intelligence, skill, and willpower.

After a civic debate that involved such luminaries as Leonardo da Vinci and Sandro Botticelli, it was decided not to consign Michelangelo's David to the rooftops, but to install the statue in a public square outside the Palazzo Vecchio. This location was already politically charged, as the statue of David replaced Donatello's bronze statue of Judith and Holofernes, which had grown to become associated with the expulsion of the tyrannical Piero di Lorenzo de Medici from Florence and the introduction of the Florentine Republic under

Girolamo Savonarola. The decision to place the statue in a public square added to its humanist appeal. Here was the rational hero standing tall and ready to embrace his civic duties, with his resolute gaze pointing in the direction of the city state's archrival, Rome. So, in this sense, David is as much a political statement as a piece of artistic eye candy. The jobbing sculptor and painter Michelangelo probably cared little for this outcome, however, as he had already shaken the Florentine dust from his sandals and departed to undertake another commission in Rome before the statue of David was raised in the square. The statue, nevertheless, may only be fully comprehended as a highly symbolic and potent work of art if due consideration is given to its context and to the contemporary politics of the northern Italian city-state (Seymour 1967: 56).

Two further points can be made about this sculpture. First, it is significant that Michelangelo chose to depict David standing in *contrapposto*, or counterpoise. David stands with most of his weight on his right foot, and his shoulders and arms are twisted and off-axis from his hips and legs. This posture makes a conscious reference to classical traditions and to the sculpture of ancient Greece, which featured standing figures of heroic male nudes. Second, it is important to note that the statue was commissioned by the *Arte della Lana*, the wool guild of Florence, whose growing wealth was called upon to fund the upkeep and decoration of the cathedral. Here, we may glimpse the behind-the-scenes power of the urban mercantile and artisan elites. The new mercantile wealth that emerged in Italian city-states and other parts of Europe in the fifteenth century sponsored a tsunami of artworks. This powerful wave of creativity has rolled on through subsequent periods of world history with the figure of David riding high, like a self-styled surfing poster boy.

It is not difficult to see why this imagined Renaissance of exquisite paintings, sculptures, and buildings is so appealing. On the one hand, the global super rich are seduced into paying ever steeper prices for Renaissance artworks by international auction houses as they jostle to appropriate perfection. And on the other, the growth of global tourism has significantly increased footfall on the marble pavements of northern Italian cities. At the same time, the process of heritization, which scours historical periods for distinctive works of art that may be replicated and marketed, has saturated the gift shops of the world's major museums and galleries with copies of Renaissance things. This Renaissance is a supremely "reproducible past," and copies of Renaissance objects are constantly refashioned and incorporated into our everyday lives (Findlen 1998: 85).

In the case of Michelangelo's David, the brooding athletic youth has been transformed and ironicized in numerous ways by pop art and twenty-first-century advertising campaigns. In 2007, a German Olympics Sports Confederation fitness campaign depicted David as a morbidly obese teenager with the slogan, "If you don't move you get fat." The image of David as an overweight youth has since been replicated by the souvenir industry in Tuscany (Figure 0.1).

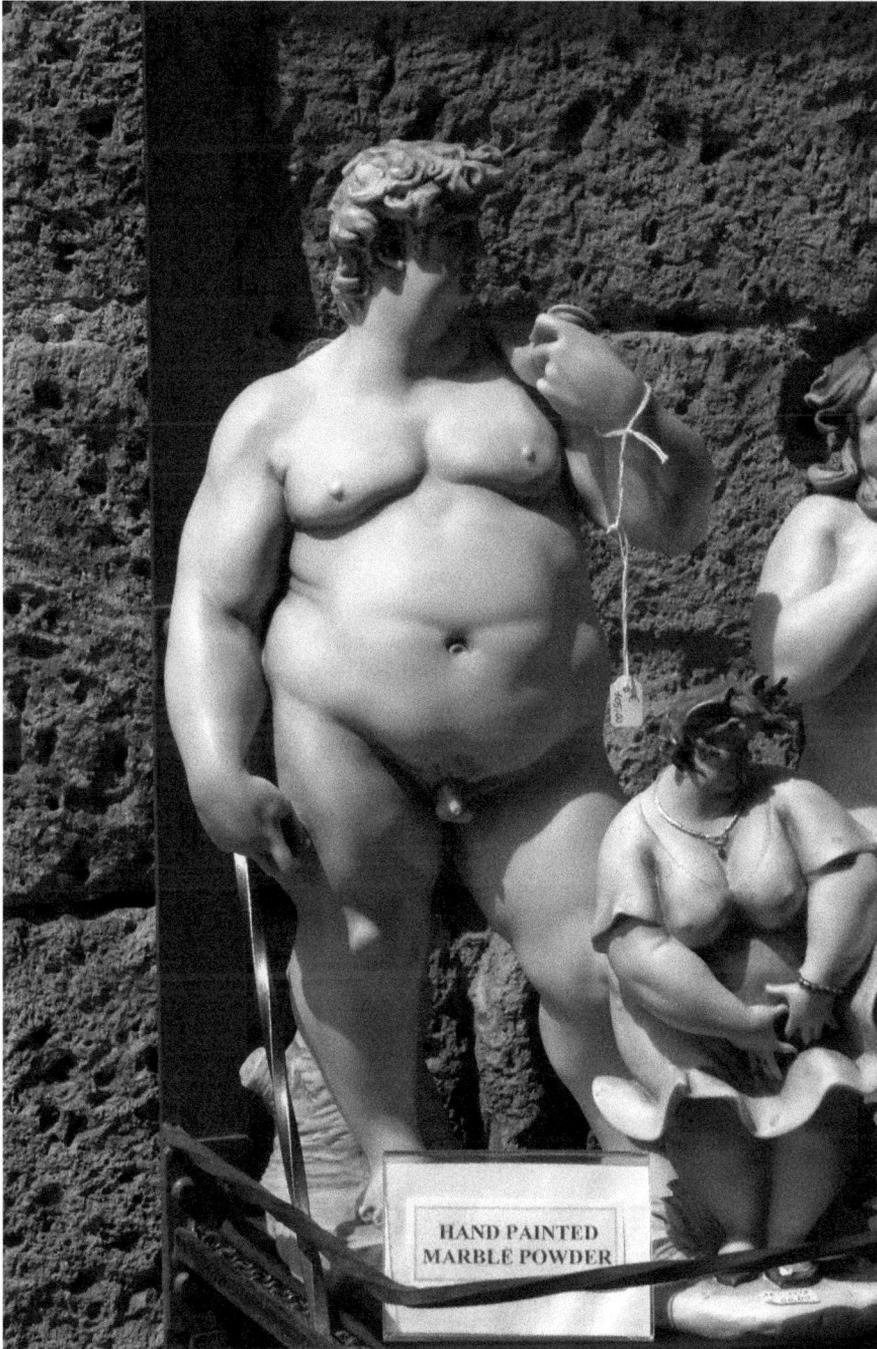

FIGURE 0.1 Overweight David tourist souvenir, San Gimignano, Tuscany. Based on a German Olympics campaign advert developed by Scholz & Friends, Hamburg, Germany. Photograph: Alamy.com.

This Renaissance is more than a lucrative brand, however. Its attraction rests not only on the beauty and creativity of its artworks, but also on an imagined cultural connection to the present. This perceived connection has meant that the Renaissance has become a particularly enduring trope. Hence, we may happily imagine the heroic geniuses Michelangelo and Leonardo da Vinci in the sunbathed piazzas of late sixteenth-century Florence as *people like us*, the only difference being their period clothing.

The statue was also a religious statement, being a materialization of an Old Testament hero, framed in a genre that created a link to, but arguably surpassed, the craftsmanship of the classical past. But David's muscular physique also embodied Florence's civic pride. He was a homegrown local hero and reflected the city's growing mercantile wealth and desire for art. All of these qualities, along with the stubborn local marble from which the statue was hewn, were essentially local to the northern Italian urban culture that commissioned the work.

Moving on to our next case study, it is important to remember that whereas some Renaissance objects were homegrown and were intended to celebrate the power of patricians and their localities, other objects stand out for their exoticism and unfamiliarity. An investment in local art signaled wealth and taste and bolstered the power of Renaissance oligarchs. The possession of fine art and architecture served to muffle criticism and to naturalize the power of elites. The collection of natural curiosities, on the other hand, demonstrated rationality and the power to assemble and domesticize or otherwise exercise control over the natural world.

WHEN WORLDS COLLIDE: NATURE, COLLECTING, AND THE EXPANSION OF GLOBAL TRADE

On May 20, 1515, an Indian rhinoceros was manhandled out of the hold of a Portuguese carrack and raised its head to sniff the air in Lisbon's Belém harbor. The rhinoceros was the first of its kind to be seen alive in Europe for 1,200 years, and it was a gift from Muzaffar Shah II, Sultan of Gujarat, to Alfonso de Albuquerque, the governor of Portuguese India in Goa. On his arrival home, Alfonso de Albuquerque presented the beast, which came to be known as Ulysse, to the Portuguese king, Don Manuel I (1495–1521). The sheer exoticism of this beast intrigued everyone who saw it, as it was paraded around the streets of the Ajuda National Palace. In the spirit of gift exchange, the young king made plans for this prestige item to be passed on up the line, as a diplomatic gift to the Medici Pope Leo X. But Ulysse never made it to Rome, as he was drowned when the ship that was transporting him foundered in rough seas off the coast of Liguria (Smith and Findlen 2013: 1–3).

A representation of the unfortunate Ulysse is known to us from Albrecht Dürer's 1515 pen sketch and woodcut entitled *The Rhinoceros* (Figure 0.2). Although Dürer never actually saw Ulysse, he was able to visualize the creature from a drawing and notes, now lost, that had been sent to the merchants of Nuremberg by Valentin Ferdinand, a German printer who lived in Lisbon. Dürer accurately depicted the Indian rhinoceros's single horn and pointed mouth, and the wart-like bumps that cover the rear and shoulders of this species. His imagination added other less precise details, however; the bird-like scales on the legs, the small, narwhal-like horn protruding from the back of the neck, and the elephant's tail. Further artistic improvisation can be seen on the rhinoceros's armored plates. Dürer was living next to the Schmeidegasse armorer's quarters in Nuremberg in 1515, and it has been suggested that the patterning on the rhinoceros's plates may incorporate designs for armor that he was also working on at the time (Clarke 1986: 20).

Thanks to the use of the printing press, Dürer's image of the rhinoceros was widely circulated in Northern Europe. In the thirteen years between 1515

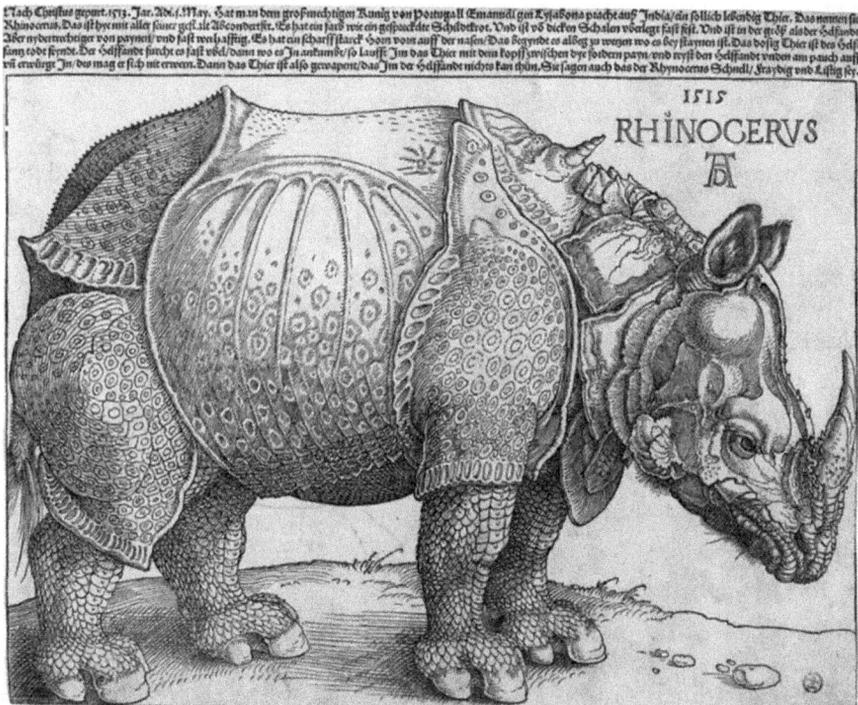

FIGURE 0.2 Albrecht Dürer, *The Rhinoceros*, 1515. © The National Gallery of Art, Washington, DC.

and Dürer's early death at the age of fifty-seven in 1528, it has been estimated that as many as 5,000 prints of the image were sold. The image promoted a sense of wonder in the mysteries of the East and fabulous beasts. And as with Michelangelo's David, the image of Dürer's rhinoceros has percolated through time and has been copied and reinvented by artists ranging from sixteenth-century German and Italian printmakers, to the Danish tapestry weavers of Kronborg Castle and the twentieth-century surrealist Salvador Dali, who produced his homage, the cast bronze *Rhinocéros Cosmique*, in 1956.

Dürer's rhinoceros, timeless and bold, is a fine example of how new conceptions of the natural world emerged from the interplay of commerce and patronage and the "intersection between patronage and commerce" (Smith and Findlen 2013: 4). The growing interest in the accurate firsthand observation and representation of nature that occurred in late sixteenth and seventeenth centuries led to an upsurge in artistic and artisan production. This thirst for knowledge and experience elevated gifted individuals such as Dürer, who could provide a "true portrait" of nature, to a high social status.

Elites have amassed collections of prestige objects to bolster their status throughout history and continue to do so. But in the sixteenth and seventeenth centuries, the desire to accumulate and order nature led to the emergence of highly distinctive collections of objects. In northern Italy, the Medici's and others assembled curiosities along with paintings in specially constructed *museo* or *galleria* (Koeppe and Maria Gusti 2008). From the middle of the sixteenth century, a new form of display emerged in Central Europe; the *Kunst-und-Wunderkammer*, or cabinet of art and wonder. This form of collecting originated among the wealthy merchants of the Bavarian imperial city of Augsburg and the Fugger family, who made use of their widespread trading contacts both north and south of the Alps to acquire curiosities (Meadow 2002).

The *Kuntskammer* was conceived as an encyclopedic collection of all kinds of objects that contained and exhibited universal knowledge. The objects and exotic specimens that were displayed, many of which were obtained for the first time through New World encounters, belonged to two major categories: natural objects (*naturalia*) and manmade objects (*arteficialia* or *artefacta*). The category of manmade objects often included a subcategory of mechanical and navigational instruments (*scientifica*). Taken together, the assembled *Kunstück*, which in modern German translates as "a trick" or "sleight of hand," and "*Kunstkammern*" provided a panoptic vision of the natural and manmade world. Such deeply meditated themes demonstrated the power of the owner, their ability to dominate and master nature, and their just place within divine providence.

In its modern usage, the term "cabinet" describes a wooden cupboard with shelves or fitted drawers for storing or displaying items. The cabinetmakers of sixteenth-century Augsburg produced pine and gilded metal cabinets, but also

created smaller, exquisitely crafted tabletop cabinets of ebony and silver. Such high-end pieces, intended for aristocratic or royal households, were the work of many hands and made use of an international network of skilled metalworkers and jewelers. Some of the finest surviving Augsburg *Kunstkammers* were decorated with *pietre dure*: Tuscan marble panels inlaid with designs of birds and flowers in deep blue lapis lazuli and brightly colored precious stones. The term "cabinet" was not only used to describe pieces of furniture in the sixteenth century, however. It could also refer to a collection or to a series of rooms in which a collection was housed, either in a private residence or a semipublic space (MacGregor 2007: 11).

The sizes of collections and the buildings in which they were housed reflected the self-esteem and ambitions of their patrons. In 1560, the Lutheran Augustus I, Elector of Saxony, created the Dresden *Kunstkammer*. Augustus referred to his *Kunstkammer* as a "working collection" and used the opportunity to make a political point, commissioning the goldsmith and clockmaker Hans Schlottheim to make a table decoration of a ship, or *nef*, in the form of a clockwork automaton. This object, now in the possession of the British Museum, is known as the Mechanical Galleon. When it was set in motion, the machine showed Augustus and the six other electors parading in a dutiful manner to the beat of a drum beneath the seated figure of Rudolph II, the Holy Roman Emperor.

The largest and grandest *Kunstkammers* were created in the sixteenth century by the Austrian Habsburg emperors. Archduke Ferdinand II of Tyrol refurbished the medieval Schloss Ambras near Innsbruck in 1570–1571 to include a large collection of arms and armor and paintings. He also created new rooms to house a *Kunstkammer* incorporating jewels and gems that he had inherited from his late father, Emperor Ferdinand I (1503–1564). Ferdinand II opened the Ambras *Kunstkammer* for guided tours and attracted prestigious visitors from across Europe, including Queen Christina of Sweden and Goethe. The Ambras *Kunstkammer* nevertheless paled into insignificance in comparison to the collection amassed in Vienna by the Habsburg emperor Maximillian II (1564–1576), and subsequently moved to the royal castle of Hradčany in Prague and installed in purpose-built rooms as the *Rudolphinische Kunst-und-Wunderkammer* by his son, Emperor Rudolf II (1552–1612).

MERCHANT CHIC AND HOUSE-PROUD WIVES: THE DOMESTICATION OF THE RENAISSANCE

The *Arnolfini Portrait* (or *Arnolfini Wedding*) (Figure 0.3) has graced the walls of the National Gallery in London for almost 180 years and is acknowledged as being one of the masterpieces of the fifteenth-century Burgundian Renaissance. A small painting on an oak panel measuring two feet in width and just under three feet in height, it offers a remarkable double portrait of a wealthy couple

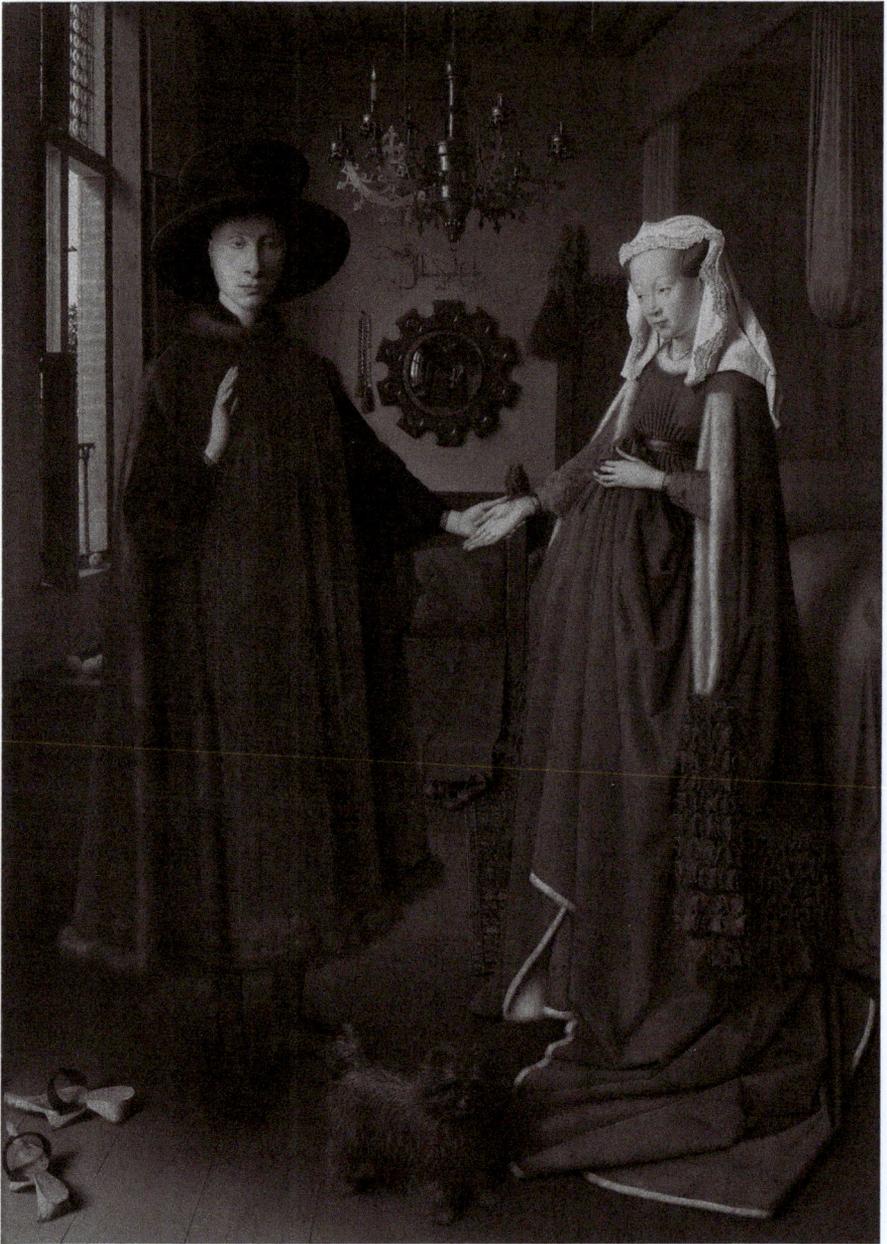

FIGURE 0.3 Jan van Eyck, *Arnolfini Portrait*, 1434. © The National Gallery, London.

standing in their well-appointed home in Bruges. In the nineteenth century, the couple were identified as being the cloth merchant and financier Giovanni di Arrigo Arnolfini and his wife Jeanne Cenami, from Lucca, near Florence. Erwin Panofsky suggested that the portrait was a form of marriage contract,

which had been signed and witnessed by the Flemish painter Jan van Eyck in 1434 (Panofsky 1934). Others have suggested that the portrait may show the act of betrothal, or Giovanni Arnolfini bestowing legal authority upon his wife to conduct business on his behalf (Carroll 1993). More recent research has questioned the identities of the subjects. It is now thought that the male figure may be Giovanni di Nicolao Arnolfini, a cousin of Giovanni di Arrigo. If this is the case, then the woman may be Giovanni di Nicolao Arnolfini's first wife, Costanza Trenta. This interpretation changes the possible meaning of the painting, as Costanza died in childbirth in 1433. The painting may therefore be a form of memorial, depicting the dead wife standing beside her husband (Koster 2003).

Whatever the truth of the matter may be, and here we must concede that the painting will probably always retain its secrets, the portrait offers a rare insight into a fifteenth-century Renaissance interior. We can say this as an innovative piece of research using computer vision algorithms to analyze the reflections in the convex mirror on the wall behind the two figures has shown that van Eyck was working with a *tableau vivant* (i.e. with real posed figures and real objects in an actual room) (Criminisi et al. 2004: 18). That said, art historians will doubtless continue to debate the possible hidden symbolism behind the posture and joined hands of the two figures and the objects depicted in the room—from the small Brussels griffon dog, to the open curtains of the bed, to the cherry tree in blossom outside the window, which have been variously interpreted as depicting faith, fecundity, and hopes for procreation (Harbison 1985; Bedaux 1986).[7]

Another way of looking at this painting is to see it at as an artifact of mercantile capitalism. When looked at in this way, the oriental carpet, brass chandelier, Venetian convex mirror, and canopied bed take on different but no less significant meanings; these are the trappings of commercial success. The couple are shown in summer, and yet both Arnolfini and his wife are dressed in the heavy formal clothes of a medieval merchant household. His purple silk tabard is edged with sable and is worn over a patterned doublet of silk damask. On his head he wears a wide-brimmed plaited straw hat that has been dyed black. The woman wears a green high-waisted wool dress that is also lined with fur, with slashed sleeves and folded cloth *dagging*. She gathers the dress, which may have been made from more than fifteen yards of woolen cloth, to her stomach, as was fashionable at the time. This stance often leads modern viewers to erroneously assume that she is pregnant. Her head is covered by a linen *kruseler* headdress and her hair is tied up, indicating her married status (Carroll 1993: 101).

Viewers of the *Arnolfini Portrait* are struck by its realism and how van Eyck has succeeded in capturing an intimate domestic moment. However, Lisa Jardine has offered a rather different interpretation of this scene: "This is not a record of a pair of individuals; it is a celebration of ownership—of pride in possessions from wife to pet, to bed-hangings and brasswork" (Jardine 1996: 15).

In this reading, the purpose of the painting—which is perhaps borne out by the unrealistic and stereotypical depiction of the woman's face—is not to create an accurate likeness of the couple, but rather to capture "the mental landscape of the successful merchant—[and] his urge to have and to hold" (Jardine 1996: 15). Here, then, is a celebration of material possessions, of goods fetched from afar, and of the opportunities that the fifteenth century offered for a successful merchant such as Arnolfini to surround himself with possessions.

This final case study was chosen to illustrate the importance of domestic objects in Renaissance life. In his description of the domestication of the Renaissance, Peter Burke has shown how the new forms of material life created in the Italian Renaissance went on to influence daily life in other parts of Europe through the spread of material culture, practices, and mentalities (Burke 1998: 175–209). Our view of the Arnolfini household is limited to an upstairs reception room. If it were possible to also see the kitchen and lower rooms, we would doubtless encounter exotic foods and spices, and new forms of technology for heating the house, such as a wood-burning tile-stove (de Langhe et al. 2015). Although no account of dining practices in the home of a Burgundian merchant has survived, the court of Charles the Bold of Burgundy (1467–1477) set a high standard and was famed for its elaborate feasts of swan and peacock, with the carving and pouring of fine wines handled by a large retinue of highly trained servants (Albala 2016: 13).

The package of refined Renaissance living, which was spread across continental Europe by means of material culture, practices, and mentalities, was diverse and transformed many households. Houses at this time—even of the superrich—did not possess designated dining rooms, and merely adapted rooms for feasting based on the occasion and the number of guests (McIver 2014: 112). A desire for comfort and the display of social status nevertheless created new forms of dining, with specially designed tablewares and accessories.

In the Middle Ages, ordinary households in Northern Europe would have used earthenware vessels and jugs and wooden plates and bowls to prepare and serve their food (Albala 2016: 131). However, in the fifteenth century, new forms of tin-glazed earthenware—or *majolica*, which imitated medieval Hispano-Moresque ceramics from southern Spain—were manufactured at Deruta, and elsewhere in central Italy. These polychrome ceramics, which often took the form of platters decorated with religious or other themes, were suitable for display as well as use on the table, and soon found their way into households across continental Europe. The success of these new tin- and lead-glazed wares spawned many imitations—with *faience* being produced in France and elsewhere, and *delft* in The Netherlands. Advances in kiln technology in Northern Europe allowed potters in Cologne to produce new forms of brown salt-glazed *Rhenish stoneware* tankards and jugs in the first decade of the sixteenth century. Other forms of *Seigburg* and *Raeren* stoneware

followed by the mid-sixteenth century. These attractive and durable gray and blue stonewares were accompanied on fashionable dining tables by thin-walled Venetian drinking glasses. Multipronged forks were also introduced at this time, initially with only limited success in Northern Europe, to accompany knives and to prevent the hands from touching food during dining (Albala 2016: 131–2).[8]

RENAISSANCE OBJECTS IN 2020

This chapter has surveyed changing ideas of the Renaissance in historical perspective from the mid-nineteenth century onwards. It has also provided a concise introduction to the study of Renaissance objects. To conclude, I would like to briefly explore current trends in the study of Renaissance materiality, highlighting recent developments and new directions of study.

One thing that is immediately apparent from a survey of recent publications is that the study of Renaissance things—hitherto often a niche field of art history or museum studies—has benefited from wider developments in the study of history and the humanities. The "material turn" that has taken place in history in the last twenty years has encouraged historians to examine a range of "sources beyond texts" (Harvey 2009). It has become fashionable for historians to consider how objects were made and how they were received and used by men and women of different social standing (Gerritsen and Riello 2015). This new interest in things has served to break down traditional disciplinary boundaries and has stimulated collaborations between university-based historians and object-oriented or collections-based researchers in museums. In this respect, the material turn has had a major impact upon the study of objects and their histories in the later medieval and early modern periods (Hamling and Richardson 2010; Findlen 2013; Richardson et al. 2016).

The most significant recent development, however, has come from what Paula Findlen has described as a concern for the "geography of objects" and the material dimensions of global history (Findlen 2013: 15). To some extent, the "globalization" of Renaissance history has followed a furrow that was opened by Jardine (1996) and Brotton (2002), who argued for transcultural perspectives several years ago. The more recent interest in the "global lives of things" has nevertheless produced a wide range of studies investigating the movement and interaction of all kinds of commodities and artifacts across seas and continents. The number of studies documenting the movement of a diverse range of items such as porcelain, silver, silk, coral, feathers, and plant seeds is now extensive (Ajmar-Wollheim and Molà 2011; Gerritsen and Riello 2015; Lemire 2018). This exciting new body of scholarship has served to destabilize many of the older master narratives of Renaissance history, creating more complex and nuanced object-oriented nonlinear histories.

An interest in the "thingness" of things has led other scholars to investigate the affective and material qualities of Renaissance objects. Ulinka Rublack, influenced by Jane Bennett's concept of vibrant matter (Bennett 2010), has argued that studies of Renaissance material culture need to move beyond documenting patterns of circulation and consumption to consider the "life and vibrancy of matter itself" (Rublack 2013: 44). Her work on the wealthy sixteenth-century Bavarian merchant Hans Fugger has shown the extraordinary lengths to which he went to surround himself with fashionable leather goods, from shoes and boots made from Spanish and Moroccan leather, to the gilded Venetian leather wallpaper that decorated his home. Rublack's interest in materials is grounded in her belief that "artefacts gained their significance and attractiveness by drawing attention to the features of their matter and to the crafting skills involved in their creation" (Rublack 2013: 42).

To support her argument that matter in the Renaissance was malleable and potent, Rublack cites Caroline Walker Bynum's study of religious objects in late medieval Germany (Bynum 2011). Bynum's study gives many examples of miraculous transformations of devotional materials, such the seemingly widespread occurrence of bleeding hosts, but Rublack selects the grisly example of fired-clay decorative stove tiles bearing images of Protestant martyrs, which are said to have reminded devout households of the suffering of the martyrs, who had been burned for their faith, as they took on heat when the stove was in use (Bynum 2011: 52; cited in Rublack 2013: 44). As we have seen, Pamela H. Smith's work has shown a similar concern for the properties of materials and artisan production methods (Smith 2004). Smith's work has taken a different tack to Rublack, however, moving beyond textual sources to include laboratory-based experimentation in an effort to physically recreate lost skills and techniques.[9] In her most recent book, *Entangled Itineraries*, Smith has made a valuable contribution to studies of the global renaissance. By examining how trade goods from the East passed over land and seas, she has shown how "knowledge, embodied in people, materials, objects, texts, and practices" flowed across the Eurasian continent and was gathered together in "hubs of exchange where different social and cultural groups intersected and interacted" (Smith 2019: 1).

Finally, following broader academic trends, theories from the New Materialisms (Coole and Frost 2010) and post-humanism (Wolfe 2010; Braidotti 2013) have recently made significant inroads into Renaissance studies. This is most clearly seen in literary and cultural studies, where classical humanist dualities, such as mind and body, human and animal, culture and nature, are increasingly being challenged. A desire to decenter the human and to question the influence of Renaissance humanist ideas, as may be seen in da Vinci's Vitruvian Man, has led Braidotti to write, "[C]lassical Humanity is very much a male of the species: it is a he. Moreover, he is white, European, handsome and able bodied" (Braidotti 2013: 24). Joseph Campana and Scott Maisano have

rejected this view as being overly simplistic, however, and while they also seek to distance themselves from the particular image of the Vitruvian Man, they point out that Renaissance ideas of the human were "at once embedded and embodied *in*, evolving *with*, and de-centred *amid* a weird tangle of animals, environments, and vital materiality in works from the fourteenth to the seventeenth century" (Campana and Maisano 2016: 3). Their edited volume contains a number of chapters that deal with aspects of post-human materialism. One of the most striking, by Lara Bovilsky, finds evidence for "mineral emotions" in the work of Shakespeare and Marvell. In her examination of the use of imagery, she writes:

> Critics have seen this imagery—of weeping statues, of stony constancy, of rocky hearts and flinty bosoms, of cruel wooden blocks insensitive to fiery passion—as representing a Neostoic ideal of life without emotional perturbation ... By contrast, I suggest that the language of mineral emotion posits a kinship both with human beings who feel too much and those who scarcely feel at all, via the surprisingly available subject position of stone or metal itself.

She goes on, "Belief in mineral emotion is used to extend the range of human experience to encompass unusual extremes of affective intensity and unfeelingness" (Bovilsky 2016: 255).[10]

To conclude, the premodern world of Renaissance objects was fashioned in a range of settings where cultural conservatism, social obligations, and religion, folk belief, and customary practices still held sway. But in sharp contrast to medieval life, Renaissance objects were also shaped by powerful new ideas about what it meant to be human, increased access to a dazzling array of new materials, and represented the first stirrings of a truly global awareness. As the wealth of merchants and patricians increased, patronage of the arts and crafts supported the growth of new forms of artistic and artisan production. The new skills acquired by artisans and their experimentation with materials created new insights into the natural world and paved the way for the emergence of modern science. Access to high-status objects was, of course, still closely guarded by the church and powerful oligarchs, who attempted to maintain their status through the use of religious dogma and sumptuary codes. However, over the course of the fifteenth and sixteenth centuries, many European households started to accumulate possessions on a hitherto unprecedented scale. Henceforth, material life became entangled in extensive global trade networks and people began to live their lives through things. In time, this led to the emergence of new conceptions of the self, consumption, and society.

Objecthood

The Early Modern Cataloguers of Matter

VISA IMMONEN

In François Rabelais's (1483–1553) satirical novel *Gargantua*, originally published in 1534, the apparel of the eponymous giant is described with painstaking detail. The man's codpiece is said to be made of

> sixteen ells and a quarter of the same cloth, and it was fashioned on the top like unto a Triumphant Arch, most gallantly fastened with two enamell'd Clasps, in each of which was set a great Emerauld, as big as an Orange; for, as sayes *Orpheus, lib. de lapidibus*, and *Plinius, libr. ultimo*, it hath an erective vertue and comfortative of the natural member. ... [B]ut had you seen the faire Embroyderie of the small needle-work purle, and the curiously interlaced knots, by the Goldsmiths Art, set out and trimmed with rich Diamonds, precious Rubies, fine Turquoises, costly Emeraulds, and *Persian* pearles; you would have compared it to a faire *Cornucopia*, or Horne of abundance, such as you see in Anticks, or as *Rhea* gave to the two Nymphs, *Amalthea* and *Ida*, the Nurses of *Iupiter*.[1]

In the passage, besides making fun of Renaissance enthusiasm of constantly referring to the authors and myths of Antiquity, Rabelais captures the early modern fascination with carefully depicting and cataloguing luxurious objects. The material qualities and their exotic origins as well as the craftsperson's skills were exhaustively recorded, and the curative

and enhancing properties of the objects laid out. Regardless of whether such lengthy inventories were intended to amuse or impress their readers, they evince a high sensitivity to objects (Rublack 2013). The receptiveness to artifacts is far from exclusive to the early modern period, and it was manifested, for instance, in the relations between humans and objects in Europe throughout the medieval period. Nevertheless, this subtleness had particular significance in the fifteenth and sixteenth centuries, which saw marked transformations in material culture and the patterns of production, trade, and consumption. Material changes were accompanied by the emergence of new ideas, not only in sciences, economics, and the arts, but also in metaphysics, theology, and being a human.

Scholars have discussed the early modern period, especially in Central and Western Europe, as an age of transition from the Middle Ages to the modern period (Gaimster and Stamper 1997; Dyer 2001). It was a time of growth after the fourteenth-century crises of climate change, commercial decline, wars, and the Black Death (Campbell 2016). In Northern Europe, archaeological evidence suggests that the changes occurred somewhat later. For instance, in the towns of south Finland, the first traces of the early modern ways of producing and using objects appeared in the late fifteenth century and increased in the sixteenth and seventeenth centuries, whereas in north and east Finland, the older forms of human–object relations are visible as late as the eighteenth and nineteenth centuries (Haggrén 2009; Nurmi 2011).

Whether these changes took shorter or longer spans of time to unfold, they nonetheless formed an age that altered and redefined material culture as well as related concepts and views. The transformations were not, however, a straightforward disappearance of the Middle Ages in the face of the modern, but rather they comprised a heterogeneous and asynchronous set of continuities and discontinuities affecting the relations between humans and objects. In fact, Martha C. Howell (2010) underscores that the age was governed by its own logic that is not reducible to the human–object arrangements of the preceding or succeeding periods.

During the age of transition, the patterns of consumption began to take the shape of modern commercialism, secularism, and individualism (Goldthwaite 1993; Jardine 1996; see also Martines 1998). In parallel, the volumes of production increased substantially, and trade relations became more efficient and global in scale, connecting Europe more firmly with the Middle East and Far East, Africa, and, from the late fifteenth century onwards, with America. The new transatlantic influx of commodities changed European economies. Concurrent with the large-scale economic developments in the aristocratic and mercantile domestic spheres, the amount and diversity of domestic artifacts increased, and, for instance, dining as a performance became more differentiated, with specialized implements and vessels. In the same vein,

the concept of private objects and the desire for privacy and comfortable environments emerged. Although these cultural and technological changes affected mostly the lives of the higher social strata, they gradually made an impact on other layers of society as well.

Metamorphoses in the European economy, trade, and material culture intertwined with notions and scholarship on objects and the material world. The circulation of these novel ideas was enhanced by new, less expensive printing technologies, which allowed wider audiences to access academic discussions and public debates. In this chapter, I will chart the vibrant intellectual environment in which concepts of matter, objects, and human engagements with objects were addressed. What were the main epistemic principles for accessing the material world? Or in other words, how was knowledge on objects constructed in the fifteenth and sixteenth centuries?

Due to the importance of the Renaissance for the emergence of modern Europe, a lot of ink has been spilled on the intellectual history of the early modern period. In their visions of the Renaissance, such nineteenth- and early twentieth-century scholars as Jacob Burckhardt (1818–1897) (1878) and Johan Huizinga (1872–1945) (1924) emphasized the abrupt breaking down of medieval traditions and the emergence of modern individualism and the Scientific Revolution (de Grazia et al. 1998). Since the late twentieth century, however, the conception of the heroic and unparalleled early modern culture has been superseded by more nuanced and complex views. In fact, the emergence of individualism and capitalism can be traced back to the Middle Ages (e.g. Gurevich 1995; Carelli 2001), and there was a strong continuum between medieval and early modern patterns of thought.

Michel Foucault (2002) characterizes the Renaissance in terms of episteme. By episteme he refers to the conditions that ground knowing and knowledge during any particular epoch. Foucault argues that the Renaissance episteme was based on resemblance and similitude. These were the main methods of deciphering all natural and artificial objects, signs, and images to uncover the underlying truth. Although Foucault's line of argument has been shown to suffer from an insufficient grasp of the versatility of Renaissance thought (MacLean 1998), it still remains a powerful framework for approaching the early modern period. Nonetheless, it is not possible to do justice to the dynamic period of two centuries in one chapter, but I will identify core issues and questions that early modern scholars shared when they addressed human–object relations.

THE ARISTOTELIAN TRADITION OF PHILOSOPHY

The continuity from medieval to Renaissance philosophy rests on Aristotle (*c.* 384–322 BCE) (Figure 1.1) (Schmitt 1983). In the thirteenth century, his

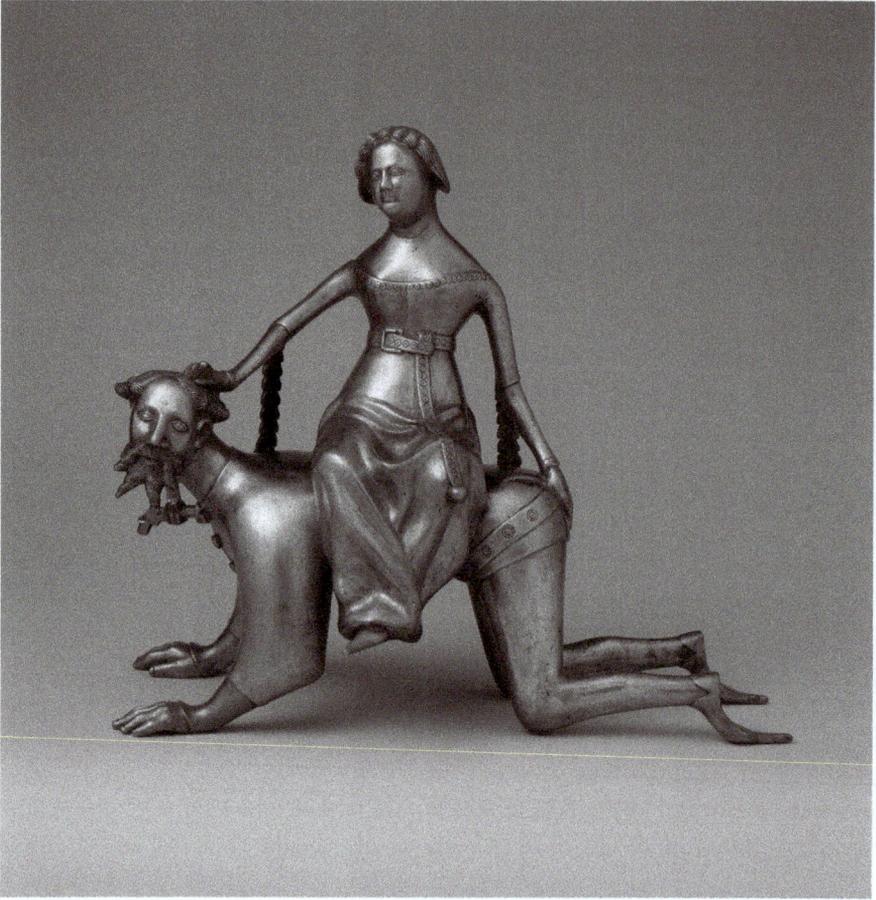

FIGURE 1.1 A late fourteenth- or early fifteenth-century aquamanile of bronze made in the southern Netherlands. Photograph: Artokoloro/Alamy Ltd.

works were established as the main philosophical authority to be followed and commented upon. Thomas Aquinas (1224/6–1274) launched a monumental attempt to synthesize and systematize Christian theology with the help of Aristotelian thought (Pieper 2001). This scholastic tradition continued to dominate professional teaching of logic and natural philosophy at European universities during the early modern period (Kuhn 2018), although the Aristotelian legacy became increasingly questioned and criticized (Kristeller and Mooney 1979). In addition to Aristotelianism, two strands of scholarship developed in the fifteenth and sixteenth centuries. The first was Humanism, a project retrieving and reconstructing ancient and Biblical texts with rigorous philological methods. While the humanist strand discussed moral problems and traditional logic, the second, Neoplatonic strand, drawing on

Plato's (429?–347 BCE) writings, was mostly interested in metaphysical and cosmological issues as well as poetry and literature (Kristeller 1980: 105).

The essential tenets of the Aristotelian approach to metaphysics and physics regarding early modern notions on objects and their study were: (1) the doctrine on matter and its change; (2) the intelligibility of reality; and (3) the view of the cosmos as finite and divided into two spheres (Shields 2014). Firstly, the metaphysical starting point for Aristotelianism is the conception of matter and its relation to form. All entities—animate and inanimate beings—comprise two metaphysical components: matter and form. Matter is pure potentiality as it undergoes transitions of form. For example, when an artist casts bronze, the metal persists, but changes its form from a lump into a statue. Bronze as a material has the potential to be all kinds of objects, but it is actualized as a statue only when it gains its form. Therefore, any individual entity or substance is defined by form, although it cannot be separated from matter. Here, the medieval tradition emphasized the distinction between substantial and accidental forms (Kretzmann et al. 1982). Any entity necessarily has at least one substantial or essential form, but it may also possess a variety of accidental or nonessential forms. Children grow to become adults as their physical and mental characteristics change, but they still remain humans, which is their substantial form.

Secondly, the reality of matter means that movements and changes follow the same principles, and these principles are intelligible. Any human can assess the structure and working of their environment as well as themselves through their own senses (Shields 2016). When engaging in scientific activity, scholars have some prior knowledge from which they proceed to sense perception, and finally progress to an understanding of the essential features of the object. However, science produces arguments that are more than mere sensory deductions. Arguments are based on demonstration where the analysis of the initial premises reveals the causal structures of the world. Eventually, each science *organizes* its data into a series of arguments revealing the true natures of things, independent of the observer's mind. Science is thus not an activity of reporting facts, but of explaining that which is unknown by what is known and fundamental.

Thirdly, Aristotle divides the universe into terrestrial and celestial spheres and places Earth into the center of the cosmos. While the world below the moon is corruptible and in constant change, the sun, moon, planets, and stars are incapable of change, apart from their eternal circular motion. The celestial sphere is built on one element, aether, whereas the world is composed of four elements: earth, water, air, and fire. The elements have their own characteristic motions, and every material entity has a drive toward its natural place according to their elements. Like an acorn actualizes its potential by growing into an oak, a stone, an element of earth, tends to descend in a straight line toward the center of Earth (Schummer 2008).

PLATONIC VISIONS

The writings of Nicholas of Cusa (1401–1464), combining theology and philosophy with mysticism, exemplify the difficulty of labeling thinkers as simply either medieval or modern. The German cardinal was well aware of both humanist and scholastic learning, but based his thought on the Neoplatonic tradition. The title of his best-known work, *De docta ignorantia* (On learned ignorance, 1440),[2] conveys Nicholas's highly metaphorical and mystical approach to writing philosophy. Like Aristotle, he sees the natural universe as being characterized by constant change or motion, but he goes even further, arguing that the universe is infinite—it does not have a center or boundaries.

"Folding" is the key term in Nicholas's vision of reality (Hopkins 2001, 2002; Bellitto et al. 2004; Albertson 2010; Miller, Clyde Lee 2017). All entities are "enfolded" in the undifferentiated oneness of God, and at the same time, they are an "unfolding" of God in time and space. In Neoplatonic terms, God emanates through all things, and they return to God, who remains both present to the entities yet ever absent. This has important epistemological consequences, since our knowledge is tied by likeness to the things God created. In other words, there is always some epistemic correspondence between divine and human minds. The universe as a macrocosm is present in each entity as microcosm, and thus humans form a solid source of knowledge, yet always an imperfect mirror of God's mind.

In *Idiota de mente* (The layman on mind, 1450), Nicholas explains the interrelatedness of ontology and epistemology with the work of a sculptor. He uses wax to make an impression of the subject, and then works on that impressed wax. The human mind is like the wax in which the entities leave their shape—it actively assimilates perceptions of objects. The mind within the wax would "configure the wax to every shape presented to that mind" and so form concepts. Nicholas therefore claims that the mind is "the limit and measure of all things." Humans become like the knowable features of the things they know, and they mold the conceptual measures whereby they take things as known.

Another Neoplatonic early modern philosopher, Marsilio Ficino (1433–1499), also argued for the knowability of matter in *Theologia platonica* (Platonic theology, 1482).[3] For him, matter has an existence that is not dependent upon form, and can therefore be intelligible (Allen and Rees 2002). Giordano Bruno (1548–1600), famous for being condemned by the Inquisition as a heretic and burned at stake in 1600, went even further in *De la causa, principio et uno* (Cause, principle, and unity, 1584) (Knox 2013). Bruno affirmed that matter is an active principle, containing within itself each and every form, whether physical or not. Matter presents a kind of infinite life, and thus the universe is also infinite.

REVISING ARISTOTELIANISM

When the early modern philosophers revised the Aristotelian tradition, they did it on several levels. One type of critique tried to revise the basic principles of Aristotelian thinking. For instance, Bernardino Telesio (1509–1588) argued that substances are actually composed of passive matter and active force, not form (Leijenhorst 2010). Force has two modes—expanding heat and contracting cold—and their dynamics define all entities. Since the survival of all entities depends on these dynamics, every natural being acquires sensations of cold and hot, although such senses are not related to the faculties of the soul.

While Telesio's metaphysics did not have a marked impact on Renaissance thought, his major contribution was in refining the relation between reason and observation. For Telesio, rather than a set of conceptual constructions, knowledge should be based on perceptions gathered from experience. Some later scientists, such as Francis Bacon (1561–1626), hailed him as the precursor of modern scientific observation. Telesio's notion of observation, however, does not refer only to a bundle of sense data, but is a broader mental process including analogical thought.

In addition to analyzing the concept of matter, the constitution of substances was also explored during the Renaissance. Theophrastus von Hohenheim, or Paracelsus (1493–1541), sought to find an underlying principle into which every substance and element could be reduced (Grell 1998). Paracelsus proceeded from the four Aristotelian elements—air, fire, water, and earth—and proposed a new triad based on metals: sulfur, mercury, and salt.

Another topic of discussion was Aristotle's concept of *minima naturalia*, which refers to the smallest parts into which a substance can be divided while still retaining its essential character (Del Soldato 2016). Scholastic thinkers in particular were interested in reconciling *minima naturalia* with the principle of infinite divisibility. In the early modern period, the problem of divisibility is also related to Neoplatonic traditions as well as the Epicurean philosophies, suggesting different forms of atomism. For instance, Julius Caesar Scaliger (1484–1558) argued that *minima* was not just a conceptual limit of divisibility, but a real physical component that cannot be divided further (Del Soldato 2016).

Since the Aristotelian model establishes a fundamental relation of similarity between the subject and the universe, everyone's senses gain the same knowledge of the world. In fact, no clear distinction was made between subjective and objective observations or forms of knowledge, although a differentiation between knowledge produced through human perceptions and that generated by external measurements began to take shape. Similarly, the lines between the disciplines of philosophy, theology, physics, and alchemy were not clearly drawn, but the differentiation was emerging, and the hierarchy of disciplines was a widely debated issue.

THE NEW BASIS OF PHYSICS

The shift from Aristotelianism to early modern science is occasionally described as a move from rational speculation to empirical observations (Shapin 1996). This view is, however, too reductive. The emergence of modern science was based rather on a new notion on how phenomena are perceived. Hence, this was not only a set of new observations, but crucially a change in the framework defining how all observations are conceptualized. In short, while Aristotelian science perceived the moving object, modern science focused on the movement of the object.

Early modern Aristotelianism is a quite flexible system, and it could incorporate experiences not seen before (Martin 2006). Nevertheless, in disciplines such as astronomy, enhanced by better measuring instruments and the growing importance of mathematics, new observations about astronomical objects did eventually provide evidence contradicting earlier assumptions. The introduction of new interpretations was still only gradual. In the fifteenth century, Johannes Müller von Königsberg, or Regiomontanus (1436–1476), did not challenge the Aristotelian view of comets moving below the moon when he calculated the faraway distance of a 1472 comet (Zinner 1990). In contrast, Tycho Brahe (1546–1601), observing a new supernova in 1577, demonstrated that it had no observable parallax. He suggested that a new star had been born in the celestial sphere, which had hitherto been assumed to be unchanging (Thoren and Christianson 1990).

The most influential figure in sixteenth-century astronomy was Nicolaus Copernicus (1473–1543) (Figure 1.2). Although medieval scholars were aware of the problems with Ptolemaic astronomy and the geocentric model, Copernicus's *Commentariolus* (Little commentary),[4] written before 1514, was the first explicit presentation of the universe with the Sun at its center. This text was only distributed among a small circle of scholars, unlike his *De revolutionibus orbium coelestium* (On the revolutions of the heavenly spheres, 1543),[5] which consolidated the new model.

Copernicus's ideas were developed by Johannes Kepler (1571–1630). His *Mysterium cosmographicum* (The cosmographic mystery, 1596)[6] argued for the great distance of the planets from the sun and presented a modified Copernican model (Shapin 1996: 59). Kepler's support for Copernicus was motivated by his theological convictions: he considered the Sun to be God, the stellar sphere as the Son, and the space between them, aether, as the Holy Spirit. Another scholar to embrace Copernicus's model was Tycho Brahe, who, however, asserted a view that the Sun moved around the Earth while the planets orbited the Sun.

In addition to Kepler and Brahe, Giordano Bruno also developed Copernicus's ideas. In 1584, he published two important philosophical dialogues, *La Cena de le Ceneri* (The Ash Wednesday supper) and *De l'infinito universo e mondi*

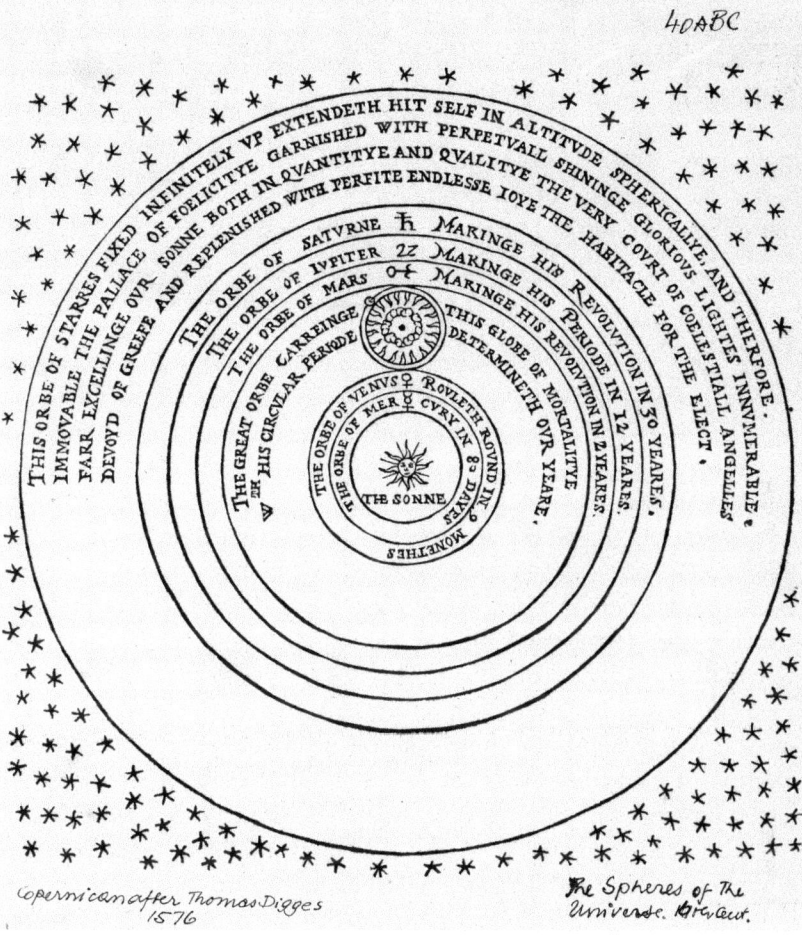

FIGURE 1.2 Thomas Digges's (*c.* 1546–1595) depiction of the Copernican universe in the 1576 edition of his father's, Leonard Digges's, perpetual almanac. Photograph: Bettmann/Getty Images.

(On the infinite universe and worlds).[7] In these works, Bruno argues for the infinity of the world and the absence of heavenly and earthly spheres, claiming, moreover, that there are no natural movements or hierarchies between the parts of the centerless cosmos.

Although it would be tempting to single out scholars such as Copernicus, Kepler, Brahe, and even Bruno as the most important scholars of their age, their work remained controversial and was debated throughout the sixteenth century. Moreover, there were other highly esteemed scholars developing the

Aristotelian framework. A case in point is Giacomo Zabarella (1533–1589). He confirmed the ancient distinction between arts and sciences (Mikkeli 1992). Sciences are concerned with the eternal world of nature, and thus are contemplative disciplines, whereas arts focus on the contingent world of human beings. Science requires knowable things—things that already exist—and the mind of scientist (Kessler 1998: 837). The task of the scientist is not to create, but to arrange the forms of existing, eternal things and to comprehend them. In contrast, art is concerned with the creation of novel things (Mikkeli 2010).

MEDICINE

The Christian theological view of the human body saw it as a battleground between matter and spirit (Figure 1.3). The body tied humans to the world of sin, pain, and death and could be overcome only by spiritually transcending that matter. Although pain and death were also present in the lay conceptions of humans, vernacular ideas also expressed the body as a site of vitality, enjoyment, and expression, as something whose abundance was experienced in dining, making love, and laboring (Tarlow 2015). Bodily vitality was cherished also in the activities of the rich, such as falconry, jousting, and romance literature.

Medicine tries to alleviate the agonies of the body. In his hierarchy of disciplines, Zabarella departed from many of his contemporaries by arguing that medicine is not part of the natural sciences. In his view, medicine is an art because it is practiced not for knowledge, but to attain better health. Whatever the position of medicine was in the hierarchy of sciences, it was also largely embedded in Aristotelian thought (Conrad et al. 1995; Wear 2000; MacLean 2002). The human body was seen as an animate and living being with a soul and composed of the four elements, which could be manipulated to improve a person's constitution (Sullivan and Wear 2017: 141).

Early modern medicine centered around the texts of Galen of Pergamon (129–c. 200/216), whose humoral theory combined ideas from Aristotle, Hippocrates, and Plato. Avicenna's or Ibn Sina's (c. 980–1037) writings also contributed to the theory. The humoral theory states that the four elements are expressed in the four qualities of hot, cold, dry, and wet, and in the four fluids of blood, phlegm, yellow bile (or choler), and black bile (or melancholy) (Conrad et al. 1995; Wear 2000; Healy 2014). The ratio of the fluids determined how the body and its organs function, or failed to function. In addition to health, the four humors defined one's natural complexion or temperament and affected emotions, cognition, and personality (Arikha 2007). The humors could be in balance, or some might be produced in excess, causing ill health (Conrad et al. 1995). These basic principles of knowing and affecting one's body were widely known across society, at least in Central and Southern Europe, and were expressed in popular practice. The aim was to know oneself and retain

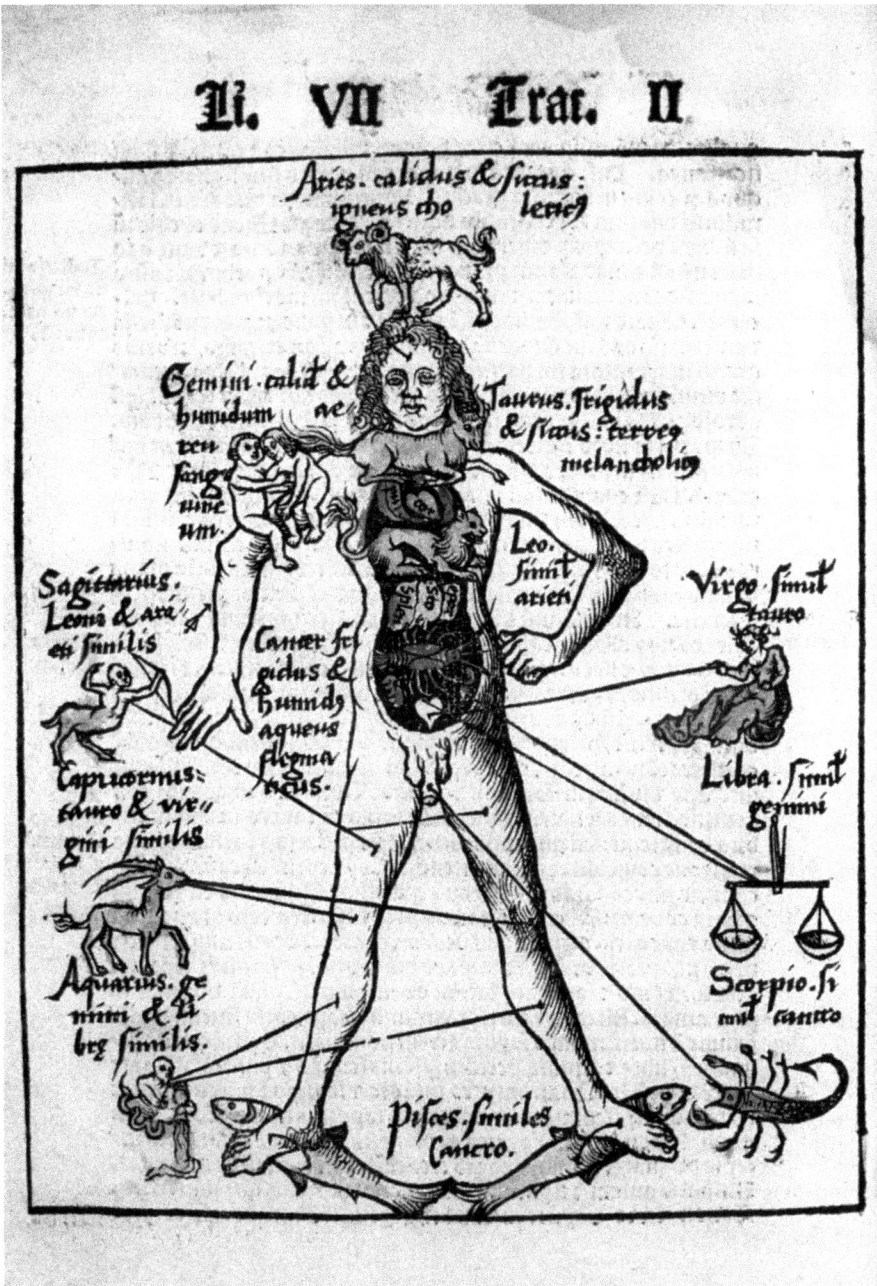

FIGURE 1.3 An illustration of the relationship between the human organs, the four humors, and the signs of the zodiac in the 1508 edition of Gregor Reisch's (1467–1525) *Margarita Philosophica*. © Hulton Archive/Getty Images.

moderation in life by controlling six aspects of daily life: environment, diet, sleep, exercise, bodily evacuation, and the emotions (Cavallo and Storey 2013).

Knowing oneself implied the possibility of knowing others by reading the signs of their bodies, the face in particular. This was the central tenet in the pseudo-Aristoteles' text *Physiognomics*, which presented the art of physiognomy. One of the early modern standard texts of physiognomic was Giambattista della Porta's (*c.* 1535–1615) *De humana physiognomonia* (On human physiognomics, 1586).[8] In addition to inner personality, the physical constitution of the body established a close connection with its environment. Consequently, the location where a person or people lived shaped their bodily and cognitive makeup, and this was noted in contemporary geographical literature.

ALCHEMY AND MAGIC

Physiognomics had a rather long life in Europe, but was eventually rejected in the nineteenth and twentieth centuries. Astrology and alchemy had a similar fate. Both disciplines are now seen as aberrations in the development of astronomy and chemistry, being closer in kind to magic, but this characterization is inappropriate for alchemy, astrology, and magic (Figure 1.4) (Copenhaver 1984). They held important positions in early modern scholarship despite the fact that, for instance, Giovanni Pico della Mirandola (1463–1494) famously attacked astrology (e.g. Yates 1964). The discipline, he argued, denied the Christian doctrine of free will. Giovanni himself advocated for Christian Kabbalah.

Astrology argued that microcosm, the human fate, was affected by macrocosm, or the movements of the planets, and similarly alchemy emphasized the resemblance between microcosm and macrocosm. The aim was to purify and perfect objects, most notably by turning base metals into precious ones (Moran 2005). Alchemist tradition derived from late medieval scholarship, but was significantly enhanced by the reintroduction of ancient Hermetic texts, or the *Corpus Hermeticum*, addressing both mystical philosophy and highly practical magic.[9] The work has later been identified to be a heterogeneous collection of Egyptian–Greek texts from the second century CE. Marsilio Ficino (2014) published the first edition of his Latin translation of the corpus in 1471.

The most famous early modern alchemist was Paracelsus, who emphasized a vision of the universe as a network of correspondences and sympathetic links, which connected the phenomena of different scales. Although Paracelsus did not reject the idea of the four Aristotelian elements, he searched for one substance from which they all evolve. He named this substance as *alkhest*, and it was the real philosopher's stone allowing the transformation of matter. Moreover, Paracelsus saw that the body functions on the same principles as alchemy: organs purify the impurities of the body, and thus he explored the use of chemicals and minerals for medicinal purposes (Porter 2006: 161).

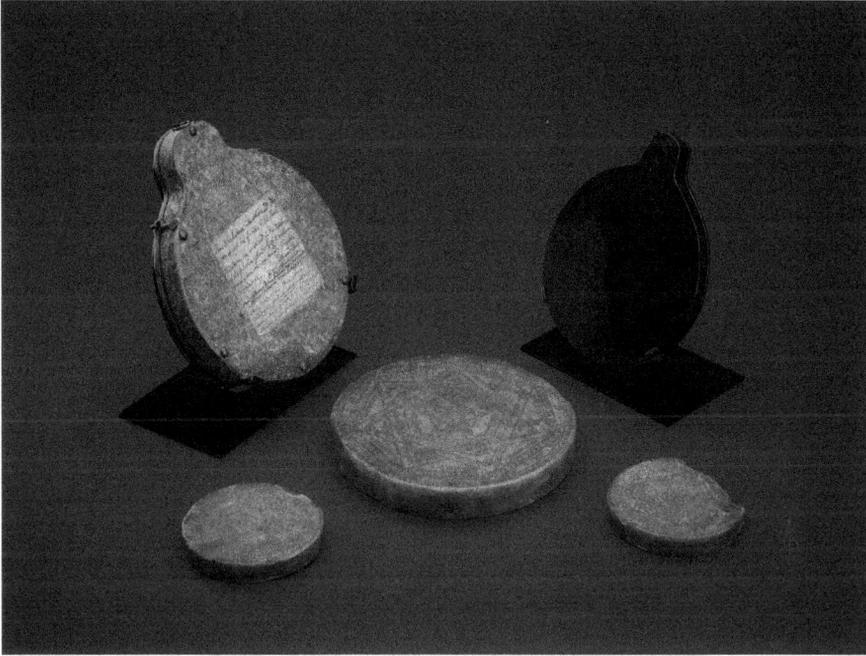

FIGURE 1.4 Magical objects, which allegedly belonged to John Dee (1527–1608/
1609), an English scholar and advisor of Queen Elizabeth I (1533–1603).
© Trustees of The British Museum, London.

While alchemy tried to find ways to purify metals, there were also scholars
studying metals and materials on a more practical basis. Georgius Agricola
(1494–1555) examined mineralogy and made careful observations of ores
and the methods of their treatment. His seminal work *De re metallica* (On the
nature of metals, 1556)[10] describes and develops the techniques of the mining,
extraction and refining of ores and the smelting of metals.

The concept of magic carries even more baggage than alchemy or astrology. It
often designates simply those practices and ideas that are considered other than
modern views on religion and science. However, magic was not a deviation or
marginal activity in the early modern period. As the fields of physics, medicine,
and alchemy show, they all shared notions and beliefs that can be considered
magical from a modern viewpoint. Magic was also a sophisticated set of beliefs
and practices followed in both scholarly and vernacular life (Thomas 1997), and
Paracelsus, for one, gave instructions on how to prepare talismans according to
alchemical principles.

To classify something as magical is to classify it as marginal, but in the
early modern devotional sphere, magic had a moral underpinning, referring

to malicious witchcraft and the devil (Jolly 2002: 22–3). If one had faith in transubstantiation, or in Christ's and the saints' powers to bring about miracles, that was not magic (Dillenberger 1999). Christian and non-Christian traditions and ideas about the divine and supernatural were subsequently fused into views of everyday life (Thomas 1997: 33, 46–57): saints, the Eucharist, the avoidance of the issue of blood, protection against evil, and classical medicine were simultaneously and seamlessly present in early modern thinking.

Having said that, a clear demarcation between religious and magical spheres did exist for some early modern scholars. Pietro Pomponazzi (1462–1525) states in *De incantationibus* (On incantations, 1556) that to consider something as magical or miraculous is actually a failure to identify the real causes.[11] Similarly, Ludovico Boccadiferro (1482–1545), Gerardus Bucoldianus (1527–1594), and Simone Porzio (1496–1554) preferred to rely solely on Aristotle when explaining wondrous events such as cataclysms or the appearance of monstrous creatures (Del Soldato 2016). Moreover, della Porta insisted on a sympathetic—or magical—logic of things, influenced by celestial virtues, and discussing optics and magnetism in *De magnete* (On the magnet, 1600),[12] William Gilbert (1544–1603) approaches magnetism and the rotation of Earth by combining experimentation with a belief in the existence of Earth's soul (Gilbert 1958).

Magic was a way to animate the seemingly inanimate and to manipulate hidden principles. A curiosity about control was also manifested in the delight in automata, mechanical devices that could move independently. Such contraptions were in vogue among the elite, and several famous artists crafted them for their rich clientele. Leonardo da Vinci (1452–1519) drew sketches for many automata, and he constructed a "mechanical lion" that was presented to King Francis I (1494–1547) by Giuliano de' Medici (1453–1478) at a royal banquet in Lyon in 1515 (Nocks 2008: 16).

THEOLOGICAL UPHEAVALS

The elaborate and systematic theology of the late Middle Ages was a magistral achievement. It clarified the character of holy images, Christian miracles, and the material presence of saints in their relics, as well as the complexities of the doctrine on the Eucharist (Figure 1.5). In fact, the Eucharist was a moment of a true miracle after the Fourth Lateran Council of 1215 proclaimed the doctrine of transubstantiation, or the real presence of Christ in the communion. In Aristotelian terms, at the moment when a priest utters the words of Institution, the substance of wine and bread change into the body and blood of Christ, although their appearance or nonessential characteristics remain the same.

Caroline Walker Bynum (2011) argued that late medieval piety was decidedly oriented toward the materiality of the world as devotional objects both inspired

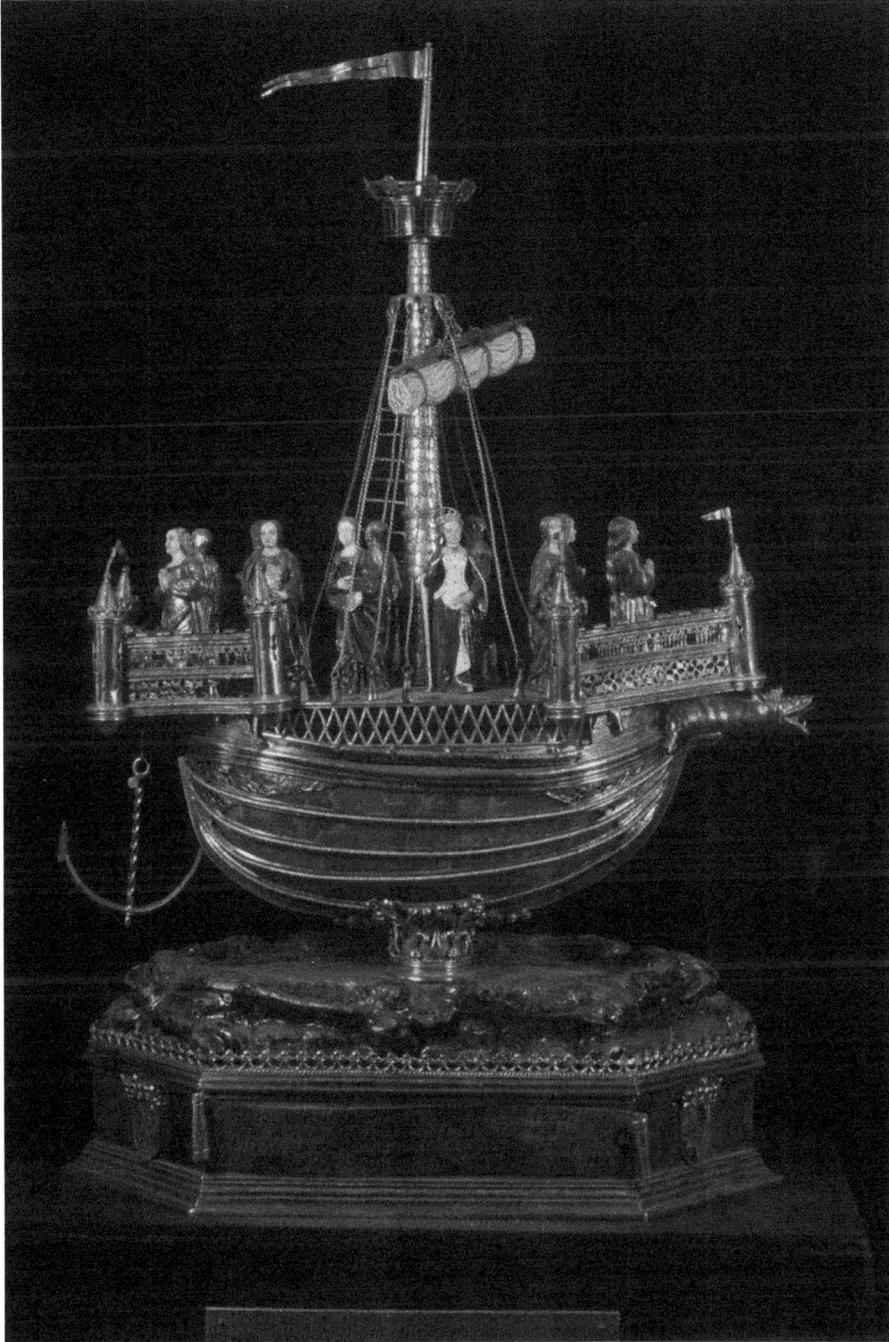

FIGURE 1.5 A ship-shaped cornelian cup in a gilt silver mount, originally a ceremonial nef, or a ship-shaped vessel that held salt, utensils, and napkins. Photograph: Xavier Desmier/Getty Images.

and reflected a proliferation of inner visions in which physical things were crucial. Liturgical and sacred objects spoke or acted physically in particularly intense ways that called attention to their thingness. Their matter was powerful and insistent, and lifted the devotee toward God. This vision of the sacred remained a reality in Catholic Europe during the early modern period, but was vigorously challenged by the Protestant Reformation.

The Reformers held on to the theological conception of the human body as the source of sin and suffering, but rejected Catholic beliefs in relics, holy images, and transubstantiation. The emphasis was to be on God's word and his scriptures. In this vein, despite Martin Luther's (1483–1546) in-depth understanding of Aristotelianism, he repudiated its use in theology. Luther wanted clearly distinguish theology from philosophy, while his collaborator Philipp Melanchthon (1497–1560) reconciled religion with natural sciences by arguing that nature was the creation of God, and everything in it had to be seen as the work of providence.

The calamities in Protestant Europe induced iconoclasm, or the destruction or disfiguration of ecclesiastical material culture considered untowardly Catholic. It found its full force in Calvinism and countries such as The Netherlands, England, and Scotland. However, Luther objected to iconoclasm and put forward a doctrine that objects are things of indifference: they have no holiness or unholiness in them (Bynum 2016). In his view, some pious but simple people might need the Catholic remnants, and they should be allowed to use them, because objects are not essential in regard to the sacred.

As a consequence of the doctrine of indifference, many Lutheran parishes could continue to use, reuse, and store old liturgical objects and works of art in their old churches. Relics were another matter. Luther's attitude to miraculous relics and indulgences is made clear in his anonymously published 1543 pamphlet *Neue Zeitung am Rhein* (New newspaper from the Rhine).[13] It informs the public that Archbishop Albert of Brandenburg (1490–1545) publicly exhibits his huge collection of relics and offers indulgences for viewers. The satirical text lists some of the collection's new relics. They include "a nice section from Moses' left horn," "three flames from the burning bush on Mount Sinai," and "two feathers and an egg from the Holy Spirit" (Gritsch 2017: 96–7). Like *Gargantua*'s list of apparel, Luther's catalog resonates with the Renaissance obsession in compiling inventories of relics, luxuries, and exotica. He saw the relics to have as little divine capacity as liturgical objects. When Luther looked at the cloth of St. Veronica, the sacred relic bearing the true face of Christ at passion, all that he saw was a cloth hanging on a board (Lewis 1986: 100; Rublack 2010a).[14]

Even though Luther wholeheartedly stripped liturgical objects, holy images, and relics of their divine qualities, his doctrine on the Eucharist provides a complex view on the relations between the divine and matter. It is based on

the concept of the sacramental union. In the communion, the elements do not change or have a divine capacity, but are Christ's physical presence in bread and wine. They are in a sacramental union with the body and blood of Christ. Other Protestant theologians presented differing views; for instance, Huldrych Zwingli (1484–1531) asserted that the Eucharist is purely a symbolic and memorial event. The late medieval vision of sacred matter came to a grinding halt.

OBJECTS IN TIME

In addition to craftsmanship and materials, age was a well-acknowledged quality of objects in the Renaissance. This is evident, for instance, in early seventeenth-century Dutch still life paintings. Some of the domestic scenes are equipped with stoneware jugs that are two decades or even a century old at the time of painting. Choosing these objects for depiction shows awareness of their long histories and the consequent accumulation of value (Gaimster 1997: 131). The appreciation of age formed the basis of antiquarianism. It systematized knowledge on ancient things by utilizing the typical methods of scholarship: making careful observations and describing and cataloguing things.

Ruins and ancient objects had dotted the European landscape for centuries, but now they became sources of information (Miller 2017). It was first in Italy that the value of critically assessing ancient text and systematically comparing them with the surviving Roman monuments was acknowledged. Scholars such as Niccolò de' Niccoli (1364–1437) and Gian Francesco Poggio Bracciolini (1380–1459) expanded their search for ancient manuscripts to inscriptions (Buonocore 2015), and Cyriac of Ancona (1391–1454) toured numerous archaeological sites in the Mediterranean, drawing ruins and copying inscriptions (Schnapp 1997: 111). This generation of Italian antiquarians included Flavio Biondo (1392–1463), who published a systematic reconstruction of the topography of ancient Rome, *De Roma instaurata* (Rome restored, 1444–1448),[15] and another work on the Italian peninsula, *Italia illustrata* (Italy illuminated, 1474).[16]

In 1515, Pope Leo X (1475–1521) commissioned Raphael (1483–1520) to construct the church of St. Peter (Schnapp 1997: 123). He instructed the builders to take note of possible antiquities, dismantle them only with his permission, and use such discoveries to adorn the new architecture. In a 1519 memorandum to the pope, Raphael described a plan for the systematic survey of the Roman monuments, but it was not until the latter part of the sixteenth century that antiquarians in Rome began to methodically survey and draw sites. The early survey methods and practices of publication spread among scholars working in the Italian courts, and then other parts of Europe. Besides architecture, the first monograph on clothing in the antiquity, *De re vestiaria* (On clothing), was

published by the French Lazare de Baïf (1496–1547) in 1526.[17] The work was based on surveying both ancient texts and archaeological remains (Acciarino 2018).

In Italy and France, abundant with Greek and Roman antiquities, scholarship focused on topography, monuments, coins, and inscriptions. North of the Alps, the scarcity of ancient texts, which helped in interpreting the finds, made the antiquarian task more arduous. Nevertheless, local antiquities could be used to support the political claims of monarchies, countries, and cities. This secured the financial means and impetus for scholars to plunge into the study of ancient monuments. For instance, Sigismund Meisterlin (c. 1435–1497) studied the historical origins of German towns, partly motivated by the interest of the free cities in the Holy Roman Empire to find support for their independence. In 1458, Meisterlin completed *Cronographia Augustensium* (The chronicle of Augsburg),[18] which incorporated Latin inscriptions and other antiquities (Figure 1.6). In his Bavarian chronicle published in 1530, Johannes Aventinus (1477–1534) even clamed to value artifacts as highly as written records (Meier 2013: 260).

In the Nordic countries, glorious ancestors were discovered in the Goths. In 1434, Bishop Nicolaus Ragvaldi (c. 1380–1448) argued that the Swedes were the oldest nation in Europe, but it was not until the end of the sixteenth century that Scandinavian scholars began to systematically collect Nordic antiquities

FIGURE 1.6 The construction of Augsburg by the Romans. Illustration in Sigismund Meisterlin's *Cronographia Augustensium* (The chronicle of Augsburg), 1522. © Interfoto/Alamy Ltd.

and connect them with historical writing. In 1555, Olaus Magnus (1490–1557) published *Historia de gentibus septentrionalibus* (History of the northern peoples).[19] It was aimed at a Catholic readership and presented a vast array of folklore and descriptions of customs and ancient monuments. Johannes Bureus (1568–1652) examined runes and documented hundreds of rune stones.

Antiquarianism established new methods of research. One of them was the historical analysis of topography. This particularly British take on antiquarianism was based on cataloguing and analyzing monuments in the landscape. In addition to ruins above the ground, some scholars resorted to unearthing ancient remains. Emperor Maximilian I of Habsburg (1459–1519) was an enthusiastic antiquarian and collector (Wood 2005). In 1495 at the Diet of Worms, Maximilian had the mythic hero Siegfried's grave mound opened. Here, the Emperor followed the late medieval practice of opening saints' graves for the collection of their remains as relics (Meier 2013: 254–5). Nicolaus Marschalk (1460/70–1525) was the first scholar to conduct excavations in order to solve a specific historical question. For his work *Annalium Herulorum ac Vandalorum* (The annals of the Herules and the Vandals, 1521),[20] Marschalk examined differences between megalithic monuments and tumuli. The former he associated with the Herules and the latter with the Obotrites, a Slavic tribe.

If there were no inscriptions or ancient texts to compare, ancient ruins and objects lacked an interpretative framework. The old explanation for prehistoric arrowheads and flint tools saw the objects as the natural remains of thunderbolts, and thus appropriate to be used as devices of protective magic. This naturalistic view was also among the interpretations presented on ancient pottery found in prehistoric cemeteries. In fact, the origins of funerary deposits discovered in the ground were among the most hotly debated antiquarian issues in the sixteenth century. The explanations raged from fantastical (underground dwarves) to natural (pots as geological formations created by subterranean fires), and archaeological or cultural. In *De natura fossilium* (Textbook of mineralogy, 1546),[21] Georgius Agricola argued that the urns belonged to the pagan Germans for preserving the ashes of burned corpses. None of these explanations became unanimously accepted until the eighteenth century (Meier 2013: 261).

OTHERNESS IN OBJECTS

The early modern discourse on ancient objects has a link with the discovery of the indigenous people of America, which is the European experience of otherness and alterity. Like prehistoric finds, the encounter of strange new people, their customs, and their objects sparked scholarly curiosity (Davies 2016). The fascination led to the production of numerous ethnographic descriptions and illustrations of the newly discovered lands (Feest 2007). To accomplish this, scholars moved the conceptual scheme created for studying ancient Roman

rituals to the analysis of Native Americans, exemplified in the works of José de Acosta (1539/1540–1600) and Bartolomé de las Casas (1484–1566) (Miller 2013: 70). The methods were basically the same: the careful cataloguing and representation of natural and cultural phenomena.

In addition to the methodological similarities, there were other commonalities, too. When there was no real need or framework to conceptualize cultural differences, early modern authors and illustrators resorted to the long-established European traditions to represent the odd and extraordinary. Native Americans could be described as the medieval figure of a Wild Man, characterized by his hairy and beast-like appearance (Husband 1981), or the fabulous semi-human creatures ornamenting the margins of manuscripts and maps. Christine R. Johnson (2008) argues that, in the sixteenth century, those German scholars and merchants who never visited America depicted their people and material cultures as stereotypically uncanny or wildly exotic. They did not do so simply because of the limits of their conceptual framework, but also because their Eurocentric conventions reinforced the assumed competence and legitimacy of European practices of knowing.

ECONOMIC CONCEPTIONS OF MARKETS AND MONEY

Developing commerce and entrepreneurship cast the earlier assumptions on economics into doubt in the fifteenth and sixteenth centuries. The flow of goods and precious metals from America and the impacts they had in European economies called for new tools of economic analysis. Many thinkers, guided by the increasing significance of money, focused on its character and how value becomes defined as part of economic processes (Boyer-Xambeu et al. 1994). They also redefined the boundaries of morally sound economic practice.

Aristotle argues that the practical aim of economics and the basis of economic value is in attaining a good life (Screpanti and Zamagni 2005: 19–20). Money is not born out of natural human needs, but is a social convention constructed to facilitate exchange. Hence, the primary function of money is to be a measure of things. This leads Aristotle to denounce the making of profit from moneylending, or usury, because the transaction does not produce anything. This strong condemnation lived on in late medieval and early modern economic thinking.

Thomas Aquinas considered money to be practically indispensable, and for that reason a naturally emerging human institution (Spiegel 1991). He analyzed the relation between money and the ruler. Although coinage can bring glory to the ruler and help in measuring and collecting taxes, the materials of coins survive even when they are melted down. Consequently, he argued, the value of money is defined primarily by its intrinsic material or bullion value. Aquinas also discussed the concept of a just price, which is pivotal for social harmony

(Brue and Grant 2007). A just price covers the costs of production, including the maintenance of producers, and the transportation of goods. Hence, unless the production costs increased or carried significant risks, setting the price beyond these costs was not morally justified.

Scholastics developed Thomas Aquinas's theories and produced highly sophisticated analyses on money and value. Archbishop Antoninus of Florence (1389–1459) addressed the issue of economic development in relation to social good. He argued that a ruler has the moral duty to control mercantile affairs for the community's benefit and to take care of the poor. Antoninus distinguished between the natural or objective value and the use or economic value, and he argued that economic value has three components: objective value (use value), scarcity, and desirability. The latter refers to the community's currently shared estimation of value (Chafuen 2003: 81). Since desirability was bound to fluctuate, the just price was not fixed, but oscillated within certain limits.

In addition to the theory of value, early modern thinkers examined the relationship between the quantity and the value of money. This was important for understanding the debasement of coinage. Many scholastics thought that the value of coinage is determined by the ruler who controls minting, but Gabriel Biel (c. 1410–1495) argued that the value is not ultimately conditioned by the ruler, but by the community at large. It therefore followed that because debasing coinage exploited the community, it was immoral for any ruler to do so.

Copernicus, although best known as an astronomer, also wrote about economics. In 1517, he briefly outlined the quantity theory of money, which states that the general price level of goods is proportional to the amount of money in circulation. He also discussed the so-called Gresham's Law in 1519, although the rule is mainly associated with Thomas Gresham (1519–1579). It states that coinage, whose metallic value is lower than the coin's nominal or commodity value, leads people to take coins of higher quality out of circulation.

The association between new economic realities and Renaissance thought was plain in sixteenth-century Spain. There, a group of thinkers established the so-called School of Salamanca, with Francisco de Vitoria (c. 1483–1546) as the founder (Alves and Moreira 2010). The group developed economic thinking in an atmosphere supporting free enterprise and private property. In their view, free cooperation and economic permissiveness ensured justice and social harmony. Diego de Covarrubias y Leyva (1512–1577) argued that people have an exclusive right to benefit from their property, and Luis de Molina (1535–1600) pointed out that owners take better care of their goods than is taken of common property. In addition, Martín de Azpilcueta Navarro (1493–1586) articulated the first fully developed theory of money in his *Comentario resolutorio de usuras* (Commentary on the resolution of money, 1556)[22]

(Grice-Hutchinson 1952: 34; Spiegel 1991: 86–8). He also analyzed the flow of precious metals from Latin America to Spain, and he saw that in countries where precious metals were scarce, their prices increased. In effect, gold and silver behave like any other commodity.

The moral stance on economics had to be revised along with the developing finances. Jean Bodin (1530–1596) studied inflation in France (O'Brien 2000). He identified several possible causes for rises in prices, including the vain demand for luxuries and the debasement of money, but by carefully analyzing price records, he showed that the flow of precious metals from Spain was actually the main cause. Moreover, during the early modern period, it became apparent that money is not borrowed only for consumption, with which European courts and the aristocracy were very familiar, but for production as well. The rejection of usury was not viable, and the School of Salamanca presented justifications for the charging of interest. Since money itself is a commodity, using it should also benefit the owner, they argued, and the interest could be considered as a premium paid for the risk taken by the loaner.

With the development of commerce and the money economy, European monarchies grew in financial and political power, and they began to establish new economic policies to protect national supply sources and regional markets. Protection meant investing in military strength. This political evolution led to the emergence of mercantilist thinking, although it never formed a coherent economic theory (Brue and Grant 2007: 17–36). It was a conviction that international trade cannot benefit all countries equally, and precious metals are the ultimate, though limited, origin of value. Accumulating large amounts of gold and silver would encourage the development of trade and national income. Exports brought in money, while imports took it away, and thus monarchies were to impose levies and tariffs to encourage exports and discourage imports.

THE GENEROUS OBJECTS OF EARLY MODERN EUROPE

Objects were in a central position when rapidly changing intellectual, material, and social realities were negotiated and made intelligible in fifteenth- and sixteenth-century Europe. At a time when the network of commodity flows expanded and grew denser, and the rhythm of material and intellectual exchanges accelerated, the basis for perceiving objects and accessing their intrinsic truths and value as sources of knowledge also transformed.

Developing forms of production, transportation, and commodification and surveying objects created new, differentiated venues of knowledge, skills, and professions—artists, craftsmen, and merchants. Their divergent sets of competence and artistry established social differences, but also allowed contacts and connections. Gerald MacLean (2005: 127) points out that merchants paid close attention to details of commodities. This also informed the works of

art they commissioned, and a cornucopia of luxurious objects—silks, rugs, furniture, jewelry, metal ware, and glass—found their way into contemporary paintings, engravings, and other forms of representation. Some of these connections between objects, spheres, and competences are unexpected. Prime examples are the prehistoric pots and other artifacts that became valuable collectibles for cabinets of curiosities. The ancient urns were embellished with new metal lids and mounts to increase their visual attractiveness, just like the adornments attached on sixteenth-century stoneware containers (Gaimster 1997: 133).

Another example of surprising connections is the figure of a craftsperson frequently used in metaphysical analyses of matter and form. Nicolaus describes the relation of the active mind to the objects it perceives in terms of wax, which the artist shapes to make an impression of the depicted subject. Such a figure of an artist as an allegory of matter, form, and the mind is pervasive in early modern philosophy. In addition to the allegorical use, recent scholarship has paid attention to the importance of arts and crafts for the epistemological change that took place during the Renaissance (Smith 2004; Rublack 2013; Richardson et al. 2016: 21–6). Artisans were experts on materials and natural processes, and they accumulated practical intelligence. This corporeal and active engagement with the world fascinated early modern philosophers and scientists, who considered the human senses to be crucial for epistemology (Smith 2004: 7–20). David Summers (1987) even argues that the development of naturalistic representation in painting, sculpture, and other visual arts provided a model of vision and thought for scholarly pursuits. Conversely, Ulinka Rublack (2013: 43–4) describes how artists and artisans accentuated and played with the material features of their products, emphasizing the skills needed and mastered. This material virtuosity provided significance for the objects. This reminds us of liturgical and other sacred objects, which resolutely attracted attention to their materiality in order to orient toward the divine.

Aristotle's notions of forms and matter were not rejected in early modern thought, but reinterpreted in a new framework that underscored observation and experimentation (Manning 2012). In fact, the figure of the scientist was like that of the artist, who combines images with mathematics, yet without the lower social status attached to artists and artisans. In physics, the gradual shift from perceiving the moving object to observing the movement of objects led to the establishment of a heliocentric model. It rejected the division into celestial and sublunary spheres, whereas in other disciplinary areas, such as medicine, basic Aristotelian principles were still maintained, though developed.

In 1587, Antonio Agustín y Albanell (1516–1586) wrote in *Diálogos de las medallas, inscripciones y otras antigüedades* (Dialogues on medals, inscriptions, and other antiquities)[23] that "I have more faith in medals, tablets and stones than in anything set down by writers," showing strong optimism and trust

in material evidence (Meier 2013: 253). In fact, for fifteenth- and sixteenth-century scholars, objects and their representations could help understand not only ancient texts, but also the world. The early modern love for allegories and uncovering the governing principles underneath appearances gave objects an important place in accessing knowledge. The careful description, cataloguing, and comparison of the gargantuan numbers of ancient and contemporary objects provided the means to decipher their concealed truths.

Technology

Making, Knowing, and Encountering Objects in the Global Renaissance

SUREKHA DAVIES

What was Renaissance technology? For the twenty-first-century reader, "technology" conjures up images of smartphones, airplanes, organ transplants, and other processes and objects with which humans are fundamentally altering the planet and their own bodies. During the Renaissance (most broadly from the late thirteenth to the early seventeenth centuries),[1] there was no distinct subcategory within the category of human-made objects of things deemed to be "technological," a usage that is much more recent. On the one hand, those human-made objects that were the products of the "mechanical arts," a group of practical disciplines involving making and knowing, might be classed as "technological" artifacts.[2] These objects typically functioned as prosthetics that extended human bodily capacities such as communication, movement, strength, speed, and health. On the other hand, objects that we might identify as "technologies"—human-made innovations that manipulated nature—also intersected with such categories as objects of magic, nature, and art (Figure 2.1).[3]

Sustained oceanic voyages, colonial and imperial activities, and the birth of the Atlantic slave trade comprise some of the defining features of the era of the Renaissance, features that stand alongside the traditional formulation of the period as one emblematized by the rediscovery of classical antiquity.[4]

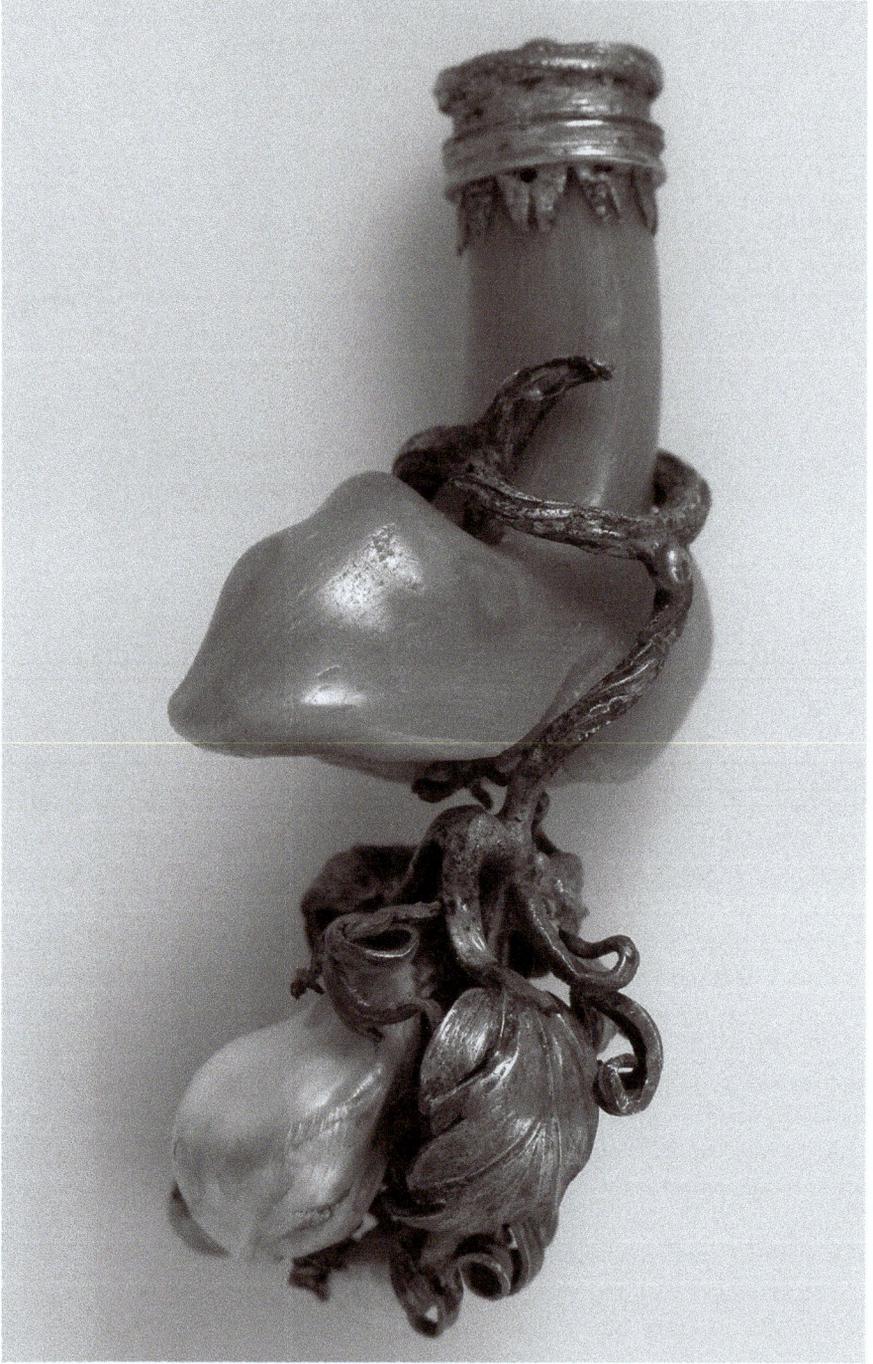

FIGURE 2.1 German or Spanish pendant jewel, coral, pearl, gold, and silver-gilt, *c.* 1500. The Metropolitan Museum of Art, New York. Gift of Alastair Bradley Martin, 1951, Inv. #: 51.125.6.

These endeavors inflected European notions of material culture (among other things) and thus of technology.[5] Historian of colonial Latin America Marcy Norton, writing about subaltern technologies in the early modern Atlantic world, defined technology as "at once process and product."[6] Norton showed how using a capacious definition of technology, one that encompasses a variety of products, techniques, and processes, from the agricultural (cultivated, prepared, and foraged foods) to the communicational (including devices and literacies), to "auditory and kinesthetic arts like music, dance, and prey stalking," and building technologies (for homes and furniture), throws into relief the agency of a wide array of extra-European actors, and the interconnectedness of the agency of European and subaltern actors and things. I define technology similarly, to encompass all of the following: objects, substances, and environments made or shaped by people; techniques and processes by which people make objects and shape or control nature and its products; and techniques of communication. This broad-brush approach enables us to better account for the ways in which objects and technologies in Europe changed during the Renaissance, as will be seen.

Technology and objecthood intersect in the concept of the artifact. "Artifact" derives from the Latin roots *arte* (by/through art) and *factum* (made), and denotes "an object made or modified by human workmanship, as opposed to one formed [exclusively] by natural processes."[7] "Technology"—in the sense of processes or products of human activity and labor—cannot, however, be fully separated from nature. There is necessarily a continuum from human to nature, from artificial to natural, and things do not remain fixed on one point along the scale.[8] To write a cultural history of objects in the Renaissance through the lens of technology is thus to write a history of artifacts—objects shaped by human agency—and their practices of making, changing views of material culture and of the nature/culture divide, and the impact of technologies and ideas about them on modes of thought or *mentalités*.[9]

This chapter explores a messy group of physical objects, techniques, disciplines, and contexts recognized by Renaissance practitioners in order to characterize some of the broad cultural changes in technologies and responses to them between the late fourteenth and the early seventeenth centuries. It focuses on two contexts that saw significant shifts during the Renaissance: the relationship between practices of making and knowing; and European encounters with overseas technologies. The intersection between the rising status of empirically derived knowledge and global expansion had consequences for European notions of cultural hierarchy: scholars, collectors, administrators, and sponsors (including royal crowns) reflected on the material cultures of overseas peoples alongside their own and that of classical antiquity. The term "artifact" is used in this chapter to refer to

technologies that are discrete physical objects made by people. The term "object," which encompasses artifacts, is used to refer to physical things more broadly (including animals, plants, etc.).

CATEGORIES

The place of technology as practice (in the sense of applied arts and sciences) in relation to other branches of Renaissance learning varied over time, and was fluid at any given moment. Understanding what technology meant to people in the Renaissance requires attention to the taxonomy of concepts—about bodily knowledge of the material world and about physical transformation of material things—as well as to the ways in which these ideas related to theoretical knowledge and its production (Figure 2.2).[10]

A family of overlapping terms signified technical processes, practical knowledge, and artifacts that had been fashioned in some way by physical work directed by people (with their own bodies, with or without other objects, animals, or other aids) in Latin and in European vernaculars. A number of these terms were also used in variant forms to indicate abstract qualities, artifacts,

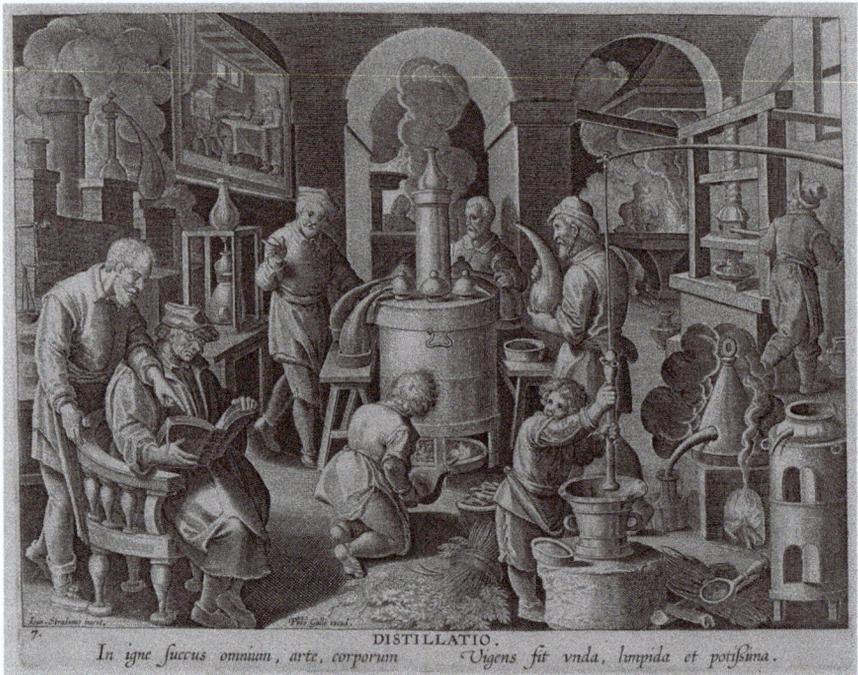

FIGURE 2.2 Jan van der Straet, called Johannes Stradanus, (designer) and Theodoor Galle (engraver), *Nova Reperta*, Antwerp, *c.* 1580–1590, plate 7, "Distillation." Call #: 1964.8.1581. The National Gallery of Art, Washington, DC. Rosenwald Collection.

and action. A secret (from the Latin *secretus*; French *secret*; Spanish *secreto*), for example, could indicate a hidden technique associated with occult or forbidden knowledge.[11] An engine (from the Latin *ingenium*; French *engin*; Spanish *ingegno*) was, among other things, a device fashioned through human skill (or cunning) and effort.[12]

The semantic distinction between invention (something made) and discovery (something found) was small in the Renaissance. Both *invention* and *discovery* could, when verbalized, denote the practice of bringing new forms of material artifacts into being. The Latin *invenire* means to come upon, and also to invent or devise. From the mid-fifteenth century, as ships under Portuguese and Castilian flags began to make long-distance oceanic voyages, many if not most new material things in European experience were things found (which subsequently offered ways of making further new things out of them), or were things provided by/appropriated from indigenous peoples, rather than unprecedented new objects designed and made by an individual "inventor."[13] In his immensely successful *De inventoribus rerum* (On Discovery, or on invented things), first printed in 1499, the Italian scholar, cleric, and diplomat Polydore Vergil (*c.* 1470–1555) used *invenire/inventor* (to make something new), *repertor*, *auctor*, and similar words for making and finding, as Brian P. Copenhaver has noted.[14]

Vernacular translations of Polydore also used versions of *invent* and *discover* interchangeably. Some of this malleability persists in contemporary vernaculars. For example, in the 2002 *I Tatti* edition and translation of Polydore's *De inventoribus rerum*, Copenhaver translates *inventa* as *discovered* in the case of agriculture, but whether agriculture is a technique that cultures stumble upon or the result of sustained and conscious engagement with nature and thus an invention is a matter of perspective. The 1551 English abridged translation by Thomas Langley translates *inventa agricultura* as the discovery of husbandry, and those who found medicinal herbs are denoted as "inventours." For Langley, there was little semantic difference between "deuisers" and "first finders out." Polydore's discoveries and inventions range from cultural practices, such as religion, to forms of scholarship like the liberal arts, to modes of manipulating nature, such as magic, to technological artifacts like stirrups and artillery, to the production of such substances as medicaments.[15] There was, in other words, no fixed boundary between technology and other spheres of activity involving artifacts or human effort.

Since the ancient Greeks, work done with the mind had had a higher status in European traditions than that performed with the body. Aristotle went so far as to argue that since "no one can practice virtue who is living the life of a mechanic or laborer," and since "there is no room for moral excellence in any of their employment," craft practitioners could not be full citizens. These practices did not appear in the curricula of the liberal arts—of the freeing arts for free

men.[16] In the Middle Ages, theoretical knowledge was imparted in Latin at universities; knowledge about nature—natural philosophy—was underpinned by Aristotle's voluminous corpus. Craft knowledge, by contrast, was imparted via apprenticeships managed by guilds, or within the home. During the fourteenth and fifteenth centuries, the movement now known as humanism brought about a new type of engagement with classical texts. Humanists sought out and studied newly uncovered classical texts as well as material remains of the classical past, eventually informing university curricula.[17]

During the Renaissance, the structures of European knowledge continued to be undergirded by classical traditions and inflected by medieval institutions (notably universities and guilds). Many terms were part of textual traditions that stretched back to classical antiquity. Frameworks of knowledge were underpinned by the writings of Aristotle, who divided human activity into three arenas: knowing things, taking action, and making things. Forms of knowledge were divided along similar lines and, in the first instance, into abstract and experiential knowledge, or theoretical and practical knowledge. Theory comprised *epistēmē* (in Greek) or *scientia* (in Latin). *Scientia* (or *disciplina*) was the most abstract theoretical knowledge, of permanent features of the world and their causes. *Scientia* was knowledge gained by thought alone, based on logical syllogism or geometrical demonstration. Empirical knowledge comprised *praxis* (Latin *experientia*)—action that required knowledge and judgment of particulars and situations (as in the case of political action, which was recorded as *historia*)—and *technē* (Latin *ars*)—the material production of material things through bodily exertion. *Scientia* constituted the most elevated knowledge; *technē*, the most lowly. The division between *scientia* and *ars* mirrored a division between scholarly and artisanal activities, between the liberal arts and the mechanical arts, and between sites of activity.[18]

"Art" was a Renaissance category that performed similar work to our current definition of technology. It signified both what we now think of as fine arts (those that produced material objects associated with aesthetic pleasure, such as sculpture and painting, and such fields as literature) and technologies (activities whose products' central functions are not perceived to be aesthetic ones). Any practices by which nature was forced into new configurations constituted art.[19]

What fell into the categories of artificial and natural and their cognates in Latin and continental European vernaculars varied with particular contexts of making and knowing, and with religious, political, and philosophical settings, all of which interacted to produce particular subjectivities. As Bensaude-Vincent and Newman put it, delineating the multifarious ways in which people articulate the relationship between art and nature: "Does art mimic nature? Represent nature? Simulate nature? Complete nature? Improve on nature? Counterfeit nature? Violate nature?"[20] While these binary categories were routinely invoked, they were also (and continue to be) contested constantly, and many physical objects

were seen to be at once natural and artificial. Moreover, Renaissance usage and lexicons did not distinguish sharply between the modern usage of "artificial" to indicate artifacts (shaped by human agency) and "natural" to indicate objects that are (seemingly) not.[21] Human effort helped to reveal virtues intrinsic in the (divine) workings of nature.[22]

Thus, in practice, no (human-made) artifact is ever entirely separate from the natural. Nature inheres in the substance of what we think of as human-made objects and changes them over time. Preserved mummies decompose and silverware rusts, changes driven by the intrinsic "natural" materiality of these objects, in spite of human artifice, will, and agency. Equally, things commonly understood as natural—from agricultural crops to metals and minerals—undergo cultivation, extraction, or processing by humans, sometimes over the course of many millennia.[23] If the categories of "nature" and "art(ificial)" can be recuperated at all, it is as a continuum, not a binary. Consequently, technology may be variously understood as an extension or perfection of nature (and, simultaneously, an extension of human capacities), a challenge to nature, or a rebellion against nature.[24]

Moreover, the moment at which nature ends and artifice begins—in crops, microchips, wooden sculpture, or in a metal extracted via chemical reduction of an ore—depends on where you look and on who is doing the looking. Since human bodies and temperaments were thought to be influenced by natural phenomena, from astral bodies to climate and foodstuff, the corporeal and the social human in the Renaissance were far from encased entities whose nature remained unchanged by external influences.[25]

MAKING AND KNOWING: ARTISANAL AND LEARNED KNOWLEDGE

Technology and objects intersected through the body: making artifacts (human-made objects) required bodily knowledge of matter and of the processes for its transformation.[26] Practical, technical, craft, and artisanal activities in the Renaissance comprised a group of activities for the production of artifacts. Those who practiced these activities were either trained in the mechanical arts via a guild-controlled apprenticeship or were practitioners whose own investigations of nature had enabled them to know and to make things.[27]

Metalworking—casting, etc.—was a complex technology, comprising artisanal practices, tools, and knowledge of the behavior of materials, all brought together to make objects of consistent form and composition. Alchemy was a related field in which practitioners strove to imitate and perfect nature, drawing on theoretical knowledge and technical expertise along the way. Renaissance technologies, then, might be identified by seeking out processes and products that were the result of inquiry into the workings of nature.[28]

The fifteenth century was an era in which literature on the technical and practical arts, written by both university-educated scholars and by artisan practitioners trained via apprenticeships, expanded. Its circulation was helped in no small part by the advent of print, a technology that spread from the Rhine throughout Europe, gaining particularly strong early footholds in the north of the Italian peninsula and in the Low Countries.[29] These works covered everything from artillery to painting, from alchemy to pottery. There was, moreover, an increasing interaction between the technical crafts and theoretical spheres, as well as a growing relationship between "mechanical arts and the rise of empirical and experimental methodologies within the new sciences of the seventeenth century."[30] Furthermore, as Eric H. Ash and others have explored, during the early modern period (c. 1450–1800), expertise in practical spheres was increasingly seen as key to economic prosperity and to the consolidation of state power.[31]

In order to uncover artisanal knowledge in the Renaissance, one must look not only at the modest quantity of texts that artisans wrote, but also at what they made, and how. As Pamela H. Smith puts it, "[A]rtisans might see reality as intimately related to material objects and the manipulation of material, which could be thought about and understood as a 'material language'."[32] In this way, artisans argued that craft operations were themselves "a form of cognition," epistemological activities in their own right.[33]

Practical and theoretical knowledge were thus related.[34] Craft writing was a genre that blurred the boundary between the mechanical arts and the liberal arts: practitioners wrote about their crafts—their vernacular science, which encompassed practical aspects of what we might call art, science, and technology—in ways that linked these skills explicitly to higher-status disciplines and occupations. What Pamela H. Smith has called a "boom in technical writing" by craftspeople, on technical practices for making things, began around 1400, accelerated sharply after the appearance of the moveable-type printing press in Europe in the 1460s, and continued throughout the early modern period.[35]

Writing about one's bodily knowledge served a variety of purposes. In sixteenth-century Germany, for example, the genre of the artists' primer or *Kunstbüchlein* explained, for "artists and craftsman in the making," how and why to make pictures, documented the techniques of craft professionals, attempted to document artistic practices, and sought to mend pedagogical networks rent asunder by the Reformation.[36]

Libri secretorum or books of secrets—writings that promised to reveal secrets long held by a small coterie of renowned thinkers and practitioners, or that were known only to nature herself—invoked the rhetoric of the how-to manual, providing not explanations of causes and underlying principles, but rather reliable techniques for harnessing nature's hidden forces.[37] The advent of the moveable-type printing press in mid-fifteenth-century Germany greatly

facilitated the circulation of these texts, as well as their affordability. The popularity of the (now perhaps somewhat oxymoronic) printed book of secrets is borne out by the hundreds of exemplars.[38] Despite the connotations of occult knowledge, these books provided practical techniques for making things.

The pseudonymous Alessio Piemontese's *De Secreti* (On Secrets) by Girolamo Ruscelli recounts, in great detail, how to make, for example, cures for a variety of ailments, how to produce inks and dyes, and methods for manipulating seeds in order to change the taste of the cropped fruit. Recipes in such books of secrets were not necessarily replicable by someone who had not witnessed or practiced the procedures.[39] Nonetheless, many readers probably did attempt the recipes in printed manuals. A heavily annotated exemplar of Wyllyam Warde's English translation, in the Folger Shakespeare Library, illuminates such a case.[40] Annotations, in multiple hands and in inks and graphite/silverpoint, range from underlining of passages and words, to side-heads that draw attention to passages (curly brackets or the word "note"), to the initials "M.B.," short comments (an ointment to cure a child's cough is described, perhaps ironically, as "prety"; or "I pressed this"; or "very good") (Figure 2.3).[41] Such manuals were not necessarily sufficient for training a novice, but could well have formed part of a reference library of a practitioner. The Folger Shakespeare Library copy, for example, contains an additional recipe as a manuscript note preceding the start of the text.

Some Renaissance craftspeople and scholars drew a sharp distinction between knowledge gained by making and doing with the whole body and that gained by reading.[42] The alchemist, physician, and astrologer Theophrastus von Hohenheim, known as Paracelsus (1483–1541), asserted that experience could not be replaced through book learning, "since paper has the property to produce lazy and sleepy people who are haughty and learn to persuade themselves and to fly without wings."[43] More broadly, Paracelsus argued that artisans who made things from matter, from miners who processed ore to carpenters and practitioners of empiric medicine, had a knowledge of nature— and consequently the word of God—that was fundamentally experiential in nature.[44]

In a number of arenas, learned and artisanal practitioners exchanged expertise and worked together in order to make and do things: cartography, the printing trade, mining, and weapons manufacture are but a few examples. Pamela O. Long has suggested that, during the fifteenth and especially the sixteenth centuries, the number and range of contexts, or "trading zones" of expertise across social divides and the theory/practice divide, expanded greatly. These zones included courts, print shops, coffee shops where social groups might mingle, arsenals, instrument-makers' shops, and urban architectural/ engineering projects.[45] Other zones were entangled with imperial projects: cartographic workshops, shipyards, and a variety of colonial knowledge-making

The seconde booke

uer diminishe, putrifye, nor corrupt.

❧ *Poulder of Iris.*

TAke *Iris* electe, what quantitie you will, and after you haue wel beaten it into poulder, steepe it, and temper it also well with Rose water, and laye it than abrode vpon a sieue couered. This done, take *Storax calamita*, and Bengewyn, of eche of theim halfe an vnce, beate them well into poulder, and make therof an infusion into a glasse of Rose water, & hauynge poured it vnder the said sieue wel couered rounde about, ye shal afterward seeth it vpon the embers. And so the *Iris* waringe cleane and dry, receiueth the parfume of the other substaunces. This poulder will be excellent to geue an odoure vnto clothes or garmentes, & all other thinges.

Poulder of Violettes.

TAke *Iris*, knoppes of Roses, of eche a pound, pilles of Cytrons drye, iiii. vnces, Gylleflowers, *Sandalum citrinum*, drye Lauender, Coliander, of eche of them two vnces, Nutmigges an vnce, Maioram dryed, *Storax calamita*, of eche of them an vnce and a halfe, Bengewyn electe sixe vnces. Beate to poulder and sift finelye all the sayde thinges, and the poulder shal be made: the whiche you shall kepe in a viole of glasse, well stopt that it take no vent.

A whyte poulder to put in litle bagges.

TAke *Saudalum Citrinum* a quarter of an vnce, poulder of the best Bengewin that may be gotten, *Iris*, of eche of them an vnce, and bofle them in Rose water inough: than take burned Alom and well sifted twelue vnces, let it lye in the sayde water and make pilles, or litle balles flatte at both endes, of the biggenesse of peason or biggar, the whiche you shall drye in the shadowe: and afterwarde beate them in to poulder, and syft them again, and than it is made. But if you will haue it musked, take Ambre and Musk, of

FIGURE 2.3 Girolamo Ruscelli, *The secretes of the reuerende Maister Alexis of Piemount … translated by Wyllyam Warde*, London, 1558, f.48v. Call #: STC 293 copy 2. Used by permission of the Folger Shakespeare Library under a Creative Commons Attribution-ShareAlike 4.0 International License.

sites.[46] The febrile activity around material production and encounter across these sites challenges the traditional chronology of the "Scientific Revolution"— an influential early twentieth-century historiographical construction, hotly contested and reconfigured in recent decades, but still powerful in the popular imagination—that produced a positivist history of the "rise of modern science" through a history of the mathematization of sciences in Western Europe.[47] The period 1400–1600, rather than 1550–1700, reveals the rise of new approaches to empirical knowledge and materiality. Pamela O. Long has argued that the Renaissance (1400–1600) saw the embedding of "the empirical values that were intrinsic to artisanal work" across numerous spheres of activity.[48]

Scholars of the rise of what early modern practitioners called the "new science"—forms of making certain knowledge about universals by means of empirical and bodily activity—have shown how experimental practitioners challenged the division between mechanical arts and theoretical knowledge.[49] Just as the techniques and processes for making objects expanded during the Renaissance, so did the materials with which to make them.[50] Oceanic expansion made available not only new sources of familiar materials, from pearls to silver, but also created contexts in which the expertise of indigenous African, American, and Asian peoples concerning materials, processes, and techniques shaped European material culture. For the English polymath and statesman Sir Francis Bacon, the mechanical arts, and the practices of experimentation via which craftspeople perfected their techniques for transforming matter and shaping nature, were the key to a new, empirical methodology for the practice of science.[51]

ENCOUNTERING TECHNOLOGY

From the late fifteenth century, overseas artifacts from an ever-expanding geographical orbit found their way into cabinets of curiosities. Here they were catalogued, analyzed, and displayed alongside everything from ancient Roman jewelry to blowfish. Cabinets were spaces in which viewers encountered, in the same sweep of the gaze, contemporary folk arts, ingenious machines, distant antiquities, ancient relics, and natural specimens. These spaces were thus prime sites of classification and comparison in which viewers could analyze exotic objects alongside the relics of Europe's own classical and prehistoric past.[52]

In the Middle Ages, object collections were assembled in religious institutions (in cathedral treasuries, for example), where they functioned as relics and ceremonial artifacts, or in royal households that assembled gifts received, booty procured, and regalia bestowing the authority to rule in treasure-houses or *Schatzkammern*. During the Renaissance, a new form of private, secular collection emerged and proliferated. Called a cabinet of curiosities, *Wunderkammer*, *studiolo*, or *museum*, this type of collection emerged among the

elites in the Italian peninsula, then crossed the Alps into the German lands and Central Europe, eventually becoming established, by the seventeenth century, in France, Spain, England, and Scandinavia.[53] Scholars and collectors attempted to organize what we might anachronistically call the material objects of human and natural worlds, their limits, relations, and entanglements. Collection catalogs and inventories provide clues to how ideas about human-made artifacts and the nature/culture divide emerged in the Renaissance in response to the rediscovery of classical antiquity and sustained transoceanic encounters.

The founders and owners of cabinets were typically princes, physicians, apothecaries, or scholars, broadly construed. Their collections fulfilled a variety of functions. The possession of rare and valuable artifacts enabled princes to flaunt their wealth, power, and imperial and commercial reach. For practitioners of natural history and the medical arts, collections were spaces of study and discussion that enabled those who owned them to demonstrate the depth of their pockets and extent of their scholarly and commercial networks.[54]

Cabinets permitted scholars and collectors to contemplate the macrocosm of the world through a microcosm that could be explored without the inconvenience of extensive travel. Commentators often wrote admiringly about overseas technologies from East Asian silk to Mexican architecture. Educated Europeans found themselves attempting to understand comparatively exotic objects and the relics of Europe's own classical and prehistoric past. Cabinets thus participated in the shaping of disciplines in the Renaissance. Paula Findlen has shown, for example, how the development of natural history as a discipline was shaped by the practices supported by collections, collecting, and collectors: the trade in objects of natural history, the publication of catalogs, and the empirical study of objects.[55]

Cabinets were heterogeneous object collections, comprising various combinations of a dizzying array of plants, animals, minerals, and artifacts from classical civilizations, from contemporary Europe, and from the wider world.[56] Artifacts that constitute material technologies in Renaissance collections fall into what today would be classed variously as art, antiquities, and ethnographic artifacts. Yet the very categories of things understood to exist in the world were inflected by attempts to describe, analyze, and classify the contents of cabinets. In the long sixteenth century, "artificial curiosities" like feather headdresses and stone axes were displayed alongside natural ones like shells and coral, inviting viewers to compare human and natural ingenuity.

The earliest known European manual on organizing a museum, the 1565 *Inscriptiones* by Samuel Quiccheberg, librarian to Duke Albrecht V of Bavaria, illuminates the motivations, organization, and rationale of such a collection.[57] Quiccheberg envisioned the museum as part of a purpose-built complex for making practical knowledge useful for governing a territory: workshops for printing, metal-casting, and wood-turning, a mint, a pharmacy, and an

alchemical laboratory. Quiccheberg's title page gives a sense of Renaissance categories for material that might be deemed cabinet-worthy:

> Inscriptions or titles of the most ample theater that houses exemplary objects and exceptional images of the entire world, so that one could also rightly call it a repository of artificial and marvelous things, and of every rare treasure, precious object, construction, and picture. It is recommended that these things be brought together here in the theater so that by their frequent viewing and handling one might quickly, easily, and confidently be able to acquire a unique knowledge and admirable understanding of things.[58]

Quiccheberg distinguished between the categories of the artificial (things wrought in some way) and the marvelous (things that seemed to break the laws of nature) ("*artificiosarum miraculosarumque*"). He conceived of the material theater of the *Kunstkammer* as a space in which objects that were either exemplary or exceptional were brought together in such a way as to perform a distinct epistemic function. Visual and material encounters— "frequent viewing and handling"—were routes to a particular understanding of nature. *Kunstkammern* were spaces where material technologies—things— from societies near and far were assembled into what we might call epistemic installations. They did intellectual work through the way in which they brought the world into a room, enabling viewers who stayed at home to claim a distinct kind of authority: the authority of flesh-witnessing objects that did not, in the world beyond the cabinet, appear together in any single place.

Quiccheberg suggested that a large princely collection be divided into five classes, each with ten or eleven subclasses called *inscriptiones* or *tituli*. These classes and subclasses do not constitute a coherent program, but rather show multiple ontologies at work simultaneously. In some subclasses, objects made of the same substance were to be placed together, regardless of place, function, or period of origin. Ancient Roman, foreign, and domestic coins appear together, for example.[59] This sort of arrangement allowed viewers to compare what different cultures were able to do with the same materials. Quiccheberg's catalog headings do not distinguish between current Western categories of animate and inanimate objects. For example, they divide one class of objects into subsections on unusual animals, animals cast from metals and other substances, parts of animals such as skeletons, and also "things artfully made into the shape of human parts" such as "prostheses."[60] Such arrangements enabled viewers to compare God's creative power to human handiwork. Other subclasses were arranged by function, such as musical instruments, mathematical instruments, and writing equipment (the first three subclasses of the fourth class).[61]

The comparative possibilities of collections are made clear by the description of the first subclass of the fifth class: "Oil paintings by all the most eminent artists, [s]o that in these demonstrations of artistic skill it might be observed to what

extent one artist seems to have surpassed the other." Overseas artifacts appear in several of Quiccheberg's classes. In the second class, the fourth subdivision encompassed "foreign vessels, made of metal, earthenware, sculpted, wooden, and differing in shape; some excavated from ancient ruins, some brought from afar or merely less used in the region of the theater's founder. Likewise, some temple and ancient sacrificial vessels."[62]

A 1655 print of the collection of Ole Worm, professor at the University of Copenhagen, teacher of Greek and Latin, and founder of Nordic archaeology, illustrates what one might call cabinet-worthy artifacts (Figure 2.4). Such objects might be category-breakers, such as unicorn horns; or rare, like the skin of a polar bear hanging from the ceiling of Worm's cabinet; or emblematic of the inhabitants of distant regions, like a kayak. They might illuminate human technical virtuosity or aesthetic skill—they might be ingenious mechanical inventions, for example.

There were many contact zones in Renaissance Europe—visual, sonic, tactile, gustatory, and olfactory landscapes created by seeing, hearing, eating, touching, smoking, smelling, and healing with such technologies as chocolate and

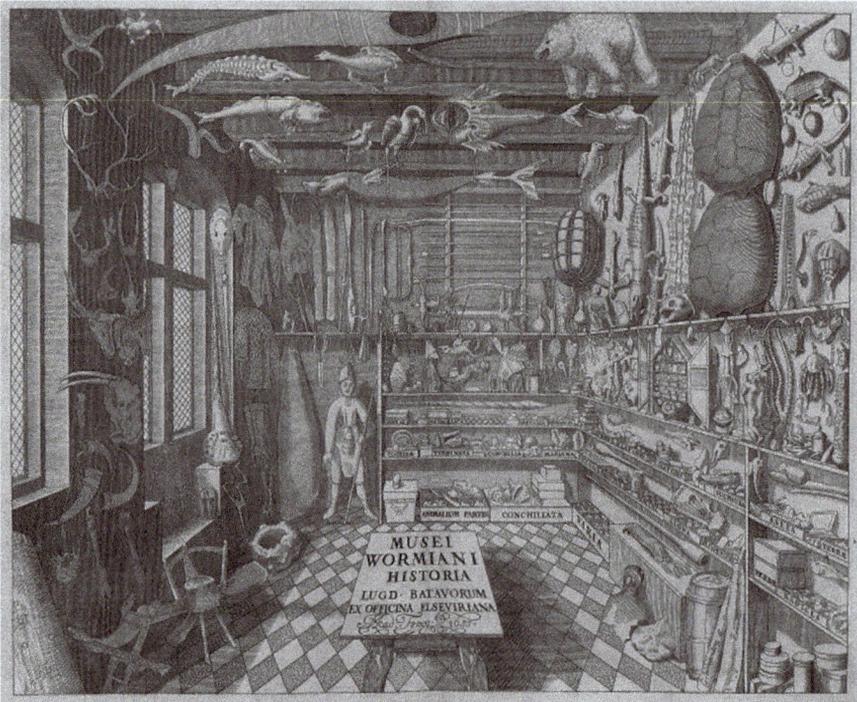

FIGURE 2.4 Olaus Worm, *Museum Wormianum, seu historia rerum rariorum*, Leiden, 1655, illustrated title page. Call #: *KB+ 1655. The Rare Book Division, The New York Public Library. The New York Public Library Digital Collections.

tobacco, chili and maize, featherwork and music. For example, technologies of healing in Europe became increasingly entangled with practitioners, techniques, substances, and processes from overseas. The health of European colonists, explorers, officials, and missionaries in unfamiliar climates and landscapes, from the Caribbean tropics to the Siberian tundra, was fundamentally dependent on access to the technologies of local peoples. These medical technologies entered European *pharmacopeiae*, institutions, and texts, thereby reconfiguring European medicine. These processes of hybridity and syncretism were not new, of course; ancient and medieval medicine in Europe had also been entangled across communities of various religious, ethnic, and political affiliations. The objects of colonial medicine transited across a number of our current categories— religious, magical, technological—and illuminate the fundamentally different, plural, and fluctuating ontological schema of the Renaissance.[63]

The medium of print, the subject of the next section, relayed images and descriptions of these experiences to an even wider audience. These experiences shaped the assumptions and expectations that viewers brought to cabinets. What distinguished the cabinet was that it enabled one to compare different regions and to practice a form of world-making, constituting new knowledge and categories through a global perspective. Cabinets could thus function as epistemic installations—arrangements intended to stand in for objects in nature and even to replace them.

THE ADVENT OF PRINT

One technology that interwove itself in among many of the technologies outlined above was, of course, the technology of print (Figure 2.5).[64] The historiography on the advent and influence of print in the Renaissance is extensive, encompassing both the technology and its entanglement with cultural, intellectual, political, scientific, imperial, social, and religious changes between the first printing of a book using a moveable-type press and the early seventeenth century.[65] The advent of print sped up the rate at which information circulated: more books were printed more quickly and more cheaply; consequently, a greater number of people could afford to acquire books.[66] Information also circulated in relatively ephemeral forms of print, such as broadsheets and pamphlets. Printed books and their illustrations facilitated the exchange of scientific information and allowed for the easier replication of diagrams, although they also helped to replicate and circulate errors. Within the context of the cultural history of objects in the Renaissance and the theme of technology, it is useful to consider printing as a web of technological processes, genres of printed artifacts, and (briefly) contemporary responses to the ramifications of print.

The broad outlines of the story of Johannes Gutenberg's development of a moveable-type printing press in the southwestern German city of Mainz

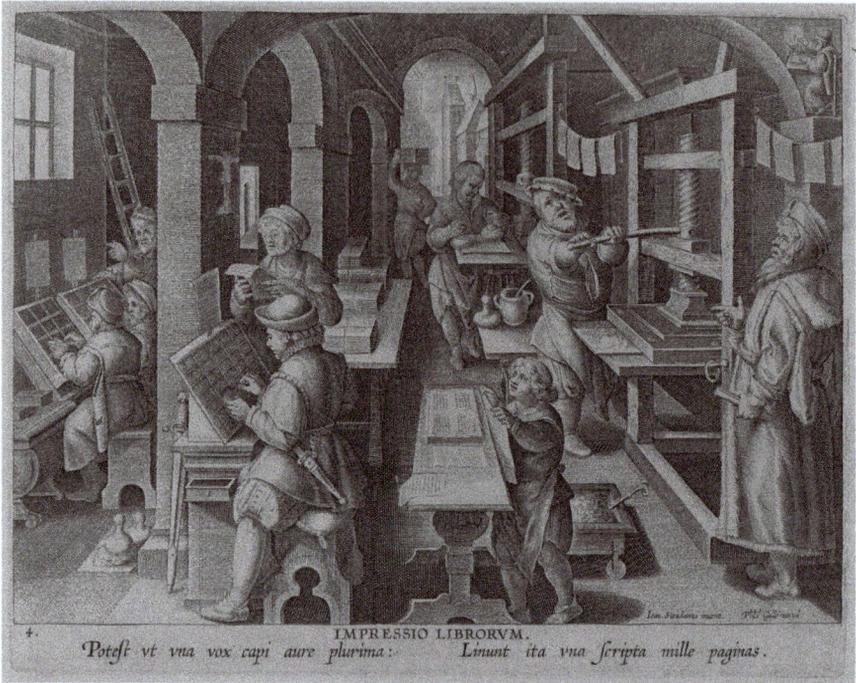

FIGURE 2.5 Jan van der Straet, called Johannes Stradanus, (designer) and Theodoor
Galle (engraver), *Nova Reperta*, Antwerp, *c.* 1580–1590, plate 4, "Printers at Work."
Call #: 1964.8.1578. The National Gallery of Art, Washington, DC. Rosenwald
Collection.

(prefaced, perhaps, by experimentation with printing in Strasbourg in the late
1430s and 1440s) is well known. Gutenberg brought together several existing
craft processes: paper-making (originally invented in East Asia, and traveling
to Europe along trade routes), woodcuts (usually single-sheet blocks made
for devotional purposes), metal-casting (to cast individual letters known as
type, which could be rearranged in an infinite number of combinations), and
the winepress (a carriage and screw arrangement which was adapted to press
"formes"—wooden frame arrangements of inked type—onto paper).[67] From its
almost mythological beginnings in a city on the Rhine (long after its adoption
in East Asia), the printing press spread quickly: first through German trading
cities, and then to cities around Europe, often accompanied by German printers
who settled in cities, from Iberia to Bohemia.[68]

 Along with the spread of the technologies of print—and arguably a key
driver of them—was the diversification of textual genres over time. A variety
of printed genres emerged. The broadsheet—a cheap printed sheet combining
woodcut images and letterpress—and the primarily visual prints—perhaps

accompanied by a descriptive caption—were two of the more affordable early modes. In size and cost, textual genres would range, by the end of the sixteenth century, from affordable chapbooks and news broadsides to hefty folio volumes, often exquisitely bound and decorated. By producing an ever-increasing range of printed work for different purposes and audiences, printers created a diverse market for their labor.[69]

Print was a wide-ranging contact zone between Europe and the wider world. Travel accounts—often letters sent to patrons—were printed in the form of slim pamphlets, translated, and circulated throughout Europe. The second half of the sixteenth century witnessed a proliferation of geographical modes. The genre of cosmography, multifarious since antiquity, ruptured into descriptive and geographical modes. New visual modes emerged, such as the illustrated costume book composed of plates showing the clothing of the world's peoples (Figure 2.6). The De Bry family of printers in Frankfurt set new standards for the quantity and quality of illustrations in travel accounts; between 1590 and the mid-seventeenth century, they produced twenty-three lavishly illustrated volumes within the series *India orientalis* and *India occidentalis*.[70]

The far-reaching implications of the technology of print were recognized early. As Polydore Vergil put it in the late fifteenth century, the advent of the book as a form "is nothing in comparison with an achievement of our own day, a newly devised way of writing. In one day just one person can print the same number of letters that many people could hardly write in a whole year." No longer did scholars have to fear the permanent loss of their works, dependent as they had been on scribes copying faster than books—or entire libraries—were being destroyed by natural or human-made disasters. Moreover, books now "poured out to us so profusely from this invention that no work can possibly remain wanting to anyone, however needy."[71]

Nevertheless, a number of commentators—who have, perhaps, been turning in their graves since the onset of the digital age—raised concerns about how print made it easier for the wrong sort to propagate erroneous ideas.[72] As the seventeenth-century English geographer Peter Heylyn said of the printing press: "[T]his most excellent invention hath been much abused, and prostituted to the lust of every foolish and idle paper-blurrer: the treasury of learning being never so full, and yet never more empty; over-charged so with the froth and scumme of foolish and unnecessary discourses."[73]

GIFTS

Artifacts considered to demonstrate distinctive technical and artistic skill were part of gift-giving material cultures of diplomacy in the Middle Ages, a trend that continued through the Renaissance. The choice of artifacts selected to function as gifts helps to illuminate the ways in which participants in these encounters

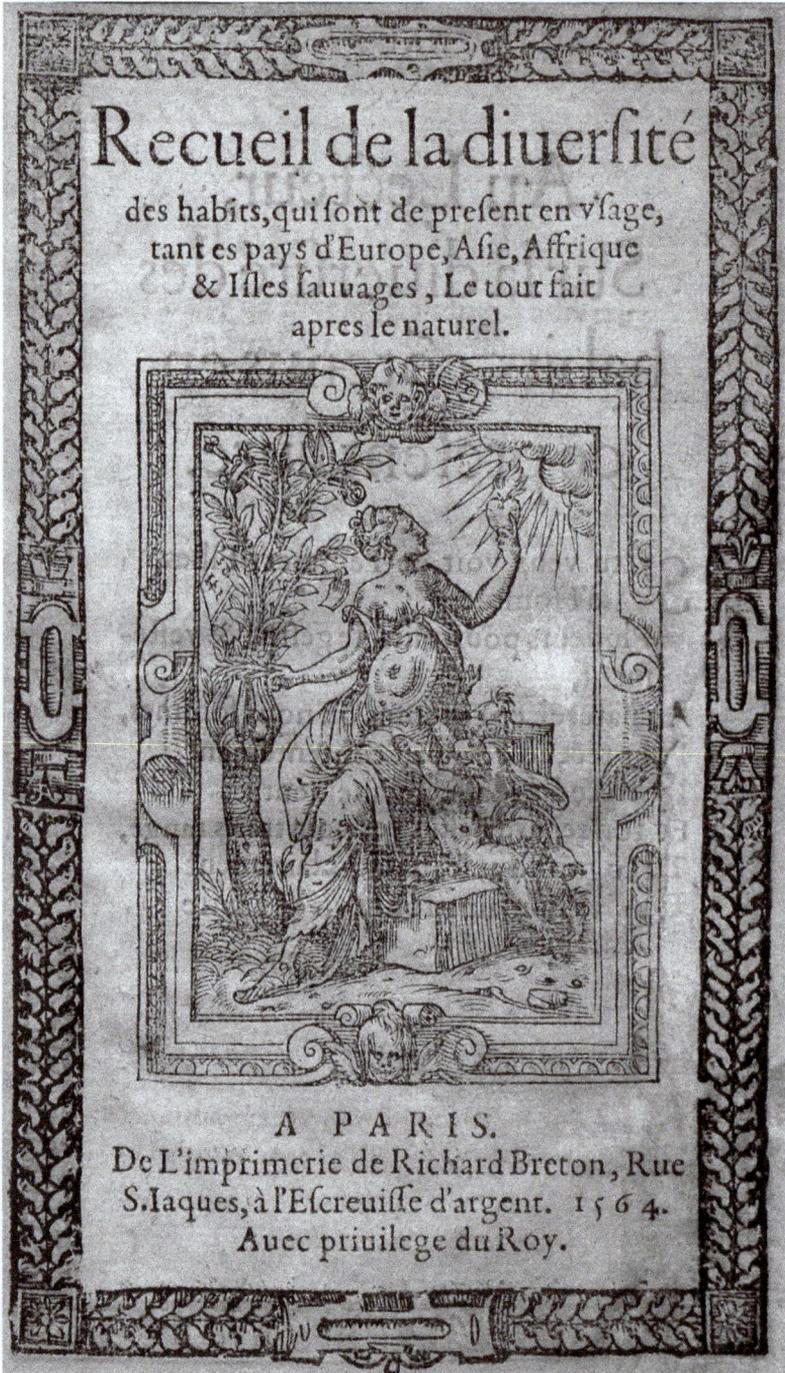

FIGURE 2.6 François Deserps, *Receuil de la diuersité des habits,* Paris, 1562,
unpaginated, title page. Call #: Typ 515.64.734. Houghton Library, Harvard
University.

viewed the power relations between the polities involved. They also reveal what gift-givers considered to be the most ingenious, rare, and valuable material artifacts in their possession. The circulation of diplomatic goods in Eurasia and beyond helped to create new markets for such artifacts and stimulated elements of global, hybridized visual culture in the long sixteenth century.[74]

By 1400, a wide array of gifts and trade goods from Asia and Africa exhibiting techniques unmatched in Europe were already entering Latin Christendom. The technologies that these artifacts exhibited included textiles (silk), sculpture (ivory), ceramics (porcelain), animal husbandry (notably horses), and metalwork and mechanics (automata).[75]

Cartography was one of the technologies that Renaissance Europeans used to emblematize their empirical knowledge, technical know-how, and artisanal skills abroad. Illustrated printed atlases and wall maps, particularly those from the Low Countries of the late sixteenth and early seventeenth centuries, were given as diplomatic gifts and carried as trading goods on ships traveling to the east. Such maps demonstrated geographical knowledge, both geometrical and empirical. These printed works were also part of the larger genre of printed books—often lavishly illustrated ones—that served as gifts to be taken on overseas voyages. In a curious case of technological diffusion, adaptation, and cultural translation, the Oxford scholar, Anglican minister, and apologist for English imperial expansion Richard Hakluyt recommended that travelers to China should display a map of England and offer as gifts the Flemish cartographer Abraham Ortelius's atlas, along with costume books, herbals, and bestiaries.[76]

CONCLUSION

In the 1580s, the Florence-based Flemish painter and designer Johannes Stradanus (Jan van der Straet or Giovanni Stradano) allegorized a number of "new inventions" in the *Nova Reperta*, an iconic series of prints published by Philips Galle in the late 1580s and 1590s (Figures 2.2, 2.5, and 2.7). The first edition of the prints was so successful that Stradanus expanded the series a few years later to encompass nineteen inventions that appeared on numbered prints after an introductory print summarizing all of them. Stradanus's choice of inventions to celebrate offers a visual encyclopedia of the sorts of artifacts and processes that constituted technological innovation in the eyes of Renaissance elites. Renaissance Europeans did not draw a hard distinction between their own technologies and those of other peoples. Far from it: scholars, artists, and writers were eager to incorporate multiple modes of making and knowing (to borrow Pamela H. Smith's formulation for artisanal and theoretical knowledge). They did not, however, tend to recognize or acknowledge these borrowings, a habit which would lead to the erasure of indigenous agency from the metanarrative of "modern" science.

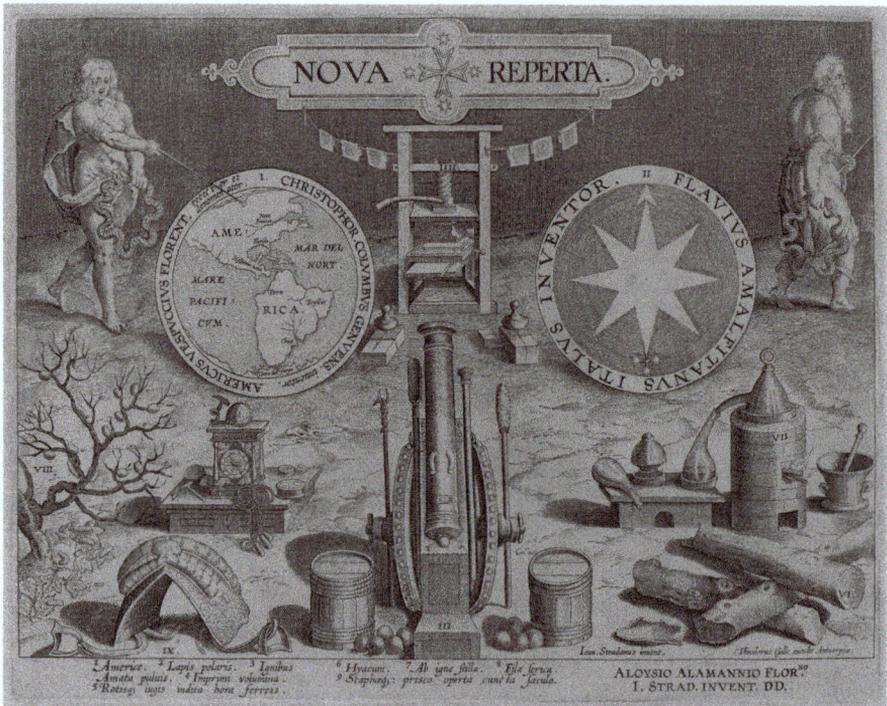

FIGURE 2.7 Jan van der Straet, called Johannes Stradanus, (designer) and Theodoor
Galle (engraver), *Nova Reperta*, Antwerp, *c.* 1580–1590, title page. Call #:
1964.8.1574. The National Gallery of Art, Washington, DC. Rosenwald Collection.

The first of the numbered prints, entitled "America," illuminates a technological
encounter. A heavily clothed Columbus bearing a staff and an astrolabe—more
technologies—has just landed in America, through the ingenuity of the ship
and boat visible on the left-hand side of the print. Columbus is met by America
personified as a woman rising, as if from sleep, from a hammock (an indigenous
technology). America is naked but for a feather cap, the barest of feather skirts,
and a (perhaps) metallic ornament around one leg. A club rests against a nearby
tree; in the background, limbs of a human victim of indigenous warfare roast
on a spit, another New World technology.

But Europe had long been encountering technologies in the East, and
Stradanus includes a number of these in the *Nova Reperta*. The compass,
gunpowder, printing, and silk appeared first in China; stirrups, windmills,
sugar, the astrolabe, and possibly alchemical distillation had Arabic and Near
Eastern roots. The opening print illustrates technologies from Europe, Asia,
and the Americas: silkworms, at various life stages, on a mulberry bush appear
alongside such transcultural technologies as saddle and stirrups, guaiacum

(a wood used to make a cure for syphilis), gunpowder, and cannon. Some of these technologies had their origins beyond Europe. Across the series, Stradanus's idealized, classicized engravings effectively efface subaltern actors who were central to the *techne* of such inventions as silk, medicine, sugar, and gunpowder.

Stradanus's prints show machines that required constant physical work from the body of the artisans who used them: watermills and windmills needing to be supplied with grain (prints 10 and 11), furnaces being stoked (print 3), presses being cranked in order to print books and produce olive oil (prints 4 and 12), and so on. At the same time, they show settings in which technology was constituted via collaborative work between scholars and artisans, such as the print shop or the preparation and administering of a cure for syphilis based on a New World wood.

CHAPTER THREE

Economic Objects

In the Renaissance

MARTHA C. HOWELL

In his magisterial *Autumn of the Middle Ages* of 1919, Johan Huizinga remarked that our fascination with van Eyck's famous *Ghent Altarpiece* of 1432 owes as much to the objects meticulously detailed in the panels as to the sacred drama so powerfully depicted. "In these details," he wrote, "the mystery of everyday things blossoms in its quiet glow. Here we sense the direct emotional stirring about the miraculous quality of all things" (Figure 3.1) (Huizinga 1996).[1]

Huizinga's remark captures something that was peculiar not just to the fifteenth-century Burgundian Low Countries from which this painting comes, but also to the entire period of the Renaissance, for objects like those drawn in the altarpiece, and in countless other paintings and engravings from the age, were supercharged. Not only did they construct both social and personal identity, as objects do in every culture, but they did so in this period with extraordinary force because of their value as economic objects. In this period, they functioned not just as the stores of wealth and signs of power they had long been, but also as the tools by which the people who traded and produced them were made rich; that quality made them a principal cause of the profound social and political changes that help define the Renaissance. The explosive intersection of economic worth with cultural significance made objects able to disorder society, disturb moral codes, and, paradoxically, reorder society in new ways.

The best known and best studied of these goods are the so-called luxuries that elite Europeans from south to north energetically collected and displayed: gowns

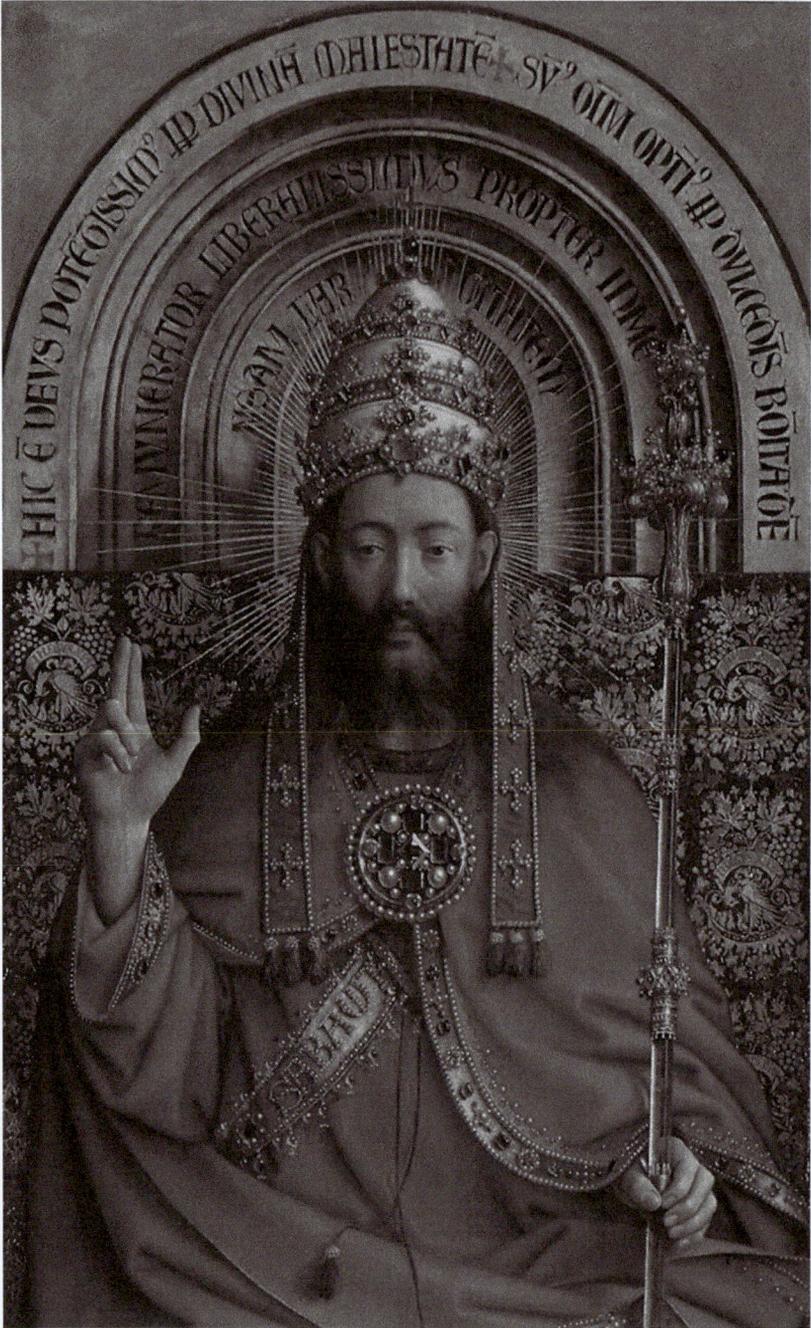

FIGURE 3.1 Jan van Eyck, *The Ghent Altarpiece—God Almighty*, 1425–1429. Oil on panel, total: 3.7 × 5.2 m. Saint Bavo Cathedral, Ghent. Photograph: Commons Wikimedia/The Yorck Project.

and cloaks, shoes and hats fashioned from rich silks, sumptuous woolens and soft leathers; armor and weapons; hollowware and flatware; bejeweled objects and sculptures elaborately worked by Europe's own artisans or imported from distant lands; huge tapestries from the looms of Brussels, Florence, and then France; paintings made or sold in Venice or Antwerp, many of them gorgeously displayed in the *Ghent Altarpiece* to which Huizinga referred. Alongside these luxuries circulated masses of humbler objects—the "everyday things" Huizinga mentioned—that were produced in this period, giving ordinary people of all but the lowest social ranks access to "things" that had been rarely available in prior centuries (Figure 3.2).

Although it would be naive to imagine that the silk-trimmed and fur-lined garments worn by a prosperous burgher or even the more common woolen gowns, pewter tableware, or tools owned by less prosperous urban people were easily affordable, there is no doubt that a significant portion of Europe's urban and rural population now had access to more and better material goods and that they avidly sought them.

In the most basic sense, all of these objects, the most elegant and most humble alike, were "economic objects," for they had come, directly or indirectly, from the marketplaces of the day and could be returned to the market in times of duress.[2] Some objects were treasured principally for their cultural meaning, as what scholars have often described as "pure sign," and thus rarely sold. Such objects, such as a tapestry depicting one of Alexander the Great's victories (and implicitly referencing a battle won by the tapestry's owner) or an item of religious significance like a reliquary, nevertheless bore recognizable exchange value. The gold thread woven into the tapestry enhanced not only its beauty, but also, as everyone knew, its cost and its potential price, as did the enamelwork or jewels decorating the reliquary. Similarly, the silks, furs, and jewels worn by nobles, it was well understood, were worth a small fortune; the embossed plate displayed by a count could very easily be melted down and traded as bullion or used as pawn for loans; his armor had come from workshops staffed by Europe's most skilled artisans and filled with metals so precious only the very rich could afford them. The boundary between economic object and cultural object in the period was even further blurred by more ordinary goods, ranging from the fur-lined cloak and pearls worn by a butcher's wife to the simpler garments tucked away in a peasant's trousseau chest, or even the pewter pots and bowls used in ordinary households or the carefully made tools in an artisan's shop. They were probably rendered economic objects more easily than the golden goblet owned by a nobleman, but that may have been more a function of economic necessity than of a casual willingness to turn their "things" into mere money.

In the following pages, drawing upon decades of work by scholars in many disciplines, I make a two-part argument about economic objects in the Renaissance. First, that the so-called commercial revolution of the Middle Ages

FIGURE 3.2 Robert Campin, *The Mérode Altarpiece* (right panel, detail), 1425–1428.
© The Metropolitan Museum of Art, New York.

that produced these objects and the sociopolitical changes that accompanied their arrival not only disturbed traditional hierarchies and existing moral codes, but also drove further commercial expansion, both fueling growth and, more significantly, directing it. Second, that most goods, whether bejeweled garments, simple linen smocks, silver and gold hollowware, plain pots, or any other good, were potential commodities (economic objects) because, and sometimes only because, they were invested with sociocultural values. In every culture, goods bear cultural significance and do cultural work, and in every society, goods function to some extent as economic objects, but in this period, objects' sociocultural values were so inflected by their relationship to the market that their value as sign was intensified; conversely, their economic value was doubly, triply charged by the cultural significance they bore and could confer. The intense, dynamic, and almost electric feedback between economic and cultural values that occurred in this age made things seem almost "miraculous," as Huizinga put it.

To illustrate this argument, I will conclude the chapter by looking first at spices, which played a starring role in the early history of European commercialization, and then, much more briefly, at tulips, which entered Europe as cultural objects in the sixteenth century, but by the early seventeenth century had been drawn into the vortex of the market in ways that deeply disturbed both society and the meaning of tulips themselves.

THE LUST FOR THINGS AND THE "ORIGINS" OF CAPITALISM

Although merchants had established trade routes along the subcontinent's coasts and river systems long before the two centuries ending in 1600—in this volume considered the age of the Renaissance—by the beginning of this period, the full effects of the so-called commercial revolution were evident. Commerce had by then escaped the enclaves where it had long been clustered; now the subcontinent was dotted with densely urbanized regions devoted both to trade and to production for the market. Florence, along with other Italian industrial and banking centers, had joined Venice and Genoa to make the Italian peninsula the engine of European commerce. The southern Low Countries, where Bruges, Ghent, Ypres, and then Antwerp dominated the commercial landscape, had become the most urbanized area of Europe. The Rhine, where Cologne had established staple rights, served as a major artery of trade linking the south of Europe to the cities of the Low Countries, England, and northern France and, above all, to the Hanseatic cities that had control of the Baltic and North Sea trade. Paris, long a center of luxury consumption, had spawned vigorous local industries and nurtured the same crafts elsewhere. Rome governed a financial network that stretched out in all directions across the continent. London had

begun its ascent, presaging the demographic, economic, and cultural explosion that would begin in the sixteenth century.

Europe was no longer an economic backwater of the known world. Its crisscrossing trade routes carried imported spices, gold, silks, books, and rare instruments, European-made cloth, metalwork, and armor, and timber, coal, and other raw materials to and from ports, inland entrepôts, financial centers, and industrial producers such as Ghent, London, Venice, Cologne, and Florence. It was dotted with fairgrounds where merchants and producers from all over Europe gathered at set dates to exchange goods, negotiate credit agreements, settle accounts, and share information. Europeans were now in the Sudan in search of gold and in the East in search of spices and silks; by 1500, they were poised to traverse the globe in search of even greater commercial profits. Indeed, by 1500, huge swathes of the rural economy, only isolated parts of which had been previously affected by commerce, were being visibly transformed. In some places, a free peasantry had already emerged; in others, entrepreneurial landlords were making wage laborers of their dependent peasants; in still others, peasants had themselves become market farmers. Industry was moving to the countryside, turning agricultural workers into industrial laborers.

Even the plagues and famines that ravaged Europe in the post-1300 period, the wars that all but destroyed some commercial networks, and the sociopolitical conflicts that broke out sporadically in the late medieval centuries did not halt the march of commerce. Instead, during these difficult periods, commerce slowed in some places and shifted to new grounds, but the class of people born of commerce, as well as those who had learned to live from it, survived, and many of them prospered mightily. The phrase "the depression of the Renaissance" perfectly captures the paradoxical fact that even during an overall decline in what we would call gross national product (GNP) from about 1350 to 1450 and when countless people died early deaths and many of the survivors lost everything, countless others got rich, many of the already-rich got even richer, and European high culture flourished. In effect, GNP per capita rose, and with it, by all accounts, so did the spread between rich and poor. After 1500, the pace picked up as Europeans ventured abroad, bringing quantities of bullion, spices, and new luxuries from foreign parts, and despite declines in some parts of Europe and continued suffering among the unlucky, the poor, and the exploited, there were massive gains among some groups of people.

Production and trade in objects was the motor of the commercial revolution. Merchants profited mightily by trading objects of all kinds, and the Europeans who made them became prosperous enough to become consumers themselves. Even though most of Europe's wealth in those days was based on agricultural production, not on what came out of the urban workshops of the day, or was imported from abroad, and even though goods like grain, wood, and raw metals constituted a much larger part of the commercial economy than did dresses

and hollowware, the trade in (and desire for) objects drove commerce. Indeed, the entire agricultural economy was commercialized in large part as a response to the commercial energy born of the trade and production of objects. This was especially the case in places like the Low Countries, England, and parts of Southern Europe, where grain and produce were grown for sale in urban or even long-distance markets or in regions where coal was mined, or silver, copper, and mercury dug from the earth, all to be delivered to people who made things for sale. Soon, Eastern Europe had become a major supplier of grain to Western European markets, producing what scholars have called the "second serfdom" in those regions. In short, the traditional economy, which was based on land and the wealth it produced, was fundamentally transformed by commerce in things and by the people who managed that commerce. Even if in terms of market value objects constituted a relatively small part of the economic whole that entered markets, they were nevertheless the leading edge of the commercial juggernaut that forever changed Europe.

Simultaneously, the political landscape was dramatically altered. Economic powerhouses born of commerce like the Dutch and English nation-states would emerge during the period, while the Italian city-states would lose political significance even as they retained their reputation for cultural achievements. The Germanic empire would be fractured by religious turmoil and be irreparably damaged by the Thirty Years' War to come in the seventeenth century, and the French state would soon begin its rise to European hegemony under the Bourbons. Disruptions of the traditional social order were just as marked. Bourgeois merchants, bankers, and artisan–merchants who had risen from commerce now threatened the traditional elite's monopoly of cultural, political, social, and economic hegemony; manual laborers, once casually dismissed as the third and lowest sector of medieval Europe's imagined tripartite society of "fighters, prayers, and workers," now were increasingly socially disaggregated, with trades like goldsmiths, apothecaries, or mercers at the top (even sometimes managing to join the aristocracy), day laborers at the bottom, and a host of brewers, butchers, bakers, dyers, and other tradesmen jockeying for places up and down a tall social ladder with many more rungs than it had once had; rural landowners were investing in market production, in the process often dispossessing peasants and inexorably turning themselves into agrarian capitalists. Military prowess, bloodline, and lordship were no longer enough to earn membership among the ruling elite. Now commoners who had control of essential trade routes, knew how to construct and manage complex financial deals, and had monopolies or near-monopolies on essential goods both luxurious and humble were steadily entering their ranks. These new men married the daughters of nobles and sired sons who inherited lands long possessed by the aristocracy, and with the land came political rights. In sum, commoners were joining, and would eventually replace, aristocrats in territorial

and national governments. In many scholars' interpretations, commerce in this age not only undid the traditional social and political order, it also gave birth to capitalism. As Henri Pirenne, one of the most influential scholars to connect commerce with early capitalism, put it:

> [I]n every direction where commerce spread, it created the desire for the new articles of consumption, which it brought with it. As always happens, the aristocracy wished to surround themselves with the luxury, or at least the comfort befitting their social rank. (Pirenne 1936: 81)

The result, Pirenne concluded, was a shift of resources and power from a *rentier* class of landowners to people who lived from trade and production for trade. Although Pirenne's argument about the nature of late medieval commerce has been heavily criticized, the link he made between commercialization and capitalism has proven sturdy. In his *Jeux de l'échange* of 1979 (in English, The Wheels of Commerce), for example, Fernand Braudel argued that trade in exotic goods produced what he called early modern capitalism. The merchants who could travel and control the mysterious routes from whence came many of the objects Europeans wanted had the freedom to set prices, control money flows, hoard information, and, in the end, amass enormous profits. This was capitalism of the early modern sort. These men had the power to privatize information so that they, and they alone, could—to use one of Braudel's examples—buy a kilo of pepper for two grams of silver in the Indies and sell it for twenty or thirty grams in Europe (Figure 3.3) (Braudel 1992: 403–8).

Braudel understood that consumer demand drove this trade, but the principal focus of his study was distribution, not consumption. That issue has, however, become central in much of the present-day literature on capitalism's beginnings and its logics. Arguing that consumers' decisions determined what and how much was produced, what and how much was imported, and who got rich providing the goods, scholars have concentrated on the particular choices consumers made. Although a major burst of work on consumption came in the 1970s and then focused on the eighteenth century, some scholars had earlier attempted to tell the story of capitalism's origin by studying elites' lust for luxury goods during the Renaissance. Werner Sombart launched the inquiry with his 1922 *Luxus und Kapitalismus*, followed by Norbert Elias's even more influential *Über den Prozess der Zivilisation* of 1939. Both books were, however, virtually ignored, lost in the miasma resulting in part from Sombart's ambiguous association with Nazism, but more generally from the isolation of Germanic historical scholarship during the decades following World War I and the distortions of cultural and social history during the Nazi period. It was only in 1969 when Elias's study was reissued and the first volume translated into English (as *The History of Manners*) that historians awoke to the possibilities offered by such inquiries.

All scholars pursuing this issue have proceeded on the assumption that what some have called "the consuming passions" are not just the hallmark of Western capitalist society, but its motor and its genesis. The best known of these early works argued that capitalism "took off" in the seventeenth and eighteenth centuries with the systematic development of luxury industries like Wedgewood's pottery in England, which fed the emergent bourgeoisie's lust for things (McKendrick et al. 1982; Porter and Brewer 1993). Since the 1980s, historians have pushed the so-called "consuming society" back in time, to the Renaissance and the late medieval centuries where Sombart and Elias

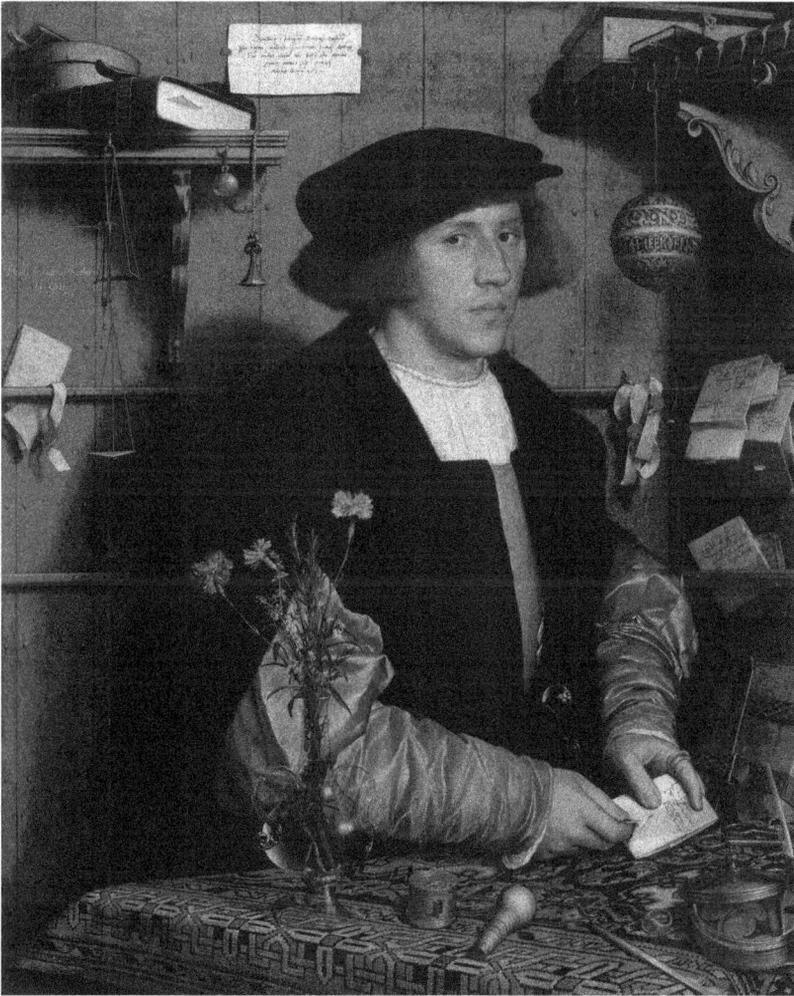

FIGURE 3.3 Hans Holbein the Younger, *Portrait of Georg Gisze*, 1532. Gemäldegalerie, Berlin. Photograph: Commons Wikimedia/Stephanie Buck.

concentrated, but they have ranged far beyond the courts that occupied these scholars. It has now become conventional wisdom that capitalism—its nature and its origin—has and had as much to do with consumption as production, and that in the Renaissance the consumption at issue was not limited to the elites who bought rare and high-priced goods. Even economic historians, whether of Marxist or liberal persuasion, have now joined the search. Think, for example, of Joan Thirsk's *Economic Policy and Projects* (1978), on the one hand, or Jan de Vries' *The Industrious Revolution* (2008) on the other, both of which concentrate on consumer demand by ordinary people and the way it affected economic growth and accumulation.[3]

Despite the high quality of much of this historical research, and despite the stimulating work of cultural theorists like Mary Douglas, Pierre Bourdieu, Arjun Appadurai, Daniel Miller, and many others who have given us nuanced interpretations of these so-called consuming passions, we are nevertheless stuck with a version of an old problem: ahistoricism. To be sure, almost all scholars today would reject a crude version of the claim that people are "naturally" desiring (although that remains the stubborn keystone of neoclassical economics). Most historians also reject any explanation that makes consumers the passive victims of advertisers or that consumption is nothing more than a form of social competition. But much of the literature on the history of consumption in this age implicitly depends on assumptions perilously close to those: their historical subjects—whether Sombart's and Elias's aristocrats or Thirsk's and de Vries' housewives—are already consumers, waiting to burst out of the world of scarcity imposed by the absence of markets and of institutions to protect them. It took only commerce to awaken them.

AMBIGUOUS THINGS

If we are to free ourselves of ahistorical assumptions about the relationship between consumption and commerce, even consumption and capitalism, we would do well to follow the lead of many cultural theorists and other scholars who have in recent decades examined consumption. In such interpretations, goods must be treated as actors rather than as inert things acted upon. In her cowritten *The World of Goods* of 1979, one of the most influential of such studies, Mary Douglas asked us to think of goods as a kind of speech, a way of communicating with ourselves and others that is constitutive of human identity, both social and personal. Daniel Miller has pursued a similar argument, his based on a Hegelian model of "objectification." In Miller's interpretation, individuals objectify themselves in the things he, she, or they create, rather as, in the Marxian model, the laborer alienates himself in the objects he produces. Unlike the "estranged" individual Marx described, however, the consumer reincorporates the object as her or his self, or can do so under certain social

and political conditions, thus enriching and elaborating the self. Unlike Marx's laborer, whose humanity is impoverished by the alienation of his labor, the consumer is rendered more fully human by the reincorporation of created objects.[4]

Miller explains that this process obtains in all cultures, even though it takes particular form in modern Western society, where masses of consumable goods compete for our attention. It also took particular form in the Renaissance, because, as I have argued, the market had then emerged as so powerful a provider of goods and had so radically transformed society. In the wake of this transformation, historians agree, people were left with uncertain markers of social place and no clear sense of what constituted their merit in a society that could seem in upheaval. Butchers' wives were wearing jewels, which was once the exclusive privilege of the nobility; men born as commoners were now sitting at the right hand of kings; the newly born Dutch state was governed by a merchant class. Birth no longer guaranteed social or political rights; the martial prowess and chivalric ethos that had traditionally defined aristocratic male honor no longer seemed enough.

Still worse, Europeans had inadequate tools for reconciling their desire for goods with religious injunctions against "superfluous" material wealth, even against consumption itself. Throughout the Middle Ages, moralists of all kinds had struggled with this problem, never being able to rid themselves of the unease that attended the quest for money and the luxuries it could buy. After all, vows of poverty were demanded of the religious, avarice was deemed one of the greatest of the mortal sins, and any trade of money was haunted by the specter of usury, for which people were regularly excommunicated—denied, that is, the sacrament that promised salvation. During the Renaissance, the tension mounted. Now there were more luxuries to be had and many more people able to buy them; even ordinary folks could assemble clothing, utensils, and the occasional bauble as never before. What, then, was the merit of a person who so eagerly sought dresses and jewels, even new pots and comfortable bed clothing? What was left of virtue?

One response to this dilemma was what scholars have labeled the Renaissance project of "self-fashioning," a paradoxical effort to use the very "things" that had caused the disturbance to construct a self worthy of honor and to secure a social place.[5] In exploring this process, scholars first directed their attention to traditional elites, whose birth and its accompanying chivalric code no longer seemed adequate, either to them or to the men and women of lower social rank who were closing in. As these people "refashioned" themselves, the luxury goods they owned or acquired no longer simply stored wealth and displayed political might as they long had done; they were also used to evidence intelligence, learning, and taste, thereby distinguishing their owners from the lower orders of people without such capacities and considered incapable of

acquiring them and, more fundamentally, assuring them of their own virtue. The search for self was, however, even more urgent among the commoners who were rising to social and political prominence. As Richard Goldthwaite put it in describing the links between consumption and personal or social identity among the Florentine mercantile and humanist elite of the period:

> [C]onsumption demonstrated taste more conspicuously than wealth. The more intimate relation with objects sharpened one's appreciation of them for their craftsmanship apart from the inherent value of materials and generated that self-conscious refinement of a sense of taste that is one of the highest expressions of culture developed in Italy during this period. (Goldthwaite 1993: 248)

Similarly, in cities like Bruges and London, as well as in the surrounding countryside in which more and more of the merchant class were acquiring residences, men of ordinary lineage but now possessors of great riches were also learning to "live nobly." This meant skill with horses and weapons echoing traditional norms, but it also implied refined manners, newly part of the mix, along with the knowledge of how to accessorize themselves, their families, their horses, and their residences with carefully chosen luxuries (Buylaert et al. 2011). If not yet the ticket to nobility in the fourteenth- and fifteenth-century Low Countries, the possession and correct use of the right kinds of material goods was nevertheless, even then, a feature of the noble lifestyle, and one of the many ways rich commoners were encroaching on noble status. By the sixteenth century, "correct" consumption alone could mark nobility.

Further down the social hierarchy, ordinary urbanites surrounded themselves with cheaper objects that sometimes mimicked those displayed by the truly rich, what Cissie Fairchilds has called "populuxe goods," even as they also stocked up on more practical things like coverlets, pillows, bedsteads, soup pots, and tableware (Fairchilds 1993). Even peasants acquired more things—never, of course, the luxuries displayed by the rich and only rarely the populuxe goods, but it was nevertheless not unusual to find a "cloth of Ypres" (the Flemish city where some of the highest-priced woolens of the period were made) in the trousseaus of young women in the Catalan countryside.[6] In short, things had come to play a more visible and profound role in establishing social place and personal identity not just because they were now available in quantity and kind unimaginable in centuries past. They were called upon to distinguish between a butcher's wife and a carpenter's daughter, to identify a peasant as a man of substance, and of course to set a count apart from a mere knight, or even from a municipal alderman, in an age when it had become harder to keep people in place or to know what places there were. Simultaneously, they told people who they were, as birth or lordship could alone no longer do, providing individuals with a personality not only represented by the things she or he wore or possessed, but also constituted by it.

Although scholars have sometimes seemed to reduce this passion for things to a version of social climbing in which lower orders mindlessly aped their social betters, the process was considerably more complex. People of different ranks, in different regions, made different choices, sometimes indeed seeking to copy those with more money and power, but often simply working out a sense of self and a place in the social sector to which they belonged with the objects available to them—and considered useful to them. For many secular elites of the age, as Goldthwaite's study of Renaissance Florence demonstrated, the key was to evidence and confirm their learning, intelligence, and discrimination; ordinary people in small towns typically had more interest in collecting religious images, for example, or in decorating their parlors in ways that appeared to imitate the style not of other ranks of people, but to celebrate or elaborate local traditions.[7] The variations in patterns of consumption and display represented more than the variations in wealth that marked Renaissance society; they also represented differences in how people saw themselves and sought to "make" themselves via what Miller called the "objectification" of the self.

The complex—and radically unstable—connection between the economic and cultural value of objects in this period is well illustrated by the history of two kinds of goods: spices and tulips. Not incidentally, both items have long featured in stories about early capitalism, but the argument I will make here is that their historical importance lies, more fundamentally, in the way they expose the dynamic relationship between culture and economy in this age.

Spices

Spices are often casually understood simply as flavorings like nutmeg, pepper, and saffron. In fact, however, the medieval category was much broader. It also included medicinal plants and animal parts, as well as a few other rare edibles like almonds, and sometimes even pearls (which came from the same regions). These were the premier international trade goods until the sixteenth century and remained a huge part of global commerce thereafter. All scholars, no matter their particular definition of capitalism, give the wealth made in the spice trade a leading role in its history.

Spices were not used (or particularly useful for) disguising the taste of spoiled food or keeping it from spoiling, as is frequently asserted. Rather, they were eagerly sought in part simply because people then preferred highly flavored food, arguably because spices enlivened the taste of grains, winter vegetables like leeks, and occasionally meat, which were the basis of their diet. Mace, cloves, cinnamon, ginger, pepper, and others literally spiced things up. They were also thought to have medicinal qualities, being used to calm stomachs, reduce joint pain, assuage headaches, and soothe nerves. Apparently, they were even used to treat cancer and other deadly diseases (Figure 3.4).[8]

Until the sixteenth century, spices came to Western Europe via the Levant, having been shipped by Muslim and Jewish merchants from Indian Ocean

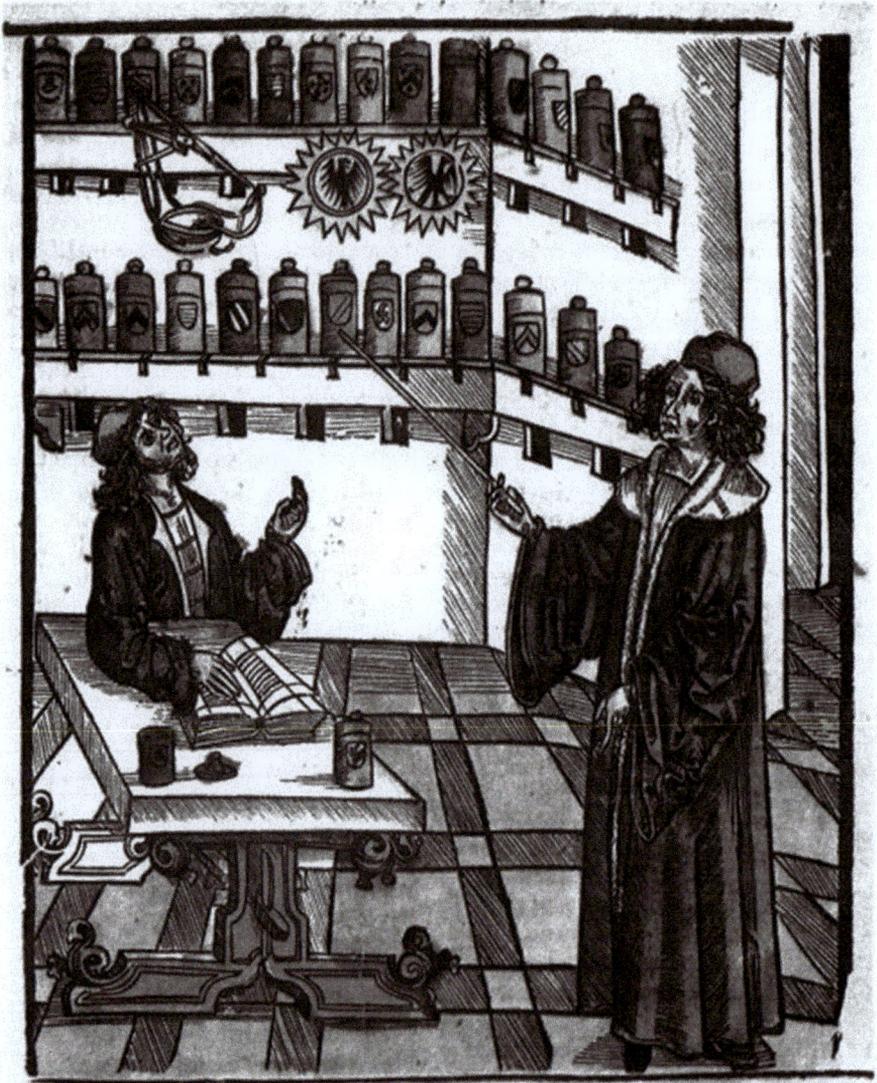

FIGURE 3.4 Medieval apothecary/spice shop. Doctor and pharmacist. *Das Buch des Lebens*, Marsilius Ficinius, Florence, 1508.

markets. In the entrepôts of Beirut, Constantinople, or especially Alexandria, merchants from Venice, Genoa, and Catalonia bought them and then distributed them in European markets such as Florence, Cologne, London, and Bruges. All were expensive. In the fifteenth century, even three ounces of pepper, the most abundant and, along with ginger, the cheapest of the spices, would have cost a *skilled* worker in England half a day's wage (today, three ounces of pepper at a

supermarket would cost an *unskilled* American worker about fifteen minutes of work). Cinnamon was then double the price of pepper, mace was three times as expensive, cloves almost four; aloe wood and camphor, which were used exclusively as medicine, were thirty-five times as dear.[9]

At one level, the Europeans's "taste" for spices was simply about culinary preferences and medical practices, and in this respect Europeans of the Renaissance were little different from the Romans who had obtained them from the same places whence came the spices consumed in medieval Europe. Also like the Romans, Europeans considered spices to be prestige goods, and in the Renaissance they served elites, along with sufficiently prosperous commoners, as evidence of their own ability to discriminate as they made culinary choices and as a visible sign of their status. As the struggle for self-fashioning intensified in this period, the rich found more ways to use spices and to display their knowledge of how to use them. They decorated their tables with pots designed to house the spices to be added to foods, and they purchased finely worked containers for spices that they would attach to their belts or put in their purses so as to have the flavorings at the ready—and on display. Courts like the Burgundian or those in Urbino, Ferrara, or Milan, then those of the English, French, and Germans, made ostentatious dining, centered on highly spiced foods, a visible mark of their "magnificence."[10] At important diplomatic encounters, cities like Bruges and Lille adopted the same practices, serving roast swan (a delicacy normally reserved for the nobility) along with other highly spiced meats and sweets laden not just with sugar (now from places like the Canaries), but also with mace, cloves, cinnamon, or other strong flavors. Although pepper reached further down the social hierarchy than did these more costly spices, pepper was also a marker of status. As the old English saying "he hath no pepper" announced, pepper demarcated those worthy of "credit" from those who were not (quoted in Smith 2007: 237).

Spices not only satisfied culinary and cultural "tastes"; they also thrilled the imagination. They came from places largely unknown before the sixteenth century, the secrets of their provenance, production, and harvesting the stuff of fantastic tales, some of them dating from the time of Horace. Even when the source of these treasures was identified, it was not easy to collect them because, according to some stories, snakes guarded them or, according to others, they were hidden in cold and watery caves (Freedman 2005). Paradoxically, however, spices were imagined to grow wild, in luxurious abundance, requiring none of the hard labor that made grain or onions grow in Europe. In combination, these stories whetted Europeans' appetites, spurring them to seek direct access to these treasures. After all, the merchants who brought these treasures to Beirut or Alexandria had figured out how to obtain them at the source; couldn't they do the same? And, by cutting out the middlemen who worked the trade routes from the Indian Ocean to the Levant, as well as the Venetians, Genoese, and

Catalans who managed the leg of the route to Europe, they could reap the huge profits that now were lost to Easterners and European rivals.

The Portuguese were the first to enter the markets where spices grew. Sailing around the Cape of Good Hope (1497–1499), they initially reached the west coast of South Asia and its pepper supplies, but soon discovered the islands in Indonesia that were then the sole source of nutmeg (with its precious mace) and cloves. Other European powers quickly followed, sparking long decades of tensions and often open warfare. In the end, the Dutch emerged dominant, and during the seventeenth century they had almost exclusive control of the trade from the Spice Islands to Europe and easy access to pepper, cinnamon, and other luxury spices that were grown elsewhere in the vast region of the Indian Ocean.

Spices were indisputably economic objects, and in the short run their prices varied according to supply and demand just as predicted by modern economic theory. The loss of cargos to storms, pirates, warfare, or other disasters would send prices skyrocketing, while the arrival of new supplies in Venice, Bruges, or Cologne would soften the market price. As supplies increased from the sixteenth century onwards, prices generally fell, as would be expected. Precise data about the extent of price declines (in real terms) are hard to obtain because the purchasing power of money declined rapidly during the period thanks to debasements, currency manipulation of various kinds, changes in coinage types and monetary units, and silver and gold imports from the New World. The trends are, however, clear: to cite one example, in the 1590s, the Portuguese were selling pepper on the Amsterdam commodity exchange at about 1.00 gulden a pound; between 1609 and 1624, it was quoted at 0.80 a pound, and in 1625–1627, it was quoted at 0.58 a pound (Wake 1979: 389).[11]

Again, as predicted by economic theory, consumption increased along with supplies. But demand fundamentally reflected "taste," both culinary and cultural—what Arjun Appadurai referred to as the "politics of demand," not price (1986). One sign of these cultural politics is that demand by elites softened as the prices for spices fell. As John Munro explained this falloff, it was a direct response to what could be called the "democratization" of the market:

> If a primary law of economics is that demand varies *inversely* with price, the consumption of spices (and diamonds and silks) proves the contrary case: that very high prices for spices, symbolic of luxury values, in themselves sustained demand among the wealthy. (Munro 2009) (emphasis in original)

While the price declines and the democratization of the market were undoubtedly the broad context for elite behavior, the downward shift of the demand curve had as much to do with cultural responses in other registers. "Luxury," after all, is not directly or exclusively determined by price. There are countless expensive goods way beyond the pocketbooks of ordinary Westerners

today that we do not consider luxuries, but oddities (powdered rhinoceros horn at about US$50,000 per pound in Hanoi, for example) and even more goods that most of us consider luxuries but do not cost much more than a beer and a burger (Fresh linens at meals? Flowers for the table in February? A vial of Chanel No. 5?). In the Renaissance, the same logics could apply. Richard Goldthwaite has demonstrated that the prices of paintings in Florence were low relative to other luxuries (like tapestries and certain textiles), but nevertheless were one of the principle means of "self-fashioning."

If price alone (and sometimes not even price) does not define luxury, we need a definition that takes fuller account of the meanings goods acquire in particular cultures—among other things, why the Vietnamese would pay so much for powdered rhinoceros horns, or why some Americans today would pay over US$5,000 for a bottle of wine.[12] Arjun Appadurai's definition is perhaps the best. Rejecting one common definition that labels luxuries as "unnecessary" goods, he counters that luxuries are indeed "necessary," but that the needs they fill are cultural and thus political, not reductively material. For a good to function as a luxury, he proposes, some sturdy combination of the following qualities must be present: (1) restriction to elites by law or price; (2) complexity of acquisition—which may or may not reflect real "scarcity"; (3) semiotic virtuosity; (4) codes for appropriate consumption that demand specialized knowledge; and (5) a high degree of linkage of consumption to body, person, and personality. By those measures, during the late Middle Ages and early Renaissance, spices emphatically qualified. Although not restricted by law, their high price kept most ordinary people out of the market. Further, spices were not available everywhere and their quality was not standardized. They could be obtained only in certain markets, where dealers who could be trusted offered their wares, or whose wares the buyer was himself or herself competent to judge. Spices also signaled a mix of culinary sophistication, medical expertise, and knowledge of and access to exotic climes; they emphatically were connected to the body, and thus to the identity of the person who ingested and displayed them.

But in the course of the sixteenth century, and intensifying in the seventeenth century, spices fell out of the luxury register. Culinary fashions changed. Highly spiced foods that had ceremoniously been served at feasts like the famous Burgundian and French (and other regions') extravaganzas of the fifteenth century had, by the end of the sixteenth century, come to be considered démodé in elite Italian circles (Figure 3.5).

Although to judge from cookbooks, financial records, and narrative accounts from the period cuisine did not change as quickly or as decidedly in the north of Europe, by the end of the Renaissance elites everywhere had developed a "distaste" for highly spiced foods and the dining practices that had accompanied them. Some medical practitioners were now recommending

FIGURE 3.5 Anonymous, from *Les Grandes Chroniques de France de Charles V: Le Banquet offert par Charles V de France à l'empereur Charles IV et son fils aîné Wenceslas en 1378* (cropped), 1370–1379. © Bibliothèque Nationale de France, Paris.

simpler diets for reasons of health alone, while humanists, latching onto the idea of restraint at table, also made new rules about comportment while dining, thus further fueling the turn away from spiced foods.[13] During the same period, new sources were found for some spices—for example, peppers from Africa and even pepper substitutes from the New World, cloves and nutmeg that now were being grown outside the Spice Islands—that not only increased supplies, but also rendered the stories about spices that had evoked the mysteries and magic of the Orient hopelessly out of date, even ignorant. One scholar has in fact attributed much of the shift in taste to such "cultural demystification" (Smith 2008).[14] Now, knowledge of spices and how to use them seemed nothing more than one of the tricks any good cook would have. Simultaneously, new kinds of food arrived from the New and Old Worlds, and soon coffee, tea, and tobacco, along with New World sugar (more abundant and cheaper than sugar from the Canaries), would displace the traditional spices as the signs of status and "taste." Cinnamon and mace, pepper and saffron, along with other spices, did not disappear from European cuisine (or apothecaries), but they no longer commanded the prices they once had because Europeans had changed their eating habits, because spices had become almost commonplace, and probably above all because knowledge of and use of spices no longer had a central role in the Renaissance project of "self-fashioning." Spices remained economic objects, but the demand curve was now significantly lower.

Tulips

The story of tulips that has come down to us places what is called the "tulipmania" squarely in the history of capitalism. We are told of masses of Dutchmen and Dutchwomen in the early seventeenth century who speculated widely on a futures market in tulip bulbs, thinking to make an easy fortune. People from all classes, frantic for easy profits, invested huge amounts of money in tulips, often borrowing to finance their purchases (Goldgar 2007: 34–5). Prices doubled in mere months, tripled and quadrupled over the course of a few years. Then, in 1637, the market crashed, for reasons that remain unexplained. Thousands went bankrupt, the Dutch economy fell into recession, and the market in tulips more or less dried up. According to this story, the tulipmania was the first of the speculative bubbles that have characterized Western capitalism: the South Sea and Mississippi bubbles of the eighteenth century, for example, the dot-com bubble of the twentieth century, and perhaps today the bitcoin bubble.

Scholars now know that much of this story is wildly misleading. To be sure, prices for some varieties of tulip bulbs reached astonishing heights in the 1630s. According to the economist Peter Garber, who collected a small sample of the few good data available, a single bulb of a rare variety (*Semper Augustus*) sold for 1 gulden in 1623 but for 5.5 gulden at the peak in 1637, a time when the daily wage of a skilled worker in the construction trades in Amsterdam was about 1

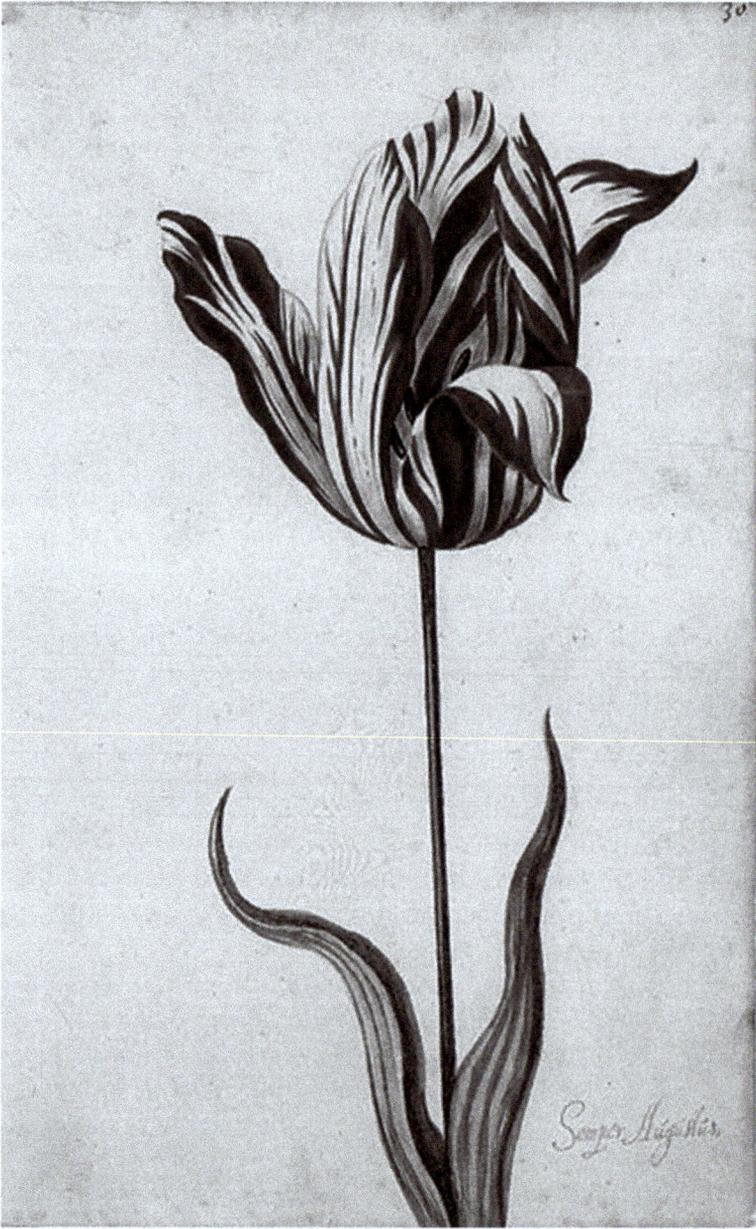

FIGURE 3.6 *Semper Augustus*, before 1640. © The Norton Simon Art Foundation, Pasadena.

gulden (Garber 1989).[15] The historian Anne Goldgar has quoted a few isolated prices as well. In 1624, the twelve *Semper Augustus* bulbs then in The Netherlands,

all held by one man, were supposedly worth 1,200 gulden each (although none was actually sold at that price) (Figure 3.6) (Goldgar 2007: 200–2).

Whatever the reliability of these quotations, it is clear that tulips became outrageously expensive in the 1630s. And then the music stopped. Prices fell by between 25 and 75 percent by 1643, even though, as Peter Garber's research suggests, this is not as dramatic as commentators have often charged.

A fuller and more accurate story of the tulipmania begins in the sixteenth century, not in the market, but in culture—and it ends, after the crash, in culture as well. When tulips entered Europe in the middle of the sixteenth century, they encountered a society long besotted by flowers. Lilies, roses, and pinks were just a few of the blooms used in portraits, poems, and prayers to symbolize purity, love, and devotion. Europeans prayed with the rosary and, in one scholar's interpretation, had formed such an intense physical bond with the flower in the process of cultivating and hybridizing it that it served as the perfect meditative object for prayer (Fulton 2004: 7).

As Anne Goldgar has explained in her *Tulipmania*, tulips had special appeal to Europeans, not just because their graceful shapes and deep colors were pleasing to them, but also because of their origin in Ottoman Turkey, source of so many "oriental" luxuries. The Dutch culture they entered, however, was not medieval, and the valences they bore and acquired were not religious in the sense that roses and lilies, for example, were sacred in the Middle Ages. Nor did they enter a capitalist market, even though many scholars have described the early modern Dutch economy in these terms. Rather than being treated as economic objects to be bought and sold for profit, tulips originally functioned as aesthetic objects that circulated within small circles of cognoscenti (*liefhebbers* in Dutch), both creating community and establishing a person's membership in it. Tulips were collected as were, for example, paintings, shells, and other exotic objects brought from around the world, and tulips were studied, fussed over, and portrayed (frozen in time as the actual flowers were not) in the famous still life paintings that ambiguously evoked both permanence and impermanence. As new varieties were discovered or produced, they were carefully labeled and catalogued, written and read about, and endlessly discussed in inns, gardens, and homes.

To know about, collect, and trade tulip bulbs was akin to knowing about, collecting, and trading paintings, rare editions, or specimens of exotic animals and plants that were displayed in *wunderkammeren* (cabinets of curiosities). In short, the tulip craze is best understood as a version of Renaissance "self-fashioning" (Figure 3.7). And both trading and knowing about tulips were done by the very same people, even as late as the 1630s when some "companies" specializing in the trade had been established, for their owners were also tulip experts, not mere anonymous brokers of economic objects. These people were not only part of the same

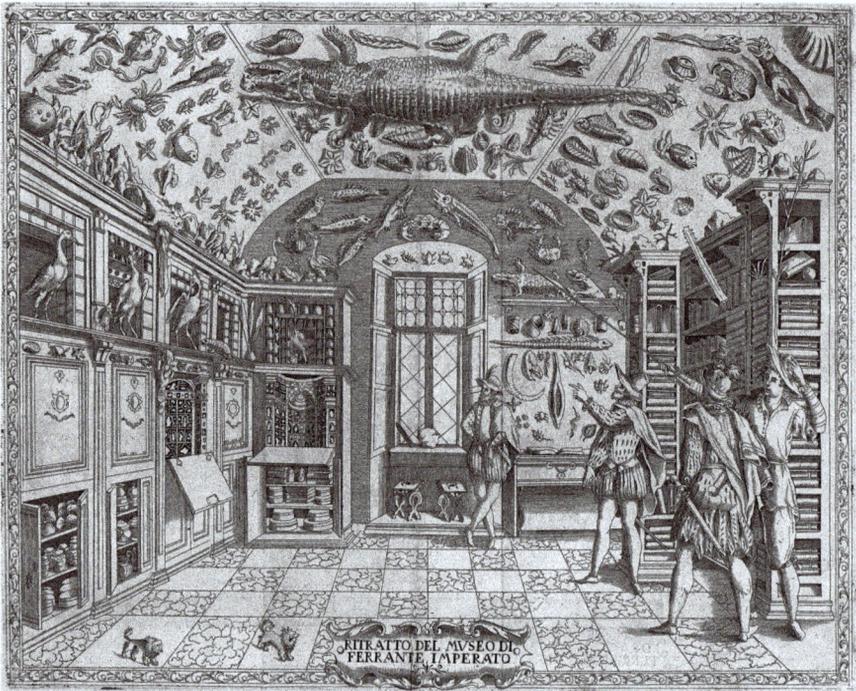

FIGURE 3.7 Frontispiece of Ferrante Imperato, *Dell'Historia Naturale*, 1599. Naples.

intellectual community of collectors and aesthetes, they also belonged to the same social class, itself composed of small groups connected by blood, residence, religion, and trade, in total a privileged slice of a complex and changing society.

Trade in tulips, although originally an exchange among social and intellectual equals, was, however, commercialized and became increasingly so as the sixteenth century drifted into the seventeenth century. It was also a futures business, for the actual bulbs were out of the ground and available for spot sales only for about two or three months a year, just after the bloom was spent and before being put back in the ground to be nurtured for the following season of bloom. Typically, therefore, a contract for sale was agreed upon long before actual delivery of the bulb (as long as nine months, as short as two), and the bulb actually delivered might or might not produce the expected flower. The "market" in tulip bulbs was thus a risky business, but one situated in a small circle of people who knew each other—or knew about each other—and trusted one another to deliver the bulb that was promised (or even replace one that was sickly or damaged) and pay the promised amount on time.

As the market heated up in the 1630s, the tension between culture and economy heightened and suddenly, it seems, elite purchasers precipitously backed out of the market. We cannot know for certain their reasons. We do know, however, that the economy was not badly affected by the crash, surely because the men and women who did most of the trading (and all the trading of the rare varieties) did not have a high percentage of their assets invested in tulips, and that the few ordinary people who had recently bought into the market had not shifted a huge percentage of their own money into tulip production and sales, but apparently had simply taken some bets on the market.

If the economic effects of the crash measured at the level of the economy were not so dramatic, punishing as they surely were for some unlucky people, the cultural effects were, however, marked. Although the Dutch had relatively well-developed laws, courts, and other procedures to deal with bankruptcies, broken contracts, and all the detritus left after a financial upheaval of this sort, people at the center of the tulip market did not operate—or did not like to think they operated—on those terms. They might have been businessmen (and businesswomen), but, above all, they were honorable gentlemen (and gentlewomen) who traded tulips with peers who shared their appreciation of tulips, whose word was their bond, and who managed their finances prudently. Although they may have been drawn into the vortex of the market, they did not consider themselves (or had not considered themselves) "of" the market, at least with respect to tulips. But now they had to face facts. They owed or were owed a lot of money, and their debtors and their creditors were their friends, family, fellow professionals, or neighbors, or were close enough to people who were, to raise serious questions about how to behave honorably. Forgive debts? Shame creditors into some kind of compromise in order to save reputations and social connections? Simply refuse to pay?

These uncertainties, as Anne Goldgar has detailed, produced a cultural crisis and generated the discourse about the "greed" and "stupidity" that supposedly fueled the bubble (much of it assigned to the lower orders who were said to have entered the market—and about whom we have little evidence). The crash—in fact, the boom itself—also produced anxiety about moral codes, about true and false values (was a mere tulip bulb really worth so much money?), and about honor and its link to credit and creditworthiness. Looked at from this point of view, the tulipmania indeed exemplifies all that is wrong with "capitalism"; looked at from the point of view of culture, however, it exemplifies how the values of Renaissance elites and the cultural practices they adopted, seemingly removed from the rough and tumble of commerce, were both fed and challenged by commerce. The tulipmania was not a financial bubble in that it did not originate in market logics and was not driven by them, at least not until its peak. It was not like the South Sea or Mississippi bubbles of the eighteenth century; they were born in efforts to make money, as was, for example, the dot-com

bubble of the twentieth century or the bitcoin frenzy of today, however much social and cultural factors contributed to those histories. The tulipmania was born in culture and entered the market, we could say, sideways. The dramatic trajectory of this story also ended in culture, as a rewriting of the facts and as an occasion for moralizing about and seeking to repair the market.

Spices and tulips are not the only objects that could have been selected to illustrate the dynamic between the market and culture during the Renaissance. Shells, paintings, tapestries, animal and vegetable specimens from exotic climes, ancient manuscripts, even dresses, purses, beds, and bedding—all precariously ricocheting between a market where perfectly fungible things were traded for monetary gain and one in which values were determined by entirely different logics—must be placed in the same context if we are to understand their allure and their price histories. Along with spices and tulips, they too can serve to remind us that to reduce Renaissance objects to "economic objects" is to miss most of what matters about their history. As Huizinga so beautifully put it a hundred years ago, things were then "miraculous" in ways particular to that age.

Everyday Objects

Paper, Letters, Playing Cards, Printed Forms, and Blank Books in Renaissance Europe

PETER STALLYBRASS

In 1958, Lucien Febvre and Henri-Jean Martin published their formative account of "the coming of the book" (*L'Apparition du Livre*), subtitled in its later English translation as "the Impact of Printing, 1450–1800."[1] As many scholars have pointed out, there is a curious tension, or even contradiction, between the association of "the coming of the book" with printing. "The book," of course, did not first appear in 1450, and there is a major bibliography on the development of the codex or book-form from the first century of the Christian era until the European use of moveable type for printing. By the fifteenth century, the book had undergone several innovations: the invention of binding techniques adequate to contain the whole Christian bible in a single codex; the making of unbelievably thin parchment as the precondition for the proliferation of pocket bibles in the thirteenth century; the creation of a wide new range of finding aids; and the development of new scripts. There was, in other words, nothing novel about "the book" as such in 1450, when many of its features had already been subject to radical transformation.

I am deeply indebted to Ann Blair, Roger Chartier, and, above all, Heather Wolfe. Wolfe's work on the cost of paper is only just beginning to change the profound misconception that paper by the quire (twenty-four to twenty-five sheets) for daily use was expensive.

But printing led to the *multiplication* of books on a revolutionary scale. Martin estimated that 11–15 million books were produced by the end of the fifteenth century, whereas 150–200 million books were produced in the sixteenth century alone. The figures are certainly now in need of revision— but undoubtedly in an upwards direction for the sixteenth century. For this revolution to be imaginable, it was necessary to develop a new material support for texts. It would have taken about 250 calves to make the 468 folios of the Winchester Bible.[2] Even the 200 copies of Gutenberg Bible, smaller though it was in scale, would have necessitated the skins of 30,000 calves. (In fact, only thirty-five copies were actually printed on parchment, using about 5,250 skins.) By the sixteenth century, folio bibles were being printed by the thousand or more, and a single edition of a bible that used 100 sheep or goat skins per copy would have required 100,000 skins. But, of course, no one was printing on parchment on such a scale. The new support for the great majority of printed books was paper. And by 1500, a single leaf of parchment cost about the same as twenty-five leaves of paper of the same size.[3]

One major, but often overlooked, aspect of Febvre and Martin's work is the attention that they paid to the paper revolution as a necessary precursor to the printing revolution (1958: 29–44). There was nothing new in itself about either printing or paper. From the eighth century, the Chinese were printing Buddhist images, charms, and prayers on paper, and by the tenth century there are records of printed editions of 84,000 rolls of *sutras*, while the Buddhist monk Yen-Shou printed an edition of 140,000 images of a Maitreya pagoda.[4] And paper is documented from the first two centuries of the Common Era in China, spreading to the Islamic world in the eighth century.[5] And it was in the Islamic parts of Spain that paper first developed in Europe. But the European use of paper through the Middle Ages was limited, particularly in the North. In The Netherlands, paper was rarely used for manuscript books prior to 1350, and in England, paper was not used for book production until much later. In the latter, manuscript books on paper were relatively rare in 1400, but by 1450, about 20 percent of all books were on paper, and by 1500, after the advent of printing with moveable type, this figure was over 50 percent.[6]

At the same time, the cost of paper declined precipitously:

Even as early as the close of the fourteenth century, a quire of paper (25 sheets) cost no more than the average skin, but it gave at least eight times as many leaves of equivalent size. The growth of the paper trade during the course of the fifteenth century, moreover, brought about a steady reduction in prices, so that they had in effect halved by the middle of the fifteenth century and then halved again by 1500. (Lyall 1989: 12)

Monastic manuscripts in the fifteenth century were still usually produced on parchment, but university texts and town and merchants' records were quick to use the cheaper medium of paper. The lower cost of paper also encouraged the use of quicker and cheaper scripts. Writing in *textualis*, the typical late medieval book hand, required several separate strokes of the pen for each letter and was slow; a scribe could usually write only four to six pages of a manuscript a day for medium quality or two pages a day for high quality. The cursive script that was increasingly used for paper books sped up the scribe's work, which was the most expensive part of a manuscript.[7]

One of the major misunderstandings in book history is the repeated statement that "paper was expensive" and was "the single most important cost in the publishing of a book." It is easy to see how the misunderstanding has arisen, because paper was indeed expensive for *printers* because of the *quantities* involved. The 1568 folio Bishops' Bible, for instance, used 409 sheets of large paper for each copy, and if we estimate 1,000 copies for the whole edition, this means that the King's Printer would have needed to order 409,000 sheets of paper for this one book alone—and he was printing a wide range of other books, pamphlets, and government documents and forms at the same time. As David McKitterick notes:

> Of all the costs involved in manufacturing a book, by far the largest was for paper. It accounted for well over half the total even in foreign presses with easier access to supplies than English presses could claim. For Plantin's press in the late sixteenth-century, paper accounted for 60% of the production cost, and up to 70% for longer runs. (McKitterick 1992: 285)

But the quantities involved in printing have been extrapolated to suggest that a single sheet of paper required a considerable outlay. This is quite simply wrong. As Heather Wolfe has shown, a single sheet of large writing paper (in itself more expensive than printing paper since it required more animal sizing to make it less absorbent) cost about 0.2 pence in the later sixteenth century, whereas a quire of 25 sheets (which was how most people bought paper) cost about 4 pence. This was in England, where paper was *more* expensive than on the continent because of the cost of importing it from the Low Countries, France, and Italy, and because of added taxes.[8]

Printers bought (or were supplied by patrons and publishers) paper in reams of 500 sheets, 480 or 490 of which needed to be usable, but even governments would usually buy paper by the quire. At the bottom end, for cheap paper, a 1612 regulation by the Stationers' Company in London required ballads to be printed on paper that cost at least 2s. 8d. a ream—which works out at 0.065 pence per sheet. But this, of course, was a wholesale price, and was for printing paper. And in 1598, the Stationers' Company ordered that a book set in pica type should not retail for more than a halfpenny for a *printed* sheet and two-

thirds of a penny for a printed sheet in the smaller brevier and long primer type.[9] In reality, prices could vary dramatically, from a farthing to a penny for a printed sheet—but this still means that a single-sheet ballad or even a deck of cheap playing cards (with multiple cards printed per sheet) was not a major expense, except for the very poor. Although every sheet had to be made by hand, a single vat at a mill with a three-person team could produce between 1,000 and 4,000 sheets a day, depending on the size, weight, and quality of the paper required.[10]

One of the reasons for the misunderstanding about the cost of paper has been the significance for art historians of the way in which Rembrandt, for instance, often crowded several drawings onto a single small page—as if this was a cost-saving device.[11] But Renaissance artists' drafts can no more be explained by the cost of paper than can the drafts of Walt Whitman and Emily Dickinson upon recycled letters and envelopes.[12] When we make shopping lists on the back of envelopes or fragments of newspaper today, it is not because a single sheet of printing paper is *expensive*, but because it is both *wasteful* and contrary to how we think about *drafts* (which should look, as well as be, provisional and revisable). In fact, by the fifteenth century, paper was ubiquitous for an extraordinary range of purposes.

There were, of course, more expensive papers, both because of size and quality and sometimes because of the addition of an erasable surface or dye. But even for an Italian artist like Leonardo da Vinci, the sheets of royal paper (the second largest) that he bought for cartoons were mainly costly in relation to the quantities required. Leonardo ordered 950 sheets of *reale* ("royal") paper for his two cartoons for the *Battle of Anghiari*, but each quire of 25 sheets cost 11 or 12 soldi (less than ½d. per sheet in English terms), and a quire cost the same as a haircut, whereas Leonardo paid 20 soldi for anise comfits, between 40 and 120 soldi for a pair of hose, and 225 soldi (or twenty times as much) for a meter of velvet.[13]

Paper was certainly used in Europe long before printing. As Armando Petrucci has shown, protocols in Genoa, recorded between 1154 and 1164, required notaries to draw up contracts in three stages:

1. A draft of the contract, written on a small leaf of paper or in a small paper book called a "manual."

2. The *imbreviatura*, written in a large paper register called a "cartulary" (the legal contract).

3. If required, a record of the contract or *instrumentum publicum*, written on parchment (Petrucci 1995: 153).

Petrucci also shows how these notarial practices, including the preservation of early paper drafts used for the preparation of a final fair copy on parchment, were adopted by Petrarch for the creation of his vernacular poetry in the fourteenth century. Petrarch began by sketching out his poems in "an extremely rapid flowing hand on loose paper leaves," making quick deletions and additions as

he wrote; he then made fair copies, also on paper, of some parts, "in an elegant chancery miniscule"; only finally did his scribe Giovanni Malpaghini or he himself make the fair copy on parchment.[14] As Petrucci stresses, the practices that would by the nineteenth century become central to the drafting, copying, and preservation of literary texts were copied by Petrarch in the fourteenth century from the everyday practices of Italian notaries. But it should be stressed that very few other European literary writers followed Petrarch in the preservation of his drafts—a practice that only became common in the nineteenth century with the establishment of literary archives in Germany and France.

Although merchants, notaries, and government officials all used blank paper, above all in Italy, from the twelfth century onwards, bound paper notebooks were not common both before and immediately after the Gutenberg Revolution. One needs, however, to distinguish between the first fifty to a hundred years after the coming of print, when blank notebooks remained scarce, and the extraordinary proliferation of such notebooks from the sixteenth century on. In the second half of the fifteenth century, most readers continued to make their notes, as they had done throughout the Middle Ages, in the margins of their books. Rudolf Hirsch observes that "the selection of texts and the typography of many Leipzig imprints [in the fifteenth century] was clearly for university use. Such books were heavily leaded and issued with wide margins for interlinear and marginal notes."[15] One such Leipzig textbook of Aristotle's works at Yale contains two and half times more manuscript annotations than printed text. In a mere sixty-eight pages of printed text, there are 36,900 manuscript words as marginal notes and 21,000 words as interlinear notes.

Far from being opposed to manuscript, many of the best-selling printed books (from textbooks of every kind to medical treatises to law books) both allowed for and encouraged manuscript writing from the very beginnings of printing. In his magisterial account of Plantin's press, Leon Voet writes that "in editions of Classical authors intended for school use, Plantin not only chose a large format and type size, but allowed generous margins and leading that made it easier for pupils to make notes or cribs."[16] Particularly in the incunable period, printers added wide margins and interlinear spaces in school and university texts for students' notes. Terence's plays were classic texts that were used throughout Europe to teach Latin in monasteries, convents, and schools, both through study and performance. And it is hard to find an early copy of Terence that is *not* heavily marked up. The printed book was an incitement to writing by hand.

Such writing was not necessarily learned, and indeed schoolchildren were encouraged to practice writing on whatever blank paper they could find, including the margins of books. In the Yale copy of an Italian edition of Terence, published in folio in 1475, the wide margins of a single page have been annotated by several different readers. At the top right, a scribe has added the folio number "25" by hand. And the under-drawing to illuminate the capital "S"

and "P" has been added, but the painting of the letters has not been completed. In the right-hand margin, a reader has added the annotation "*cesare male*." But another annotator (probably a child) has used the text to learn how to write, imitating the capital letters of the author's name, "Publius Terentius." But while the "PVBLII" comes out correctly, "Terentii" is reduced to "TENTII." And the writer has decided to try the "B" of "PVBLII" again in the right-hand margin.[17]

In the early sixteenth century, it remained common for students to write their notes into the books that they were studying. When Luther prepared to lecture on the Psalms in 1513, he first ordered a special edition of the psalter "with wide margins and space between the lines for the reader's annotations" from the Wittenberg printer Johann Gronenberg. As Brian Cummings notes:

> Luther ordered copies of this edition for his students to use in his lecture, and continued this practice with [his lectures on] Romans, Galatians, and Hebrews. The lectures were largely dictated ... In addition to ... *glossae* [interlinear and in the margin], Luther provided more extended theological interpretations or *scholia*, again dictated to the students, written by hand onto blank pages bound in after the printed text. (Cummings 2002: 72–3)

The fact that "[t]he blank pages have identical watermarks to the printed pages"[18] suggests that the whole teaching edition was ordered with note-taking paper for the students. But by the end of the sixteenth century, it was increasingly taken for granted that students would have their own blank notebooks to hand.

As the example of Luther above suggests, any imagined opposition between "printing" and "writing by hand" has the totally false implication that printing led to a decrease in writing by hand (as opposed to a genuine decrease in the number of manuscript *books*). Printers and publishers encouraged their readers to make manuscript corrections. In his 1623 edition of Mateo Alemán's picaresque *Guzmán de Alfarache*, the English publisher Edward Blount printed a preface in which he asks "the Discreet and Curious Reader" to emend "these few escapes (as you finde them here-under noted) before you begin to reade." But corrections and emendations were only a small part of what readers were encouraged to write in the printed book. In his own preface "To the discreet Reader," Alemán wrote: "In this Discourse, thou maist moralize things, as they shall bee offered vnto thee; Thou hast a large margent left thee to doe it." Blount took Alémn at his word, and included ruled margins around the text, with further space outside the ruling on which the reader could "moralize things" in his or her own hand.[19]

The connection between reading a printed book, writing by hand in the margins, and transcribing the passages so marked into a notebook was commonplace in sixteenth- and seventeenth-century educational treatises. In *Ludus Literarius*, first published in 1612, John Brinsley wrote that to remember the lessons from their printed grammar books pupils should make a mark or write

in the margin of the book "in a fine hand," or else transcribe the passage into "some little booke." In fact, Brinsley's text bristles with advice on the importance of margins. In making their own manuscript books, pupils must, as the printed margins of Brinsley's text insist, "leave good margents" in which to "set downe quotations as they are spoken." And headings must be afterwards added in the margins both so as to imprint the lessons on the pupil's memory and to make it easier to find and retrieve the passages later. Two pages later, Brinsley writes: "Helps for memory in the margent, & for the understanding." The pupil's *manuscript* notes are to be the organized meeting point of the master's *oral* presentation, the *printed* textbook, and other *printed* miscellanies, themselves compilations of other *printed* books. "All who can write to take notes," we are advised—while the difficulties of the "auncient Classical Authors" can be made easier because they have all been "collected into one by M. Stockwoods last Edition, printed Anno. 1607." If the difficulties of reading can be supplied by a printed miscellany, so can the difficulties of composition. The pupil is advised to turn to the *Thesaurus Poeticus* and the *Sylua Synonimorum*, "a booke of notable vse for each scholar: for helpes of Epithets and variety of Poetical phrases." And the easiest way to compose one's own verse is by stitching together selections from the *Flores Poetarum*. Brinsley and/or his printer use the margins of the printed textbook to drum home the significance of manuscript and printed margins alike. Texts are incitements to the formation of further texts in an endless interweaving and interchange of manuscript and print.[20]

In the seventeenth century, Johannes Comenius, in his famous Latin textbook that was to remain a bestseller throughout Europe until the nineteenth century, took it for granted that a scholar would read printed books and take notes in a personal notebook. As the English translation of his lesson on the *Museum* or study puts it:

> The *Study* is a place where a *Student*, a part from men, sitteth alone, addicted to his *Studies*, whilst he readeth *Books*, which being within his reach, he layeth open upon a *Desk* and picketh all the best things out of them into his own *Manual*, or marketh them in them with a dash, or *a little star*, in the *Margent*. (Comenius 1672: 200–1)

There are two different (but usually complementary) ways in which the student should actively appropriate what he or she is reading: by making manuscript signs, in the form of dashes or little stars, in the margins of a printed book; or by transcribing the "best things" into his or her manuscript "manual." And we find increasing records of money spent on blank books in the sixteenth and seventeenth centuries. On March 20, 1627, Sir Edward Dering bought "6 paper bookes of 5 quire in a booke for notes." Each book was bound in parchment, and the six books together cost 12 shillings, so each sheet of paper cost less than 0.2 pence and each book (consisting of 500 pages in folio or 1,000

pages in quarto or, implausibly, 2,000 pages in octavo) cost 2 shillings. By the seventeenth century, the difference in cost between parchment and paper had increased dramatically. In 1643, the English Parliament regularly paid 8 shillings for twelve skins, whereas even the "best Royall paper" only cost 1/6 a quire. And the best quality parchment could be considerably more expensive. In 1627, Dering paid one shilling and two pence for a single "skinne of Vellom."[21]

There is very little evidence that medieval stationers sold blank parchment notebooks in any quantities, if and when they sold them at all. Richard and Mary Rouse were surely correct when they wrote in 1989:

> [A]s a support for the written word, wax tablets had a longer uninterrupted association with literate Western civilization than either parchment or paper, and a more intimate relationship with literary creation. (Rouse and Rouse 1989a: 220, 1989b: 175–91)[22]

From Classical Antiquity to the Middle Ages, short notes and rough drafts were written on wax tablets. And even the largest wax notebooks were severely constrained in terms of size. Baudri de Bourgueil (c. 1050–1130) gives a detailed account of his wax notebook in one of the several poems that he addresses to it: it is composed of eight small wooden leaves, bound together with leather thongs, making sixteen potential pages. But only the fourteen interior pages have been covered with green-dyed wax on which he can write. Each wax page, Baudri tells us, can contain only 8 lines of poetry, which means that he can write a maximum of 112 lines before they must be transcribed onto parchment. In another poem, he complains that his scribe, Hugh, cannot keep up with the pace of his composition, with the result that he has to spend tedious hours waiting before he can erase what he has written and carry on with his composition.[23] And because wax tablets were continually erased, they could never be used for *storing* notes.

Hildegard of Bingen (1098–1179) is repeatedly depicted as writing in a blank notebook. The notebook is composed, like Baudri's, of several wooden leaves bound together, their surface covered in wax that has been dyed. It is her faithful scribe, the monk Volmar, depicted on the right, who will transcribe her writing in pen and ink onto the parchment that he holds beneath his arm. Hildegard herself is never depicted writing with a pen. She writes in her wax notebook with a stylus, one end pointed, the other a horizontal bar that she can use to erase what she has written so as to reuse the wax surface for her next inspiration.[24]

We take it for granted today that students come to class with blank notebooks of one kind or another. But the cost of parchment alone must have placed serious restrictions on the making and purchasing of blank books in the Middle Ages. Although paper was being used in Spain in the eleventh century, it was not widely adopted until the fifteenth century, particularly in Northern Europe,

where paper books remained relatively uncommon in 1400. By the end of the fifteenth century, paper had become the dominant material for printed and manuscript books alike and, by the sixteenth century, the paper revolution had made both quires of paper and bound notebooks readily available.

In Jan Gossart's *Portrait of Jan Snoeck*, painted in Antwerp in *c.* 1530, we can see a variety of different ways in which paper and parchment can be treated and conserved.[25] Snoeck, who had recently been appointed as collector of the river tolls at Gorinchem in Holland, is writing with pen and ink in what appears at first to be a paper notebook. But it is not. He is writing on a single sheet, folded to make a bifolium, which itself rests on a gathering of sheets that have been folded but not stitched. It is only beneath this unstitched gathering that one can see what it indeed a blank notebook, the sewn gatherings bound into a cover of limp vellum. The actual paper on which Snoek writes will need to be gathered together with other sheets and sewn before it can become part of a book. On either side of the merchant's head, however, we can see a simple but revolutionary form of binding: the use of a piece of string to gather together multiple leaves of paper into files. The word "file," in fact, derives from the Latin *filum*, meaning a thread or piece of string. Here, in other words, we have string theory in practice.

The two files in the painting are identified as *Alrehande Missiven* (miscellaneous letters) on the left and *Alrehande Minuten* (miscellaneous drafts) on the right. The letters are hung upside down and back to front. So hung, not only were the contents of the letters preserved from the observation of casual intruders, but also they could be read by the merchant by the simple expedient of turning the letters up. It was only after seeing Gossart's representation of this filing system that Heather Wolfe and I discovered that Cambridge University routinely kept its archives in this way as late as the seventeenth century. Just as in Gossart's painting, the filed documents at Cambridge are protected by a piece of vellum at the back, in which they can be rolled up when they are transported. Indeed, one crucial aspect of this new organization of information was the combination of permanent depositories with portable units of notes.[26]

One can trace the spread of such filing systems throughout Europe in dictionary entries:

> "File, *filacium*, is a threed or weier whereon Writs or other exhibits in Courts are fastned for the more safe keeping of them." (Minsheu 1617)

> "[T]o File up a letter, *Eenen brief aan een snoer rygen.*" "*Snoer, a String, Cord.*" (Sewel 1708)[27]

Increasingly, inventories of large-scale purchases of stationery include the simple but necessary equipment for filing. In England, a 1643 Parliamentary

bill records the range of writing materials that an early modern bureaucracy required. The bill is headed: "A Bill of money expended be me Henry Smith for necessaries etc for the Committee at Cambden howse Dec[ember] 21th [I.e. 'one and twentieth'] 1643." Among the requisitions are paper, parchment, and quills, but also the government "Needle thred and Lases," costing not much less than the quire of best royal paper. The needle, thread, and laces are all means to stitch together scattered leaves into semi-permanent files.

The evidence for how Parliament filed its papers has been rapidly disappearing in recent years. But by a lucky chance, I was working at the Public Record Office (PRO) in London when I got an email from Heather Wolfe, the Curator of Manuscripts at the Folger, who was working on letters at the Huntington Library. She had noticed that hundreds of the letters that she was looking at had small holes in the bottom of them. At first, she hadn't made anything of this. But we had both been analyzing Jan Gossart's portrait of a merchant for quite different reasons, to which I will return. She suddenly realized that most of the letters she was looking at had been *filed*. Like the letters in Gossart's paintings, the holes were in the bottom because they had been filed so as to hang on a wall upside down and back to front. To consult them, you simply flipped them up. The blank forms that I was examining in the PRO had, for understandable if misguided reasons of conservation, been recently pasted into large blank books. But every single one of them had one or more holes. In fact, the PRO was in the very process of disassembling the files that Parliament had so carefully put together three and a half centuries earlier. By luck, and with the help of Jason Peacey, I was able to discover some of the few files that were in their original condition. They were held together in a variety of ways: by parchment threaded through two holes and twisted together; by thread that had been sewn across the whole file at the top; by a single pin; or by lace and string. But several had precisely the laces that Henry Smith was ordering in 1643. Just like shoelaces, these laces are tipped at the end with metal, so that the lace doesn't fray at the end and so as to make it easier to push the lace through the stabbed holes.

These files are part of the massive proliferation of paper that coincided with the Gutenberg Revolution. At the same time, printing promoted blank books in which one could record every kind of transaction, from daily events, to financial accounts, to the weather, to sermons, to sketches. And if we return to Gossart's painting, we can indeed see such a notebook in the bottom right corner. It is at first rather difficult to make out because a scale for weighing the gold coins that are also depicted has been put on top of it. It has a wallet binding with metal clasps on the flap and the clasps are secured by a brass stylus. By an extraordinary coincidence, the earliest notebook of this kind that I have discovered was made at the same time and in the same city, and, I believe, by the same man as the notebook in Gossart's painting. It is now in the New York Public Library, where, in contrast to the painting, you can take out the brass

stylus and open the book to see what is inside. I said that this is a blank book, and so it is, but it is a blank notebook that includes a wide range of printed material, from an almanac to tables for calculating the weight of gold. And it begins with a printed title page in Dutch:

> Calendar: ¶ Item you may write here with a stylus of gold, silver, tin, copper, or brass, and you may erase [what you have written] with a wet finger. ¶ And when you have worn out [the erasable surface], so that you cannot write on it any more, you can get it repaired by Jan Severszoon, parchment maker, for a little money, and you can then write on it as if it was new. ¶ Sold for your benefit in the famous mercantile city of Antwerp, on the Lombaerde veste: wholesale by Jan Severszoon, at the house of Jan Gasten, bookbinder.
> ¶ Item if you get grease on it by erasing with your finger, you should use a clay sponge [*cleyspongie*] with a little flour, and the grease will come off.
> ¶ In the year of our Lord, 1527.[28]

As I noted, the notebook is partly obscured by a pair of scales for weighing the gold coins that are also depicted. In fact, scales and coins directly relate to one of the printed tables within that give the appropriate weights for the different kinds of gold coins in circulation. Such tables were a standard feature of these erasable notebooks.[29]

Similar notebooks were being mass-produced in London by the later sixteenth century. Like the Antwerp notebooks, they had a printed almanac and printed instructions for how to erase what you had written. But in London, the latter instructions were incorporated into the calendar, where they appear under "December":

> To make cleane your Tables when they be written on, [and in early editions one finds the addition: *"which to some as yet is vnknowne."*] Take a little peece of a Spondge, or a Linnen cloath, beeing cleane without any soyle: wet it in water, and wringe it hard, and wipe that you haue written very lightly, and it will out, and within one quarter of an hower, you may wright in the same place againe: put not your leaues togeather whilst they be very wet with wyping.

The erasable leaves follow the printed material and they are made of either paper or parchment, coated with a mixture of gesso and glue. You can write on this surface with any kind of soft metal, as well as with ink and graphite. All three can be easily erased. But, like the Antwerp notebook, these blank books also contained printed tables giving the appropriate weights. There are also six pages of woodcuts of gold coins to help in identifying the different currencies in circulation. An additional feature of these English tables helps to account for the curious "backwardness" of English merchants in the adoption

of Arabic numerals, which were in standard use in France at the same time, for the English tables contained convenient multiplication tables—but these tables were still in Roman numerals.[30]

Government officials, merchants, students, scholars, and shopkeepers were all making extensive use of blank paper notebooks of one kind or another by the sixteenth century. But many more people, including the children of artisans, were learning how to write letters. Such letters were simultaneously a sign of literacy, a practical business technology, and a means of maintaining connections with family and friends. Letter-writing in the Middle Ages was above all the preserve of the clergy, scholars, officials, and elite merchants. But it massively expanded in the sixteenth century not least because of the emergence of new postal systems and news networks throughout Europe.[31]

That printing was an incitement to writing by hand is nowhere clearer than in letter-writing. Erasmus's *Opus de Conscribendis Epistolis*, first printed in Basle in 1522, was undoubtedly the most influential such incitement, stressing the need for boys (and a very few girls) to acquire the ability to write letters in Latin. By 1540, Erasmus's textbook had gone through more than fifty editions, being printed in Basle, Strasbourg, Cologne, Antwerp, Paris, Lyon, Venice, Verona, Kraków, and Alcala, and circulating from the major printing centers (like Antwerp, Cologne, and Paris) to smaller towns and villages throughout Europe. Moreover, it was repeatedly imitated and abridged to reach less-learned circles—and finally, it was adapted and translated to provide models for letter-writing in the vernacular.[32]

In 1789, nearly 200 years after the terminating date for this volume, the inventory of a small printer and bookseller in Troyes recorded the 433,069 pamphlets and books that were left in his stock. That stock included a staggering 5,832 copies of three model-letter pamphlets in French. In fact, such model-letter books were first published in France in the vernacular in the 1530s: *Prothocolle des Secretaires et Autres Gens Désirans Sçavoir l'Art et Maniere de Dicter en Bon Françoys Toutes Lettres Missives et Epistres en Prose* and *La Maniere d'Escrire par Responce*. In the same decade, familiar letters in French by living authors began to be printed by living writers, starting with the epistolary romance of *Les Angoysses Douloureuses qui Procèdent d'Amours*, published under the name of Hélisenne du Crenne, the pseudonym of Marguerite Briet, "a young woman who, after leaving her husband, launched herself on a literary career." And in 1569, Etienne du Tronchet, previously the secretary to the Queen Mother, printed a collection of familiar and secretarial letters, mixing personal accounts with models imitated from other French letter-writers and translated from the Italian, in a book that would go through twenty-six editions by 1623.[33]

England, as usual in this period, was considerably behind France in terms of fashions in book publication. And in the first half of the sixteenth century,

English readers had to make do with imports of model-letter books in Latin, Italian, and French. But in 1568, William Fulwood published *The Enemy of Idlenes*, a model-letter book translated and adapted from Jean de la Moyne's 1566 *Le Stile et Maniere de Composer, Dicter, et Escrire Toute Sorte d'Epistre, ou Lettres Missives*. It was a substantial success, being reprinted ten times by 1621, and leading to other model-letter books in English like Abraham Fleming's *A Panoply of Epistles* (1576) and Angel Day's *The English Secretary* (1586).[34] But the relevant point of my account of these letter-writing manuals is not that they themselves used paper as their support (as Latin letter-writing manuscripts would not usually have done 200 years earlier), but that they encouraged their readers to buy paper, take up their quills, and write. Mark Bland's argument that a mere quarter of the paper that England imported in 1600 was used for printing is from this perspective doubly important: on the one hand, it is a reminder that the majority of books in England were imported; but on the other, it reveals that paper was being used in ever greater quantities for writing by hand and by an increasing range of writers, above all the women, men, and children who had never acquired Latin.[35]

A striking feature of the few letters from these latter groups that survive is that they are *short* (unlike some of the Ciceronian models) and extraordinarily wasteful of paper. Indeed, the great majority contain large amounts of unused blank space—and were designed to do so. In the astonishing variety of handbooks on letter-writing from the sixteenth century, despite their attention to nearly every material aspect of letters, there are very few references to what correspondents simply took for granted: namely that, before one began to write, one *folded* a rectangular sheet of paper once to make two leaves and four pages. The massive quantities of paper that printers needed for editions of books have no relevant application to the single sheets of paper that letter-writers used. And the more blank the paper, the less you had to write: pre-folding a sheet to make four pages makes the first page (if it fills the page) look like a long letter, even though it uses only a quarter of the available space. It is true that the fourth page was used for the superscription (the address) before the introduction of standardized envelopes in the nineteenth century, but as many later letter-writers show, one can write all around the fourth page's superscription, as well as cross-writing. But this was to avoid postal costs, not to save paper.

Figure 4.1, for instance, shows a typical personal letter from Cardinal Reginald Pole to his niece, Katherine, the Countess of Hastings. Katherine and her husband had arranged a child marriage for their daughter, and Pole was anxious that the two children should not be forced into having sex *"afore they* [are] *ryper in age to take the frute of mariage."* He reminds Katherine that he had intervened on her behalf when she herself was married before she was twelve years old. Having given this warning, he concludes with the subscription: *"Wryten hastely at Grenewych thys xx of Ianuary./Your loving*

FIGURE 4.1 Cardinal Reginald Pole to his niece, Katherine, Countess of Huntington, January 20, 1557. © Huntington Library, California.

Vncle." But then, Pole turns the sheet 90 degrees and adds in the margin another thirty-two words to the 212 words of the main body of his letter: "*The quenys highnes thanked be good* [sic] *is in very good helth. I trust to here the lyke of you & my lord withal your fruetes ther whom god preserue with hys grace.*" Pole's letter is written on a single page and, when there is not enough room in the predefined textual space (created by a large left-hand margin), the message is finished in the margin.

But the reproduction above gives a completely misleading impression of the actual sheet of paper that Pole sent, which is written on the right half of one side of a sheet that contains the superscription as its left half (page 4) (Figure 4.2). And if one now turns over the sheet, you can see that pages 2 and 3 on the other side are completely blank (Figure 4.3).

The Huntington Library has ten letters by Cardinal Pole. All ten letters are written on folio sheets that have been pre-folded to make two leaves and four pages. On only one of the ten letters does Pole write anything at all on the second page, whereas four of the ten letters are completed in the left margin of page 1. In other words, Pole stages a "long" letter, as if he is using all of the available space, whereas his letters are mainly composed of blank paper. If one

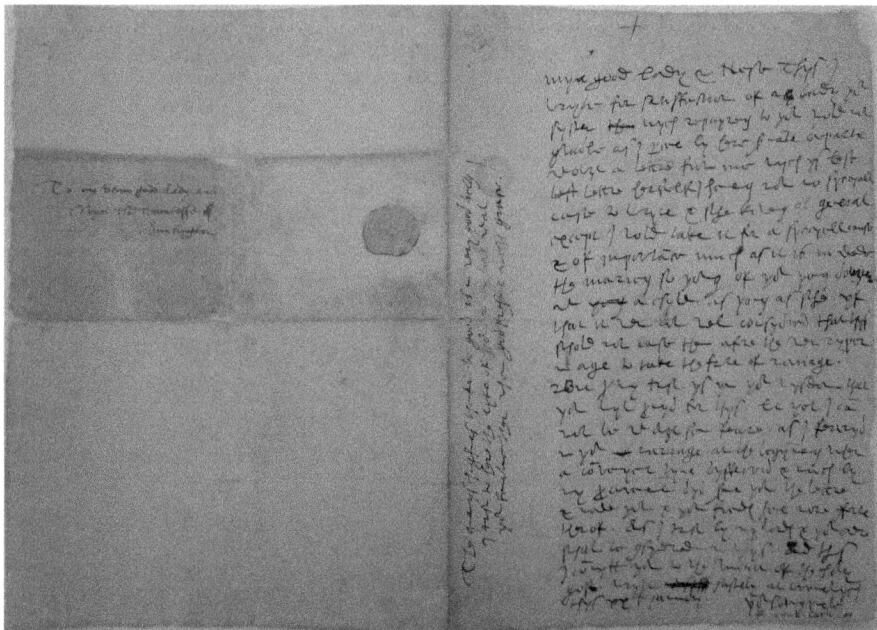

FIGURE 4.2 Cardinal Reginald Pole to his niece, Katherine, Countess of Huntington, January 20, 1557. Pages 4 and 1. Page 4 is blank apart from the superscription (added by a secretary) and the seal. © Huntington Library, California.

FIGURE 4.3 Cardinal Reginald Pole to his niece, Katherine, Countess of Huntington, January 20, 1557. Blank pages 2 and 3. © Huntington Library, California.

ignores the brief superscriptions, Pole usually wrote on just over a quarter of the available space. Pole's 1-of-4-page letters are the *norm* for sixteenth-century familiar letters throughout Europe. Of the sixteenth-century letters that I have examined, the great majority consist of a single page or less. Indeed, I would estimate that half or less of one page is nearer the norm. To put it another way, more than three-quarters of an average sixteenth-century letter consists of blank paper.

Small quantities of paper were *cheap*—a precondition, as Ann Blair observes, for the vast stockpiling of notes by encyclopedists for the first time in history.[36] The supposed cost of paper is directly contradicted by the preservation of massive quantities of letters in the archives consisting mainly of blank paper.[37] If paper was really so expensive, why did the recipients not make use of all this blank paper? And why is blank paper *more* common in sixteenth-century letters that in the twentieth-century ones, when paper was considerably cheaper? Even more curiously, as paper became cheaper from the eighteenth to the twentieth centuries, the *size* of paper that letter-writers used got steadily smaller, rather than the reverse. Moreover, the smaller sizes of paper were often introduced by aristocrats, rather than by poorer people trying to save on paper costs.[38]

Even when we return to printed texts, it is important to stress that the great majority of them in terms of editions (if not in terms of paper consumed) consisted of millions of copies of *short* texts that reached many more people than books did. Gutenberg stopped working on the edition of about 180 bibles in 1454–1455, when he started to print 2,000 copies of his thirty line indulgence in 1454–1455. He undertook this work because it was paid for up-front and brought an immediate cash return. The massive project of printing the bible required a large investment of money, above all to buy paper. Gutenberg both kept afloat and subsidized his larger project by printing broadsides (that is, single sheets printed on one side only).[39] But Gutenberg's 1454–1455 edition of 2,000 indulgences was only a foretaste of what was to come. In Augsburg in 1480, Jodocus Pflanzmann printed 20,000 certificates of confession, four to a sheet, and Johan Bämler printed 12,000 indulgences. In 1499–1500, Johann Luschner printed 142,950 indulgences for the Benedictine Monastery at Montserrat.[40] As Clive Griffin has shown, so profitable was the printing of indulgences that printers competed fiercely for the patents to print them. Successful printers sometimes had to set up new printing houses to cope with the work. Varela, for instance, set up a second house in Toledo where he printed indulgences from 1509 to 1514.[41]

As with Gutenberg, so with Caxton. The first surviving dated text that Caxton printed in England is an indulgence. The names of the recipients (Henry Langley and his wife) and the date (December 13, 1476) are written in by hand in the carefully placed blank spaces of the printed text.[42] Caxton depended for his survival and success upon an extensive patronage network for his more substantial projects,[43] but the ready money for the job of printing indulgences presumably appealed to him as a merchant. Other printers in England followed Caxton's lead. While only eight editions of indulgence documents by Caxton survive, nineteen editions were printed by Wynkyn de Worde and ninety-two editions by Richard Pynson. Eighty of Pynson's editions of indulgence documents were printed between 1500 and 1529, an example of the rapid increase in the production of indulgences in the early sixteenth century.

In England, indulgences or letters of confraternity were issued on behalf of an extraordinary range of institutions: excluding London, they were issued to the Confraternity of St. John in Beverley, the Church of St. Botolph in Boston, St. James's Chapel in Bosworth Field, the Hospital of Burton Lazarus, the Monastery of the Holy Cross in Colchester, the Hospital of St. Roch in Exeter, Hereford Cathedral, the Franciscan Convent in Ipswich, the Augustinian Priory in Kirkby, the Trinitarian Priory in Knaresborough, the Monastery of the Virgin Martyr and St. John the Evangelist in Langley, the Hospitals of St. Katherine and of St. Sepulchre in Lincoln, the Palmers of St. Lawrence in Ludlow, the Chapel of St. Mary in the Field in Newton (Isle of Ely), the Hospital of Pity in Newton (Suffolk), the Chapel of St. John the Baptist in North Newington, Christ Church

and the Dominican Friars in Oxford, the parish church in Rickmansworth, the Collegiate Church of St. Wilfrid in Ripon, the Hospital of the Trinity and St. Thomas in Salisbury, the Guild of St. George in Southwark, the Monastery of the Blessed Virgin in Strata Marcella, the Hospital of St. Sepulchre in Suffolk, the Trinitarians in Thelsford, the Hospital of St. Sepulchre in Thetford, the Chapel of St. Margaret in Uxbridge, the Confraternity of St. John in Wakering, the Hospital of the Holy Trinity in Walsoken, the Confraternity of St. Cornelius in Westminster, the Confraternity of St. Mary of Mount Carmel, and the Guild of Saints Christopher and George in York.[44] And dozens of other indulgences, indulgenced pictures, and licenses were issued in general or on behalf of specific individuals, continental institutions, or to raise money to fight the Turks or to ransom captives.[45]

England's contribution to the sale of printed indulgences in the fifteenth century, though, was small compared to that of the Holy Roman Empire, from where thirteen editions survive for 1453, thirty editions for 1480, forty-three editions for 1481, thirty-six editions for 1482, thirty-three editions for 1488, eighteen editions for 1489, and twenty-six editions for 1490.[46] Paul Needham estimates that copies from at least 600 editions of indulgences survive for the fifteenth century. But that number is the tip of a much larger iceberg. We know that more than two dozen editions of the 1479 Rhodes indulgence were printed in Germany, Switzerland, and the Low Countries. But of the thousands of copies from the six known English editions of the Rhodes Indulgence, just nine copies survive, and four of the editions are known only through fragments that have been preserved as printer's waste that was reused in the binding of other books.[47] If the majority of copies have disappeared, so almost certainly have the majority of editions. In 1500, the Bishop of Cefalù paid for copies of more than 130,000 indulgences: not one survives.[48] And the 20,000 Spanish indulgences that Jacopo Cromberger printed in 1514 and the 16,000 that he printed two years later are only recorded in notarial documents. Again, not a single copy survives.[49] Given how many editions survive in only one or two copies, it is statistically certain that hundreds of other editions have vanished without trace.

Tessa Watts notes that the survival rate of sixteenth-century English ballads is perhaps 1 in 10,000 copies and 1 in 10 *editions*. And she cites Folke Dahl's estimate of 0.013 percent of English newsbooks surviving from 1620 to 1642. Even for the slightly more substantial chapbooks, many editions (and even whole titles) were lost through use. The first surviving copy of William Perkins' chapbook *Deaths Knell* (1628) is labeled the "9th edition"; had it not been announced as such, we would have no knowledge of its popularity.[50] The estimates of one in 10,000 copies and one in ten editions are much too optimistic for fifteenth- and sixteenth-century indulgences.

Given the mass production of printed indulgences, Luther's *95 Theses* attacking indulgences must be read as a *response* to printing, and in particular to the campaign that was underway in Mainz, spearheaded by the pardoner John Tetzel, to sell massive numbers of indulgences to finance the rebuilding of St. Peter's in Rome.[51] Luther responded by initiating a new phase of printing in which the single sheets that Tetzel was offering had to compete against a remarkable proliferation of pamphlets. As Andrew Pettegree notes, more than three-quarters of the 10,000 or so pamphlets printed in Germany between 1500 and 1530 were printed in the six years between 1520 and 1526. But 50 percent of those pamphlets consisted of two sheets of paper or less, usually in the form of the small quarto *Flugschriften*, in which two sheets were folded to make sixteen pages.[52] But Elizabeth Eisenstein is surely right to argue that we must see the thousands of Lutheran pamphlets within the context of the millions of Catholic printed indulgences. As she notes, it was "a late medieval crusade against the Turks in response to the fall of Constantinople, not Florentine humanism or the Reformation, that made printing a form of mass production from its very inception." While "Luther's Theses received top billing in their day and are still making the headlines in our history books," it was the indulgences and bibles that came from Mainz in the middle of the fifteenth century that revealed the revolutionary possibilities of the new technology. Eisenstein continues:

> If first things were placed first, it would ... be noted that indulgences got printed before getting attacked. The first dated printed product from Gutenberg's workshop was an indulgence. More than half a century lapsed between the Mainz indulgences of the 1450s and Luther's attack on indulgences in 1517. During this interval the output of indulgences had become a profitable branch of jobbing-printing. "When ... Johan Luschner printed at Barcelona 18,000 letters of indulgence for the abbey of Montserrat in May 1498 this can only be compared with the printing of income tax forms by His Majesty's Stationery Office." (Eisenstein 1979: 178, 368, 375)[53]

Printer–publishers who did not undertake job printing like indulgences to underwrite the expenses of larger projects were much more likely to fail. In late fifteenth-century Ulm, Lienhart Holler attempted to survive by printing deluxe books for private consumption. As Martha Tedeschi has shown, he went bankrupt, while two other Ulm printers flourished by printing single-sheet broadsides.[54] Clive Griffin reaches the same conclusion:

> Spanish printers of the early sixteenth century were surrounded by evidence of colleagues who had failed to establish their operation on a sound economic foundation and who had collapsed ... There is evidence that printers had to engage in other commercial activities unless they were fortunate enough

to corner the market in one of the few lucrative areas of jobbing printing. [Arnao Guillén de] Brocar, for instance, made his money not from the magnificent editions for which he is now remembered, but from the privilege which he enjoyed on the best-selling works of the grammarian, Antonio de Nebrija, and by his appointment as joint printer of the indulgences of the Santa Cruzada. (Griffin 1988: 9, 18n)

Like Brocar, Gutenberg made his wealth less from his large undertakings than from job printing and the publication of small books, such as calendars and schoolbooks.[55]

As Elizabeth Eisenstein suggests, we can learn more about the printing revolution from indulgences than from the celebrated printing of Gutenberg's bible or Caxton's Chaucer. Printers were businessmen, pursuing profit, and profit was rarely to be made by publishing huge folios that required major capital investments. Christopher Plantin, who ran one of the greatest printing houses of early modern Europe, almost bankrupted himself in printing his most famous book, the Polyglot Bible, despite the official patronage of Philip II of Spain.[56] The bible took him four years of hard work to publish, and he never had adequate financial support for the immense quantities of paper and parchment that he had to buy in advance. Indeed, so bad was his situation that he was forced to sell some of the paper that he had acquired even before he had begun the printing. As Colin Clair concludes, if the Polyglot Bible brought Plantin fame, "it left him burdened with crippling debts which were covered neither by the sales nor by the King of Spain."[57] Ephemeral printing by the sheet rather than by the book was always in demand.

Two final examples may suggest how the combination of the paper and printing revolutions transformed everyday life from the 1450s to the end of the sixteenth century. My first example is the only surviving advertisement of its kind that I know of: an uncut broadside, composed of eight different recipes, clearly meant to be cut up for separate sale with the medicines that they accompanied. The broadside was printed on one side of a sheet of paper in London for "Hans Smit" (presumably a Dutch or German apothecary). One of the advertisements for a "salue" reads:

> If there bee any man or woman that hath any mischaunce, that is cut, or haue prickt themselues or haue a brooze or a fall, or els byt wyth a dog, or any suche like chance, and dwelling far from any Chirurgian, you may haue of this master an excellent salue for to heale your selues, whiche salue healeth and cureth all these diseases folowing.
>
> Imprimis, this plaister or salue healeth all manner of greene wounds and olde sores, so the old sore bee made cleane with a water whiche thys master hath.

Secondly, this water healeth all maner of burning, that is too saye, of fire or whote water, or els of Gonpouder, spreaded vpon a fine cloth, & layd vpon the sore twice a day, it helpeth & healeth foorthwith.

Thirdly, if any man or boy, be shot in with an Arow or a bolte, you must take a siluer or a pewter spoone, and melt a little of the same vpon the fire and dip a tent in the foresayed salue, and put your tent warme in the wound, and make your tent so long as you think the wound is of depth and spred a plaister of the same, and lay it vppon the wound, this healeth without fayl, and dresse it twice a day.

By M. Hans Smit.[58]

Like the great majority of such pieces of ephemera, this broadside only survives because it was cut up and used as binders' waste—in this case, for the endpapers of a copy of the *Sermons of John Calvin vpon the Book of Iob*.[59] This is a single example of what must have been a standard piece of printing for thousands of shopkeepers throughout Europe—shopkeepers who were availing themselves of cheap paper and printing to make multiple copies of advertisements that would have been for most of them far too expensive and time-consuming if they had still been using parchment and scribes.

For my second example, I have many more materials to draw from and over a wider period: playing cards. But again, the survival rate of such small pieces of paper is staggeringly low and does not begin to give a sense of the number of people who might have owned playing cards without ever having bought a book.[60] Playing cards are of particular interest because their availability depended upon the combination of paper and printing *prior* to Gutenberg, since they were being widely disseminated in the early fifteenth century through both woodcuts and copperplate engravings. Like paper itself, playing cards came to Europe via the Islamic world. Playing cards are first recorded in Europe in the late fourteenth century, when a later account of the 1379 Chronicles of Viterbo notes that playing cards were brought to Italy by a *saracino*; moreover, "the frequent use of the word *naibi* or *naybi* for 'playing cards' in fifteenth- and late fourteenth-century Italy, and of *naipes* to this day in Spain (an early form is *nahipi*)," demonstrates their Islamic origins.[61] In 1436, a maker of playing cards known only as "the Mantuan" established "a little press for printing cards" in Ferrara: "this burgeoned into a successful business for between 1446 and 1454 we learn of a Pier Andrea di Bonsignore to whom this Mantuan was now farming out at least some of the printing and coloring of his cards."[62] Moreover, as Anne H. van Buren and Sheila Edmunds have persuasively argued, the cards engraved by the Master of the Playing Cards, far from being subsequent to Gutenberg's bankruptcy, had been designed by as early as the 1430s and had been copied, with the plates broken up by 1449.[63] Moreover, these *printed* playing cards *precede* any surviving *manuscript* cards. This is not, of course, to say that there were no earlier such cards, but rather to emphasize that printing

technologies often emerge in close relation to new writing technologies (as printing with seals and stamps is closely related to the invention of Sumerian writing on clay tablets).

It was the combination of woodcut printing and paper that brought about the ubiquity of texts and images in even poorer households throughout Europe before moveable type, whether as cuts to commemorate a pilgrimage, devotional images (often with xylographic prayers) of the Virgin and St. Christopher, or playing cards. The latter, in fact, made extensive use of one of the ingredients that was central to the manufacture of paper: animal glue, made from "sheep's hooves, deer feet, bones, and hides," as sizing for paper and to glue sheets of paper together in the making of playing cards so as to make them stiff and durable. For instance, the Cloisters Playing Cards (*c.* 1475–1480) are made of four layers of paper and glue—and the dating of the cards is made possible by the watermarks of a Gothic "P" with a quatrefoil and a shield with the letters "iado" surmounted by a crozier that were used in paper from southern Flanders between the 1460s and 1480.[64]

From my perspective, the most problematic feature of Martin and Febvre's great work is the conjoining of "the book" with "printing"—less because books continued to be written by hand throughout the fifteenth and sixteenth centuries, if in diminishing numbers, than because printing has nothing to do with *books* as such. Before Gutenberg, woodblock printing was used to make huge numbers of single-leaf texts and images. Paper was the crucial medium. And moveable type was itself employed by Gutenberg and his successors to print single-sheet calendars and indulgences by the tens of thousands. The voracious concept of "the book" has the serious drawback of focusing upon what, in my view, was only one aspect of printing: the multiplication of lengthy texts. But the need for rapid economic turnover meant that small, apparently trivial items, almost none of which have survived, were as important as books for publishers, booksellers, and chapmen. This is further occluded by the fact that libraries and library shelves are primarily designed for the storage and preservation of books rather than ephemeral publications like unbound pamphlets and broadsides. The Gutenberg revolution turned above all on the most modest of everyday objects—indulgences, printed forms, tickets, proclamations, broadsides, playing cards, almanacs, ABCs, pamphlets, chapbooks—all of which were in turn stimuli to writing on paper by hand, whether to trace the alphabet or to meet the demands of state bureaucracies, business, friendship, and love. Paper transformed reading, writing, calculating, and playing cards into daily features in sixteenth-century Europe.

CHAPTER FIVE

Art

JILL BURKE

Love is like a painter. The works of a good painter so charm men that, in contemplating them, they remain suspended, and sometimes to such an extent that it seems they have been put in an ecstasy ... This is what the love of Jesus Christ does when it is in the soul.

(Girolamo Savonarola, 1495)

The spoon, the art historian can claim, is not art ... Art history has the potential to be a discipline of objects, but its predilection for high art stands in the way.

(Michael Yonan 2011: 235)

Seen today in hushed huddles of visitors in fifteen-minute slots, Leonardo da Vinci's *Last Supper*, painted from 1495 to 1498 in the refectory of the monastery of Santa Maria delle Grazie in Milan, is one of the most famous paintings ever made (Figure 5.1). We see thirteen men sit at a table in a room with a coffered ceiling and three windows at the far side that open out into a landscape. Christ's head is framed by the light of the window. He reaches out with his left hand to gesture to some bread on the table. His right hand, fingers splayed, hovers near a glass of wine. The men at either side of him gesture in various ways, as if reacting to some news they have just heard—as based on the dramatic moment when Christ declares, "I say to you that one of you is about to betray me" (Matthew 26:21).

This brief ekphrasis (description or evocation) of an artwork scarcely conveys what we actually see. This image today is barely there. It is a ghost, a conglomeration of flakes of pigment clinging to the wall. Painted with an

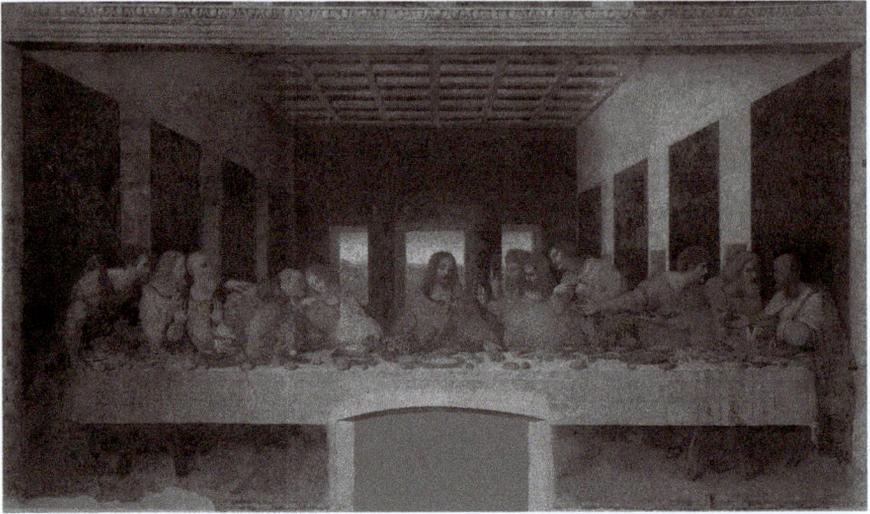

FIGURE 5.1 Leonardo da Vinci, *Last Supper*, 1495–1498. Milan, Convent of Santa Maria delle Grazie. Photograph: Commons Wikimedia/Haltadefinizione.

experimental mixed tempera and oil technique during Leonardo's stay in Milan, it started to degrade within a few years of its creation. It was already showing the effects of humidity by 1517, and by 1582 it was "in a state of total ruin."[1] Despite (or perhaps because of) this, the *Last Supper* was immediately famous, spawning several reproductive prints, paintings, and even tapestries,[2] as well as comments in journals and letters.[3] The stark contrast between the painting's ramshackle materiality and its considerable fame epitomizes the complex relationship in the Renaissance between the kind of objects we now call "art"—generally meaning various forms of painting and sculpture—and their materiality.

Ekphrasis is, arguably, at the heart of what art historians do, and certainly at the heart of the beginnings of art history that we can see in the Renaissance period.[4] It is a profoundly literary discipline based on conveying or explaining appearance through words—a project that is in some ways always doomed to fail, but which is intended to test the verbal acuity of the writer and to allow the reader/viewer to see more intensely, and to understand an image in a new way both by looking more closely, but also by re-visioning it in one's mind. This is, perhaps, why art history has had a sometimes vexed relationship with the study of material culture.[5] The two quotations that open this chapter demonstrate the intellectual fissure between seeing paintings and other representations as windows onto another imaginative or spiritual world, and perceiving them as objects. I would guess that "love is like a painter" makes more intuitive sense to most readers than "love is like a spoonmaker"—but why should this be the case?

Why do we categorize these objects so differently? These issues occasionally come to the fore in the current historiography of Renaissance art, where there is some mutual suspicion between those who focus on material culture and those who continue to research old master painting, sometimes dismissively referred to as "flat art."[6] Where does painting and sculpture stand in the light of what has been called the "material culture turn?"[7]

There is certainly space for seeing painting and sculpture as "objects"—understood in terms of their "stuffness," their material makeup, techniques of creation, or how they were collected—their role particularly as items displayed within the *Wunderkammern, studioli,* and Cabinets of Curiosities of the early modern elites, new spaces that exemplify the urge to collect and display wealth to *cognoscenti*. However, as I will outline here, the representative arts, particularly painting, have their own history, and their own theoretical frameworks. Interpreting painting and sculpture as "objects" can risk ignoring their status as representations, their function in communicating ideas that could not otherwise be so effectively vocalized—arguably, a painting is more like a poem than it is like a spoon; while materiality forms part of its function, it is not necessarily the most important part. The idea that images can link the viewer to immaterial worlds can be traced to back to classical antique and early Christian theories of images, but as we shall see, ideas about representation were revisited with urgency in the Renaissance, when image creators gained a new divine aura and divine images were dismantled into their constituent parts in some areas north of Alps.

LOOKING WITH VASARI

Every account of the development of Renaissance "art" has to grapple with Giorgio Vasari's *Lives of the Most Excellent Painters, Sculptors and Architects* (*Le Vite de' più eccellenti pittori, scultori, e architettori,* often abbreviated in English as *The Lives of the Artists*). This was far from the first treatise dedicated to the history of the visual arts, but certainly the most influential. As well as being responsible for the beginnings of a new discipline—"the true founder of the history of art," according to many[8]—Vasari's narrative of the development of Renaissance art still governs the organization of major art museums globally.[9]

Vasari's *magnum opus* was first published in 1550, then in a much-expanded edition in 1568. His approach leaned heavily on previous accounts of artistic achievement by both classical and near-contemporary authors, but this book was the most systematic and thoroughgoing attempt to create a history of painting, sculpture, and architecture.[10] Vasari argued that after the perfection of antiquity, the arrival of Christianity and the fall of the Roman Empire brought the ruin of the visual arts of painting, sculpture, and architecture. His stated aim in writing his book was to trace the course of the arts from the beginning of

their revival in the age of Giotto (1276–1337) to their perfection in the present day, a perfection consisting of an ability to represent the natural world and to mimic, or even surpass, the technical and creative achievements of antiquity. He did this through a series of artists' biographies that he divides into three parts, or ages. Part 1 focuses largely on the late thirteenth and fourteenth centuries, including the lives of Giotto and Simone Martini (1285–1344). Part 2 is largely concerned with the fifteenth century, including the Florentine painter Masaccio (1401–1428), the sculptor Donatello (1386–1466), and Sandro Botticelli (1445–1510). Part 3 considers the sixteenth century up until the time of writing. It starts with Leonardo da Vinci (1452–1519), includes Raphael (1483–1520) and Titian (1488–1576), and culminates with Michelangelo (1475–1564), whom Vasari considers to have reached "perfection" in the three allied arts of painting, sculpture, and architecture.

It is important to understand why Vasari's story of Renaissance art is so influential, and how audiences can still relate to his ideas visually. A basic method in art historical scholarship since the introduction of the slide lantern in the late nineteenth century is the comparison of two images to consider differences in approach and style,[11] and Vasari's discussion of stylistic difference lends itself neatly to this type of approach. Readers might at this point pause to have a close look at Figures 5.2–5.4 in order to consider how to articulate the visual differences between them. The difference between Vasari's three ages can be readily grasped through careful looking.

Giotto's *Virgin and Child Enthroned with Angels* of c. 1310 (Figure 5.2) was originally part of a much bigger multi-panel altarpiece (polyptych) in the church of Ognissanti in Florence. It shows the Virgin Mary dominant in the center looking out directly at the viewer. She is by far the largest figure, clad in a dark blue robe seated on a throne at the center of the panel with the Christ child on her lap. The throne is surrounded by figures with halos, with a color palette largely made up of rich red, blue, and rose against a background dominated by gold leaf. The image recedes spatially, creating an illusion that the picture plane is extended backwards beyond its surface, occupying part of the real world. The illusion of tangible space is increased through the device of steps that recede backwards into the painting, allowing a pathway between the Virgin, the viewer, and the jumbled mass of saints that stand in front of each other, sometimes blocking each other from view. The Virgin and Christ's drapery, free of the gold striations that served to increase the sense of surface beauty in earlier painting, convincingly hangs on their bodies, indicating the massive physicality below. For Vasari, Giotto abandoned the "lustreless eyes, the tip-toed feet, the attenuated hands, the absence of shadow, and all the other Byzantine absurdities" of earlier painting replacing them with "graceful heads and beautiful colouring … a measure of vivacity … a closer approach to nature."[12]

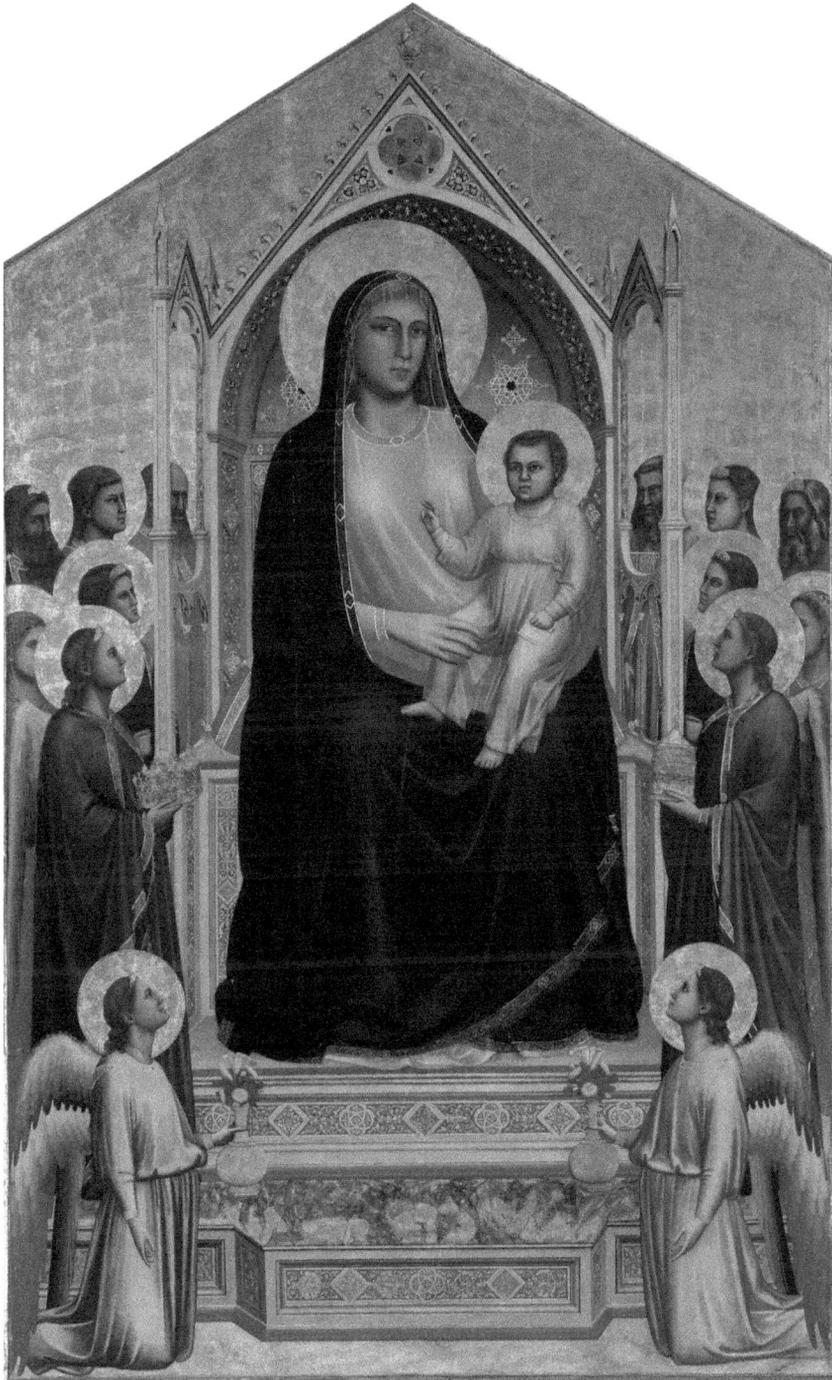

FIGURE 5.2 Giotto, *Virgin and Child Enthroned with Angels and Saints*, *c.* 1305–10.
Uffizi. Photograph: Commons Wikimedia/Google Art Project.

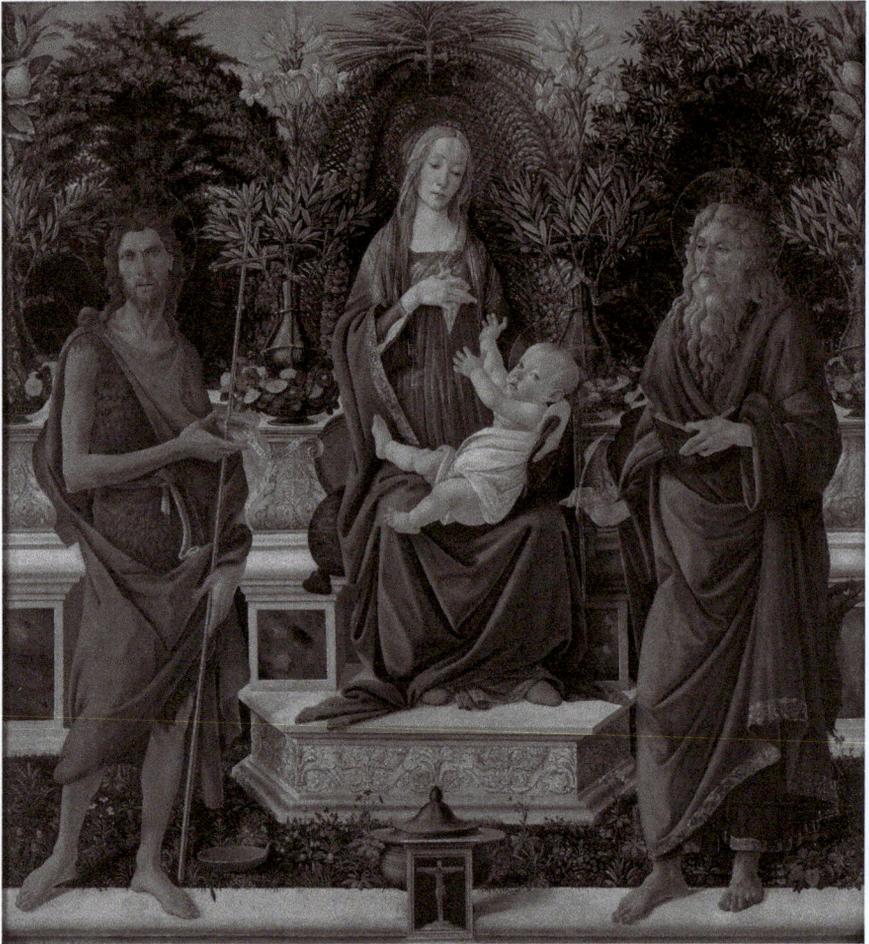

FIGURE 5.3 Sandro Botticelli, *Virgin and Child Enthroned with Saints John the Baptist and John the Evangelist* (the "Bardi Altarpiece"), 1484. Staatliche Museen, Berlin. Photograph: Commons Wikimedia/Google Art Project.

There was much more to do, however, before art could reach its perfection: "and if [Giotto] did not succeed in giving his eyes the beautiful expression of life, or the right expressions to his weeping figures, or make his hair pretty, his beard downy, his hands knotty and muscular, or his nudes like the reality, he must be excused on account of the difficulty of the art, and because he had not seen any painters better than himself."[13] Compare Giotto's *Virgin and Child* with a similar image by Botticelli, commonly known as the "Bardi Altarpiece" (*Virgin and Child Enthroned with Saints John the Baptist and John the Evangelist*) made in 1484–1485 (Figure 5.3) for the Bardi chapel in the church of Santo Spirito,

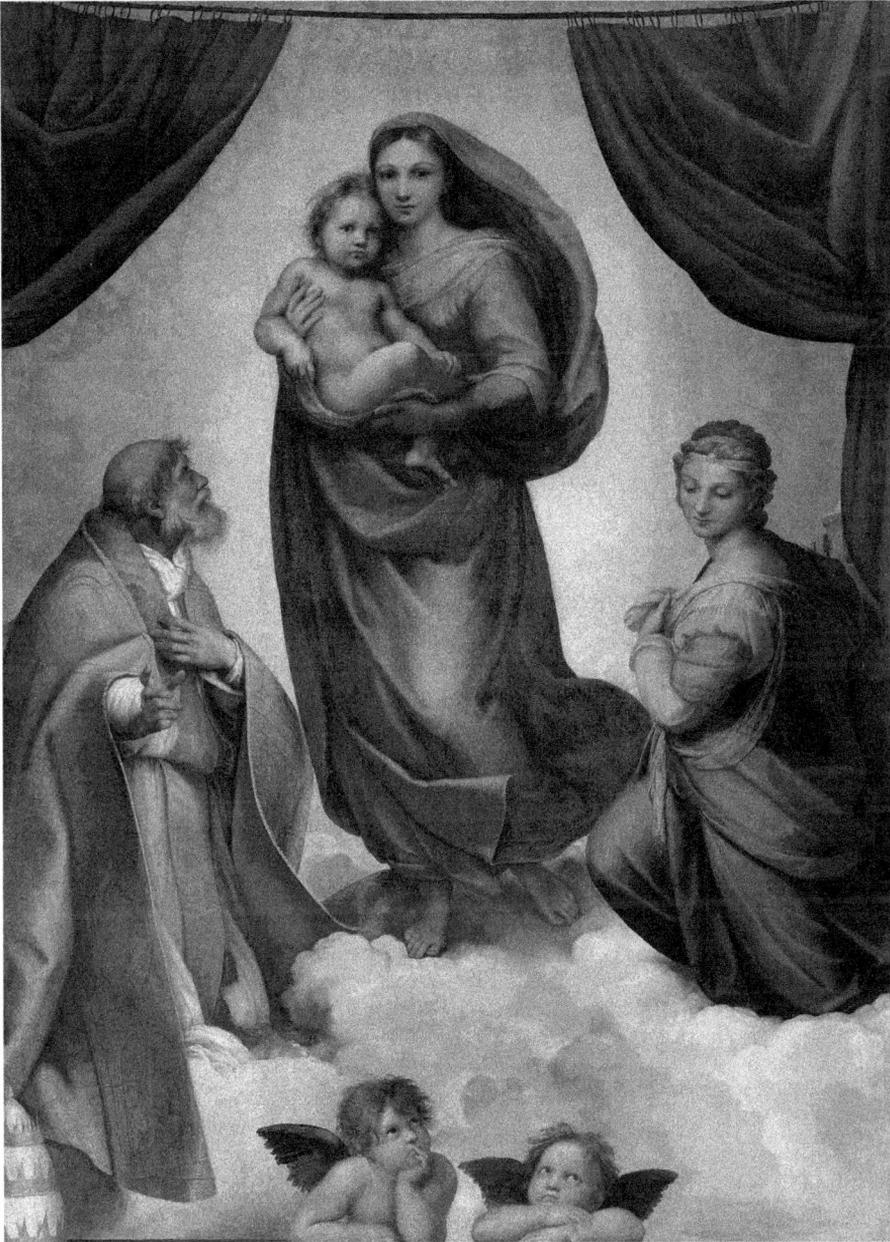

FIGURE 5.4 Raphael, *Virgin and Child with Saints Sixtus and Barbara* (the *"Sistine Madonna"*), 1512. Source: Gemäldegalerie Alte Meister, Dresden. Photograph: Commons Wikimedia.

across the river from Ognissanti. Gone are the gold backgrounds that draw attention to the materiality of the panel; instead, on this painting, pigments are manipulated to create the illusion of a space that continues that of the viewers'. Botticelli has created a garden opening from an illusory window in the wall of the church, and the figures are silhouetted against verdant arches of foliage. The lively (and unusually believable) Christ child gazes at us while extending his arms up to his mother, who presents her breast to him. The flanking saints stand on a step that truncates just at the edge of the picture plane; the placement directly above an altar-table would have meant that small Crucifixion at the center would have directly linked our world to that of the painting. Rational perspectival space has been created in this painting to create what Leon Battista Alberti was to call a pictorial "window."[14] Botticelli uses his considerable skill here to mimic nature and persuade the viewer that his revelation of the Virgin is real.

Most onlookers, given the comparison of these two images, are able to place them in chronological order. What is Renaissance art, after all, if not the triumph of naturalism? They often have more trouble with Vasari's third age. Although, he acknowledges, the second period artists made "[g]reat additions to the arts," "they lacked a freedom which, while outside the rules, was guided by them." They lacked "good judgment in proportions which ... invests them with a grace ... they did not possess that lightness of touch ... their draperies lacked beauty, their fancies variety, their colouring charm, their buildings diversity and their landscapes distance and variety."[15] Raphael's *Sistine Madonna* (*Virgin with Saints Sixtus and Barbara*), commissioned in 1512 by Pope Julius II for the church of San Sisto, Piacenza (Figure 5.4), is an archetypal painting of the third age—we would now call it a "High Renaissance" image.[16] Rather than creating an earthly space, Raphael sets his figures on hazy clouds that resolve into small faces of seraphim around the Virgin; rather than a halo, her whole body gives off a glowing aura; and rather than the static, hieratic figures on Botticelli's altarpiece, the Virgin seems to be stepping towards us, in the direction that Saint Sixtus is pointing. Cheeky angelic *putti* lean on the picture plane, and the whole composition is framed by green curtains, suspended from a bent curtain rail. The curtains, reflecting real curtains that were often put in front of altarpieces, tell the viewer that we are witnessing a revelation—the curtains are open to a divine scene—but this scene is more theatrical than iconic, occupying time as well as space; these poses are unstable and likely to change, if only the viewer could wait long enough.

It is my hope that the close comparison of these images, and the ability to grasp the chronological developments in Renaissance painting style has given the reader/viewer some reward and pleasure. One of the charms of Vasari's work is the clarity of his exposition, and the comforting idea that if we follow his precepts we will be able to appreciate art "properly"—and know that Raphael is "better" than Botticelli, who is "better" than Giotto. These

ideas, indeed, dominated art historiography for centuries, and still feature in much of the rhetoric of advertising in the museum and publishing worlds. But, as many scholars have noted, it is the attractive simplicity of Vasari's scheme that makes his legacy deeply problematic. Even he noted that the neat differentiation between ages was problematic—the Florentine sculptor Donatello, he admitted, might have been better off placed stylistically in the third age, though chronologically he belonged in the second.[17] There are many paintings and sculptures—let alone other objects—that simply do not fit into these neat chronological categorizations. Moreover, Vasari makes claims for the global historical importance of the artistic trajectory he traces, yet his focus is almost entirely on Italian artists (though there are brief discussions of some Northern European painters), with a marked concentration on central Italian painters. His role as an employee of the Florentine dukes meant that Florentine artists, particularly, played a starring role. Accuracy of information was often less important than how artists' lives fitted into his narratives, so art historians have to be careful about using Vasari as a source.[18]

Perhaps most seriously from our point of view, however, is that by creating a history of painters, sculptors, and architects, Vasari makes objects that were created for a variety of reasons in a number of contexts all feed into one history—the progress of artistic skill. It is a fundamental misunderstanding to look at Giotto's altarpiece merely as a waypoint to Botticelli's (and so on), when these works were made primarily as church furniture with precise devotional functions, designed to aid the viewers' access to the divine, rather than to impress them with the painter's skill. There is a long distance chronologically and cognitively between the time when Vasari was writing and the time when Giotto, Botticelli, and even Raphael were making their altarpieces.[19] By taking on Vasari's vision, we gain a false sense of clarity, and lose much else.

TAXONOMIES

The Oxford English Dictionary (2010 edition) defines the word "art" as "the expression of application of human creative skill and imagination, typically in a visual form such as painting or sculpture, producing work to be appreciated primarily for their beauty or emotional power." The term is derived from the Latin word *ars* (*techne* in Greek), but did not settle to this modern meaning until the eighteenth century. The meaning of *ars* at the beginning of our period (1400–1600) was still related to the definition given by Aristotle in his *Nicomachean Ethics* VI.4: "the reasoned state of the capacity to make." Like nature, art creates things, but is equally distinct from nature in that its "origin is in the maker and not in the thing made." From the point of view of the 1400s, then, "*ars*" is a kind of practical knowledge concerned with making objects—more akin to our words "craft" or "skill."

It is worth remembering that, for most of this period, painting, sculpture, and architecture were not taught to students as academic subjects in the setting of schools or universities, but to apprentices in workshops, subject to the legal framework of trade guilds; in terms of organization and teaching, they were considered more manual than intellectual.[20] Moreover, in most European cities in the fifteenth century, the three visual arts of painting, sculpture, and architecture were located in different guilds depending on the materials they used. Thus, in Florence, painters were part of the guild of doctors and apothecaries, due to them using similar chemicals for pigments as were used for medicine, whereas stone sculptors were in the mason's guild, and metalworkers in the silk guild—a recognition of the prestige of these materials and the use of precious metal threads in luxurious textiles such as cloth of gold. Many Florentine sculptors, notably Lorenzo Ghiberti and Benvenuto Cellini, were in the silk guild—in terms of the legal frameworks of their trade, then, they had more in common with spoon-makers than poets.[21] Similarly, in Bruges, the painters' guild of Saint Luke also included saddle-makers, probably because both artisans were employed in the decoration of animal skin—leather, vellum, or parchment (prepared calf/sheep skin); whereas wood sculptors shared a guild with carpenters.[22] We can see here how the Aristotelian definition dominated organizational structures; these pursuits were structured around which raw materials provided by nature artisans manipulated to make new objects. Painting and sculpture becoming grouped together for the training of "artists" only happened late in the period with the establishment of art academies based on the skills of drawing and design (*disegno*), the first being the *Accademia delle Arti del Disegno* (Academy for the Skills of Drawing/Design), which our old friend Vasari founded in Florence in 1563, but was followed quickly by others in other European artistic centers.[23]

However, coexisting with this practical world of work, legal definition, and trade apprenticeships was a tradition of a different kind; a centuries-long taxonomy that elided painting and sculpture with pursuits that mimicked nature. As far back as Plato (428/427 or 424/423–348/347 BCE), these two visual arts were grouped together with poetry, music, and dance—because all five were concerned with forms of imitation, or mimesis.[24] The idea that the task of painters and sculptors was to copy nature was assumed well before the advent of Renaissance naturalism (discussed in more detail below). Although Plato thought of this act of mimesis unfavorably, banning painters and poets from his Republic, the Christian framework gave image-makers particular metaphorical status in relation to God, the creator of nature. Likening God to an artisan maker—"*deus artifex*"—was a commonplace in theories of painting from well before 1400. Thus, St. Augustine (354–430) argued that the key difference between artists and God is that the former creates out of existing materials,

and God created the world from nothing.[25] The Dominican theologian Thomas Aquinas (1225–1274) likened God's creation to that of an artificer, as he first had the idea of the form of the world in his mind before making it material just as "the house pre-exists in the mind of the architect."[26] The Dominican friar Girolamo Savonarola knew Aquinas's work well, and was resting on a long tradition when he compared painters to God in a Florentine sermon of 1493: "[T]he master painter from his intellect and from his hands brings forth an image on paper, which is the same as that idea and image he has in his mind … in the same way all natural things, and all creatures proceed from the divine intellect."[27] The "object"—the paper, in this formulation—is merely a vehicle to express a concept, a means through which the onlooker can perceive ideas that are otherwise inexpressible.

The fact that we look *through* rather than *at* the types of object we now categorize as "art" might seem obvious, but at its heart is a debate that is central to Western Christianity's acceptance of images in worship, an acceptance that created a separation from the aniconic Christianity of some traditions and marked it out from other monotheistic religions. The second commandment states that "thou shalt not make to thyself a graven thing, nor the likeness of any thing that is in heaven above, or in the earth beneath, nor of those things that are in the waters under the earth" (Exodus 20.4). Much-repeated ideas from a sixth-century letter by Pope Gregory the Great justified the use of images in Christian worship by averring that although pictures must not be adored themselves, they should be retained due to the usefulness of teaching aspects of the true faith to the illiterate "who read in them what they cannot read in books"—both for conversion and for reminding worshippers of Biblical stories. Moreover, images can have an emotional charge that aids devotion. Around the eighth century, another defense of images was included with Gregory's letters that related images to the incarnation of Christ, who, like an image, was an earthly visible sign of an intangible and ineffable God: "When you see the picture, you are inflamed in your soul with love of him whose image you wish to see. We do no harm in wishing to show the invisible by means of the visible."[28] As Georges-Didi Huberman has noted, the foundations of image-making in the Christian West thus rest on a paradox—a suspicion of the power of material objects to lead the viewer astray, combined with the assertion that the visual is a powerful means of understanding God. The visible world of mere appearances is idolatry, but visuality can lead to higher truths.[29] In the years 1400–1600, this paradox was to lead both to artists being hailed as "divine" as they made manifest the perfection of God's creation and, in Northern Europe, to religious images being destroyed into their constituent parts, breaking the illusionistic magic. As we shall see, ideas inherited from the Middle Ages were fundamental for the development of a new type visual theory that was to prefigure our understanding of art.

The linking of painting and sculpture (and sometimes architecture) as more than mere *"ars"* can already be seen in the mid-fourteenth century in elite scholarly conversations about the visual arts. A new type of approach to classical texts, what we now call humanism, started in central Italy in the mid-fourteenth century. Humanists were primarily at this time interested in the revival of a type of Latin language used in certain classical texts, especially those written by the Roman orator Cicero, and also in the rediscovery of these texts and a revival of classical culture and artifacts more generally. The Tuscan humanist Petrarch (Francesco Petrarca, 1304–1374) discussed the visual arts in the most detail, particularly in chapters 34–40 of his renowned advice book, *Remedies for Fortune* (written *c.* 1354–1360). These ideas, derived from a variety of sources, set the stage for the development of art theory in the centuries to come, establishing a series of commonplaces and a humanist vocabulary that were to be elaborated and developed into what we would now call art theory over the subsequent 200 years and finally secured for posterity by Vasari.[30] In summary, Petrarch's work laid down the following commonplaces:

1. Painting and sculpture are cognate arts that share a common historical trajectory.
2. The test of their quality is how they compare with the work of classical antiquity, and this can only be judged by knowledgeable people.
3. Good painting and sculpture mimic nature, but great painters combine manual skill with intellectual ambition.

PAINTING, SCULPTURE, AND *DISEGNO*

Petrarch averred that "painting and sculpture are really one art ... [that] spring from a single source, namely the art of drawing."[31] The Italian word *disegno* combines the meaning of both drawing and design, so drawing encapsulated the relationship between a mental image and its execution by the hand. Despite its long existence, drawing gained a new and important status during the Renaissance and allowed for increasing complexity of compositions, close study of natural objects, and a new emphasis on invention.[32]

As well as intellectual reasons, one factor that was crucial to the increasing status of Renaissance painting was the availability of relatively inexpensive paper. Until the fourteenth century, paper had been very expensive. The introduction of paper mills to Italy in the late thirteenth century and Germany in the early fifteenth century meant that this surface soon became considerably cheaper than parchment and vellum.[33] The advent of printed books in the mid-fifteenth century meant demand for paper went up, more mills were built, and paper became cheaper. Artists started to use paper for drawing regularly from around the 1410s. Before then, wax tablets were used to try out ideas and

parchment was used for workshop albums. This change saw the beginnings of sketching for all types of artisans from architects to engineers,[34] but for artists this meant rapid transposition of the ideas form their minds onto paper and an ability to try out a variety of poses before committing themselves to paint or other more expensive media.[35] Perhaps the archetypal examples of thinking through drawing are Leonardo da Vinci's sketches. Over 4,000 pages of drawings and notes by Leonardo survive;[36] this simply would not have been possible if it weren't for the availability of inexpensive paper. The drawings range from designs for flying machines, to accurately rendered town plans, to observations on the flight of birds, to minute anatomical drawings. Many of them render his thought processes clearly across the sheet.

Although Leonardo is an extreme example, his German contemporary Albrecht Dürer (1471–1528) also started to execute drawings for their own sake from early in his career.[37] Dürer habitually signed and dated his own drawings, even occasionally misdating them—an indication that far from being merely practical sheets for the use of a workshop, these drawings were put together with an eye to posterity and the artist's historical reputation. By around 1500, certain people, especially in the mercantile cities of northern Italy and Nuremberg in Bavaria, started to collect drawings for their own sake. Dürer's friend, the Nuremberg cartographer Hartmann Schedel (1440–1514), for example, collected both drawings and prints,[38] whereas the Veronese scribe and antiquarian Felice Feliciano was possibly the first person to collect drawings systematically[39]—suggesting that already by the mid-fifteenth century there was an appreciation of the process of art-making rather than just the final results.

COMMON HISTORY

Petrarch observed that the arts based on *disegno* reached a peak of excellence in pre-Christian classical antiquity and then went into a long decline. He pointed out that the great sculptors and painters of classical antiquity—including Apelles and Praxiteles—all flourished under the emperor Alexander the Great, but he saw some painters of his own day as matching up to the quality of antiquity.[40] This idea of peak, decline, and revival was applied to many aspects of Renaissance life, but painting and sculpture always tended to be held up as a demonstrable example of revival. This was repeated in a multiplicity of sources, particularly in the writings of humanists working in the Italian city-republic of Florence, eager to claim that their city was particularly blessed. So the chronicler Filippo Villani (1325–1405) writing his book *On the Origin of the City of Florence* in 1381–1382 included a chapter on the city's painters. He explained that due to Giotto, "glittering brooklets of painting flowed … and brought about an art of painting that was once more a zealous imitator of nature, splendid and pleasing."[41] Similarly, in 1440, in a treatise on the proper use of Latin,

the humanist Lorenzo Valla (1407–1457) pondered: "I do not know why the arts most closely approaching the liberal arts—painting, sculpture in stone and bronze, and architecture—had been in so long and so deep a decline and almost died out together with literature itself; nor why they have come to be aroused and come to life again in this age; nor why there is now such a rich harvest both of good artists and good writers."[42] A few years later, the Florentine humanist Marsilio Ficino (1433–1499), who translated Plato from Greek into Latin, wrote to his fellow philosopher Paul of Middelberg that "this golden century … has brought back into the light the liberal arts, which were almost extinct: grammar, poetry, poetry, rhetoric, painting, sculpture, architecture, music, the ancient art of singing to the Orphic lyre … And all this in Florence."[43] The rebirth of painting and sculpture was a highly self-conscious affair.

A key feature of this narrative was that the best painters and sculptors were found in classical antiquity, and this fact in itself suggests that Renaissance "art" was more of literary than visual endeavor. Most information about classical art was derived from Pliny the Elder's *Natural History* and a handful of references in other texts.[44] Although there were many classical sculptures visible in Europe around 1400, almost all of these were not attributed to particular individuals— indeed, they were typically Roman copies after Greek prototypes, and much of the surviving figural sculpture was in a fragmented state.[45] An exciting exception to this was the Laocoön that was dug up in 1508 and recognized immediately as a work of art mentioned by Pliny.[46] As for painting, hardly anything was visible until the discovery of Nero's Golden House around 1480 (the *Domus Aurea*), so the imagination of what antique painting looked like was not hampered by any material evidence.[47] Instead, it was derived from the evidence of sculpture, particularly relief sculpture, and surviving classical literary descriptions.

Probably the most famous painter of antiquity was Apelles, who had been commissioned by Alexander the Great. Petrarch, again, seems to have been the first writer to associate contemporary painters with Apelles, naming both the Florentine painter Giotto,[48] and claiming that the Sienese painter Simone Martini surpassed his classical predecessor.[49] By the late fifteenth century, there was a cacophony of poets and writers eager to show off their classical credentials in the praise of their painter colleagues, to the extent that it seems as if every artist working in the late fifteenth and early sixteenth centuries was likened to Apelles at some point, despite (or perhaps because of) the fact that his works only survived in literary descriptions.

Although there is little evidence for painting and sculpture being ranked as a "liberal art" rather than a mechanical skill in classical times, several late medieval and Renaissance commentators suggest that this was the case.[50] Petrarch, once again, is the likely source for this.[51] Filippo Villani similarly noted that the writers of antiquity celebrated painters and sculptors, and so the "*egregi dipintori fiorentini*" should be remembered in the same way.[52] The

northern Italian humanist Bartolomeo Facio's book *On Famous Men* (1456) included a section on painters just after poets, as "between painters and poets there is much affinity,"[53] basing his idea on the classical poet Horace's famous aphorism *"ut pictura poesis."*[54] The fact that painting was not widely accepted as a "liberal art" like poetry was a bugbear for some well into our period. Thus, in his short verse treatise about painting of 1509, the Florentine painter Francesco Lancilotti aimed to show that although painting was called a mechanical art, "Read and you will see how much [painting] has given to the world."[55]

As the above might suggest, there is an increasing amount of theoretical writing about painting and sculpture as we go through our period. Some books, such as Cennino Cennini's *Libro dell'arte* (*Book of the Craftsman, c.* 1400), are linked with a wider "explosion" in the number of technical treatises that occurred in several fields around this time.[56] Others, like Lancilotti's verses, aimed to bring the practice and appreciation of the visual arts squarely into the remit of humanism. The first text of this kind was Leon Battista Alberti's *On Painting* of 1434–1435.[57] Most likely written in Italian first then translated into Latin, this book employed Alberti's considerable knowledge of Latin humanistic texts to create an entirely new theoretical structure for painting as a liberal art, like poetry or history. Divided into three books, the first largely outlines new geometrical techniques for the depiction of three-dimensional space on a two-dimensional plane (what we now call "single-point perspective"). Book 2 considers different approaches to painting and the importance of *disegno* and argues that *istorie* (narrative paintings) are the most noble type of image for painters to tackle. Book 3 is concerned with the general education of a painter. Far from being treated as a craftsman, the painter should be "a good man, well-versed in the liberal arts," as the ancients gave them "highest honour." Alberti's aim seems to have been pedagogical—to start with structural elements and then gain more complexity as he went through the text.[58] Alberti himself was to write further influential treatises on the visual arts of sculpture and architecture, but his main legacy was creating a humanist Latin framework that allowed painting and sculpture to be talked about in the same way as other more elevated art forms—history and poetry. This meant that appreciating these visual arts properly started to be a test of intellectual belonging, a test as much of the education of those who look at the images as those who make them.

The emphasis that writer–artists and their humanist friends put on the need for an educated response to the visual arts became more pronounced as time went on. True appreciation of these arts was only available to those who were educated and discerning, This was not new in the fifteenth century—Petrarch declared of a painting of the *Virgin and Child* by Giotto: "The ignorant do not understand the beauty of this panel, but the masters of the art are stunned by it"[59]—but it became increasingly diffused in a variety of texts made for European elites. It is no surprise that Baldassare Castiglione's *Courtier*, one of

the best-selling and most translated books in Europe in this period (written from *c.* 1508, first published 1528),[60] included a section on painting and sculpture. Courtiers should paint themselves—despite the fact that some may think it "savours of the artisan"—because it allows them to properly understand beauty and to be an expert judge of beautiful women.[61] These ideas both reflected and promoted a new type of art patron who focused on commissioning work from the "best masters" of the day, and they could become quite competitive in the pursuit of the most fashionable objects, the most famous, perhaps, being Marchioness Isabella d'Este, who furnished her *studiolo* in Mantua with a mixture of antiquities, exquisite marquetry, and commissioned paintings by the best masters of the day with complex allegorical meanings.[62]

IMITATING NATURE

One distinctive feature of European visual culture in 1400–1600 is its emphasis on "naturalism"—which we can define for our purposes as a technique of mimicking (though not slavishly copying) nature, as distinct from "realism."[63] A feature of Renaissance naturalism is that in its most typical form it seeks to use human skill to exploit the properties of one material to mimic another, and the artist's skill was shown in the distance between these materials rather than in an admiration of the materials themselves, so turning away from the "overt materiality" of earlier medieval art.[64] This shift can be seen in various European centers more or less simultaneously around the turn of the fifteenth century—most notably the courts and mercantile cities of northern Italy, Burgundy, and France. Indeed, one of the great problems with the way history of art has developed is the concentration of most art historians on national schools, whereas it is clear that relationships between the diverse centers and courts of Europe were very fluid. Even before the age of print, linked by extensive trade networks and international banking, European aristocratic elites sent each other luxurious artistic gifts throughout this period, exchanging ideas, fashions, and all manner of objects, including paintings, tapestries, and illuminated manuscripts.

It is in these lavishly decorated manuscripts that we first see a close attention to the naturalistic rendering of the natural world. Books like the Carrara Herbal (now British Library Edgerton 2020, made in Padua around 1400) are early examples of the illustrator both copying and investigating nature.[65] The most famous illuminators at the turn of the fourteenth and fifteenth centuries, however, were connected with various branches of the Valois family, most famously three brothers from The Netherlands—Herman, Paul, and Johan Limbourg, who made minutely detailed images for a series of lavishly illuminated manuscripts, including the Great Book of Hours made for John, Duke of Berry of 1412–1416.[66]

It is through the patronage of another wing of the Valois family, the Duke of Burgundy, that we see some of the most startlingly veristic sculpture of this period in Claus Sluter's figures for the "Well of Moses," the great cross at the Carthusian monastery (Chartreuse) in Champmol, near Dijon, commissioned by Duke Philip the Bold and executed from 1395 to 1403 (Figure 5.5). The original monument, at eleven meters high, had a crucifix extended from a hexagonal column with six sculpted figures of prophets ranged around the sides. Startlingly naturalistic even in their now much-damaged state, the polychromy executed by the court painter Jean Malouel must have heightened their illusionism. This was no mere artistic flamboyance; the purpose of the cross, which monks would circle on their way back from worship in the monastic church, was to enhance their prayers for the soul of the convent's patron. It was appreciated by its audience—one fifteenth-century onlooker describing it as "the glorious Cross ... of very beautiful and wonderful workmanship."[67] Not surprisingly, it is in the milieu of the Valois courts that we see the enthusiastic adoption of Italian humanist art theory, where painters and sculptures were expected not merely to have manual skills, but also considerable intellectual powers—in French rendered as the stock phrase "engin and artifice."[68] This pairing was ultimately derived from the Tuscan Giovanni Boccaccio's description of famed female painters and sculptures in his *Lives of Illustrious Women*,[69] and it was a pairing that was to be equally important in humanist discussions of the visual arts in Italy, where the pairing of "*ars*" with "*ingenium*" became commonplace by around 1400.[70]

Around a decade later, also in Burgundy, the painter Jan van Eyck was also experimenting with close observation of nature, developing oil glaze painting techniques that were able to produce more saturated color and detailed line, a process that spoke of a "fundamentally new understanding of reality."[71] This approach to visual representation was demonstrated in monumental scale in the altarpiece he made along with his brother, Hubert, for the church of St. Bavo in Ghent, present-day Belgium (see Figure 3.1 in Chapter 3). With multiple folding panels, fully open this altar measures 3.7 by 5.2 m (12 by 17 feet) and is a masterclass in the new naturalistic style. Italian humanists used the Petrarchan vocabulary of praise to celebrate the feats of men like van Eyck and his compatriot Rogier van der Weyden. Thus, in 1449, the humanist–traveler Cyriaco of Ancona said of a triptych by Rogier van der Weyden in Ferrara that "there you could see those faces come alive and breathe," as if "reproduced not by the artifice of human hands but by all-bearing nature herself."[72] The world of art-making in the fifteenth century was far from restricted to regional schools and was characterized by intellectual exchange across wide geographical areas.[73] Italian patrons and writers marveled over the works of northern painters.

This new attention to mimicking the natural world was far from being merely an optical trick; at its heart was a belief that it aided the viewer's devotion and

FIGURE 5.5 Claus Sluter, "Well of Moses," 1395–1405. Former Chartreuse de Champmol, Dijon. Photograph: Commons Wikimedia.

was a means to reach God.[74] There are many religious texts from the fourteenth to sixteenth centuries that emphasize focusing on concrete images—sometimes imagined, sometimes real—to reach a higher level of religious understanding. Many spiritual exercises prescribed for the faithful at this time were linked to visualization. Mendicant friars made focusing on the body of Christ a central part of prayer. Thus, the Franciscan theologian Ugo Panziera's injunction to keep "the humanity of the lovely son of God" in mind "before the corporeal and mental eyes."[75] This emphasis on personal devotion increasingly spread beyond the convent into domestic space, and objects designed to enhance devotion also increased, ranging from Books of Hours to religious pictures from grand paintings, ceramic or wooden sculptures, to prints pasted on walls.[76]

While undoubtedly helpful to devotion, this use of images as a step toward the divine could also make them dangerous. What if images provoked people toward the wrong kind of response? Bonfires of vanities, promoted by Franciscan and Dominican Observants from the early fifteenth century, prompted laypeople to burn objects that could lead them to sin, including paintings and drawings of profane subjects.[77] Religious imagery, too, could be appreciated for its superficial qualities rather than used as an aid to devotional practice. Wealthy patrons just paid for chapels in order to put their coats of arms there; images distracted from true worship, and were compared to "whores" both north and south of the Alps—the preacher Johannes Geiler von Kaisersberg warned that painters portrayed saints "no differently than noblewomen or tramps—as there is no difference between the clothes of noblewomen or whores." Savonarola berated painters for making "the Virgin Mary appear dressed like a whore."[78] These paintings were distracting to true worship.

In response to these anxieties, Italy from the 1490s onwards saw a period of intense experimentation in the painting of religious imagery—in Florence, for example, Botticelli eschewed straightforward naturalism in favor of a highly symbolic art that sought to evoke painting of an earlier time.[79] In the north, image-making was to become much more complex as the relationship between worshippers, God, and the institutions of the church were reevaluated. Martin Luther (1483–1586), though highly critical of many aspects of the Roman church, was relatively moderate in reference to images, arguing in 1525 that pictures on walls were useful "for the sake of remembrance and better understanding."[80] However, his conservatism was not shared by others, and waves of iconoclasm—both "popular" and state-sponsored—spread across Europe from the early 1520s. Andreas Karlstadt, Luther's colleague at the University of Wittenberg, was the first to elaborate on the problems with images in worship, making image destruction part of a more general war against externalized piety. His pamphlet of 1522 *On the Abolition of Images* justified iconoclasm. He argued that the presence of images in churches was contrary to the commandments, and that "idols" on altars were dangerous—all religious

images should be prohibited, as they "murder the spirits of their worshippers"; "I say to you that God has forbidden images with no less diligence than killing, stealing, adultery and the like." Material objects cannot teach anything beyond the flesh, the argument went, and correct worship must be spiritual and based only on the Word of God.[81] Inspired partly by Karlstadt, the government in Wittenberg was the first in the Christian West to call for the removal of images from churches in 1522—partly to circumvent violent image-breaking by laypeople. This new hatred for image-based worship spread to many other centers in Northern Europe—iconoclastic attacks and governmental removal of church furnishings occurred over the next few years in Basel, Zurich, and Strasbourg.[82] These initial iconoclastic forays, sometimes popular, sometimes led by the state, were to set the scene for waves of destruction occurring at various points across a divided Europe for the remainder of the century. It was governmental policy in England from the mid-1530s, for example, and the *Beeldenstorm* ("image storm") of 1566 saw mass popular iconoclasm starting in the southern Netherlands and then spreading north into Holland. As Peter Arnade describes it, "[T]he iconoclasts ... exposed religious objects and images as so much wood, canvas, stone, alabaster, marble, metalwork, and other materials, reading these revered objects as mere concrete matter."[83] The windows onto a spiritual world were returned to the status of "stuff."

The effects on religious art were obvious. There were many other consequences, too. The losses have made some areas of art history hard for scholars to reconstruct, and they at least partly explain the reasons behind the dominance of Italian art in the historical record.[84] Moreover, northern painters and sculptors now had to look for alternative subjects and different types of patronage to earn a living. Some artists, just like their Florentine counterpart Botticelli, saw naturalism itself as suspect. Joseph Koerner has shown how Lucas Cranach eschewed the "reality effects" of naturalistic painting from the 1510s onwards, creating a new type of visual expression that emphasized Biblical text and eschewed painterly effects that closely mimic experience.[85] Indeed, scholars see the era of iconoclasm as profoundly affecting the understanding of images and the creation of "art" more generally—and not only in Northern Europe; religious controversies also played a role in the reevaluation of the role of painting and sculpture in Italy as the relationship between the image-creator, the divine, and nature was rearticulated.[86]

BEYOND NATURE: ARTISTS AND GENIUS

When Desderius Erasmus of Rotterdam (1466–1536) gave a eulogy on the death of the German printmaker and painter Albrecht Dürer, he claimed, "He can paint anything, even things one cannot paint—fire, sunrays, thunder, lightning and banks of fog ... the sensory perceptions, all the feelings, and finally the whole

human soul as revealed in the body's form, and almost even the voice itself."[87] By the early sixteenth century—what Vasari was to call the beginning of the third age—the drive to mimic nature started to be diminished by the belief the interior images of an artist's mind can somehow be truer than the appearance of the outside world. In his treatise on statues of 1504, for example, the humanist Pomponio Gaurico criticized the Florentine sculptor Andrea del Verrocchio for his "crudely realistic" sculpture of Bartolomeo Colleoni—made less than twenty years before and still *in situ* in Venice.[88] Giulio Camillo del Minio argued that painters should not imitate nature, but go straight to examples of antique art, as these artists had already brought together many examples from nature to create a refined and beautiful image.[89] The fashion for the closely mimetic art of northerners such as Jan van Eyck declined as the fascination for mimesis was deemed rather naive. The Spanish humanist Francisco da Hollanda, writing in the character of Michelangelo, decried this work as only being attractive to women and the devout. "In Flanders they paint with a view to external exactness ... done without reason or art, without symmetry or proportion."[90] Around this time, the idea that artists had special powers to conceive images that went beyond nature in some way became increasingly commonplace. The "idea" in the mind of the artist started to be celebrated more than the facility for copying the imperfect world.

That artists could, and should, go beyond nature was not, of course, completely new. Cennini's *Libro dell'arte* (*c.* 1400) claimed that painting combines imagination with manual skill to discover "invisible things hiding in the shadow of ones in nature ... to make manifest what is not there."[91] However, the idea of painters and sculptors having superior visionary powers to other artisans became increasingly central to the understanding of the visual arts as the century wore on, and started to be diffused in many different kinds of texts. In Lancilotti's treatise of 1509, he claims that painting is like "another God and another nature" because it "makes a dead thing seem alive."[92] By the time Michelangelo was painting his ideation of God's creation of the world on the ceiling of the papal (Sistine) chapel from 1508 to 1512, the near-supernatural power of artistic genius was commonly discussed. In his popular epic poem *Orlando Furioso*, Ludovico Ariosto famously declared that his was "Michael more than mortal, a divine angel." It was not just Michelangelo that received this type of treatment: at the death of Raphael in 1520, the outpouring of poetry praised the painter in the highest possible way, comparing him to Christ: "He is the God of Nature, you the one of art."[93] In Northern Europe, too, painters like Albrecht Dürer and Hans Holbein were being compared to God—Holbein's *Portrait of Derich Born* of 1533 (Windsor, Royal Collection) includes an inscription that declares "you wonder whether the painter or the Creator had made him."[94] Visual sources made this explicit, none more so than Albrecht Dürer's *Adam and Eve* engraving of 1504 (Figure 5.6). This print

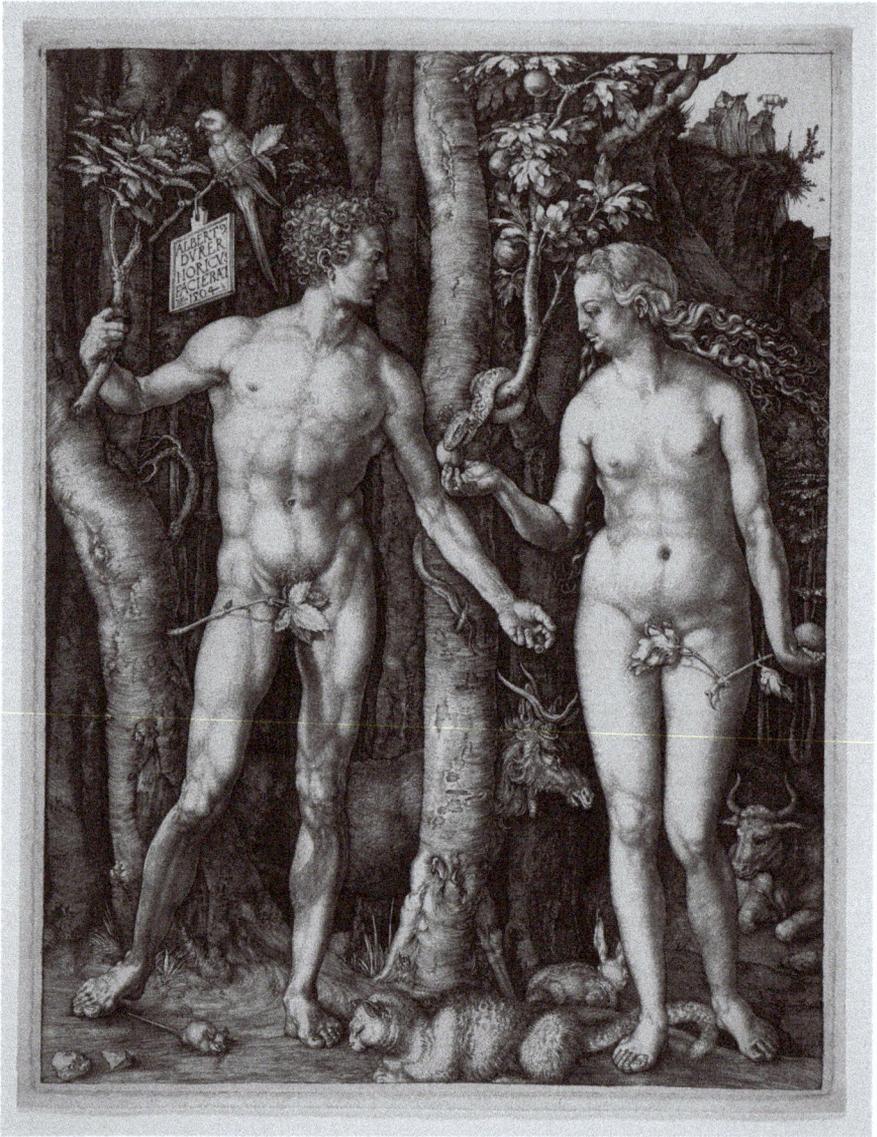

FIGURE 5.6 Albrecht Dürer, *Adam and Eve*, 1504. © The Metropolitan Museum of Art, New York.

crystallizes a moment in Genesis 3.1, just after God had created the Garden of Eden and just before Eve succumbed to temptation and ate the fruit from the Tree of Knowledge—thus condemning humanity to labor, physical frailty, and ultimately death. Here, we witness God's most wonderful creation, the human body—in the words of Pico della Mirandola's 1486 *Oration on the Dignity*

of Man, "neither of heaven nor of earth, neither mortal nor immortal, so that you may … fashion yourself in whatever form you prefer."[95] This image was a very important one for Dürer. There are many extant preparatory drawings of observations of animals and plants and even more of constructed nudes, as well as two incomplete test plates. The final image also exists in three states. Dürer's naked figures are derived from geometric constructions built on classical prototypes: Adam, a muscled and broad-shouldered *Belvedere Apollo*, and Eve with the torso of a classical Venus. Dürer's ability to create the impression of life through his artisanal skill likens the artisan–practitioner to God-the-Creator.[96]

It is no accident that Dürer focused on the creation for his reputation-defining engraving. As several scholars have pointed out recently, ideas of artistic creativity were, by the early sixteenth century, closely entwined with ideas about procreation.[97] The broad understanding was that women's bodies produced the matter for the fetus, whereas semen provided the shaping force. The medic Alessandro Benedetti explains in 1497 that generation is like a painter that "traces the outline [of the fetus] in seminal fluid," which is typical of many metaphors of artisanal crafting for the action of the male seed.[98] Griselda Pollock's assertion that "women were not historically significant artists … because they did not possess the innate nugget of genius (the phallus)"[99] is borne out in the Renaissance sources that discuss the inception of the idea of the creative artist linking, for example, the brush to the penis and paintings to offspring. Female painters, not surprisingly, were never going to operate on the same level and, anyhow, typically worked on a more domestic scale, as they were largely excluded from guild organizations and, later in the sixteenth century, from artists' academies. The most renowned woman painter of the sixteenth century, Sofonisba Anguissola, in her *Self-Portrait with Bernardino Campi* (1550s) (Figure 5.7), paints herself being painted by her teacher in a brilliant exposition of the complications of being a female creator in a society that normally denied women an active role.[100] This painting also usefully reminds us of the possibility of dissent; image-makers could use their roles to critique power as well as to bolster it, despite the inherent difficulties of doing so in a world dominated by elite patronage.

Improvements in print technology and diffusion sealed the fame of many early sixteenth-century artists and were material manifestations of the separation between mental concept and manual creation. Some practitioners such as Mantegna, Raphael, and Dürer were quick to exploit this new medium, either printmaking themselves or supplying designs to others to execute. So-called reproductive prints that echoed famous compositions were common; so it was possible to buy an image of Leonardo's *Last Supper*, Michelangelo's Sistine ceiling, or Raphael's *School of Athens* without ever seeing the originals. Normally, these works were credited to these famous masters but executed by others.[101] This allowed compositional ideas to be diffused easily throughout

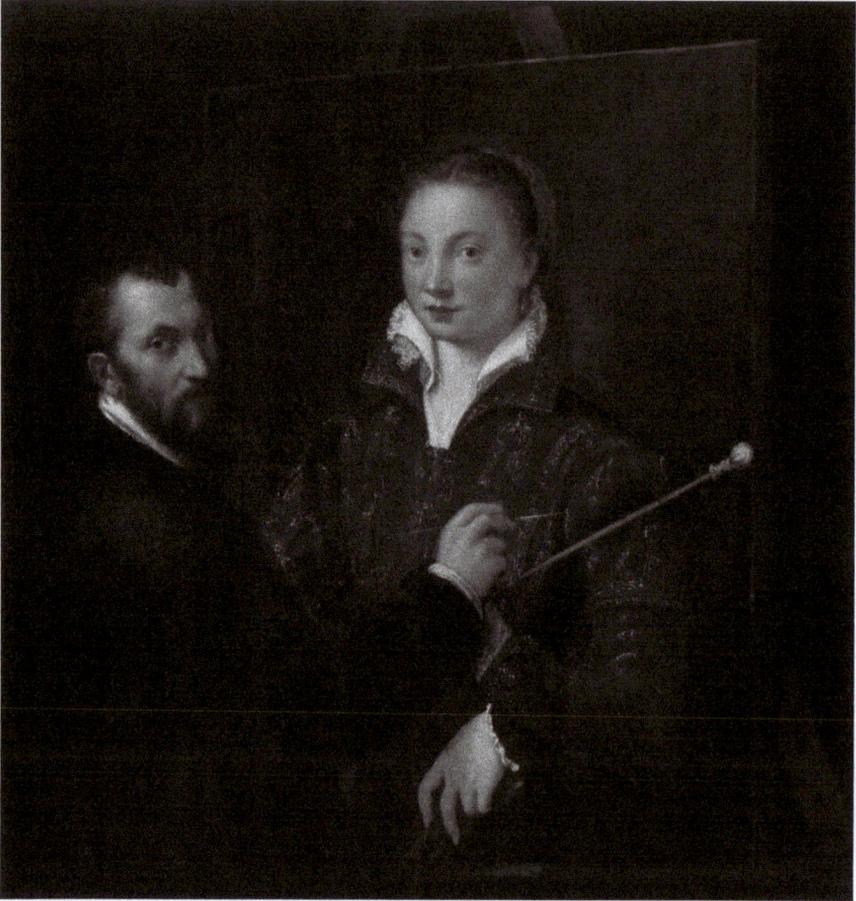

FIGURE 5.7 Sofonisba Anguissola, *Self-Portrait with Bernardino Campi, c.* 1559.
Pinacoteca Nazionale, Siena. Photograph: Commons Wikimedia.

Europe, being visible to a much wider audience than previously. It went toward
forming a "canon" of famous works that artists could use in their own works,
and also made a fundamental separation between the "idea" of a composition—
its conception in the mind of the artist—and the materiality of the work made.
The "object" was separated from the art. Notably, Giorgio Vasari was an avid
print collector, and the availability of these reproductions acted as memory aids
in his project of writing his mammoth history of art.[102]

To return to our opening juxtaposition, the difference between our
understanding of a painting and of a spoon is related to the centuries of
theory dedicated to the former, a theory based on ideas of divine creativity, the
replication of nature, and the pursuit of beauty and the ideal (in whatever way

these complicated concepts are understood). This theory was already present in ancient and medieval times, but it gained complexity and popularity in the Renaissance, becoming diffused among elite groups who performed their knowledge as viewers, as well as profoundly raising the status of painters and sculptors. This does not mean that we should not take non-art objects seriously, that objects were not intellectually valued, or that they do not demand more study, but it does remind us that "art" is its own defined category and has its own history. Having started with his profoundly immaterial *Last Supper*, we should give Leonardo da Vinci the last word on the relationship between nature, objects, and ideas: "The painter is lord of all types of people and of all things ... whatever exists in the universe, in essence, in appearance, in the imagination, the painter has first in his mind and then in his hand."[103]

CHAPTER SIX

Architecture

Renaissance Building Culture between Production and Place

MICHAEL J. WATERS

Architecture in the Renaissance was conceptualized as a fundamental human activity, one that emerged to meet the needs of humanity and derived its form from human proportions. As a discipline, it encompassed a wide array of constructive practices and types of artifacts, most notably buildings, which, like all objects, were understood as physical things that existed in space. Yet architecture was also inherently different from other classes of objects. It was by its nature inhabitable, and Renaissance writers commonly associated it with the foundational human need for shelter. Architecture was typically tied to the place of its creation, defined by local practices and ecological considerations, and typified by its permanence and immobility. Practical concerns, such as functionality and structural stability, along with deep-rooted social conventions often made it conservative and resistant to rapid, dramatic transformations, especially across a range of traditional building types. In the Renaissance, however, some of these characteristics started to change as new technologies and modes of production as well as the increased mobility of ideas, materials, people, and images came to shape architectural practice. As this chapter outlines, fifteenth- and sixteenth-century European building culture was defined in new ways by issues of production and place. It was through these vectors that architecture, both as a concept and a physical thing, entered into a new dialogue

with other types of objects and looked in different ways back to the past and toward an emerging modernity.

MAKING RENAISSANCE ARCHITECTURE

Architecture, construction, and the building trades constituted a substantial industry in Renaissance Europe, matched only by the agricultural and textile sectors. Buildings and infrastructure were enormous investments that required tremendous financial, material, and human resources. Consequently, monumental architecture had long been reliant on the ruling elite, religious institutions, and collective public expenditure. From the late Middle Ages onward, these dynamics began to change. With the proliferation of dense urban centers and the numerous associated social and economic transformations born of capitalism and the commercial revolution, private demand for building greatly increased. While the scale and cost of architecture made it resistant to typical commodification, in growing cities, merchants, bankers, and other individuals used their newfound wealth to construct large palaces for their families. In Florence alone, it is estimated that a hundred such structures were erected in the fifteenth century. As the merchant Giovanni Rucellai, himself a patron of a grand Florentine palace, wrote in the mid-fifteenth century, "men do two important things in this world: the first is to procreate, the second is to build" (Kent 1987: 42). The construction of splendid palaces was in fact seen as a virtue by humanists, who celebrated it as the embodiment of personal and civic magnificence (*magnificentia*) (Clarke 2003: 54–65). It was also part of a luxury economy, a form of conspicuous consumption, which, in turn, along with the continued construction of civic and ecclesiastical architecture, helped feed the development of a highly advanced building industry, and even led to a shortage of craftsmen in late fifteenth-century Florence (Goldthwaite 1982).

Histories of Renaissance architecture have typically placed the figure of the architect at the center of these developments. Architects, however, did not construct buildings autonomously; the scale of architecture and the expertise required in its production precluded a solitary designer–builder. Rather, architectural practice was by its very nature a collaborative enterprise that relied on a range of artisans, who increasingly specialized as demand for skilled labor expanded. For example, by the sixteenth century, Italian stonemasons— typically members of a single guild and referred to generally as *scarpellini* or *lapicidi*—included *sbozzatori*, who roughly dressed stone, *squadratori*, who finished squaring stone, *sigatori* (sawers), *arrotatori* (grinders), and *lustratori* (polishers), as well as *intagliatori* (architectural sculptors) and *scultori* (figural sculptors) (Schlimme et al. 2014: 244, 283). This type of specialization also emerged out of large-scale construction projects such as the new basilica of

St. Peter's in Rome (begun 1506) and the Royal Monastery of San Lorenzo de El Escorial (1563–1584), which necessitated the division of labor. These building enterprises, the most expensive undertaken in sixteenth-century Europe,[1] similarly pioneered complex systems of construction management. The gargantuan St. Peter's, a building the humanist and theologian Giles of Viterbo claimed would stupefy the visitor and make them more receptive to Christianity ([c. 1513–1517] 1898: 655), was, from 1514 onward, supervised by a *misuratore*, who inspected work done, a *computista*, who handled financial accounting and operations, and a *depositari*, who distributed funds. The *fabbrica* (building works) itself was composed of hundreds of workers overseen by a *curatore*. Whereas architects had previously supervised building sites, this new type of intermediary came to dominate the whole chain of architectural production from the procurement of materials to the execution of construction. These somewhat independent entrepreneurs delegated work to foremen, who directly managed the workmen, and often earned huge profits by establishing monopolies over building materials (Ait and Vaquero Piñeiro 2000). Large building projects, along with the decline of guilds, also transformed the labor market. Traditionally, individual craftsmen earned a day wage or were paid by the piece (or by the measure). In the sixteenth century, however, they were increasingly contracted in teams and paid a pre-established sum for a certain amount of work (Bernardi and Vaquero Piñeiro 2007: 521–3).

These managerial measures, which sought to regulate construction and make it more efficient, paralleled the rise of drawing in architectural practice. While drawing was not a Renaissance invention, the greater availability of paper in the fifteenth century enabled builders to exploit its potential as a design aid, didactic tool, communication device, and documentary record (see Brothers 2017). At St. Peter's, architects employed various types of drawings, from small perspectival sketches to carefully rendered plans, along with physical models, as a means of experimentation and a mode of visualizing what would become the world's largest church. Drawing also served as a critical tool of graphic communication with patrons and craftsmen, and over time, it progressively gained primacy in building construction. Philip II, for example, ordered that the Escorial (Figure 6.1)—described by the contemporary historian José Sigüenza as appearing like a monument carved from a mountain—be built expressly from drawings and instructions provided by the architect Juan de Herrera and approved by the King. Here, fidelity to the graphic and written source material, which even specified the size, shape, and location of every granite block, was paramount. Unsurprisingly, local masons and builders resisted these authoritarian measures that valued standardized workmanship over individual technical skill (Wilkinson 1991: 270–3).

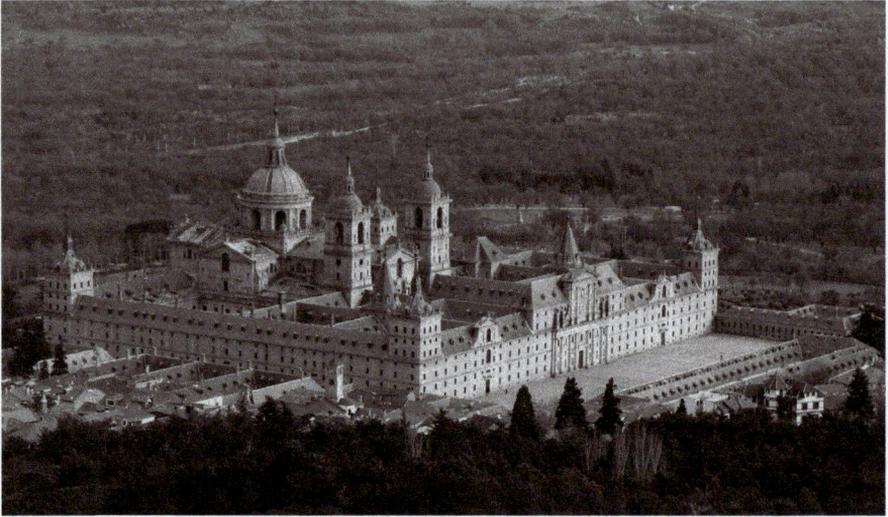

FIGURE 6.1 Juan Bautista de Toledo and Juan de Herrera, Royal Monastery of San Lorenzo de El Escorial, Spain, 1563–1584. Photograph: Hans Peter Schaefer.

The expanded role of representation in architecture was also a condition of the emergence of the modern architect. While what defined an architect was never agreed upon in the Renaissance (the title itself had long been given to a range of individuals who directed building projects), architecture became a distinct profession during this period, one that was increasingly populated by artists rather than craftsmen trained in the building trades. At St. Peter's, with exception of Antonio da Sangallo the Younger, all of the chief architects (*capomaestri*) in the sixteenth century were trained either as painters or sculptors. While architects throughout the period remained engaged with construction problems and structural issues, they focused ever more on the creation of architectural plans rather than physical buildings. As a consequence, well-established, fluid design practices in which buildings continued to be modified and refined during the course of construction gave way to a more rigid mode of production, one that gave authority to finished drawings produced by the architect. Representations in this fashion gained authorial agency, just as architects became more like authors, whose works were treated as products of individual genius rather than collective enterprise (see Trachtenberg 2010).

This shift was propelled by the emergence of theoretical writings on architecture. The earliest of these was Leon Battista Alberti's *De re aedificatoria* (finished around 1452). Inspired by Vitruvius's *De architectura*, the only surviving treatise from antiquity, Alberti wrote his book in Latin for an elite audience of patrons and fellow scholars. Rather than being a practical guide to

building design and construction, it was a work of theory as well as an erudite compendium of classical texts and astute observations that attempted to cast architecture as a liberal art. Alberti, for instance, conceptualized architecture as consisting of abstract forms (*lineamenta*), conceived in the mind of the architect, perfected through drawings and models, and only subsequently realized in physical materials by craftsman, who were "but an instrument in the hands of the architect" ([*c.* 1452] 1999: 3–5). This definition, which established a dichotomy between form and material, design and making, and architect and craftsman, was not grounded in contemporary practice. Rather, Alberti envisioned an intellectual architectural profession, separated from manual labor, which was suitable for a humanist like himself.

In contrast to Alberti, most practitioners acknowledged that architecture was a highly collaborative discipline that required a range of knowledge, skill, and experience. For example, Francesco di Giorgio Martini, who also worked as a painter and sculptor, wrote in his treatise that the architect required not just theoretical knowledge, but also *disegno* (drawing as both a mechanical skill and creative process of composition) and *ingegno* (ingenuity and expertise derived from practice) ([*c.* 1487–1500] 1967, 2: 483–4, 489–90). Later in the sixteenth century, the French architect Philibert de l'Orme, who was the son of a master mason, similarly claimed that architectural practice demanded practical know-how and proficiency in construction as well as intellectual acumen. He even promoted a novel method of wooden joinery in his architectural treatises and sought to elucidate artisanal knowledge by illustrating and theorizing stereotomy, the complex art of cutting stone for the production of vaults (see Galletti 2018). However, like Alberti before them, both authors also sought to elevate the status of architecture and distance the figure of the architect from builders, who lacked professional credentials and a proper understanding of design (see Wilkinson 1977; Merrill 2017).

BUILDING CULTURE AND MODERN TECHNOLOGY

Architecture was also transformed by the emergence of distinctly modern technologies in the Renaissance, especially as related to warfare and construction. Fortifications had always responded to developments in war, and military engineering had long facilitated the refinement of machines essential to construction: cranes, treadwheels, windlasses, capstans, and pulleys. But it was the emergence of effective, mobile artillery in the fifteenth century, along with the improvement of gunpowder, that truly revolutionized building practice. Large cannons, such as those used by the Ottomans in the 1453 siege of Constantinople, laid waste to traditional city walls and enabled rulers like Charles VIII of France, who invaded the Italian Peninsula in 1494, to crush antiquated fortifications. In response to the destructive power of this new,

seemingly diabolical invention, cities and citadels came to be surrounded by ditches, large earthen ramparts, and thick, steeply sloped masonry walls. All of these measures were intended to shield and repel ballistic fire while projecting an image of strength and security. Architects across Europe also developed ever more elaborate systems of angled bastions, so defenders could more effectively return fire. They pioneered radially planned cities, such as the Venetian new town of Palmanova, that centralized control and facilitated communication during times of siege (see Adams and Pepper 1986; Hilliges 2011). These massive fortified constructions required exponentially more building materials and earth-moving than earlier designs, and like Renaissance warfare itself, demanded vast resources, including skilled workmen and a huge, often conscripted, sometimes enslaved labor force numbering in the thousands (Lamberini 1991: 229–33).

Fortification design and construction became a central task of architects in the Renaissance. Antonio da Sangallo the Younger, for example, simultaneously supervised, among other projects for Pope Paul III, the construction of the new St. Peter's and numerous fortifications across the Papal States, including an enormous new fortress in Perugia (Adams and Pepper 1994). Royal architects, such as Philibert de l'Orme, similarly were tasked with supervising fortifications alongside domestic projects (Pérouse de Montclos 2000: 123–7). Even Michelangelo provided designs for the defenses of Florence while under Medici rule in 1526 and subsequently served as governor general of fortifications for the reconstituted Florentine Republic in 1529 (Mussolin 2017). Architects and artists, including Albrecht Dürer, thus had reason to advertise their engineering acumen through publications dedicated to the design and construction of fortifications. Yet by the mid-sixteenth century, skilled, battled-hardened military engineers increasingly executed defensive works. Treatises, such as Giovan Battista Belluzzi's *Trattato delle fortificazioni di terra* (c. 1545, published 1598), also came to promote military architecture as a distinct profession, one that required experience rather than simply knowledge acquired by studying books and built precedents (Merrill 2017: 23–6).

Despite these developments, the architecture of the Renaissance is often characterized as backwards-looking, defined by historicist tendencies. The desire to revive antiquity, however, also engendered achievements in engineering and the development of modern construction technology. Filippo Brunelleschi, for example, famously erected the massive dome of Florence Cathedral (1420–1436), the largest constructed since the Pantheon, by pioneering a new method of vaulting without timber centering or falsework (see Fanelli and Fanelli 2004). He and his contemporaries likewise sought to equal the ancients through use of large monolithic columns, which spurred the opening of new quarries and the invention of novel lifting mechanisms (Belli 2008). The moving of large objects, in fact, became a paragon of Renaissance building culture. Architects such as Aristotle Fioravanti, for instance, gained fame in the 1450s by moving a brick bell tower in Bologna as well as a pair of giant ancient

monolithic granite columns from the Baths of Agrippa to the Vatican. He even made plans to move the ancient Egyptian obelisk that stood next to St. Peter's, a performative act of revival only executed over a century later by Domenico Fontana (Oechslin 1976).

Engineering marvels such as these were also enacted and perpetuated through the media of drawing and print. Indeed, most experienced the moving of the Vatican obelisk, a spectacle that required a massive timber scaffolding with a built-in crane and a complex system of capstans, ropes, and pulleys powered by almost a hundred horses and a thousand men, through a printed treatise illustrated with lavish, step-by-step engravings (Fontana 1590). A century earlier, Francesco di Giorgio Martini included numerous perspective renderings of mechanical inventions—column lifters, obelisk movers, and cranes, in addition to a variety of mills, pumps, hoists, and other machines—in the first version of his architectural treatise (*c.* 1478–1481). His earlier *Opusculum de architectura* (*c.* 1475), which he dedicated to the Duke of Urbino, Federico da Montefeltro, is composed almost exclusively of this material (Figure 6.2). Inventions such as these were the product of a Renaissance mode of design that relied heavily on iterative sketching rather than physical experimentation. Drawn mechanical exempla, in fact, were rarely practical or efficient. They were instead a new

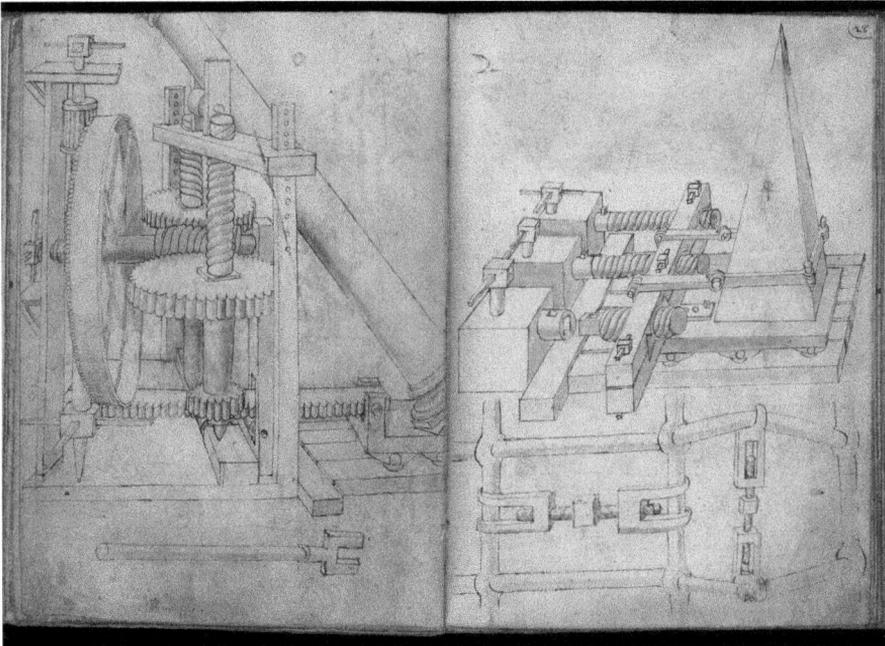

FIGURE 6.2 Column lifter and pyramid mover, from Francesco di Giorgio Martini, *Opusculum de architectura, c.* 1475. © British Museum, London.

type of theoretical exercise, born of contemporary architectural problems, such as the lifting of large monoliths (see Popplow 2004). These images, which demonstrated technical skill, mechanical ingenuity, and intellectual prowess, impressed elite viewers, who delighted in studying such mirabilia and saw the mechanical arts as essential to the maintenance of political and military power, and elevated the status of the architect–engineer (Long 2001; Lamberini 2003).

Architecture, both in practice and on paper, thus became over the course of the Renaissance imbricated in an emerging cult of the machine. This fanned the desire for ever more impressive feats of engineering, and like the ceaseless yearning for height in French Gothic cathedrals, eventually pushed building technology to its limits. The early seventeenth-century facade of Milan Cathedral is just such a case in point. Here, builders spent over a decade attempting to produce ten enormous granite columns, some of the largest monoliths ever quarried, each measuring almost twenty meters in length and weighing around 280 tons. According to the Archbishop of Milan, Federico Borromeo, this was to be a herculean task that would eclipse the achievements of the Romans, Greeks, Egyptians, and Solomon. It would not only require elaborate, newly invented machines, but also necessitate the effort of every citizen as well as the assistance of God, who he believed "often helped pious and trusting worshipers to transport large stones for the construction of sacred buildings" (Borromeo [c. 1628] 1986: 45–7). Nevertheless, despite years of arduous quarrying and careful preparations, including the construction of new roads, barges, and machinery, the undertaking proved impossible. In 1628, shortly after the first column broke into three pieces while being transported to the shores of Lago Maggiore, the project was abandoned (Repishti 2004: 80–3).

PRODUCTION IN THE ERA OF PRINT

The advent of mechanical reproduction and the propagation of printed treatises also shaped the development of Renaissance architecture. On the one hand, it enabled the widespread circulation of earlier books, which had previously only been available to a limited number of patrons and scholars. At the same, with the rise of printing also came practical books on architectural design and production. In the same years the unillustrated treatises of Alberti and Vitruvius were first being printed in Florence (1486) and Rome (c. 1487), Mathes Roriczer, a mason from Regensberg, and Hanns Schmuttermayer, a goldsmith from Nuremberg, published the first treatises made with moveable type and woodcut illustrations (Figure 6.3).[2] Focused on the proper methods of constructing pinnacles and gablets, their illustrated works were to be useful not just for builders, but a wide variety of artisans. Roriczer was conscious of the differences in this diverse audience, explicitly stating "since each art has its own matter, form, and measure, I have tried to make clear this aforesaid art of

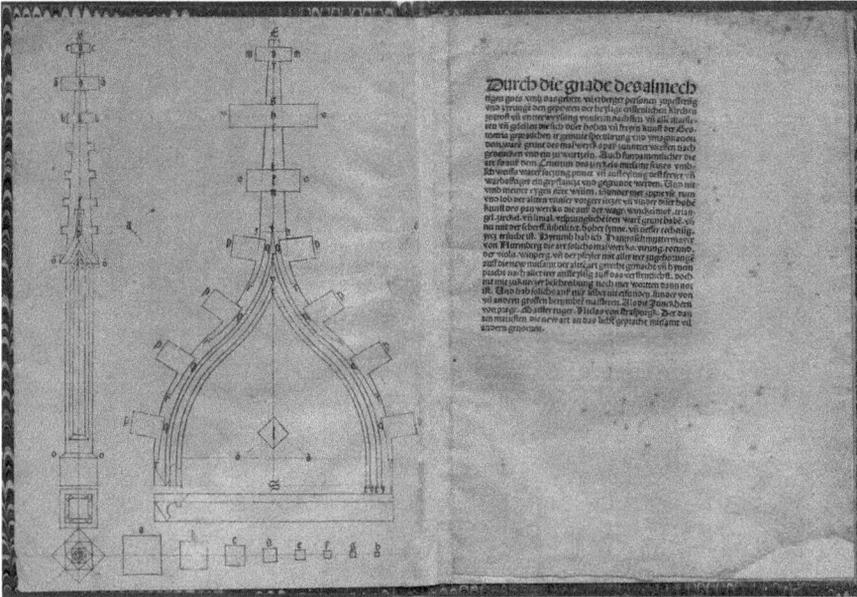

FIGURE 6.3 Designs for a pinnacle and gablet, from Hanns Schmuttermayer, *Fialenbüchlein*, Nuremberg: 1487–1488. © Germanisches Nationalmuseum, Nuremberg.

geometry" (Shelby 1977: 83). Geometry was the essential link that enabled the transfer of these designs across domains of artisanal production. The same can be said about the earliest single-sheet architectural prints, which also date to the 1480s. Produced by the Netherlandish master mason Alart Duhameel and the goldsmith–engravers Wenzel von Olmütz and Master W with the Housemark, these finely detailed images of pinnacles, some with accompanying diagrams, were designed to serve as workshop models across a range of craft production from micro-architectural tabernacles to monumental crossing towers (Kik 2014: 77–81). Sixteenth-century northern architectural treatises also consistently marketed themselves to a wide array of readers. Even disparate examples, such as Walther Ryff's 1548 German translation of Vitruvius and Hans Blum's 1550 pattern-book of columns, claim on their title pages to be of use to builders, masons, painters, sculptors, goldsmiths, and others who use a compass and rule, the essential tools of geometrical construction. Rather than limiting the scope of architecture, these and many other illustrated treatises opened up the potential for use and enabled various types of craftsmen with limited knowledge of the subject to create novel architectural designs.

The Italian architect and theorist Sebastiano Serlio similarly understood the didactic power of print and its ability to disseminate architectural knowledge through universally legible images. As he claimed in the first installment of his heavily illustrated treatise, he "formulated some rules concerning architecture"

so that "not only exalted intellects could understand this subject, but that every average person might also be able to grasp it" ([1537] 1996: 253) These general rules took the form of a system of composition based on a graduated sequence of columns—the first time the now canonic five Orders appeared in print—and a series of ancient and contemporary architectural exempla. Many sixteenth-century architectural books followed this model, focusing on formal issues of design, especially the architectural Orders. While some treatises, like Philbert de l'Orme's *Premier tome de l'architecture* (1567) and Andrea Palladio's *I quattro libri dell'architettura* (1570), limit discussions of columnar ornament to a single section, others, including the treatises of Hans Blum (1550), John Shute (1563), Jean Bullant (1564), Jacques Androuet du Cerceau (1583), and Julien Mauclerc (1599), are dedicated exclusively to this subject. Numerous engravers also produced hundreds of single-sheet prints of column capitals, bases, and cornices, which circulated widely without accompanying text (Waters 2012). A whole genre of *säulenbücher* (column-books) even developed in German-speaking lands at the end of sixteenth century.[3] This obsession with columns is not just indicative of the spread of classicism across Europe in the sixteenth century, but also testimony to a shift in architectural culture. These treatises and prints promoted an almost completely image-based system of design, one that required little knowledge of the material side of building production. Even in dissimilar cases, such as Giacomo Barozzi da Vignola's canonical *Regola delli cinque ordini d'architettura* (1562), which championed a simple universal method of modular design through a series of engravings, and Hans Vredeman de Vries' etched books on columns (1565), composed of heavily ornamented architectural details that could be endlessly combined, architectural prints rather than text were the near-exclusive point of reference. In fact, Vignola explicitly sought to make architecture so easy that "at a single glance and without much bothersome reading, every ordinary talent can understand everything and make use of it at opportune moments" ([1562] 1999: 22). Architectural composition consequently became progressively reliant on the study, deployment, and reinterpretation of mechanically produced graphic models. Some celebrated this shift as the democratization of design, while others lamented it as the debasement of the profession. Jacopo Strada, in his 1575 preface to Serlio's seventh book, praised the architect as making "the art of architecture ... easy to everyone" and enabling "any average architect ... to construct buildings of admiration" (Serlio [1575] 2001: 160, 162), while Giovanni Lomazzo, a decade later, wrote that Serlio had "truly created more dog-butcher architects than he had hairs in his beard" (1584: 407). Both nevertheless agreed that the illustrated printed treatise had changed architecture.

At the same time, these treatises represent just a small selection of the staggering number of prints and publications on architectural subjects produced

in the sixteenth century. These include books dedicated to geometry, perspective, surveying, machinery, construction, engineering, gardens, fortifications, town planning, theatrical design, and ornament, not to mention the numerous volumes illustrating ancient, contemporary, and even biblical architecture. These hundreds of different volumes were often reprinted and commonly plagiarized, going through numerous editions and translations. In the case of Serlio's treatise, by the early seventeenth century, its various parts had been published in six languages (Italian, Flemish, German, French, Spanish, and English) and over fifty editions (Deswarte-Rosa 2004; Vène 2007). This proliferation speaks to a burgeoning demand for all types of architectural knowledge across a broad section of society, as well as the increasingly elevated status of that knowledge. Part of the larger Renaissance emergence of authorship in the mechanical arts, practitioners sought to record their theoretical ideas, artistic ingenuity, and technical know-how for public consumption (see Long 2001). Learned men at the same time also turned their attention to understanding architecture, writing on everything from its practical foundations to its esoteric meaning. Printing in this way did not just transform processes of design across Europe, but also spurred the production and dissemination of architectural knowledge.

THE PLACE OF RENAISSANCE ARCHITECTURE

Unlike other types of objects, architecture is not by its nature portable. It is instead typically created for a specific place by local architects and craftsmen using easily accessible natural resources. Early Renaissance treatises highlighted the importance of site selection and considerations such as the quality of climate, light, air, and water, as well as the availability of proper building materials (Alberti [c. 1452] 1999: 9–60; Filarete [1464] 1965, 1: 22–37). The fifteenth-century architect and theorist Francesco di Giorgio Martini even detailed how whole cities, from the organization of their streets and urban spaces to the design of defenses and infrastructure, should conform to topographic variation ([c. 1478–1481] 1967, 1: 3–25). For Renaissance writers and builders alike, physical geography was of profound importance and directly shaped architectural production. Understanding the natural environment was often cast as the first task of any architect. Even Sebastiano Serlio noted that "because the regions of the earth differ in air, water and terrain, an architect who has arrived in a place which he has not seen before should seek the counsel of those who were born in that region and who have grown old there, particularly those who are knowledgeable in these matters" ([c. 1550] 2001: 3).

The concept that geology, topography, and climate conditioned building culture was by no means new in the Renaissance. The ancient author Vitruvius had already described the evolution of architecture in ecological terms. He claimed, for instance, that the Colchians of the western Caucasus Mountains built

log cabins due to the abundance of timber, whereas the Phrygians of Anatolia produced well-insulated conical huts with mud, straw, and branches because they lived in a land with few forests and extreme temperatures ([c. 30 BCE] 1999: 34). Renaissance writers remained similarly attentive to these types of differences and believed in a comparable environmental determinism. They understood, for example, that the width of urban dwellings conformed to the size of available trees for roof trusses and floor beams and that builders employed high-pitched roofs in rainy and snowy locales. Ecological considerations in building practice were also perceived through a lens of cultural difference. A case in point is Sebastiano Serlio's unpublished book on habitations. Produced between 1541 and 1550 while living in France under the employ of the king, it illustrates side-by-side French and Italian dwellings for rural and urban citizens progressing from the poor peasant to the noble prince.[4] These comparable structures, which reinforce a monarchical system of social hierarchy, vary not just in their use of architectural ornament, but also the profile of their roofs, size of windows, and disposition of interior and exterior spaces (Figure 6.4). Since loggias and terraces were ill-suited to inclement environments exposed to wet and cold weather, they were to be omitted in northern settings. For some of the grandest of buildings, however, he sought to "harmonize Italian custom with the commodities of France" (Serlio [c. 1550] 2001: 8), producing princely palaces with pitched roofs and dormers, as well as grand column-lined courtyards and spacious vestibules. These specific attempts at architectural acculturation were ultimately theoretical exercises; Serlio built little during his time in France. As he later complained, he was but "a poor foreigner in an alien land where there is no place for my art" (Frommel 2003: 38).

The commensurability of an Italian mode of classicizing architecture with a Northern European climate remained a common concern in the architectural literature. As the subtitle to Hans Vredeman de Vries' *Architectura* (1577) states, the Netherlandish artist and architect sought to provide "builders, stonemasons, carpenters, engravers, and lovers of architecture" with a means of "accommodating the antique building manner of Vitruvius … to the building customs of all countries." This meant not only providing models of Dutch dwellings with classicizing gabled facades, but also adapting an Italian architectural mode to the climate and urbanism of the Low Countries. As he notes, the crowded mercantile cities of the north, where access to light was limited, increasingly demanded large glazed windows, foreign to the "antique Italian manner" of building. While these great glass facades exacerbated problems of heating, they became a hallmark of the late sixteenth-century Northern European built environment, which developed an ever-greater desire for interior illumination (Ng 2017).

This dialogue between north and south was also heavily inflected with nationalistic biases. According to Vincenzo Scamozzi, who sought to

FIGURE 6.4 Houses for poor artisans outside the city in the Italian and French manner (*top*). Houses for citizens, merchants, or other similar persons in the Italian and French manner (*bottom*). From Sebastiano Serlio, *Libro sesto di tutte le habitationi* ..., 1541–1550. © Avery Architectural and Fine Arts Library, Columbia University.

establish architecture as a universal science in his *L'idea della architettura universale*, since Italy was endowed with a mild climate, "buildings can be constructed according to architectural principles and correct careful building procedures," whereas the densely populated walled cities of intemperate Germany, which he had seen during his travels, required tall houses with easily heated, medium-sized rooms ([1615] 2003: 46, 98). Without spacious courtyards or lofty vaulted ceilings, even the greatest of German palaces were, in his opinion, manifestly inferior. In Italy, Teutonic architecture was also inherently linked to the Gothic. It was indeed in the fifteenth century that this manner of building (and sometimes medieval architecture in general) came to be known, derogatorily, as the *moda* or *maniera tedesca* (see Sankovitch 2001). Homogenized under this heading, theorists from Antonio Manetti to Giorgio Vasari set it in opposition to a native Italian architectural mode, which came to be known across Europe interchangeably as "ancient" or "Roman" work.[5] For Raphael, this foreign Germanic architecture was distinctly the product of its environment, born from a dense, arboreal northern landscape in which builders bent and tied together branches to make pointed arches ([*c.* 1519] 1962: 165). While local styles were also defined in fifteenth-century Italy—documents from the 1460s related to Filarete's architectural commissions refer to distinct Venetian, Lombard, and Florentine forms and modes (Schofield and Sebregondi 2006–2007)—architecture was increasingly associated with broader national identities in the Renaissance.

By the sixteenth century, architects were even consciously promoting geographically defined, nationalistic architectural forms. Philibert de l'Orme, for example, developed a "French Order" built of multiple column drums separated by bands, like those he used on the facade of the now destroyed palace of the Tuileries (1564–1572). As he explains in his treatise, because "in this country we cannot find large stones that are not in danger of disintegrating and splitting" when set against the grain, architects should embrace this limitation and "make columns of several pieces" (1567: 218v–219v). This non-monolithic type of column, derived from nature like those invented in antiquity, was thus the product of local geology and therefore distinctly French. To emphasize this, de l'Orme suggests these columns could also be adorned with symbols of the kingdom such as the fleurs-de-lys. Diego de Sagredo, in his earlier 1526 treatise *Medidas del Romano*, similarly saw the emblematic potential of architectural elements and attempted to link baluster-shaped columns, a common feature of contemporary so-called Plateresque architecture, to the pomegranate, a symbol of Castilian Spain (Llewellyn 1977: 294–300). John Shute, in his *The First and Chief Groundes of Architecture*, even compared the Tuscan Order to an image of the ancient god Atlas in the guise of an English king with mace and crown (1563: pl. 1).

ARCHITECTURE ON THE MOVE

Architecture in the Renaissance also transcended national identities and geographic boundaries. While architects and builders frequently worked locally, many others were peripatetic and traveled well beyond regional borders (see Ottenheym 2014). In the late fourteenth century, German and French architects had already visited Milan to debate the design of its recently begun monumental cathedral, and almost a century later, experts from Strasbourg and Graz were called on to assist with the construction of the cathedral's still-incomplete crossing tower (Ackerman 1949; Rossi 1982). Late fifteenth-century patrons across Italy also sought out specific architects, such as Francesco di Giorgio Martini, a native of Siena, for his engineering, mechanical, and military knowledge, as well as his artistic acumen. Skilled craftsmen, such as stonemasons from Lombardy, were likewise widely in demand. In Rome, where the local building industry had collapsed during a century of papal absence, this imported labor force was essential to the fifteenth-century *renovatio* of the dilapidated city (Battisti 1959). Northern Italian architects and builders were also brought to Moscow during the time of Ivan III (r. 1462–1505) to erect monumental masonry structures, from the Cathedral of the Dormitian to the palaces and walls of the Kremlin (Cazzola 1976). Throughout the sixteenth century, rulers across Europe similarly recruited Italians skilled in the design and construction of new types of fortifications (Viganò 1994–1999). The Portuguese especially relied on these foreign experts in their colonial expansion, building a network of defensive structures along the coasts of Africa, India, and beyond (Moreira 1994). In these cases, technical knowledge, which was still primarily obtained through experience and cloaked in secrecy despite the rise of treatises, was fundamental.

This type of architectural mobility was also conditioned by the growing desire of patrons for an Italianate style. Northern architects, such as Philibert de l'Orme and Inigo Jones, traveled to Italy to study ancient and modern monuments, in part through the support of noblemen. The Hungarian and Polish courts already in the late fifteenth century employed several Tuscan sculptors and builders. The Bakócz Chapel in Esztergom (1506–1519) and Sigismund Chapel in Kraków (1517–1533), both of which resemble the Florentine Chapel of the Cardinal of Portugal (1460–1468), are products of this type of stylistic importation. Yet, these and other similar examples were typically executed by workmen of various nationalities in materials that had distinctly local meaning. They were also the creation of patrons who intermarried with Italian noble families and ruled over cosmopolitan centers of trade (DaCosta Kaufmann 1995: 29–73; Kalina 2009). Unlike in the figural arts, where artists are understood as prime movers and style is seen as a meaningful personal choice that defines an artist's relationship to a place (cf. Kim 2014), architecture in the Renaissance was the

result of a complex network of actors and style was conditioned more directly by the dynamics of production and patronage.

Foreigners, moreover, often worked in a local architectural mode or created a hybrid synthesis of traditions. In the case of the Château of Chambord (1519–1547), built for King Francis I and based on a wooden model produced by the Italian architect Domenico da Cortona, a traditional French fortified château, complete with high-pitched conical roofs, is given bilateral symmetry and adorned with a mixture of classicizing motifs and flamboyant Gothic forms. In the interior, an innovative double-helix spiral staircase, set at the center of a cross-shaped hall, is flanked by four apartments arranged in the conventional French manner (Chatenet 2001). The building thus maintained many of the established architectural trappings of feudal power while also clearly departing from tradition. It even served as a model for one of Serlio's theoretical designs that attempted to reconcile the *costume Italiano* with the *commodità francese*. Hybridity was an inherent consequence of architectural mobility in the Renaissance. Even a centralized institution such as the Jesuit order, which oversaw the construction of churches as part of its evangelical mission, and eventually sent trained architect–priests around the globe, embraced provincial architectural cultures as much as it sought to impose a distinctly Roman model (Levy 2017).

As the fifteenth-century theorist Leon Battista Alberti noted, architects had long enabled mobility, facilitating the exchange of goods and knowledge, "opening new gateways to all the provinces of the world," and "improving health and standard of living" by tunneling mountains, filling valleys, damming lakes, draining marshes, building ships, dredging rivers, and constructing harbors and bridges (Alberti [*c.* 1452] 1999: 1–2). Architecture itself also became increasingly mobile in the Renaissance. Fadrique Enríquez de Ribera, the Marquis of Tarifa, following his 1518–1520 trip to the Holy Land, for example, commissioned sculptors in Genoa to produce elements for his family palace in Seville, which he had rebuilt in commemoration of his pilgrimage. While the marble portal of this structure, known since the seventeenth century as the Casa de Pilatos, resembles contemporary Genovese examples, the columns of the interior were to be explicitly hybrids (Figure 6.5). According to a building contract, the bases were to be "in the ancient style" (*a lanticha*) and capitals "in the manner done in Spain" (*al modo che core in Spagna*), much like fourteenth-century mudéjar examples in the nearby Alcazar (Lleó Cañal 1998: 23–41, 104). These were then incorporated into a courtyard adorned with local Hispano-Moresque carved stucco, ornate glazed tile, and geometric wooden marquetry, as well as a stone balustrade adorned with Gothic tracery reminiscent of the recently built cathedral. Even when literally exported, Italian architecture was shaped by the desires of patrons and part of a complex network of exchange. This was also the case with the courtyard of the castle La Calahorra located

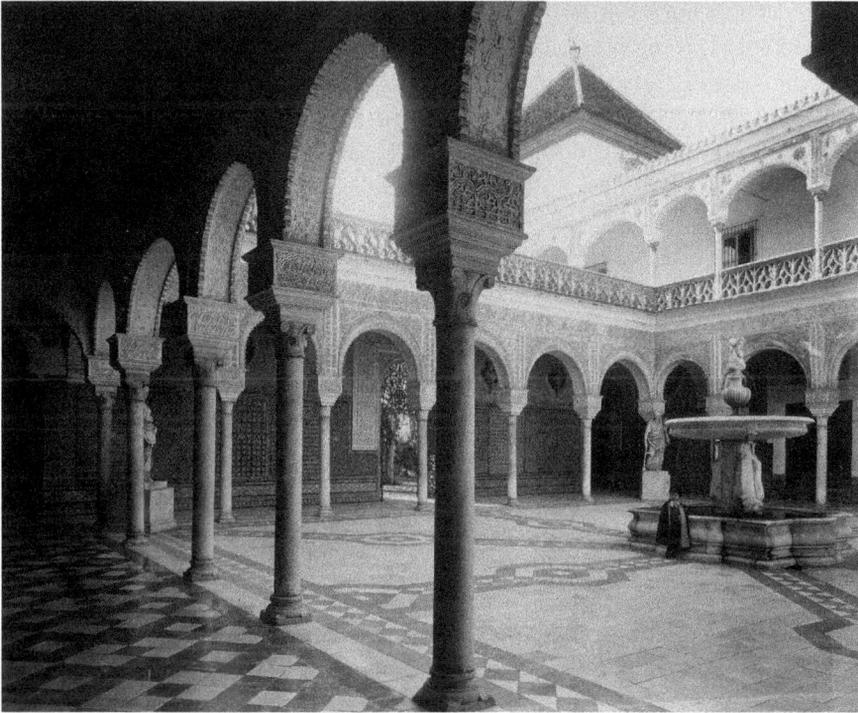

FIGURE 6.5 Main courtyard, Casa de Pilatos, Seville, Spain, 1528–1535. Photograph: Johanna Kempes, 1895. © Hallwyl Museum, Stockholm.

outside of Granada. Built for Don Rodrigo de Mendoza beginning in 1509, it too was composed of marble architectural elements shipped from Genoa. Yet here, the patron stipulated that these features be modeled on specific drawings from a sketchbook (known today as the Codex Escurialensis) he had recently acquired in Rome (Marías 1990). Assembled in Spain, carved in Genoa, and based on drawings inspired by Roman antiquities made by a Florentine artist, the courtyard of La Calahorra was the product of an emerging interconnected Renaissance.

The physical movement of architecture, moreover, was not limited to the Mediterranean and finely sculpted marble for elite residences. Flemish architect Hendrik van Paesschen built the Royal Exchange in London beginning in 1566 using glass, slate, iron, and prefabricated stonework brought from Antwerp (Burgon 1839, 2: 115–21). Northern carpenters throughout the period manufactured and tested heavy timber frame structures at their workshops before transporting them to their final destinations. Leonardo da Vinci, shortly before his death, was so taken with this foreign method of construction that he contemplated how traditional French wooden houses could be disassembled,

moved by boat, and re-erected in his newly built town of Romorantin (Pedretti 1972: 93, 321). This vernacular practice of prefabrication even extended across the Atlantic. When the privateer Martin Frobisher made his third voyage to North America in 1578, the ship carried a similarly prefabricated frame blockhouse along with 10,000 bricks for the establishment of the first English colony (McDermott 2001: 211). Heavy building materials, in fact, often served as essential ballast for ships before they were made into roads and buildings around the world (DaCosta Kaufmann 2004: 345).

MOBILITY AND MEDIA

It was also through other media that architecture became progressively mobile. Drawing on paper, as already mentioned, emerged as an integral part of architectural practice in the Renaissance. It played a critical role in the process of design and permitted architects to explore formal and spatial arrangements in new ways. It additionally acted as an important means of communication and facilitated the complex practice of construction. In some cases, such as in the later sixteenth-century works of Galeazzo Alessi and Juan de Herrera, it even enabled the production of architecture by remote control (Wilkinson 1991; Gill 2016). Drawing also increasingly served as a tool for documenting buildings, ancient and modern, and circulating architectural knowledge in visual form. It was in this capacity that it most conspicuously transformed the relationship between architecture and place.

As early as the mid-fourteenth century, the Franciscan friar Niccolò di Poggibonsi sought not only to record the monuments of the Holy Land that he had seen on pilgrimage with textual description, but also to "represent them as they appear" through drawing so that "they may be better understood" (Moore 2009: 402). These hundred-some schematic illustrations of cities and individual monuments, which he had originally recorded on wax tablets, enabled readers of his book to visualize the sacred architectural landscape of this distant land, perhaps as a substitute for arduous travel. They were also subsequently copied and translated into prints, and even possibly served as inspiration for the physical recreations of the Holy Land constructed in Varallo, San Vivaldo, and elsewhere. The Italian traveler Ciriaco de' Pizzicolli (also known as Cyriac of Ancona) produced comparable amateur architectural drawings in the mid-fifteenth century. Yet his depictions of the monuments of Greece and Asia Minor, including the Parthenon and Hagia Sophia, were motivated not by religious devotion, but rather antiquarianism (Bodnar 1960).

In the succeeding decades, drawing became an essential tool in the exploration and dissemination of antiquity for artists and architects, who began to travel to Rome to study its ancient remains. This investigation yielded measured analytical drawings of ruined buildings made with the aid of magnetic compass as well as inventive reconstructions of partially destroyed ancient monuments

and drawings of sculpted architectural fragments. Recorded on loose sheets of paper and in sketchbooks, these images were even occasionally redrawn in finely produced albums such as Codex Cholmondeley, which may have even been a gift to Catherine de' Medici, Queen of France (see generally Nesselrath 2014). These drawings circulated widely and were continually copied. They were even sometimes translated back into built architecture, as seen in the decorated capitals of La Calahorra.

Through this process of transmission and replication, antiquity was constantly transformed. To take just one example, in the 1530s, an unknown draftsman produced a plan of a centralized building with measurements and a caption indicating it was located in Palestrina and built of polished bricks. Though no such structure has ever been found by archaeologists, this drawing was subsequently copied at least seven times in the sixteenth century, along with several additional partially invented, seemingly antique examples.[6] The architect Sallustio Peruzzi, for instance, created a quick partial sketch of it, while others carefully reproduced the original image and text. The French architect and printmaker Jacques Androuet du Cerceau even translated it into etching perhaps as early as 1545. In the process, he removed any identifying information and added an invented elevation and section, something the architect Giovanni Battista Montano would also later do.[7] The mobility of drawings and prints therefore not only made ancient architecture more and more accessible, but also rendered it progressively fungible and enabled spurious antiquities to gain authenticity.

On the pages of sketchbooks, albums, and treatises, ancient buildings, separated from their original context, also freely intermixed with designs for contemporary architecture. Donato Bramante's famous Tempietto di S. Pietro in Montorio (founded 1502), a round peripteral Doric structure built in Rome to mark the site of St. Peter's martyrdom, is a case in point. Based in part on surviving Roman temples and constructed using reused antique granite columns, the small building soon after its completion was drawn alongside representations of analogous ancient monuments.[8] Sebastiano Serlio and Andrea Palladio likewise included woodcuts of the structure in the sections of their treatises dedicated to antiquities (Serlio [1540] 1996: 131–4; Palladio 1570: 65–6). This graphic telescoping of past and present was a critical component of Renaissance architecture. It validated in visual form that antiquity had been revived, while also blurring the distinction between old and new, as well as Pagan and Christian. In fact, many reconstructions of ancient round temples came to resemble the Tempietto, even with its anachronistic balustrade and dome set on a drum.

The rise of printing only further accelerated this fluid process of transmission and translation. Through the production and circulation of printed treatises and single-sheet engravings, representations of architecture, ancient and modern, real and invented, became widely available for the first time. Like other objects

in an emerging colonial world, this material traveled great distances; Serlio's treatise was already in Mexico, Peru, and India by the 1560s. Architects and patrons also seized on the potential of print to promote their own architectural projects. Phillip II, for example, proclaimed his power and authority to the world in 1589 through a series of engravings of his monumental monastic complex at El Escorial. Palladio touted his architectural skill, and celebrated his clients, by publishing his designs for palaces and villas, many of which were still under construction. Detached from place, time, and materials, two-dimensional serial images by their nature were also endlessly mutable, ready-made for reuse and reinterpretation at any scale and in any medium. The Elizabethan architect Robert Smythson, for example, freely borrowed and combined motifs from a variety of printed sources (see Girouard 1983). At Wollaton Hall (1580–1588), built outside of Nottingham for Sir Francis Willoughby, who owned several architectural books, Smythson overtly copied a fireplace from Serlio's treatise and adorned the exterior with elaborate Dutch gables, tracery windows, and cartouches similar to those published by Hans Vredeman de Vries (Figure 6.6). He also creatively amalgamated the work of these two authors to create a Doric hall screen adorned with strapwork. Smythson may have also derived Wollaton's overall plan from an etching in Jacques Androuet du Cerceau's *Premier Livre* (1559) and even built the false hammer beam ceiling of the hall using a technique similar to one illustrated by Philibert de l'Orme in his *Nouvelles inventions pour bien bastir* (1561). This type of appropriation and mixing of traditions was only possible in an era where printed images were readily available and widely accepted.

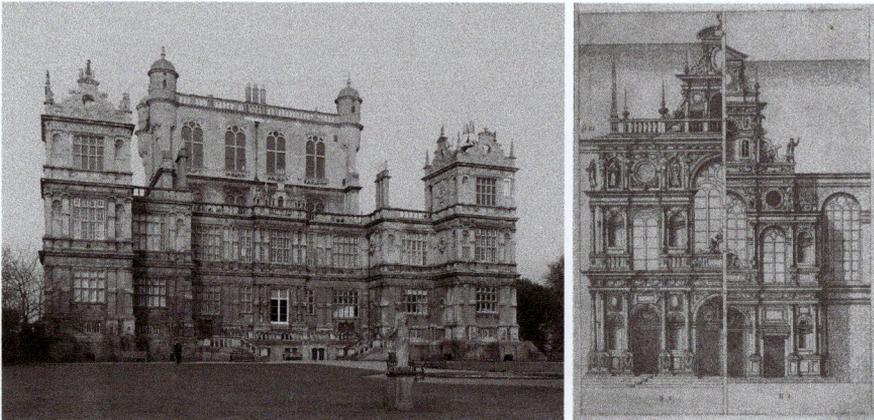

FIGURE 6.6 Robert Smythson, Wollaton Hall (*left*), Nottingham, England, 1580–1588. Photograph: Michael J. Waters. Church facade designs in the Corinthian Order (*right*), from Hans Vredeman de Vries, *Architectura* … (Antwerp, 1577). © Getty Research Institute, Los Angeles.

CONCLUSION

Renaissance architecture, in terms of both its production and place, was defined by seemingly inherent contradictions. It was subject to modern technology and newly invented machinery, while simultaneously looking back to antiquity for inspiration. Its production was increasingly shaped by private capital, a market economy, and the demand for domestic architecture, but the largest construction projects remained monumental religious complexes. Through its theorization, architecture was professionalized and raised to the status of a liberal art. Yet with the rise of the modern architect, a figure that focused ever more on abstract design rather than construction, also came the emergence of amateur practitioners who were educated through printed books and exploited an ever-expanding corpus of mechanically reproduced imagery. Architecture in the Renaissance was also the product of a growing internationalism made possible by peripatetic architects and builders, as well as portable drawings and prints. But this mobility did not lead to homogeneity or aesthetic unity. The foreign, instead, often merged with the local to form a syncretistic architectural mode, one that remained keenly aware of climatic and cultural difference. In other cases, patrons and builders, confronted with a burgeoning stylistic multiplicity, magnified by the availability of printed images, sought to use architecture to emphasize national identity. Renaissance writers, in fact, never conceived of unifying Europe by means of a shared classical language of architecture. Instead, just as architectural culture became more interconnected across the continent and beyond, it was subject to a rising nationalism and sectarianism that sought to transform the universal into the culturally specific. It is in this way that classicism was simultaneously rejected by some Protestants in Elizabethan England as being too "popish" and seen as an appropriate new architectural mode by Calvinists in France. Some of these phenomena were not distinctly the product of the Renaissance. The movement of people and materials, for example, had long shaped architectural production in Europe— the Romans shipped partially prefabricated architectural elements great distances; Byzantine builders worked as far away as Spain and Germany; and the Normans in Palermo employed craftsmen from throughout the Mediterranean and exploited *spoila* taken from ancient Roman and Muslim buildings to create a number of distinctly hybrid monuments. Yet the architecture of the fifteenth and sixteenth centuries was progressively defined by different forms of mobility, evolving concepts of architectural practice, and shifting means of production. It was distinguished by not just its historicist style, but also by the new ways it came into being and the various manners in which it moved, and like other objects of the period, it reflected a culture that was rapidly changing through the emergence of new technologies and modes of exchange.

CHAPTER SEVEN

Bodily Objects

SUSAN GAYLARD

In the Renaissance, the relationship between bodies and the objects that shaped them, and were in turn shaped by them, underwent a profound transformation. The items that molded the body changed rapidly, and now included a plethora of new things, altering the imagined constitution of the body itself. Much of this reimagining and reshaping occurred through clothing, but also via technologies worn on the body (like spectacles and perfumed jewels) or consumed by bodies (including New World imports like sugar and pottery). As the body was reshaped and reimagined through the objects around it, so was the self.[1] New approaches to dress and cleanliness made the individual responsible for physical and spiritual health, so that it was increasingly impossible for those who were not very wealthy to be "clean" or "moral."

The early modern body was in tension between Aristotelian medicine based on the humors and an emerging empirical approach based on evidence; between religious imperatives that largely denied the body and a precarious new aesthetic that valued the flesh; between a sense of bodily unity and an emerging emphasis on dissection and fragments—in both visual representation and the envisioning of social systems (Hillman and Mazzio 1997; Campbell 2002; Biow 2015: 117–51; Lingo 2016). The body was moreover in transition between two paradigms of fashioning: clothing that fashioned the body and clothing seen as transitory and detached from the body (Jones and Stallybrass 2000). Today, ancient ceremonies recall the agency of clothing that fashions: as the wedding ring goes onto the finger, it fashions the bride into a spouse. This paradigm of clothing as *fashioning* identity began to generate anxiety when precious objects adorning European Christians were imagined as coming directly from "savage

heathen" bodies. Partly for this reason, Jones and Stallybrass (2000) argue, early modern Europeans gradually reconceptualized clothing as transient and unrelated to identity: clothes increasingly came to lack the agency they once had had. This shifting paradigm helped to propel the growth of clothing production and new trends, as well as the reconceptualization of identity as located in the face rather than in clothes.[2] At the same time, styles increasingly isolated body parts from each other: ruffs and cuffs separated head and hands from the body; parti-colored hose and the codpiece broke up men's lower halves (Squire 1974: 45–9). The transfer of agency from clothing to the wearer contributed to the fragmentation of the European body into a set of parts molded together by constrictive clothing and health-giving elite objects—rather than a coherent whole granted immediate recognition by its clothing, as in the idealized medieval paradigm.

CLOTHING

In Guercino's sketch (Figure 7.1), the leg is defined through breeches, stocking, garter, and shoe—elements that further break up a body that is already fragmented. The fringed ribbon at the knee echoes medical and votive practices, as it resembles a ragged bandage attempting to reconstitute a broken body.[3] As we see here, the newly fragmented Renaissance body is evident in artists' practice of drawing body sections from life and in the related medical practices of anatomy and dissection. Bodily fragmentation is also emphasized in Petrarchan poetry, which insists on parts (eyes, hands, lips) rather than the whole (Vickers 1981). Metaphysically, the notion of disintegration was profoundly exacerbated by the breakup of the Church, the body of Christ, along with related divisions in the body politic and the Protestant separation of body from soul. The Guercino sketch is not a study of muscle anatomy or body contours more typical of the late fifteenth and sixteenth centuries. Instead, it demonstrates both the problem of fragmentation and the tension between fashion and *fashioning*, as the clothes simultaneously define the body for the viewer and divide the leg into sections, but also appear to be separate from the body.

Like the fragmented body, Renaissance clothing comprised separable pieces that circulated independently, often in lieu of cash. During the fifteenth century, in response to sumptuary laws and the self-propelling logic of fashion itself, single elements like sleeves and bodices assumed greater significance and autonomy (Frick 2002: 179–200). Increasingly, collars, cuffs, sleeves, bodices, buttons, and trim were passed on and recombined by successive owners, borrowers, or renters.[4] Given the fragmentary nature of clothing, Bella Mirabella (2011b) has argued that today's distinction between *accessory* and *clothing* would have made little sense in early modern Europe. Most bodily objects were very durable and had a monetary value that could extend well

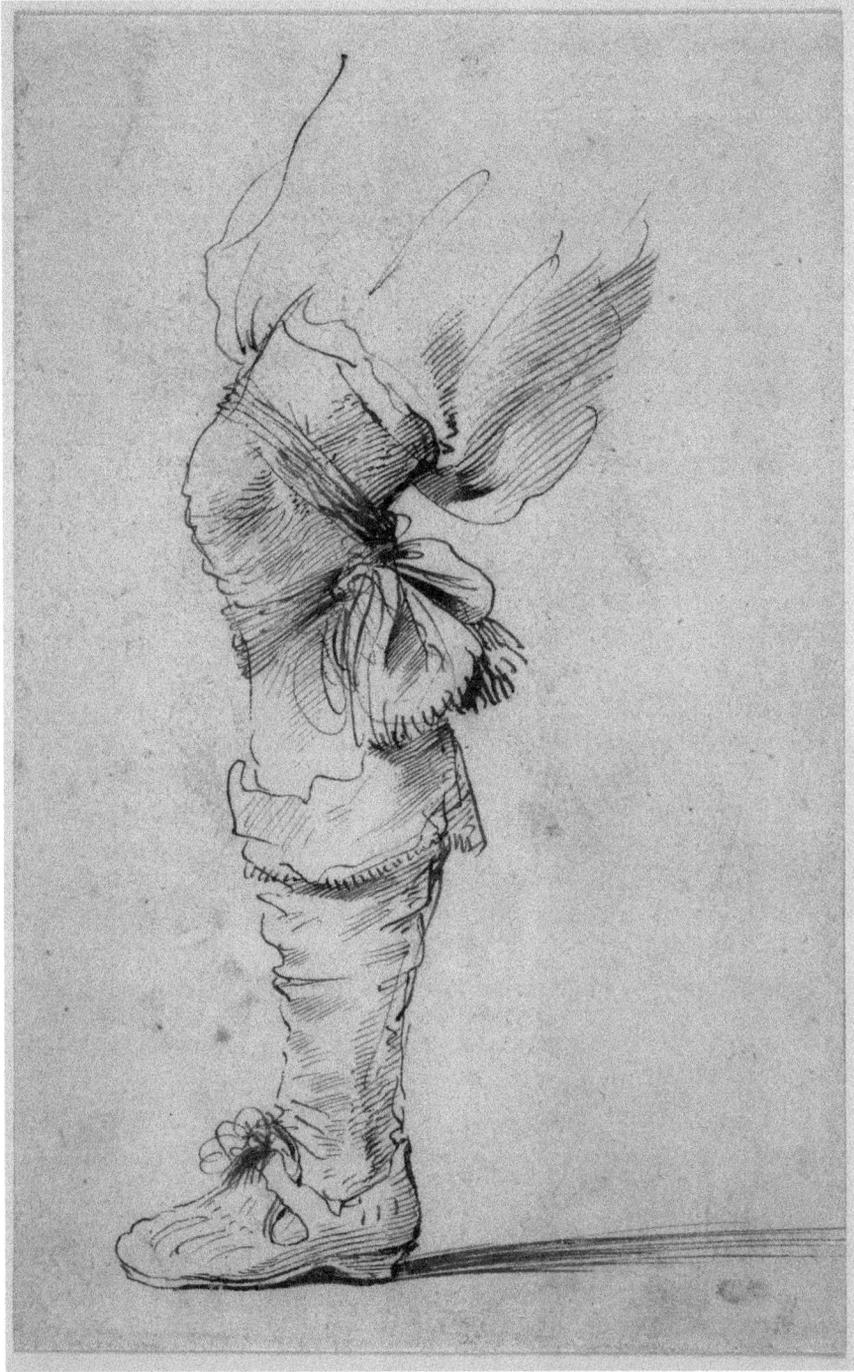

FIGURE 7.1 Guercino, *Study of a man's left leg wearing a shoe, c.* 1630s. © Trustees of The British Museum, London.

beyond the life of a single owner. Once the material began to wear out, an item could be cut down and remade for a smaller or less wealthy body—an age-old practice that continued through the nineteenth century. Jones and Stallybrass (2000) have shown that clothing, when recirculated, carried a "material memory": some hint of an item's former wearer inhered in the object, so that the queen's old gowns, handed down to her ladies-in-waiting, incorporated the ladies into the queen's most intimate circle.

Cutting fabric to specific bodies was a fairly new trend: most scholars agree that, in thirteenth- and fourteenth-century Europe, fashions began to change rapidly and significantly. Italian urbanization and growing mercantile activity made new consumer goods like buttons and knitted fabric available to a much larger public than before (Welch 2005). Expanded trade routes likewise promoted new markets in Northern and Western Europe. For centuries prior, clothing had primarily marked bodies for status rather than gender. Higher-quality fabrics in longer lengths often denoted the elite, but the basic garment was a belted tunic made from a rectangular piece of fabric. Easy to make, the same tunic could be passed down and worn by both men and women. By the late fourteenth century, however, male and female European bodies were immediately distinguishable: the woman's garment had lengthened to hide her feet, with the bodice now high-waisted and tight. By contrast, men's bodices were low-waisted and padded to create a convex belly, while men's hemlines had retreated toward the torso, revealing feet, legs, and sometimes even underwear.

With these changes, the early modern European body—and the objects that created and curated it—altered its meaning dramatically. By molding and being molded to the human form, clothing highlighted the body as a site of gendered display or even sexualized power. Horrified contemporaries commented on the wastefulness of cutting cloth to fit individual bodies, and many condemned men's revealingly short skirts. Yet the trends spread rapidly, offering the elite more opportunities to exhibit their wealth and to challenge others through visual spectacle.

NOSTALGIA FOR THE BELLICOSE MALE BODY

Elite men's bodies were traditionally encased in armor. We read in countless medieval romances of the signs on armor that proclaimed a knight's identity— and, by association, his worth. Such signs could, however, be misread: written in the late fifteenth and early sixteenth centuries, the chivalric poems of Boiardo and Ariosto repeatedly insist on mistaken identity deriving from misappropriated armor. These stories echo an anxiety elicited by the new urban context in which, with so many people who were strangers to each other, clothing could constitute a false identity: merchants could dress as notaries, men as nuns, and so on. Sumptuary laws attempted to reinstate visual legibility by legislating who

could wear what, but as we see in the stories of muddled identities, anxiety persisted. Despite the nostalgia and anachronism of presenting autonomous armored knights in the sixteenth century, accounts of borrowed and stolen helmets, shields, and cuirasses reflect the reality that armor, like clothing, comprised separable, easily dispersed pieces. The emphasis on dispersal in literary discussions of armor echoes the emerging focus on single, isolated body parts. Both the tales and the new paradigm of fragmentation reflect the emerging split between body and clothing: donning a knight's armor did not necessarily *make* one a knight.

Armor was progressively divorced from the body. Medieval armor protected the body from harm and identified the wearer as belonging to a particular group. Increasingly, however, the protection provided by armor belonged to chivalric fiction, even as metalwork processes produced more elaborate armor than before. By the sixteenth century, armor was primarily decorative, worn by the elite for parades and state occasions but largely useless against firearms. As a result, armor was less and less a *bodily* object: beautiful suits of armor were still regularly commissioned, by they were used primarily as palace decoration by the wealthy elite. The bellicose, autonomous knight had become a phantasm, represented by a set of metal objects assembled into an empty shell. This phantasmic state is epitomized by the ghost in *Hamlet*, whose appearance in full armor recalls an idealized past in which armor made sense.[5]

It is thus not surprising that men's clothing fashions in this period, led by the elite, were in many ways more idiosyncratic than women's, and were often hyper-masculinizing.[6] Articles such as the leather *colletto*, which covered the upper body and was used with armor, were also worn with civilian dress (Ventura 2003). Piero Ventura even suggests that items of luxury armor, like the *colletto*, could take the place of civilian clothing, occasionally to the point of equivalency between military and civilian dress (2003: 453). Men's adoption of items recalling armor and (as we shall see) fashion's emphasis on an explicitly male, virile body make sense in light of both the new irrelevance of armor and women's large-scale adoption of many masculine fashions.

SHOES

Feet and legs, newly on display, became the most visually obvious locus of masculine fashion. Stallybrass (1997) has highlighted the ubiquity of metaphors related to "trampling underfoot," pointing out that the foot was central to hierarchical display—both the humblest part of the body and the symbolic "basis" of society itself. Despite this plethora of metaphors, one might assume that Renaissance footwear was primarily utilitarian and that shoes lacked the *shaping* function that I would argue was inherent to bodily objects. Yet fashionable footwear was not only for the elite: in the sixteenth century;

custom-made shoes were available at a variety of price points, and might be passed down to a new owner, bringing with them the nostalgic "material memory" associated with secondhand clothing (O'Malley 2010). Styles were generally adapted to climate, terrain, and activity (Rublack 2010b: 53–4). Basic footwear for men included a low heel and might reach the ankle; boots that laced up the side were used for hard walking. Yet in the visual arts, footwear and legwear are sometimes almost indistinguishable: in the fifteenth century, hose cut close to the leg often included a foot with a leather sole (Levi-Pisetzky 1964–1969, 3: 138; Muzzarelli 2006). To protect soled hose from dirt and weather, raised wooden or cork clogs were often used—such as those visible in the left-hand foreground of Jan van Eyck's 1434 *Arnolfini Portrait* (National Gallery, London). Clogs would also be used to protect the kinds of shoes often seen in paintings: embroidered with gold or silk thread and available in a range of fabrics and colors.

Nowadays, we recognize heels and narrow-toed shoes as fashion trends, primarily for women; yet they originated as Renaissance men's styles. Figure 7.2 shows a moderate version of the fifteenth-century narrow-toed shoe: the more exaggerated, long, pointed-toe *poulaines* of the earlier fifteenth century elicited moral outrage and, in many places, sumptuary legislation. *Poulaines* were seen as phallic symbols that extended the visual length of men's legs. While the *poulaine* was considered a man's style in most of Europe, Michelle A. Laughran and Andrea Vianello have shown that, in Italy, the extended pointed toe was less successful among men—perhaps because many elite men were engaged in active trade or government, and the *poulaine* hampered mobility (2011: 258–61). Italian women, however, being far less mobile than men, often adopted the phallic-shaped *poulaine*—to the horror of commentators who saw this as revealing the sensuous foot (supposedly concealed under long robes) and, worse, as an appropriation of male power and sexuality (Muzzarelli 2006; Laughran and Andrea Vianello 2011: 260–1).

In the sixteenth century, footwear discussions often concentrated on *chopines* (called *pianelle* in Italy), a woman's shoe elevated by a stilt-like heel, usually made of cork and lower at the toe than the ankle (Figure 7.3). This kind of footwear likely developed from the raised wooden clogs used by men to keep their shoes dry outside (Laughran and Vianello 2011: 264). By the early sixteenth century, *chopines* were gendered as feminine and often elicited condemnation for drawing attention to women's feet and requiring longer and therefore more expensive dresses. These platforms could be elaborately decorated and were available in many fabrics; they ranged from two to twenty inches in height. Like high heels today, *chopines* conferred an unnatural gait and height, and exaggerated *chopines* often required that the wearer be supported. Despite their origin as an appropriation of a men's style, *chopines* were eventually applauded by some traditionalists for hampering women's mobility (Vianello

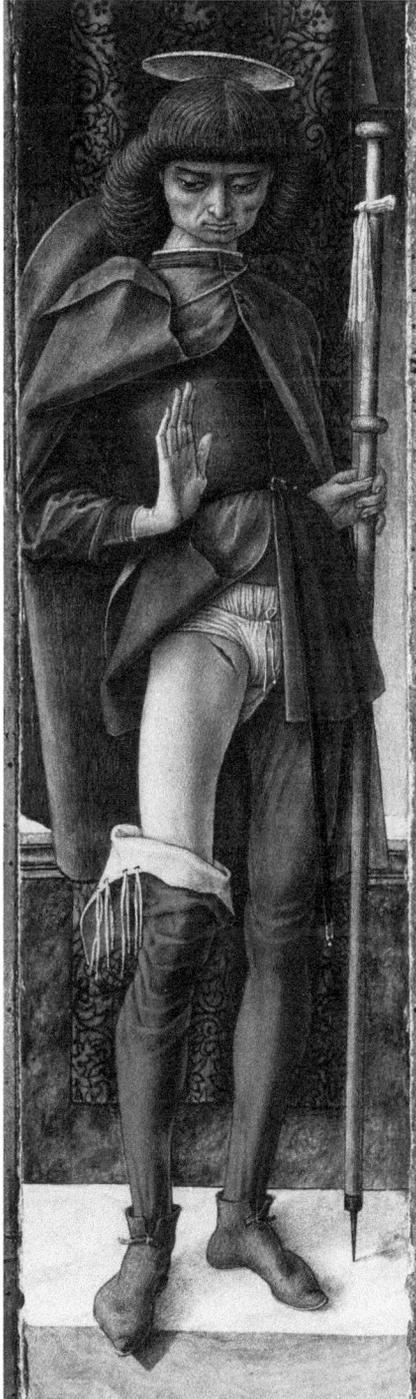

FIGURE 7.2 Carlo Crivelli, *Saint Roch*, *c.* 1480. © The Wallace Collection, London.

2006: 92–3). While scholars often link these elevated shoes with prostitution (as in Figure 7.3), Vianello shows that, by the mid- to late sixteenth century, moderate *chopines* appropriately signaled elite status, in comparison with the twenty-inch stilts typical of courtesans (Vianello 2006). Seemingly a Venetian invention, *chopines* persisted the longest in Venice (through the seventeenth

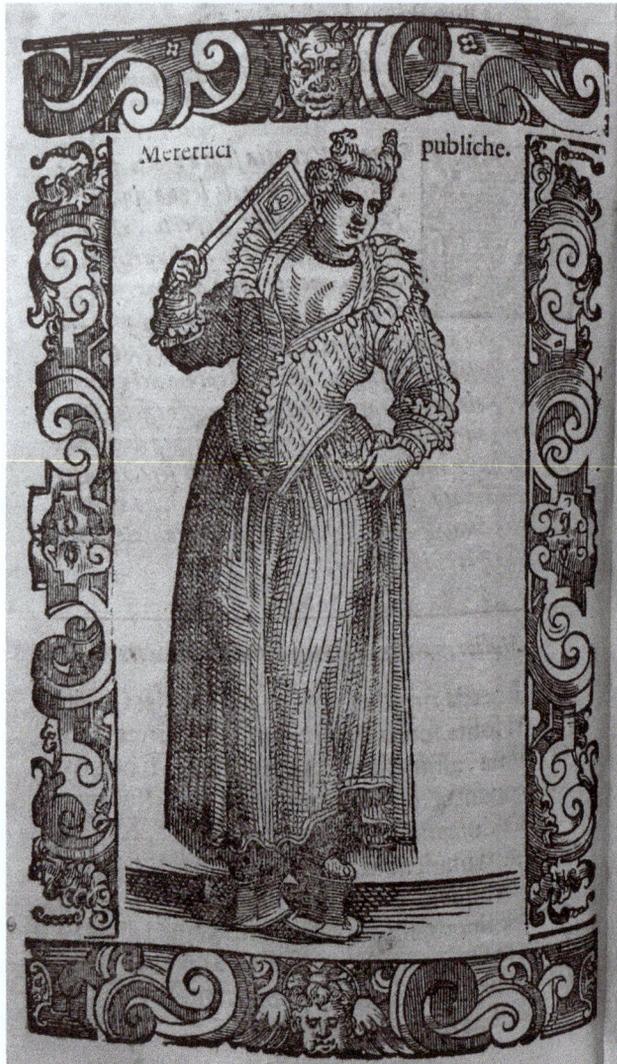

FIGURE 7.3 Cesare Vecellio, *Meretrici publiche*. In *Habiti antichi et moderni di tutto il Mondo*, vol. 1, 1598. © Special Collections, University of Washington Libraries, Seattle.

century), a city in which—unusually for the period—women walked when they moved outside the house.[7]

HOSE

Since around 1200, Europeans had been wearing hose made from loosely woven fabric cut on the bias for stretch. By the mid-1400s, hose extended from the foot to the hip and tied onto the doublet (Figure 7.2); for the elite, these were often very tight and might be parti-colored. The meticulous sculpting of men's legs increased: by the early 1500s, hose were joined at the back where they covered the buttocks, and were often divided into highly decorative, slashed, and enormously padded upper hose (with shifting styles and shapes of padding), which met or were sewn onto lower hose at mid-thigh. If the hose were not lined, men might wear linen liners or socks, in addition to underpants. Around the 1560s across Europe, the divided upper and lower hose began to give way to stockings that covered the lower leg and foot, paired with many different styles of breeches that hung from the waist, rather than reaching up from the foot (Squire 1974: 48–50), as in Figure 7.1.

In order for traditional fabric hose to fit correctly from the foot to the thigh, they had to be tailored by a professional. Knitted hose, however, fitted the leg closely and could be bought ready-made (Belfanti 2003: 590). While knitting seems to have been introduced to Europe from the Arab world by the thirteenth century, European knitted stockings date to the sixteenth century (Belfanti 2003: 583).[8] A dramatic advance in comfort, fit, and economy (knitting wastes very little yarn), they were rapidly adopted by everyone in a fashion that swept Europe.[9] Stockings were typically knitted of wool, with silk stockings a luxury product. By the late sixteenth century, tight knitted stockings that tied beneath the knee had displaced tailor-made, full-length fabric hose. The knitted stocking was the first ready-made fashion garment fitted to the body and available for both men and women.

Despite the fact that women's legs were meant to be invisible, they adopted the increasingly decorative stockings (often multicolored and lavishly embroidered) that had started as a men's fashion. In cities across Italy, sumptuary legislation was introduced from the 1520s onward barring women from ornamented stockings (Levi-Pisetzky 1964–1969, 3: 81). Some Italian women also seem to have adopted drawers (decorated with embroidery or lace) for warmth and for riding; in England and Northern Europe, women apparently used the white linen shift or undershirt as their only undergarment well into the seventeenth century (Levi-Pisetzky 1964–1969, 2: 287; Levi-Pisetzky 1964–1969, 3: 80–1; Scott 1980: 80; Roche 1994: 182–3; Vincent 2003: 51–2; Orsi Landini 2005: 133).[10]

CODPIECE AND BOMBAST: HYPER-BELLICOSE BODIES

With the upward retreat of men's hemlines, an additional piece of cloth was used to cover the underwear (Figure 7.2). This explains the fifteenth-century advent of the codpiece as a triangular piece of cloth or gusset attached to the front of the hose (Payne et al. 1992: 251). These origins, however, bear no relation to the bulging sixteenth-century decoration that has elicited much scholarly attention. Like body armor, the conspicuous codpiece "aestheticizes masculine power" (Springer 2010: 11); it became large and prominent by the mid-sixteenth century, when armor was functionally obsolete and reserved only for the wealthiest elite. A widespread and relatively affordable fashion, the codpiece can be understood as a nostalgic expression of lost body armor.

Will Fisher identifies two main codpiece styles: the "bagged" version associated with modesty; and the "ornate phallic sheath" familiar from mid-sixteenth-century portraits (2011: 103). In Fisher's reading, the two styles reflect reproductive masculinity versus hyper-virile sexual conquest. But Thomas Lüttenberg (2005) argues that the outrage one might expect in sumptuary laws and local ordinances was largely confined to covering the naked body, with late fifteenth-century laws decrying men's high hemlines and low-cut doublets. This focus reflects the new exposure of both legs and undershirt (discussed below). Yet Lüttenberg shows that even the ornate and prominent sixteenth-century codpiece elicited surprisingly little comment, as sumptuary laws instead condemned the new baggy breeches for wasting fabric. The conspicuous codpiece did, however, invite condemnation for creating a monstrous body by human artifice (2005: 66–9).

After about a century of popularity, in the 1560s the codpiece began to lose its appeal, and by the early seventeenth century was no longer worn. Fisher (2011) points out that, like armor that might be borrowed or stolen, the codpiece was increasingly suspected of false advertising. This rejection of a falsified body part reflects a much broader cultural embrace of the idea or appearance of sincerity (if not sincerity itself) over masks and masking (Martin 1997).

The potently virile codpiece was part of a broader reshaping of men's bodies in the absence of armor. Stuffing and quilting in most garments (from doublets to sleeves to hose) had the practical function of keeping out the cold; historically, it had protected the male body from worn armor. On the other hand, bombast (stuffing made of sawdust, dry moss, or linen fibers) was used to mold protuberant bellies with low waists (late fourteenth and sixteenth centuries); thickly padded skirts with puffy sleeves (late fifteenth to early sixteenth centuries); barrel-shaped chests, broad shoulders, and bulging upper hose (in the first half of the 1500s); pumpkin-shaped hose with wasp waists (as in Clouet's 1596 portrait of Charles IX of France in Vienna's Kunsthistorisches Museum); and even bulging toecaps (as in Holbein's 1533 *Ambassadors*). This

body was explicitly and repeatedly fashioned as imposing and larger than life, with bulky clothing advertising wealth and (at least until the late 1500s) suggesting a strong, masculine physique.[11] The codpiece was part of this broader move to reinvent the male silhouette; the close scholarly attention it has received likely derives from the fact that—unlike huge sleeves, high heels, and knitted stockings—the codpiece was not available for appropriation by women.

CORSETS AND FARTHINGALES: REFASHIONING WOMEN'S BODIES

As with men's codpieces, the artificial shaping of the female silhouette enabled women of varied means and body types to model an ideally fashionable body: a privilege not available with today's unstructured garments (Wunder 2015: 163). The Spanish farthingale—suppressed by law in Milan as early as 1498—was widely accepted by the mid-sixteenth century (Levi-Pisetzky 1964–1969, 3: 69). Originally a set of hoops sewn to the outside of the skirt to shape it like a bell, the mechanisms that held out the skirt (from bamboo hoops to cotton stuffing) were soon hidden from view. By the late sixteenth century, women's bodices dipped below the waistline and were extremely tight (Figure 7.2), pressing the breasts up and away from the waist. By flattening out the breasts, the corset or stays—in conjunction with the busk (a smooth piece of wood, whalebone, or metal that fitted into a bodice and ran from sternum to waist)—provided a smooth surface to show off rich, decorative fabrics (Orsi Landini 2005: 131; Jones and Stallybrass 2011). The fragility of a narrow waist was emphasized by a farthingale that held skirts out horizontally from the hip. Like many women's fashions deemed controversial (from *chopines* to nineteenth-century tight lacing), the farthingale was sometimes condemned as dangerous to pregnant women, since it supposedly threatened the unborn child (Levi-Pisetzky 1964–1969, 3: 69–71n126; Wunder 2015: 145n35). The farthingale, added to rigid bodices and many layers of padding, hampered women's movement and reshaped the female body into "a broad-based cone, exactly reversing the abstraction of the male" (Squire 1974: 42).

SHIRTS AND RUFFS: CLEANSING AND ENNOBLING THE BODY

By the late fifteenth century, men's and women's necklines dipped to show the shirt underneath.[12] Technically an undergarment of the same basic shape as the old medieval tunic, this linen or cotton shirt gained visual and symbolic prominence. Small puffs of white shirt could appear beneath the slashes in a sleeve or in the gaps between the laces that tied sleeves onto a bodice. Now on view, the shirt was often finely embroidered, particularly at the throat and

wrists. Its whiteness must be maintained, to symbolize purity and demonstrate the wealth required to keep shirts freshly laundered. As a result, Europeans of all classes owned more shirts in the sixteenth century than in the fifteenth century. By the late sixteenth century, the elite seem to have changed their shirts almost daily—in contrast with outer clothing, which would be brushed and refreshed, but never washed (Vigarello 2012: 380–2).

Besides suggesting the body beneath, the linen shirt also assumed the work of cleansing that body, both physically and metaphorically. Despite the popularity of Roman-style baths in late fifteenth- and early sixteenth-century Italy, bathing in water was problematic by the mid-sixteenth century: one could be exposed to infection (especially at a public bath); humidity might enter the body and generate illness; and exposure to cold air was dangerous (Cavallo 2006: 183; Cavallo and Storey 2013: 250–6). The preferred way to clean the body was to wipe it with white linen cloths, considered a great modern advance as compared with the ancients' reliance on water (Vigarello 2012: 375–6). Like all underwear, shirts were generally made by women (men typically controlled outerwear production): shirts thus bore both an erotic charge (Vincent 2003: 54–5) and some of the moral cleansing power of that whitest, purest cloth, the Veronica. Since linen shirts were unaffordable for many (hemp was a cheaper alternative), the cleansing and purifying power of linen was a privilege of the wealthier classes (Vigarello 2012: 382–5). Rodrigo Fonseca's *Del conservare la sanità* (1603) condemns bathing as overly vigorous exercise for elites, but still recommends it for the menial classes (Cavallo and Storey 2013: 257). Linen shirts were thus the ideal garment, not merely absorbing sweat and grime, but simultaneously cleansing the body and marking it as elite.

The shirt was often closed at the neck with a drawstring that, when pulled tight, created pleats over the bust and a small ruffle at the neck (Pendergast and Pendergast 2003, 3: 482–4). During the sixteenth century, this ruffle grew in size and importance, eventually becoming a detached collar known as a *ruff*. Following the introduction of starch around the 1560s, linen ruffs could be made to stand out from the body (Figure 7.4).[13] By the late sixteenth century, ruffs could be multilayered compilations made mostly of lace, an expensive new textile designed as decoration, more hole than substance.[14] A ruff might comprise ten meters of cloth sewn into hundreds of pleats to make a neckband of a mere fifty centimeters. Each time the ruff was washed, it could be starched and pinned in a different way—a process that could take up to five hours and would be ruined by a shower of rain (Ashelford 1996: 33; Vincent 2003: 32–3). Without proper care, the ruff flopped in failed emulation of the elite, as in the *Fruit Vendor* of Il Pensionante del Saraceni (*c.* 1615–1620, Detroit Institute of Arts), whose bedraggled collar reflects the lively trade in used clothing.

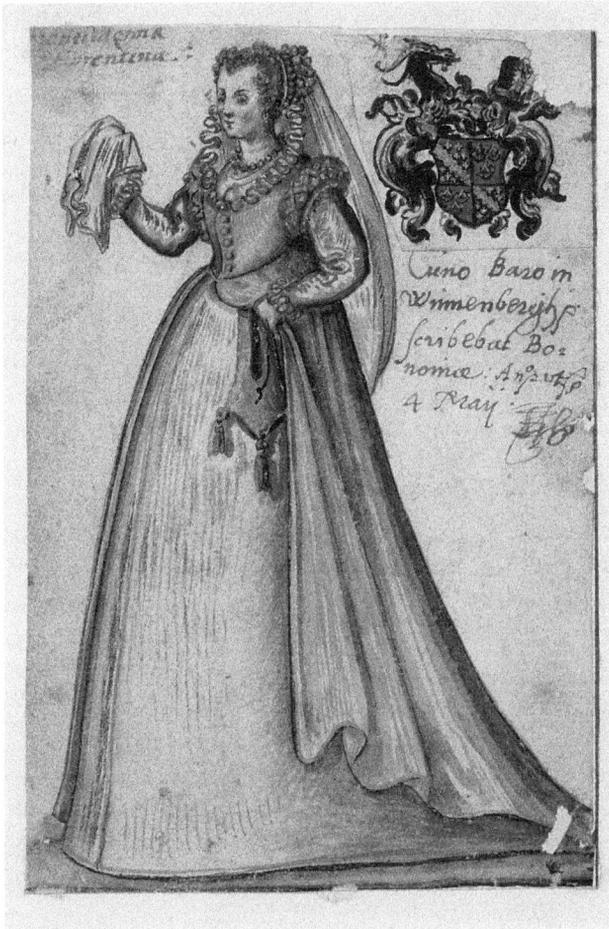

FIGURE 7.4 Florentine lady with handkerchief, *Album amicorum of Paul van Dale*, 1578. © Bodleian Library, Oxford.

Given the expense of creating and maintaining the ruff, it set apart the elite at a time when the old European nobility was increasingly threatened, especially following the wars, famines, and economic uncertainty of the later sixteenth century. The fashion produced the "Medici collar" (introduced by Catherine de' Medici of France but famously associated with Elizabeth I of England), a vast fabric frame for the face, which was open in front but rose above the head at the back. Even modest linen ruffs "ennobled" bodies: wearers had to stand more erect, with the head upright. The ruff moreover visually separated the clothed body from the physiognomic specificity of the bare face. Unlike other bodily objects that coopt the face—veils, helmets, earrings—ruffs were both

pan-European and used by men and women alike. The ruff's highlighting of the face corresponds with new cleansing regimes for the head (as we shall see) and with the pan-European adoption of the face as the locus of identity.

VEILS, TURBANS, AND HANDKERCHIEFS: PURITY, SEDUCTION, AND OTTOMAN BORROWINGS

With the face increasingly central to identity, veils generated much anxiety, despite being integral to women's fashions across Europe and the Mediterranean (Burghartz 2015). Often imagined as signaling chastity and purity, the veil could also be read as seductive, coquettish, and even dangerous (Bass and Wunder 2009; Milligan 2017). Eugenia Paulicelli (2011) has highlighted the many sixteenth-century Italian book illustrations showing women whose veils hide their face but emphasize their cleavage. The fact that fully veiled women could see without being seen was considered so threatening that in Madrid the *Cortes* successfully appealed to Philip II in 1586 to ban veiling (Bass and Wunder 2009). Yet as Laura Bass and Amanda Wunder point out, the Spanish mantle-style veil, which draped over the head and body, was so easy to manipulate and remove that the legislation must have been difficult to enforce.

Unlike the fluid and equivocal Spanish mantle, angular fifteenth-century veils projected rigidity through wire supports, intricate folds, pleats, and pins. In Robert Campin's *c.* 1435 portrait of a woman (Figure 7.5), we see a multilayered, concealing white veil. The brightness of the headdress highlights the woman's face and the idea of purity and cleanliness. The pins and ring are her only jewelry, emphasizing her married chastity. In Figure 7.6, the seductive but decorous *Portrait of a Lady* (*c.* 1460, National Gallery, London), the workshop of Rogier van der Weyden depicts a woman's face framed by a transparent veil. The vertical headdress, emphasized by a high forehead (shaved or plucked, to indicate nobility), is typical of fifteenth-century Ottoman-influenced Burgundian styles (Jirousek 1995). The fabric is pinned in a pleat at the forehead, covering yet showing off the elaborate hairstyle and jeweled hairband beneath. Pins in the partlet covering the woman's chest invite the eye to linger on the gaps between the pleats, where only the sheerest material shields the skin from view.

Even these canonical examples suggest that actual artifacts diverged widely and might not always be recognizable as veils. Thanks to the new availability of small pieces of high-quality silk, hair coverings became lighter and more transparent, with sheer pieces of silk often an integral part of women's headdresses (Orsi Landini 2003: 371). At various points in the fifteenth and sixteenth centuries, sections of fabric might be attached to the back of the head to draw attention to it (Figure 7.4). In the late fifteenth century, nets stiffened with wire and even jeweled mesh cages were often used over the

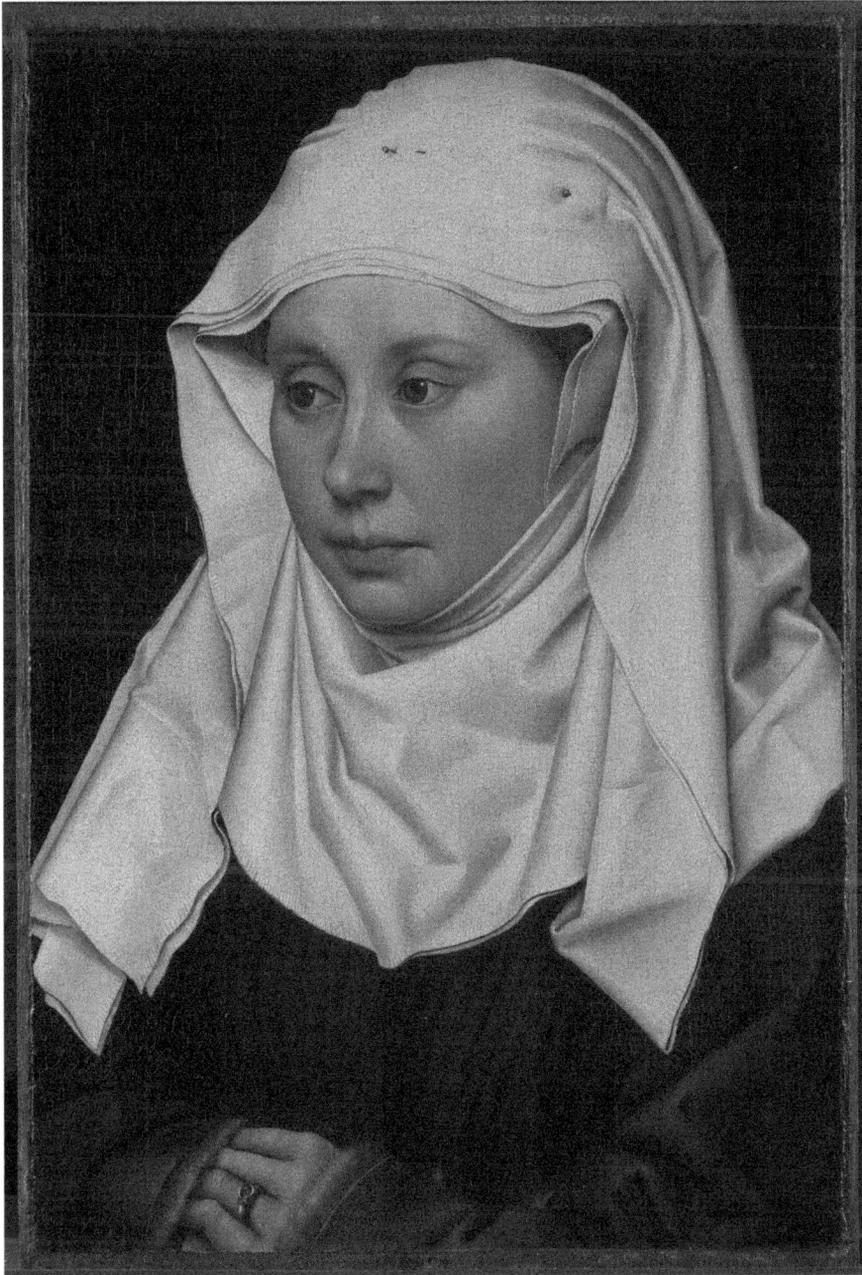

FIGURE 7.5 Robert Campin, *A woman, c.* 1435. © National Gallery, London/Art Resource, NY.

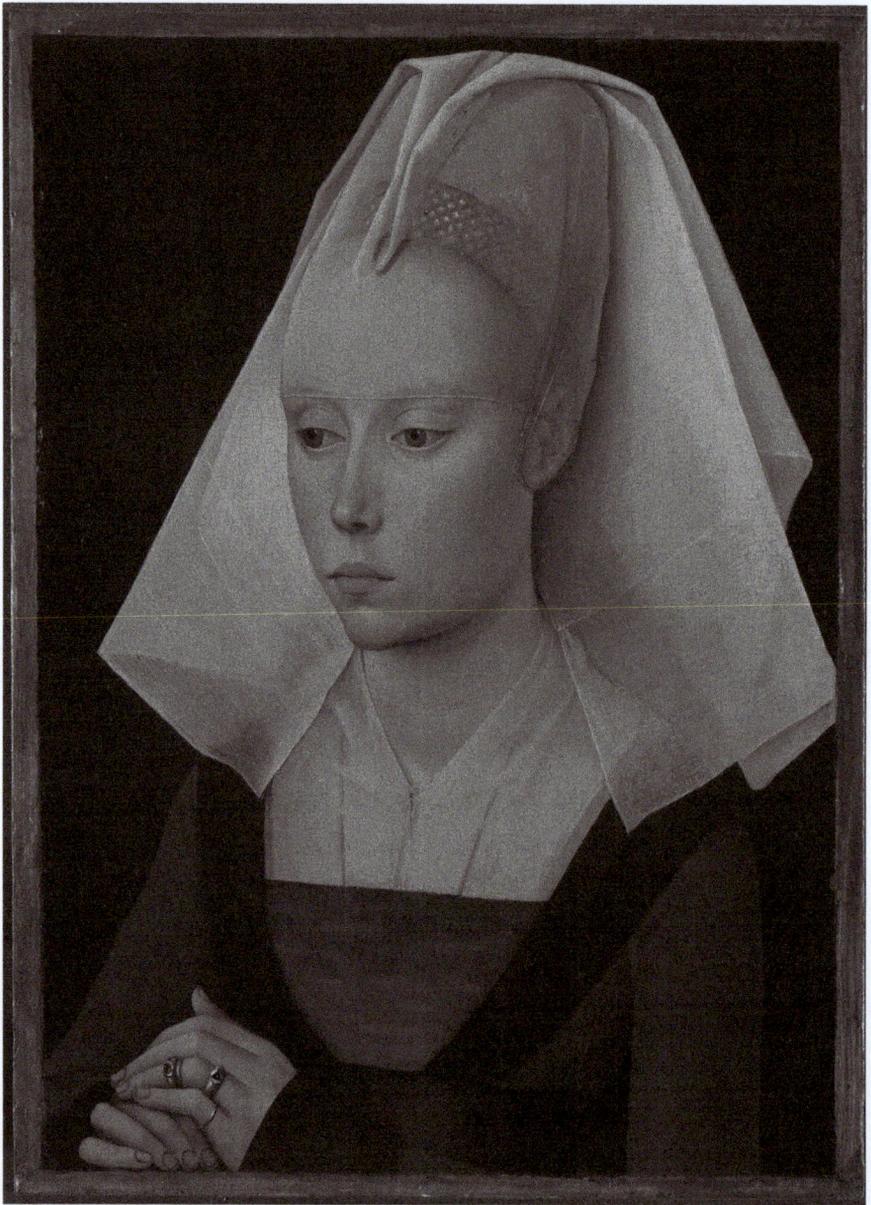

FIGURE 7.6 Workshop of Rogier van der Weyden, *Portrait of a Lady*, c. 1460. ©
National Gallery, London/Art Resource, NY.

hair, to highlight rather than hide it (Payne et al. 1992: 206; Pendergast and Pendergast 2003: 457). Early sixteenth-century paintings show fine silk mesh covering but emphasizing the hair, as in Raphael's *Donna gravida* (*c.* 1505, Palazzo Pitti).

Men and women alike wore lengths of decorative fabric as headdresses that defy labels like *veil*, *hood*, or *turban*. From the late 1300s to the early 1500s, hoods and veils evolved into turban-like headdresses: the *chaperon*, *mazzocchio*, and *balzo* (Jirousek 1995). A man's fifteenth-century *chaperon* could be worn with the tail and cape hanging down, recalling its origin as a hood. Alternatively, these could be tied around the headpiece to resemble a turban—as in the companion portrait to Figure 7.5, *A Man*, by Robert Campin; or Jan van Eyck's 1433 *Man in a Turban*, both in London's National Gallery. By the mid-fifteenth century, Italian women had embraced the *balzo*, a length of cloth tied like a turban around the head (illustrated in Vecellio 2008: c. 96). Smaller versions of the *balzo* (like that in Andrea del Sarto's *c.* 1514 supposed portrait of his wife, in Madrid's Museum del Prado), although made of decorative fabric, resemble simpler fifteenth-century caps and head-wraps, again demonstrating the problematic nature of labels. The visual prevalence of such headgear suggests that it was not just an artistic device for otherness or, as Friedman argues for illustrations of women, an "ennobling and distancing ornament" (2008: 191). Still used in the early sixteenth century, the *balzo* seems to have been superseded by the *capigliara*, a cross between a wig and a turban, from beneath which the hair was visible—as in Titian's 1534 *Isabella d'Este*, in Vienna's Kunsthistorisches Museum, and Lorenzo Lotto's *c.* 1530 *Lucrezia*, in London's National Gallery (Levi-Pisetzky 1964–1969, 3: 90–3). In addition to these adaptations of Ottoman headgear, Charlotte Jirousek (1995) has shown that even the fifteenth-century taste for tall, brimless hats derived from Turkish fashions.[15] Yet despite contemporary polemics (and much recent scholarship) on veils, these borrowings seem to have elicited little comment.

Like veils, handkerchiefs were often imagined as cleansing white linen, recalling the Veronica. Rectangular in the fifteenth century, the square handkerchief became a visible accessory during the sixteenth century, with lace and fringe borders for the elite (Figure 7.4). Finely embroidered handkerchiefs referenced women's leisure, refinement, and well-regulated domesticity. Despite being a universal sixteenth-century accessory, handkerchiefs, like veils, could signal women's chastity or availability (Mirabella 2011a). Yet legislation sometimes circumscribed women's agency in using handkerchiefs: prostitutes in certain cities were at times required to wear a yellow handkerchief or veil (2011a: 70). Moreover, as Mirabella argues, the handkerchief was an intimate cloth worn and used next to the skin: even if deployed to signal purity and domesticity, it could be misread.

TECHNOLOGIES FOR PERMEABLE BODIES:
SPECTACLES, WATCHES, DRUGS, AND JEWELRY

According to traditional medical theories, the eye and body were permeable and impressionable: anything the eye could see might heal or harm the body (e.g. Henderson 2006; Leonhard 2011; Gage 2016). Saint Luke, patron saint of painters, was a doctor; in Florence, painters belonged to the doctors' and apothecaries' guild until the sixteenth century. This approach to vision suggests the medical importance of attending to clothing and appearances, curating the home, and collecting art.

The invention of spectacles in Pisa was thus deeply significant: glasses were widely adopted across Europe, with the first patent granted in Venice in 1471 (Ilardi 2007). Despite early glasses' poor quality, they dramatically extended a man's useful working life. (Women are rarely depicted in spectacles.) The frames bore a hinge at the bridge of the nose, allowing one to fold the frames and double the lenses, turning spectacles into a magnifying glass. Although regarded with suspicion for a couple of centuries—doctors wore glasses but preferred to prescribe medicines for failing sight—the invention of spectacles eventually forced revisions in optical theory about 300 years later (Ilardi 2007: 237).

Clocks, invented around 1300, produced by the sixteenth century the mechanical "pocket watch," which took the form of a large ornamental pendant or sphere worn on a chain around the neck, or a small box attached to a ring (Cuss 1952; Levi-Pisetzky 1964–1969, 3: 101, 169). Although watches only had an hour hand and were used more as decoration than for accuracy, the idea of measuring the hours in a day in a repeating circuit attached to a specific body was dramatically different from measuring time by the seasons, the Church calendar, and the linear time of God (from Creation to the Last Judgment). The pocket watch, used as jewelry, advertised ownership of time as wealth.

Despite rapidly changing clothing styles and the prominence of expensive body decoration like watches, the conspicuous consumption of goods—antithetical to the medieval Christian valorization of poverty—still generated anxiety. Unease with the consumption enabled by Spanish colonial expansion emerges from a *c.* 1627 still-life painting by Juan van der Hamen y León (Figure 7.7; National Gallery of Art, Washington, DC). Untouched sweetmeats and preserved cherries share the canvas with a German round-flask and, in the left foreground, imported earthenware called *búcaros*: items newly available thanks to Spain's imperial wealth and Europe's expanded access to sugar since *c.* 1500 (Huetz de Lemps 1999). Sugar had been transformed from a luxury spice in the Middle Ages to a staple food, now grown in the New World; that said, in Elizabethan England, per capita sugar consumption was no more than a pound per year—as compared with Britain today, at eighty pounds per person per year (Freedman 2008:

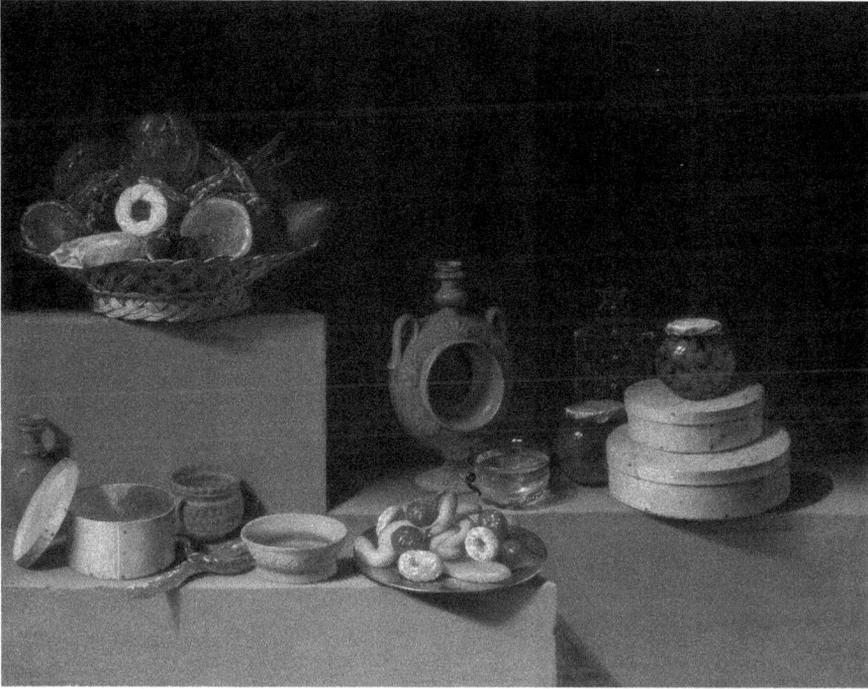

FIGURE 7.7 Juan van der Hamen y León, *Still Life with Sweets and Pottery*, c. 1627.
© National Gallery of Art, Washington, DC.

219). The relative prevalence of sugar enabled the popularization of drinking chocolate at the turn of the seventeenth century, often showcased in still-lifes like this one (Huetz de Lemps 1999). Carmen Ripollés (2016, 2017) argues that such paintings simultaneously highlight the wealth and hospitality of Madrid's elite and the excessive material consumption and the moral and physical illness deriving from New World imports. *Búcaros*, brought to Spain from Portugal and the New World, were used to store and cool water, apparently giving it a delicious taste (Seseña 1991; Hamann 2010). This flavor was so particular that the *búcaros* themselves became objects of consumption, particularly among elite women, as small pieces were broken off from the flask and eaten.[16] But the flasks, delicious as they may have been, were addictive, and in some cases eating them was fatal. If paintings themselves could heal or harm, then the fashion for this kind of subject suggests a cultural sickness.

Eating earthenware was more commonplace than it might seem nowadays: early modern doctors often prescribed medicines that included fragments of precious stones like emeralds, which were believed to have specific healing properties (Cavallo 2007: 77–81). Wearing particular stones could also

promote health or balance the humors: since the skin was porous and open to outside influences, the right stone could heal the body wearing it. Symbols and colors, as well as the stones themselves, were thought to affect the body: a woman nearing the end of pregnancy might be protected by a pelican symbol, while snakes and dragons carved onto jewels guarded against poison (Venturelli 1996: 134; Cavallo 2007: 76–8). Sandra Cavallo notes that faith in protective colors and symbols actually grew during the Counter-Reformation, with a new emphasis on jewelry bearing a religious charge created through prayers or carved symbols (2007: 78–9). Despite their power, colors did not have universal meaning even within single cities, and combining colors changed their meaning; but the brilliant shades that characterized much fifteenth- and early sixteenth-century fashion gradually gave way, under Spanish influence, to more sober blacks.[17] While this change is often associated with Reformation and Counter-Reformation piety, author and commentator Francesco Sansovino observed in the 1580s that Venetian women's faces contrasted strongly with their black clothing, appearing even whiter and therefore more beautiful (1683: 400).

One reason that women's faces appeared so white was the widespread use of cosmetics, particularly in the sixteenth century. For this reason, locating identity in the supposedly sincere face (rather than possibly falsified clothing) remained problematic: in *Twelfth Night*, Olivia speaks of removing her veil, saying "we will draw the curtain and show you the picture" so that beneath the veil is an image rather than the true person (1.5.223).[18] Despite the tradition condemning makeup, elite women commonly painted face and décolletage, using noxious substances like ceruse (white lead) and fucus (red crystalline mercuric sulfide) to whiten the skin and redden the cheeks and lips (Phillippy 2006: 31). Sixteenth-century men and women commonly exchanged cosmetic recipes, especially for lightening the hair (Levi-Pisetzky 1964–1969, 2: 123–5); while women might add padding or additional locks to their hair, full wigs for men were not common until the mid-seventeenth century. Apothecaries supplied medicines, cosmetics, and artists' paints, which used the same pigments as in cosmetics. This range of products reflects the many sides of the cosmetics debate: cosmetics might beautify and thus present a more pleasing (even more healthful) vision to a woman's menfolk. Yet makeup was also paint that concealed God's creation with a falsified mask; and cosmetics, like other chemicals, might harm or poison the body. As with the veil, makeup could signal chaste submission, falsehood, or unchastity; or it could be a tool of self-determination (Phillippy 2006).

The newly bright white faces of the late sixteenth century echo the changing regimes of bodily hygiene, as the head and hands—now highlighted by white ruffs and dark clothing—became the focus of cleaning. Increasing attention was paid to ridding the porous body of its excretions, which included hair on the head: barber-surgeons were often deputed to cleanse fluids released via the scalp, ears, and nose, in addition to extracting teeth and freshening the breath

(Cavallo 2007: 38–54). While in the early 1500s jeweled toothpicks and ear cleaners of precious metals were shown as collectibles or worn prominently on the body, Giovanni della Casa (writing in the 1550s) condemned such display; later in the century, these hygiene items were no longer displayed and seem to have been made of simpler materials (Cavallo and Storey 2013: 244). Increasing attention was paid to cleansing the head of grease and dried skin by using fine-toothed combs and rubbing cloths, so that "morbid vapours generated by the digesting stomach during sleep" might escape through the scalp (Cavallo and Storey 2013: 243). As with toothpicks and ear picks, combs seem to have become utilitarian: rather than being treasured and exhibited, they were frequently bought new for sanitary reasons (Ago 2006: 175–7; Cavallo and Storey 2013: 245). This increased focus on emptying the body, especially the head, of its putrid excretions led to an equation of cleanliness (and therefore wealth) with health.

In Galenic medical theory, odors penetrated the body: the brain was the main scent receptor and the nose a mere pathway to the brain. Perfumed objects were thus used as protection against the unhealthy smells that might penetrate and sicken the body. Cavallo traces a shift from a late medieval and early Renaissance focus on ambient foul air that must be guarded against (e.g. with a pomander or by burning aromatic herbs or closing windows) to a new insistence on pure and healthful air, now curated in the domestic interior by the judicious use of perfumes (2016: 709–16). Doctors advocated balancing the humors of the ambient air through appropriate scents: for example, using vinegar ("cold and dry") for summer and herbs like mint and sage ("warm") for winter (2016: 708–12). In fifteenth- and especially sixteenth-century Italy, smells were gradually reconceptualized to emphasize the agency of the individual in selecting and using scents to promote both health and "spiritual well-being" (Cavallo and Storey 2013).

As a result, in the sixteenth century in particular, many bodily objects were perfumed. It is often difficult to distinguish among cosmetics, medicines, and jewelry, since the function of much physical ornament was to perfume the air and promote the health of the wearer. This was true not just of pomanders, which were worn around the neck or attached to the belt. Rosaries, necklaces, buttons, belts, chains, and gloves were very often perfumed as well. Evelyn Welch (2011) has linked the sharp rise in perfumed objects in the second half of the 1500s to both the dissemination of perfume recipes via print and the plague of 1576–1577. Print may likewise be responsible for the emerging tendency to associate specific scents with particular humoral qualities (Cavallo 2016: 712). Anyone with the ingredients could make many of the scented pastes to fill filigree buttons or jeweled chains, and perfumes for gloves or linens: no single guild controlled the emerging industry (Welch 2011: 23). As more scented objects were produced, they became more widely available and affordable: by the early

seventeenth century, perfumed gloves were commonly distributed to mourners at the funerals of English nobles (Vincent 2003: 65; Welch 2011: 23). Sweet-smelling hands were so important that perfumed gloves fell within the ambit of perfume-sellers (Levi Pisetzky 1964–1969, 3: 123; Welch 2011: 24–5).

The glove is particularly emblematic of the new personal agency in curating bodily objects to promote a healthy and moral body. Gloves moreover reflect many of the issues explored above as they highlight bodily fragmentation, and simultaneously suggest sincerity but also mask the hand that they cover. In an urban environment in which it was often difficult to trust appearances, gloves were frequently used as a sign of faith or a pledge, since they metonymically stood in for the hand. But they were also empty, hollow, and often dispersed, phantasms of the absent wearer. Jones and Stallybrass (2001) have argued that the gloved hand—and the glove without a hand—came to assume a peculiar significance, with gloves being sometimes merely functional, and at other times invested with profound meaning: they were signals of nobility, tokens of friendship or love, or symbols of actual lovemaking. The new medical emphasis on using clean hands to perform tasks like eating or cooking generated anxieties about dirty hands, making the glove even more important. Perfumed gloves could guarantee cleanliness and beauty; they protected from dirt, but also limited dexterity, disabling the wearer while preserving soft white hands. At the same time, gloves could hide and disguise filth, covering the signs of menial labor and deftness. With the face now conveying identity, hands signaled agency: together, the two indicated sincere action. Yet, like the shoe, the glove could "ennoble" while essentially rendering the wearer helpless (Jones and Stallybrass 2011: 120). Gloves simultaneously emblematize faith and masking, agency and uselessness, cleanliness and filth. By highlighting the hand as both present and absent, gloves epitomize the paradox of Renaissance bodily objects, which simultaneously curated, created, and eliminated the body.

The new emphasis on clean personal linen for healthy moral bodies followed the externalization of "underwear" via the visible linen shirt. Spiritual well-being was further tied to the individual body by the new importance of curating healthful air. Continually remolded to a changing silhouette, this body must now have money for linen shirts, frequent laundering, and individual scent and perfumed items like buttons and gloves. By around 1600, the visible "moral goodness" of a person no longer depended on the renunciation of personal wealth and denial of the body, but rather on the curation of fragmentary bodily objects. Paradoxically, bodily objects allowed for the triumph of the self as moral essence through the tools of social construction: starched white ruffs, a whitened face, a constructed carapace of clothing, beautiful but decorous shoes, and sweet-smelling hands, clothing, and breath.[19] Given the important work performed by objects, only wealthy bodies could be both physically and spiritually healthy.

Object Worlds

Kunststück and Kunstkammer

ANDREW MORRALL

OBJECT WORLDS

From the 1550s onwards, in the courts of Northern Europe, habits of elite collecting, already well established in the fifteenth century, coalesced around a new concept of the *Kunst-und-Wunderkammer*, the cabinet of art and wonder. Among the earliest such collections were those of Emperor Ferdinand I, begun in *c.* 1553, and Elector August of Saxony I Dresden and Archduke Ferdinand of Tyrol in Schloss Ambras, both begun in the 1560s; Duke Albrecht V of Bavaria housed his collection in a purpose-built structure, erected in Munich between 1564 and 1567. The most extensive collection of all was that of the Habsburg emperors, extended by Maximilian II (emperor 1564–1576) in Vienna and further substantially enlarged and transferred to Prague by his son, Rudolf II (emperor 1576–1612). These collections were organized broadly around an encyclopedic principle that saw in the manifold things collected a physical compendium of knowledge about the larger world. This form of collecting had begun among the wealthy merchants of Augsburg, especially the Fugger family, prompted by the geographic reach of their trading connections and their enlightened, humanist interests. Samuel Quiccheberg, the erstwhile librarian and archivist of Hans Jakob Fugger before becoming advisor to Duke Albrecht of Bavaria, and the author of a treatise on the *Kunstkammer*, envisaged the ideal collection as a theater of wisdom, a system for organizing knowledge about the universe (Meadow

2013: 9, 61). The objects within these collections generally conformed to two broad categories: natural objects (*naturalia*) and human-made objects (*artificialia*). Natural objects, drawn in large part from the explorations of new worlds, were chosen for their rarity, their exotic origins, or their aberration from nature's norm. Human-made objects were collected for their ingenuity of invention and intricate skill. A subset of this category, sometimes classed as *scientifica*, included mechanical and other instruments of measurement. Although each collection differed markedly according to the individual interests of its owner, the driving concept behind the formation of such collections, as Quiccheberg's treatise for an ideal collection suggests, was an attempt to build as complete and systematic an instantiation of human knowledge of the world as possible. In this sense, the *Kunstkammer* brilliantly contained within itself many of the impulses and aspirations of Renaissance culture. The *naturalia* brought back from newly discovered worlds constituted physical evidence of things formerly unknown—of new knowledge of the natural world; and the scientific instruments—*scientifica*—were both the tools of contemporary scientific research and examples of new, up-to-the-minute technical expertise. But besides these, what of the large numbers of works of art and craftsmanship that were contained within the category of *artificialia*? Modern scholarship has tended to regard them mainly in terms of their technical virtuosity and explained their presence in terms of an art/nature paradigm—as demonstrations of human *techne*, largely understood in terms of practical skill, made in rivalry to the wondrous creations of nature. And while these qualities were an important aspect of their appreciation, they can obscure the point that these works as often as not were also expressive of deeply meditated themes: their materials, forms, and iconography embodied or addressed other areas of human knowledge and experience.

The term that is frequently used in inventory and contractual descriptions of such kinds of works is "*Kunststück*," or its cognates. It is a word that is difficult to translate, meaning literally a "piece or example of art," while containing strong connotations of demonstration or display: "a demonstration of art," therefore, or "demonstration piece." Thomas Rucker, sword-maker at the court of Dresden, described a monumental iron throne that he fashioned as a "*Kunst stühck*" (Krull and Netzer 1981, 2: 497). Destined for the imperial collection of Rudolf II, it contains in every member—legs, arms, and back rails—small chiseled scenes that described the entire course of Roman imperial history from Aeneas to the sixteenth-century present, framed within an allegory of the Four World Empires drawn from the Book of Daniel. In 1572, the prominent Augsburg instrument-maker Christoph Schissler wrote to the Elector August of Saxony, offering a range of specialized goods, including terrestrial and astronomical globes, astrolabes, "planispheres," "unusual and wonderful" clocks, sundials, and compasses.

But beyond purely practical instruments, he also offered collectible luxury items such as a so-called *"Horologium Ahaz Hydrographicum,"* a "clock of Achaz" that followed the biblical narrative (2 Kings 20:11) in which God, as a sign to King Hezekiah, caused the shadows to retreat a full ten hours backwards in time. Yet another instrument on offer boasted the ability to replicate the miracle described in Joshua, X, 13–15, whereby the sun stood still in its course through the heavens for a full day at the behest of Joshua as a sign of God's favor. Schissler, too, described his inventions as "remarkable demonstrations of art" (*"sonderlich kunststück"*) (Bobinger 1954: 34). These examples serve as examples of the *Kunststück*, whose chief purpose was not so much utility as a demonstration of skills: of ingenuity of design and virtuosity in manufacture, for sure, but also expressive of an original concept that, in the case of Rucker, drew on multiple historical sources to create an allegory of imperial dominion over time and its place within divine providence, and in the case of Schissler, sought to reenact the mechanics of a biblical miracle.

A further important part of their meaning and appeal to their owners was their uniqueness. Their makers repeatedly stressed the fact that their creations were their own inventions and were marketed and sold as such. At a deeper level, behind these works lay a new conception of making, driven by the idea that the modern world in all its new discoveries and innovations was one now made by human endeavor and by human making. It was both a fundamental consequence of and a determining factor in the paradigm shift from the Middle Ages to the modern age ushered in by the Renaissance.

The intention of this chapter is to examine this category of works more critically and to set them within the context of the *Kunstkammer*, for which they were often specifically intended, so that, set between the objects of the natural world and the instruments of practical knowledge, they might fully emerge as objects of contemplation, as material interventions into the world of the intellect, human knowledge, and ideas.

"KUNST": A DEFINITION

At the heart of the term *Kunststück* is a concept of *"Kunst"*—of art—that is more than simply *"techne,"* understood as a practical skill, technique, principle, or method by which a work is made. By the mid-sixteenth century, in a process that began much earlier, an idea of *Kunst* had evolved that involved not just craft skill, but rather a conversation among all the arts. It was a conception of *techne* wider than that of the medieval epoch and that, indeed, was emblematic of its passing. This new attitude, already well established in Quattrocentro Italy, was ushered into Northern Europe in the early years of the sixteenth century as artistic links between north and south gathered momentum. One of the most complete statements of these new claims for art is to be found in a remarkable

memorandum, addressed to the elector Frederick the Wise, duke of Saxony, by Jacopo de' Barbari, the Venetian artist, who first settled in Nuremberg in 1500 and who subsequently worked for Frederick between 1503 and 1505 (Kirn 1925: 130–4). Jacopo, an artist of fairly modest talents, yet whose theoretical knowledge was highly regarded and anxiously sought after by Albrecht Dürer, acted as an important early conduit for Italian ideas about art into the north. In his memorandum, which is entitled *De la ecelentia de pitura* (sic), he makes an explicit claim for painting as "an eighth liberal art" (Kirn 1925: 134).

The true painter, he claims, belongs in the company of the Liberal Arts, for great art is impossible without such knowledge being within the practitioner's grasp; more, painting stands above all the other arts as it incorporates them all into itself: geometry and arithmetic are necessary for measurement and proportion, which in turn are necessary to properly express the forms of nature. Drawing upon Vitruvius' description of the necessary skills of the architect, Jacopo cites a necessary knowledge of music and philosophy for a proper understanding of place, of the condition of the air and the influence of air currents, the nature of trees and of stones and their virtues (Vitruvius 1914: 1, 5–6). Equally necessary is a knowledge of poetry and history, of their subject matter as well as their constituent parts, grammar, dialectic, and rhetoric. Lastly, it is most necessary for the artist to possess knowledge of astronomy, which, as the basis of chiromancy and the study of physiognomy and the influence of the stars upon human character, was indispensable for the proper depiction of human types in the various forms of narrative painting ("*istorie*" and "*poesie*"). In a further remarkable passage, Jacopo asserted that the painter must have knowledge of Aristotle's *De anima*, in order to know how the forms of nature appear to the sight and to understand the nature of (light) rays, so as to know how to render nature's materials onto the surface of his blank panels (Kirn 1925: 134).

Such passionate advocacy for a form of art based upon learning and intellectual precept famously left a deep and lasting impression upon Albrecht Dürer, who befriended the Venetian and, by his own account, actively (and in vain) sought to learn Vitruvian principles of proportion from him (Rupprich 1956–1969, 1: 102). Dürer's own subsequent theoretical investigations, particularly his deep immersion in the problems of mathematics, geometry, and proportion, as laid out in his hugely influential treatise on human proportion, *Vier Bücher von menschlischer Proportion durch Albrechten Dürer von Nurenberg erfunden* … (1528); and his painter's manual, *Underweysung der messung mit dem zirckel und richtscheyt in Linien, ebnen unnd gantzen corporen durch Albrecht Dürer zu samen getzoge[n]* (1525), paved the way for subsequent craftsmen to follow.

The Italian Renaissance ideal of the liberal arts was in fact fully articulated by German humanists writing on art in the 1540s. Johann Neudörfer, Nuremberg mathematician and writing master, in his "Notes on Artists and

Craftsmen from the Year 1547" (*Nachrichten von Künstlern und Werkleuten aus dem Jahre 1547*), reveals an essentially artisanal attitude to art and aesthetics, characteristic of Nuremberg craftsmen in the 1540s, in his interest in and praise not just for technical accomplishments—skill or innovation in craft processes—but also for a grasp of theoretical principles. Typical is his account of the famous goldsmith Wenzel Jamnitzer and his brother Albrecht, whose status as innovators Neudörfer acknowledges when he characterizes them as equals in "the invention/discovery of art" ("*Erfindung der Kunst*") (Neudörfer 1547: 126). "*Kunst*" here is to be understood in terms of practice, for it is essentially technical accomplishments that Neudörfer then enumerates: the skillful carving of coats of arms and seals in silver, stone, and iron, glass enameling in the most beautiful colors, etching in silver, and, most particularly, casting small animals from life. But accompanying and constituting a part of such accomplishment is an important theoretical dimension: their proficiency in perspective and measurement ("*Haben der Perspectiv und Messwerk einen grossen Verstand*") (Neudörfer 1547: 126). Elsewhere in his biographies, Neudörffer frequently marks out for praise a grounding in similar principles. Peter Flötner and Georg Pencz are but two of many artists praised for a grasp of "*Perspectiv und Masswerk*," the former also for his skill in composing narrative histories to adorn goldsmiths work, the latter for his understanding ("*Verstand und Geist*") of the principles of narrative composition (Neudörfer 1547: 115, 137); "*Perspectiv*" is what characterizes Georg Glockendon the Elder, illuminator and *Briefmarker*, whose son published a book on the subject (Neudörfer 1547: 140). The sculptor Johann Teschler "created … whole images according to such painstaking and correct proportion, that it was wonderful to see" ("*machte … ganze Bildnisse von solche lieblichen und gerechten Proportion das es wunderbarlich zu sehen war*") (Neudörfer 1547: 116). The goldsmith Jacob Hoffman is highly sought after by kings, princes, and noblemen for his protean technical skills. Yet it is his great understanding of "*Symmetria*" that gives his large output its particular distinction (Neudörfer 1547: 127); and so on. Perspective, measure, proportion, symmetry, as well as antique subject matter and style: these were the principles that Neudörfer most highly valued in the work of his contemporaries. And throughout his account, Italy is cited as the source of proper theoretical grounding for such true principles of art.

An extended formulation of these Italianate principles is to be found in the exactly contemporary work of Nuremberg doctor, humanist, and translator of Vitruvius, Walter Ryff (Rivius), his *Unterrichtung der Skulptur* (*Instruction in Sculpture*), part six of his 1547 compendium of Italian and classical writings on "*Architecture and the ancillary mathematical and mechanical arts.*" He stressed the impossibility of making truly great art without a firm understanding of the mathematical arts ("*Mathematische Kunst*"). And this grasp, he says, reflects "the learning and mathematical grounding" of current Italian sculptural practice,

which in turn is based upon emulation of ancient sculptors, those he calls the *"echten alten antiquen"*—literally, "the true old ancients" (Rivius 1981, 6: XIX v.). Such knowledge, moreover, involves careful study and absorption of both ancient literature and modern sculpture. To effectively portray a colossus, for instance, Rivius recommends that the modern sculptor read and reflect upon the style of Virgil's dramatic description of Polyphemus; or to effectively create a "beautiful well-proportioned horse," he should bear in mind "a form such as that Donatello made in Italy, which is regarded as a wonder amongst works of art"—a reference to the *Gattemelata* in Padua. And to grasp the characteristic attitude and behavior of a "frisky" (*"gefreudigtes"*) horse, the sculptor should read the songs of Virgil in which he so artfully (*"künstlich"*) describes the horsemanship of the Trojan youth (Rivius 1981, 6: XX). The practitioner is thereby encouraged to adopt the rhetorical conventions of ancient literature into his own artistic language of forms.

Neudörfer's account demonstrates how the city's elite craftsmen had fully adopted a developed theory of art. The *Kunststück* evolved naturally from within this craft world; and this newfound creativity and artistic self-consciousness was given particular momentum and direction by the collecting interests of the wealthy patrons who sought out works of technical and conceptual ingenuity that might fit within the knowledge systems of their newly conceived collections. Generated in the atmosphere of a blossoming urban humanism, these works then entered the strange, heady world of the *Kunstkammer*, where, jostling among the fragments of nature and instruments of science, they mutely transmitted their own distinct forms of knowledge.

THE *KUNSTSCHRANK* AND THE AESTHETICS OF INTARSIA

Modern scholarship has been largely inattentive to the qualities, context, and reception of the *Kunststück*, which found expression in virtually all of the different craft media. The remainder of this chapter will be devoted to exploring the invention, development, and reception of one particular and representative object type—a completely new artistic form that was wholly the product of the new culture of collecting. This was the *Kunstschrank* (pl. *Kunstschränke*), or art cabinet, which was purpose made to house collectibles and other small works of art; a miniature, in fact, of the larger *Kunstkammer*. The earliest examples were constructed using intarsia, or wood inlay, a newly developed technique of surface decoration made by the intricate patterning of differently figured, grained, and textured woods. In the process, their makers created an entirely new visual language that had no equivalents in the other visual media of the period.

The technique of intarsia originated in fifteenth-century Italy and eventually spread north of the Alps to Nuremberg and Augsburg. It flourished by virtue

of these cities' long tradition of woodworking and where, in addition, an equally technologically advanced metalworking industry was able to produce wire saws of a sufficient thinness necessary for the fashioning of thin veneers of wood. From about 1560 onwards, a taste for such intarsia *Kunstschränke*, gathered the momentum of a European-wide fashion. They were produced in considerable quantities and to varying standards of workmanship and complexity of design, ranging from very high-end, possibly commissioned pieces, to what amounts to a kind of serial production, made with simplified and easily reproducible motifs.

From its beginnings in fifteenth-century Italy, by virtue of the particular qualities of its medium, intarsia had been considered a different order of visual experience, associated with artists like Uccello, for whom artistic creation was inseparable from a veritable obsession with geometric solids. Vasari's anecdote, according to which Donatello reproached Uccello for spending too much time on geometric investigations, particularly the study of polyhedrons, expressed a history painter's disdain for the medium: "These things," he wrote, "are no use except to artists who work in intarsia ..." (Vasari 1991: 75–6). Vasari's disdain notwithstanding, intarsia work in Italy was a major art, closely linked to the development of perspective. In Germany, practitioners tended to be interested in the mapping of solid objects and surface patterns rather than in the rendition of space. Yet to practitioners and patrons on both sides of the Alps it was a singular art form that literally "constructed" representation by assembling geometric shapes; an art in which, as André Chastel put it, "mathematical form creates its [own] object" (Chastel 1953: 141–54).

The heightened attention that the technique lends its material base, the insistent presence of the wood medium that creates an almost tactile play between the sectioned wooden pieces and what is represented, also produced new and unique conceptual and aesthetic possibilities: in effect, a different aesthetic order. It is a technique that generates dimensionality out of flatness; recognizable things coalesce out of non-things, shape from the inchoate, representation from an abstract patterning together of hard-edged shards of differently colored and toned woods. As late as 1677, the Jesuit Daniello Bartoli could compare the aesthetics of intarsia—this paradoxical representation of a material thing by means of wood, another material thing—with the literary form of the emblem:

> Is not the source of wonder, and therefore of delight in such works, the fact that one sees one thing used to express another? The deception being all the more innocent in that in the whole composition of a false thing there is yet no one element which is not true. The same happens when we use anything taken from history from fables, from nature and art, to represent something in the moral order which it is not. (Praz 1964: 19; Bartoli 1677)

This exceptionalism was registered by the cabinet-makers of Augsburg who petitioned their city council in 1568 against painters who were painting directly onto the wood: "… it is because of our cabinet-making that men in foreign parts praise our city for objects inlaid so sharply ('*scharfe Dinge*'), that no painter can rival it in colors, since colors do not render it as purely as wood …" (Alfter 1985: 24). For Paul von Stetten, antiquarian and historian of the Augsburg craft tradition, writing in the eighteenth century, the art of intarsia still carried with it an important tradition of local craft excellence:

> … this so-called inlay work was very sought-after, and there were few places in Germany with the knowledge to make it. They were mostly of architectural and perspectival fantasies … but also views of cities, flower pieces and also historical scenes, though these latter did less well. These works, among which there were real works of art (*wirkliche Kunststücke*) were sought after from far and wide and paid well. (1779: 113–14)

Beyond the singularity of technique and its novel interplay between materials and representation, what made these designs so distinctive and unlike any comparable pictorial conventions was their imagery, which combined naturalistic landscape settings, ruins, and abstract geometric forms, often incongruously rendered as startling showpieces of perspectival construction.

These qualities can best be illustrated in the so-called *Wrangelschrank*, one of the most elaborate of the surviving examples, today in the Westfälisches Landesmuseum für Kunst und Kulturgeschichte, Münster (Figure 8.1). Although it takes its name from its seventeenth-century owner, the Swedish *Reichsmarschall* and General Governor of Pomerania Carl Gustav Wrangel, it is dated 1566 and attributed to an anonymous "Master with the House Mark," made possibly for one of the Fugger family. It is one of the very first surviving *Kunstschränke*. The box-like form opens to reveal a two-storied, double-columned facade, like a Roman temple, which encloses arched doors decorated with carved scenes of famous Roman battles, each one carefully labeled, behind which are drawers and shelves. By contrast, the outer panels and doors are entirely covered in rich intarsia scenes of an almost surreal complexity: tortured landscapes of ruination—depicting the disintegrating remains of ancient buildings, choked with encroaching weeds and plant life and scattered with strange, scrolling ornamental forms (*Rollwerk* or *Rollkörper* in German), lying cheek by jowl with bizarre geometric constructions (Figure 8.2). In the foreground, a series of different elements—putti asleep against the shattered fragments of classical torsos, (statues of?) obliquely rearing horses, a looming vase of flowers, a turkey, a crouching owl—interweave in a medley of forms and emblems according to a wayward poetic logic quite indifferent to logical scale relationships or narrative coherence. These outer panels, in contrast to the interior scenes of human history and action, turn upon a vision of the world strangely voided of human presence, implied only in broken remains scattered in a restless realm of nature.

FIGURE 8.1 Unknown Augsburg master, *The Master of the House Mark, The Wrangelschrank*. 1566. © Westfälisches Landesmuseum für Kunst und Kulturgeschichte, Münster.

These strange images defy categorization within the usual orders of sixteenth-century art. They neither adhere fully to pictorial conventions of landscape or still life, though they share elements with each, nor are they purely decorative in any contemporary sense of ordered ornamentation. Previous scholars have explained them almost exclusively in formalist terms and from the standpoint of Italian Renaissance perspective and its influence. For Liselotte Möller, the author of a monograph on the piece, they were the extreme offshoots of European Mannerism (1956: 36–7); for James Elkins, they were a "radical transformation and rearrangement of Italian, German, and Flemish forms into a style both eccentric and new" (1994: 159). Christopher Wood regarded them as the products of "genuine but incompletely realized intellectual ambitions" of German craftsmen (2003: 236). Yet the poetics of this strange style and subject matter and the ontologies of its forms still remain to be explored.

THE POETICS OF INTARSIA

Such cabinets were exported all over Europe and appear variously in the inventories of such rulers as the Duke of Bavaria, the King of Denmark, and Catherine de' Medici of France. Catherine's inventory, drawn up after

FIGURE 8.2 *Wrangelschrank*, detail of the outer door. © Westfälisches Landesmuseum für Kunst und Kulturgeschichte, Münster.

the death of her husband Henry II in 1589, lists several cabinets, seven of them in ebony and marquetry, including "a suite made in the German manner (façon d'Allemagne) with gadrooned silver pilasters at the corners of the drawers in marquetry, in the form of a theatre ..." (de Champeaux

1885: 36). Indeed, such intarsia was a sufficiently familiar and distinctive art form at the French court that when Jean Dorat (1508–1588), humanist and court poet, looked for an apt simile to sum up the elaborate formal and poetic inventions of a dance spectacle given by Catherine de' Medici in the Tuileries Gardens in 1573, later known as the *Ballet des Polonais*, the image he chose was of an intarsia writing table (Kocieszewska 2012: 819–20). His comparison between the qualities of wood intarsia and the intriguing, complicated, never-before-seen movements of the ballet gives an important and all too rarely articulated sense of how contemporaries viewed this difficult and complex aesthetic. It appears in his poem, the *Chorea Nympharum* (Dance of the Nymphs), part of a Latin poetic description that served as the official account of the festival (*Magnificentissimi spectaculi ... Descriptio*, Paris, 1573) in the following way:

> ... see the band of Nymphs begin to dance in a set rhythm ... Now you would think as many Queens were passing by as Nymphs, such is their dignity in their slow severity. Now you might think them as many dolphins swimming playfully as they flit with effortless mobility. They repeat a thousand short advances and a thousand short returns; they combine a thousand flights, a thousand pauses of their feet. Now they cling like bees by clasping hands together, now they form a point like a flock of voiceless cranes. Now some cleave to others in oblique knots, like a hedge made of artfully entangled brambles. Now they form variously this figure, now that, on the dance floor; *no writing table ever carried more signs, nor that which shows Euclidean lines drawn in the sand, nor that on which the fleeing [chess] piece is lost to the swift enemy.* There were not so many turnings in the structure of the Labyrinth, nor did the waters of the Meander ever wind so sinuously. (Kocieszewska 2012: 819–20)

Dorat employed the image of the writing table to evoke the dance's unusual and novel qualities: the varied and complicated movements, the short advances and returns, flights and pauses, the lack of any typical narrative action, the sense of the dance as a sequence of unusual images, emerging and receding—of queens, cranes, bees, entangled brambles—emblems in which the meaning of the festival was encoded. Thomas Greene, who identified the classical sources of most of the references, described the poem as a cluster of motifs from classical poetry (2001: 1403–66). More recently, Ewa Kocieszewska has shown how "each simile offers a precise hint to pursue, making the text a legible praise of the French monarchy" (2012: 821). It was these fluid similes that echoed the formal complexity—the seeming inchoateness—the changeling sense of form—as well as the "signs," "the Euclidean lines," and the checkerboard-like designs of the (equally novel) intarsia surfaces of luxury furniture. Dorat, moreover, structured his own poem according to the same, essentially unnaturalistic, aesthetic: he,

too, eschewed any kind of narrative, and proceeded emblematically, in a series of enigmatic and concealing, rather than revealing, Latin poems.

Dorat's simile of the writing table demonstrates the extension—or at least an equivalence—of a particular poetics of marquetry into other artistic domains of literature and theater. It also implies a ready familiarity of his audience with the emblems ("signs"), abstract mathematical forms, and patterns characteristic of this particular medium. One can intuit, too, an equivalence that he found in the loose and unspecific way meanings are attached to forms. Like the dance, the individual elements of the *Wrangelschrank* offer a suggestiveness rather than a clear articulation of meaning attaching to them.

THE *KUNSTSCHRANK* AS VANITAS

Certainly, between the *Wrangelschrank*'s outer and inner states, a broad symbolism of human transience is clear: the outer imagery of time's destruction surrounds and envelops the interior spectacle of past Roman greatness, referenced in the battle scenes and in the ordered architectural facade. It was a fitting conceit for an object that housed collectibles—the ancient coins, cameos, and other curiosities of the collector—by which the historical past is literally enclosed—swallowed up, as it were—by the processes of its own dissolution. It would have prompted appropriate reflections upon the pathos of time's passage and of the evanescence of earthly fame and achievement in the manner of the *vanitas* still-lifes or allegories such as the *Sense of Sight* by Jan Brueghel the Elder and Peter Paul Rubens, which often prominently featured such collectors' cabinets (Figure 8.3). In fact, the imagery of the *Wrangelschrank* works in a manner very similar to that of the Brueghel. Meanings—poetic, historical, philosophical, and aesthetic—are generated not by any precise matching of signifier to a specific signified, but by an allusiveness of juxtaposition, of jostling fragments drawn from different cultural registers, of variety and density, of *amplificatio*, of the piling up of ornaments as a means of intensification. These are the rhetorical methods, applied here in the *Wrangelschrank* in visual, ornamental terms, which Walter Benjamin found employed in the structures of the Baroque *Trauerspiel*, and which work in both literary and visual genres to similar effects of pathos, melancholy, and a sense of loss attached to the historical.

What, then, is the place of the ruin in the *Wrangelschrank*'s imagery? Walter Benjamin's discussion of the ruin within the conventions of the German Tragic Drama is particularly resonant in this context: "The word 'history' stands written on the countenance of nature in the characters of transience ... In the ruin history has physically merged into the setting. And in this guise history does not assume the form of an eternal life so much as that of irresistible decay" (Benjamin 1998: 177–8). Benjamin moreover links the artistic form of the allegorical fragment embedded within the body of the poem or play with the

FIGURE 8.3 Jan Brueghel the Elder (with Peter Paul Rubens), *Allegory of the Sense of Sight* (detail), 1617. © Museo del Prado, Madrid.

ruin as a meaningful historical fragment embedded in Nature. "Allegories," he wrote, "are, in the realm of thoughts, what ruins are in the realm of things" (Benjamin 1998: 178).

What relationship do the intarsia ruins bear to the realm of thought? To take a step backwards and examine the nature of the intarsia ruins more closely, what is striking is their lack of specific historical reference, especially to classical Rome: they are not locatable, identifiable historical remains. These ruins are not images of archaeological interest such as the drawings of Roman buildings by Antonio da Sangallo, which were accompanied by measurements, or Hieronymous Cock's 1558 publication of Sebastian van Noyen's studies of the Baths of Diocletian, which contained precise studies of ground plans, measurements, and elevations of the ruined complex. Nor are they illustrations of actual Roman remains that allegorize their loss, like Cock's own series of etched views of the ruins of the Coliseum and the Capitoline Hill, published in 1561 and 1562 (Heuer 2009: 9–11).

RUINS AND NATURE

This abstraction from any kind of historical specificity or context confers upon the intarsia ruins the status of symbolic constructs. The genealogy of this approach can be traced back to fifteenth-century religious art, to the crumbling pagan temples, symbols of the Old Dispensation, portrayed in the printed Nativity scenes of Schongauer, Dürer, and their followers. In Wolf Huber's woodcut of the *Adoration of the Magi* (c. 1520–1525), for instance (Figure 8.4), one sees in the ruins that dominate the scene the pronounced perspectival construction, an interest in the oblique projection of interrupted arches and half-destroyed arcades, the open attic beams and the fragments of local landscape seen through broken arches: the whole repertoire of motifs, in other words, that was to reappear repeatedly in the later intarsia designs.

These formal concerns underpin a more profound set of meanings that ruins acquired when they were transferred from religious to secular forms of art. Huber's woodcut was the model for the crumbling, weed-strewn ruins that form the frame and setting of the large limewood relief portrait carved by Hans Schenck in *c.* 1525 of the Danzig cleric Tiedemann Giese (1480–1550) (*Der Mensch um 1500* 1977: 58–9) (Figure 8.5). Once transposed to the context of a secular portrait, what do these architectural ruins come to signify? They are archaeologically and historically unspecific; even as architecture, one cannot be sure what kind of buildings they represent. Neither do the crumbling piers bear any narrative relation to the sitter. Yet the theme of transience is clear and works on two chief levels: first, the skull that Giese holds is the form in which man's inevitable subjection to Nature is made most obvious. It points in that sense to the biographical historicity of Giese the individual. Second, the

FIGURE 8.4 Wolf Huber, *The Adoration of the Magi*, c. 1520–1525. Photograph: Andrew Morrall.

enframing architecture, in its suggestion of a long process of decay over time, summons to mind broader, enigmatic questions of the nature of human existence as such. What the skull is to Giese the individual, the ruins are more generally to human life. Bereft of identifying or other historical associations, the ruin is purely allegorical: it stands in effect for the course of Giese's life, enclosing

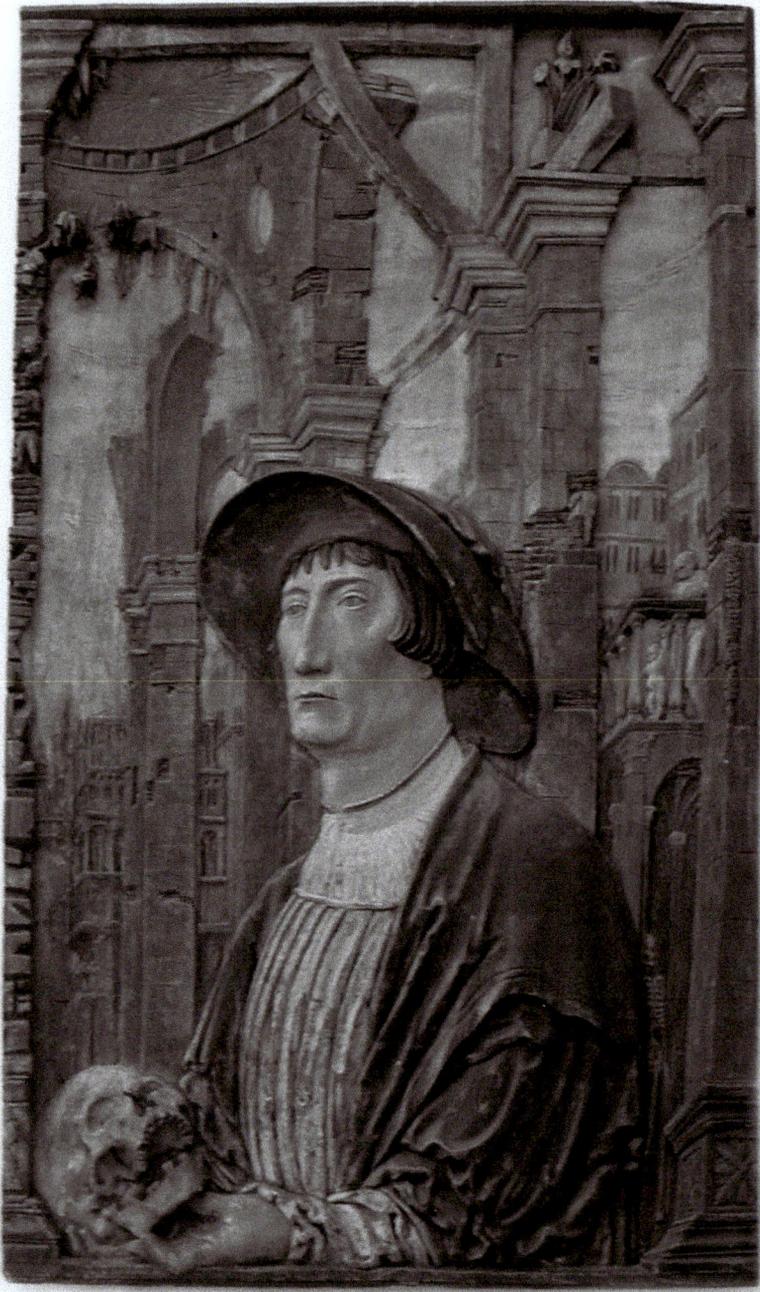

FIGURE 8.5 Hans Schenck, *Portrait of Tiedemann Giese* (1480–1550), *c.* 1525. Berlin, Bodemuseum, Skulpturensammlung (on permanent loan from the Foundation of Prussian Palaces and Gardens, Jagdschloss Grünewald). © Skulpturensammlungen der Preussischer Kulturbesitz.

the hubris of the immediate moment, in which Giese stares out in robust, if sober, confidence, with the spectacle of continuous and inevitable decay. The ruined setting also creates for the sitter a kind of *theatrum vitae humanae*: it contains the naked figures of a young boy holding an old man by the hand on a balcony to the right, a reference to the theme of the Stages of Man; it is also the domain of Death, whose skeletal form loiters off stage in the wings, holding a slingshot. It is a proscenium in decay, a theater of life continuously subject to Nature's slow, blind, ineluctable march. In fact, this portrait is one of the first instances in German art to use ruins to articulate the role of Nature in the drama of human transience; and it is Nature in a fundamentally unfamiliar role: no longer as beneficent provider, but Nature as a blind destructive force. In this abstract edifice's process of ruination, one glimpses the first inkling of a concept that comes more emphatically to the fore in the later intarsia ruin images: a sense of elemental forces at play between the aspirations of human culture and the deterministic weight of natural law.

This is both the formal and conceptual starting point from which the intarsia workers took their cue. In the great majority of intarsia cabinets, made to less ambitious design than the *Wrangelschrank*, the idea of human civilization submerged by nature is paradoxically more directly expressed. In an example today in the Metropolitan Museum of Art, New York (accession no: 25.135.112), the panels show ruins, like those of the *Wrangelschrank*, overwhelmed by vegetation; and in the smaller door panels, whole townscapes are similarly submerged. And inasmuch as they incorporate church steeples, they are modern townscapes, eerily deserted. In these simpler, serially produced versions, where the design is reduced to a thumbnail simplicity, the idea emerges with crude directness.

PLATONIC GEOMETRY

These ideas were mediated in part via the woodcuts of Lorenz Stöer, published as a pattern book, the *Geometria et Perspectiva* of 1567, which was explicitly aimed at intarsia workers (Figure 8.6). Here is the same interest in the odd curves formed by half-destroyed arches and arcades, and fragments seen through broken arches, all subsumed by Nature's advance. In Stöer, too, one finds the source for perhaps the most enigmatic elements of the intarsia designs: the looming polyhedrons, abstract whorls, and scrolling ornamental volutes that become standard motifs in the intarsia ruinscapes. Stöer's image in effect collapses the distinctions between architecture, ornament, and constructive geometry. James Elkins aptly observed how in them, "... arches and *Rollkörper* seem to grow together according to some natural law ... [while] the ruins ... have become so simple that they are nearly demoted to ornaments" (Elkins 1994: 163–5). We can observe a similar process in panels of the *Wrangelschrank*.

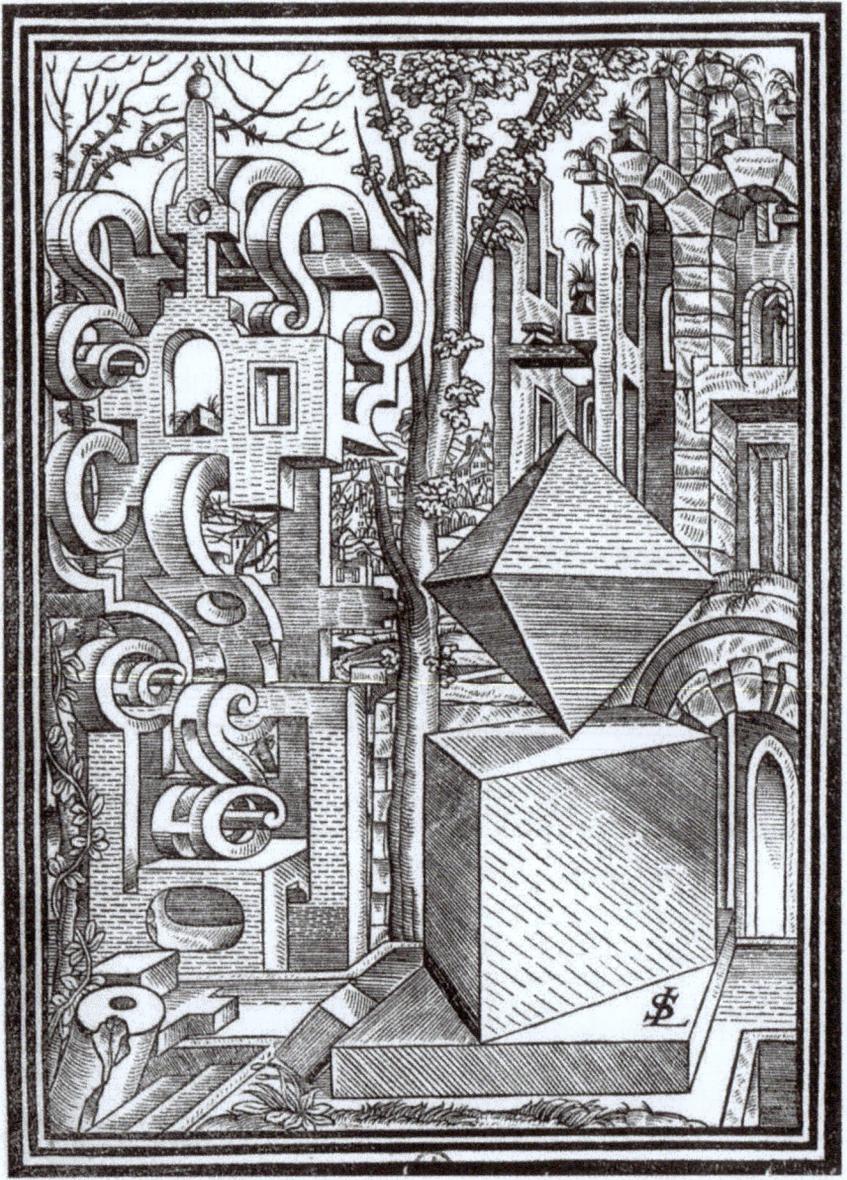

FIGURE 8.6 Lorenz Stöer, plate from *Geometria et Perspectiva*, 1567. ©
Universitätsbibliothek Salzburg/Wikimedia Commons.

This strange process of metamorphosis from architecture to ornament to
geometric form leads back to the mental world of urban craftsmen, and to a
strand of Platonism that dominated the perspective handbooks produced by
a circle of Nuremberg artists and craftsmen in the 1560s. The most elaborate,

Wenzel Jamnitzer's *Perspectiva corporum regularium* of 1568, explicitly tied the five so-called Platonic solids—the five mathematically regular geometric solids—to the five elements, and, citing Plato's *Timaeus*, saw them as the irreducible building blocks of matter out of which all things were formed (Jamnitzer 1568: Aiii). Jamnitzer assigned each of the five bodies to one of the four elements, while the fifth, the dodecahedron, represented the celestial sphere; each was furthermore associated with one of the five vowels, a principle that does not appear in Plato but belongs to the medieval encyclopedic tradition of associative numbers. Thus:

The Tetrahedron is associated with the element of fire and the vowel "A"
The Octahedron represents "Air" and the vowel "E"
The Hexahedron is the Earth and the vowel "I"
The Icosahedron represents Water and the letter "O"
The Dodecahedron represents the Heavens and the letter "V" ("U").

Jamnitzer's treatise subjected each solid to a spectacular series of variations in a demonstration of the mathematical correspondences with the boundless variety of natural forms.

That Lorenz Stöer, too, possessed a continuing fascination with the theme of solid geometry is evident from a bound folio volume of 336 pen and watercolor drawings by him, today in Munich University Library, made over a period of at least forty years (Pfaff 1996; Stöer 2006). An explicit Platonic association with the elements is made in one of the woodcuts in Stöer's booklet, *Geometria et Perspectiva* (1567), in which the solids, similarly arranged, are labeled respectively, "Terra," "Aqua," "Ignis," "Aer," and "Coelum" (Wade 2012: 57). Stöer's influence and, with it, a strong suggestion of attendant Platonic meanings are to be seen in a cabinet, today in the Museum für Angewandte Kunst, Cologne (inv. no. A 1451) (Figure 8.7). Its outer panels are decorated with scenes of topographical naturalism, of male and female personages, in costumes suggestive of different continents, including probable portraits of the patron-owners set in recognizably local natural settings. On opening the cabinet, these scenes fall away dramatically to reveal an interior display of the Platonic solids, set in combinations and in regular and irregular forms—in a manner very close to Stöer's drawings (and in a layout comparable to Jamnitzer's arrangements). In the contrast between naturalistic exterior and abstract interior it is possible to see an expression of the harmonic principles of creation that underlie the mundane reality of the natural world, a theme well in keeping with the collector's cabinet's function as a world in miniature. Looking at Stöer's woodcut ruin landscapes and the imagery of the *Wrangelschrank* in a similarly Platonic light, we may regard the transmutations of architecture to ornament and thence to geometry amid the encroachments of nature as suggestive of the slow but wholesale dissolution of matter back into its most primal elements.

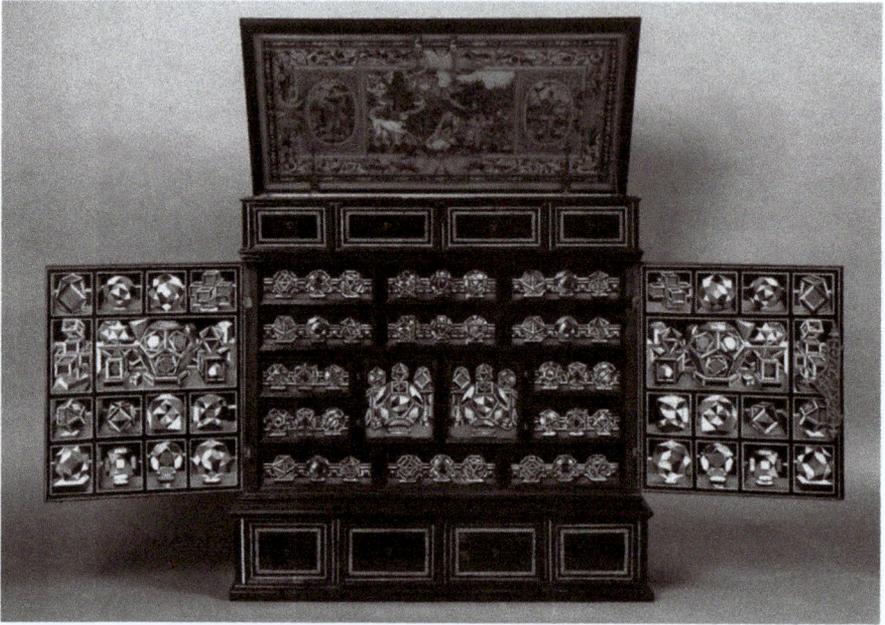

FIGURE 8.7 South German (Augsburg?) master, *Cabinet*. © Museum für Angewandte Kunst, Cologne.

OBJECTS AND MODES OF THOUGHT

The *Wrangelschrank*'s imagery and its function as repository mirrored quite precisely the larger space and objects of the *Kunstkammer*, for the cumulative effect of demonstrative works of this kind in many different media, including metalwork, hardstones, clockworks, automata, sculptures, vases, and jewelry, which jostled for attention amid a welter of like objects and trafficked so promiscuously in materials, form-language, imagery, and themes, was that it encouraged the owner to be by turn naturalist, theologian, cosmologist, ethicist, historian, and antiquarian. These objects addressed large questions—some ontological (the nature of existence), some ethical (how best to live in the world). Their themes could encompass the universe, and sometimes specific histories. Like the *Wrangelschrank*'s imagery, the *Kunstkammer*'s space and its objects together communicated through metaphor and correspondences; they crossed disparate fields, frames of reference, states of being—between cosmos and mind, or nature and history. In some works, knowledge was transmitted in narrative form; in others, it was related rhetorically or emblematically. Their meanings often moved between the factual and the mythological or allegorical, and sometimes, again, as in the *Wrangelschrank*, between all three in the same

object. The registers of meaning are sometimes clear; at other times, they are vague, generating an effect akin to a thought dimly emerging to consciousness. Such variety of theme and means of transmission encouraged an exhilarating heterodoxy of thinking. It required viewers to draw upon and cross-reference their own reservoirs of learning in theology, history, literature, natural philosophy, and mathematics.

Evidence for the kinds of interactions that such an artwork would have stimulated among the patron and his circle can be gleaned from the correspondence and diaries of Philipp Hainhofer (1578–1647), the Augsburg merchant, dealer, diplomat, and art collector, who, in the seventeenth century, single-handedly developed the *Kunstschrank* into a monumental work of art. He commissioned many different craftsmen to work on a single project that often took several years in the making, and filled their drawers with suitable *Kunstkammer* objects he assembled himself, before arranging their sale to wealthy clients. These contents, together with the complex iconographic programs that he designed to ornament their outer and inner surfaces, he explicitly described as serving both practical and contemplative ends: besides "serviceable utility," they might prompt "noble meditations and contemplations" ("... *neben dem nutzen und dienst, schöne meditations und contemplationes*") (Mundt 2009: 25).

On delivering a *Kunstschrank* commissioned for the Duke of Pomerania's *Kunstkammer* in 1617 that had been six years in the making at the hands of twenty-seven individual craftsmen, its many drawers filled with objects and instruments pertaining to astronomy and astrology, surgery, the arts of war, surveying, mechanics, and courtly amusements, Hainhofer recounted in his travel diary how, after formally displaying the cabinet several times, he and the Duke spent a whole day examining two works, and continued to discuss artists and artworks well into the night. On another occasion, he recorded how the Duke gave him several viewings of his coin collection, during which both men discussed the nature of the *impresa* and inscriptions these specimens contained (Mundt 2009: 25).

At a higher intellectual and more abstract level, the astronomer and mathematician Johannes Kepler provides evidence for precisely the flexible, genre-crossing faculty of mind that the *Kunstkammer* might have encouraged. On a visit to the collections of the Dresden court, he recounted seeing "a panel of silver ore from which a dodecahedron the size of a small hazelnut blossomed forth so that half of it stood out" (Kepler 2010: 111–13). He remembered this natural curiosity some years later when probing the question as to why, in nature, organized forms arise from seemingly shapeless, inchoate matter. In the case of crystal formation, he posited a putative formative faculty within the earth that determined their growth into regular shapes. This discussion appears in Kepler's treatise, *De Nive Sexangula* (*On the Six-Sided Snowflake*), which he

presented as a new year's gift to his friend and patron at the court of Rudolf II in Prague, John Matthew Wacker von Wackenfels, in 1610. The work addresses the question as to why snowflakes, the tiniest, most insignificant and evanescent forms of nature, are always regular, six-sided, and flat. Kepler's ensuing search leads him to seek patterns and analogies with other kinds of natural structures, including the honeycomb, the inside of a pomegranate, the clustered crystal formations that miners extracted from the earth, and the geometry of the five Platonic solids. His discussion of the latter parallels the understanding that underlies the geometrics of the intarsia panels, for he, too, was alive to a belief in the correspondences between mathematical truths and the forms of nature. He took seriously the notion that the pentagon, whose five sides are constructed by means of the golden section, itself derived from a self-generating numerical series, could therefore be inherently imbued with a procreative faculty. This led him to suggest that a mathematical order underlay the natural processes of biological and geological growth and reproduction. Ultimately, none of his speculative theories satisfied him, and he left the problem of the snowflake unsolved. Yet the spirit of the exercise was less the pursuit of truth in strictly logical Cartesian terms as rather a kind of intellectual fireworks display—a playful and immensely wide-ranging entertainment, which, by creating a universe of ideas out of a thing of such tiny compass, even took as its framing conceit the structure and operations of the *Kunstkammer*. As he exclaims at one point:

> But I am getting carried away foolishly, and in attempting to give a gift of almost Nothing, I almost make Nothing of it all. For from this almost Nothing, I have nearly recreated the entire universe, which contains everything! ... am I now to present ... the orb of the earth in a tiny atom of snow? (Kepler 2010: 99).

Kepler had used the Platonic solids already in 1596 in his early work the *Mysterium Cosmographicum* (*The Secret of the Universe*), assigning to each a planet and nesting them, one within the other, within a sphere so as to "discover" the distances of the planets from the Sun and from each other in a new Copernican universe. A sphere circumscribing a cube carries the outermost planet Jupiter, which circumscribes a tetrahedron, the sphere of Mars, inscribed within that, which is inscribed within a dodecahedron, and so on. Kepler's proposition was that the structure of the planetary system followed a strict geometrical order. And it is striking and not irrelevant for a man who was later to spend several years at the court of Rudolf II and within the orbit of his *Kunstkammer* that he conceived his universe in the form of a goldsmith's presentation cup: that the basis of Kepler's astronomical thinking, in other words, was aesthetic. He was drawn to use the Platonic solids because, as he said, they "were the most beautiful and perfect because they imitate the spherical image of God as much

as a figure with straight lines can do" (Kepler 1938 et seq., 7: 272). Kepler thus created a universe ordered in the mode of an artistic tradition that had been developed by Jamnitzer, Stoër, and the Nuremberg constructivists and extended by the intarsia workers. It was an attitude that, nurtured within the particular culture of the *Kunstkammer*, was slowly to give way—even in Kepler's own subsequent work—to a mathematical method based on empirical observations.

Certainly, the taste for the intarsia ruinscapes and their association with the polyhedrons of constructive geometry seems to have been on the wane by the early years of the seventeenth century. Its decline coincided with the gradual emergence of a more empirical and rational attitude in matters of philosophy. Indeed, the positive association between marquetry and an artificial, highly ornamented literary style, expounded in the poem of Jean Dorat discussed above, finds a negative echo in a critique that Galileo, the scientist and exponent of logical, deductive thinking, leveled against the poet Torquato Tasso. Galileo reproached Tasso for filling his verses with conceits that are not "necessary" to the plot and whose meanings seemed to be grafted onto the subject rather than unified with it. He charged that reliance on such procedures showed a poverty of invention: "Since he often has nothing to say, he is obliged to patch together unrelated and disconnected *concetti*." The veneer of conceits he creates is comparable to intarsia: "this filling of stanzas with *concetti* lacking any necessary continuity with things said or to be said, we call marquetry" (Galileo 1970: 493; Hallyn 1993: 198). Galileo's sharp rejection of this poetic form registered the gradual passing from favor of a rhetorical attitude of mind in the arts and in science, according to which art was produced and meanings generated by a piling on of ornament—an attitude that he recognized was perfectly articulated in the "signs" and "Euclidean lines drawn in sand" of the aesthetics of intarsia.

Yet for the period of its flourishing, the *Kunststück* ultimately offered up for contemplation and appreciation a set of skills—technical and ratiocinative—that offered new means—formal and aesthetic—by which to describe experience, how to evaluate it, and, at its best, how to imagine its transformation. For those patrons and members of their circle, like Kepler, who engaged in their evaluation, they modeled the liberating way in which the world itself might be remade. In an important way, therefore, the *Kunststück* stood as an emblem of the larger creativity that characterized the culture of the Renaissance.

NOTES

Introduction

1. Greenblatt's account of Bracciolini's discovery of Lucretius's "On the Nature of Things," which was written for a popular audience, has been criticized as being oversimplified. In particular, his account, which takes a Burckhardtian line in linking the Renaissance rediscovery of lost ancient knowledge to the origins of modernity, overlooks the atomistic theories of Islamic and other medieval philosophers in the West. See Lüthy et al. (2001).

2. An attempt to overcome the period divide that archaeologists make, seeing the Middle Ages and the modern world as separate periods, was made in the late 1990s when the idea of an "Age of Transition" was introduced to refer to European archaeology in the period 1400–1600 (Gaimster and Stamper 1997).

3. The publication of Greenblatt's *Renaissance Self-Fashioning* inaugurated a new historicism in the 1980s that often used the discussion of common subjects as a way into discussing royalty, the state, and male power. Patricia Fumerton has termed this "political historicism" and has contrasted it with the "new new historicism" that emerged in the 1990s, with its focus on the common people and everyday life. See Fumerton and Hunt (1999: 1–17).

4. See also Hohti (2010), which explores how shopkeepers, barbers, shoemakers, and secondhand dealers used alternative mechanisms to acquire and make use of material possessions in their homes.

5. For the trade in secondhand goods in Renaissance Italy, see Allerston (1999), and for an insight into the use of credit and pawning by artisans and others, see Hohti (2007).

6. There is an extensive literature on the so-called "Scientific Revolution." Maria Hall is widely acknowledged as having coined the term (1962). More recently, Peter Dear has suggested that the Revolution had two phases: a fifteenth- and sixteenth-century recovery of lost knowledge, followed by a seventeenth-century phase of innovation and new discoveries (2001: 72–3). See Roberts et al. (2007).

7. It is tempting to apply modern beliefs and values to the interpretation of objects in Renaissance paintings. This will, however, give a very misleading impression of how objects were perceived, used, and valued in the fifteenth and sixteenth centuries. The convex mirror in the *Arnolfini Portrait* is a case in point. Far from being a simple wall ornament, the mirror is laden with symbolism. It may, for example, represent the all-seeing eye of God overseeing the betrothal or wedding and bestowing eternal salvation upon the couple. A perfectly clean mirror was also widely understood to be a symbol of the purity of the Virgin Mary; see Panofsky (1953: 202–3). Another intriguing suggestion is that, prior to the late seventeenth-century mirrors, individuals did not see their faces in any introspective or self-conscious way when they looked into a mirror. Instead, they had a relational understanding of selfhood and only saw their likeness as mirrored in others; see Shuger (1999).

8. The material impact of the "Continental Renaissance" upon ceramic usage in English urban households and the so-called "Post Medieval Ceramic Revolution" (*c.* 1450–1650) has been examined by the archaeologist David Gaimster and colleagues. See Gaimster (1999: 214–25), Gaimster (1994: 283–312) and Gaimster and Nenk (1997: 171–92).

9. Pamela H. Smith's Making and Knowing Project (https://www.makingandknowing. org) has been working to create a digital edition of a sixteenth-century French artisanal and technical manuscript (BnF Ms. Fr. 640). The intention is not only to allow modern audiences to read the text, but also to investigate the materials and working methods used by artisans in the Renaissance.

10. For other examples of post-human approaches to seventeenth-century literature, see Feerick and Nardizzi (2012) and Herbrechter and Callus (2012).

Chapter 1

1. The quotation is from Thomas Urquhart's (1611–1660) English translation from 1653.

2. For English translations of Nicolas of Cusa's philosophical treatises, see Hopkins (2001).

3. For an English translation, see Ficino (2001–2006).

4. For an English translation of the text, see Copernicus (1992a).

5. For an English translation of the work, see Copernicus (1992b).

6. For an English translation of the work, see Kepler (1999).

7. For English translations of these texts, see Bruno (1977, 1995).

8. A digitalized version of the Latin text is available as della Porta (1586).

9. There are several English translations available of the corpus, but see Hermes Trismegistus (2002).

10. For an English translation of the work, see Georgius Agricola (1950).

11. For a modern edition of the text, see Pomponazzi (2011).

12. For an English translation, see Gilbert (1958).

13. For an English summary of the text, see Gritsch (2017).

14. Although Luther rejected relics, his signatures and inscriptions were treasured collectibles, and Luther's cassocks, rings, pieces of furniture, etc., became appreciated paraphernalia, attracting pilgrims (Roper 2015).

15. The Latin work is available online as Biondo (1510).
16. For an English translation of the work, see Biondo (2005) and (2016).
17. The work is available online as de Baïf (1536).
18. For a modern edition of the work, see Meisterlin (1998).
19. Several editions and translations of the work have been published; e.g. see Olaus Magnus (1972).
20. The work is available online as Marschalk (2016).
21. For an English translation, see Georgius Agricola (1955).
22. The work is available online as de Azpilcueta Navarro (2006).
23. For a modern Spanish edition, see Agustín y Albanell (1987).

Chapter 2

1. "Renaissance" is variously used to denote a period, roughly 1300–1700, or (and in its original sense) a particular intellectual and cultural movement with a chronological scope that varied with geographical region. "Renaissance," used only occasionally before the late eighteenth century, originally described a new, distinctive philological and historical approach to classical antiquity, whereby scholars in the Latin West endeavored to rediscover ancient Greek and Roman material culture and scholarship and to strip medieval accretions and errors of interpretation and textual transmission from those texts that had been known or found during what these scholars came to call the Middle Ages, a period that they considered to be a rupture between classical antiquity and their own age of the rebirth of the classical tradition. This scholarly movement, known as humanism, spread from Tuscany across Europe at different moments and speeds. Humanistic education consequently shaped art, literature, investigations into nature and the material world, and politics. In current scholarship, disciplinary traditions chart the beginning and ending of humanistically informed scholarship and cultural production using different markers. Art historians, for example, might wish to claim Giotto (1267–1337) as a painter whose work was informed by Renaissance humanist scholarship. At the other end of the timescale, scholars of English literature frequently claim Shakespeare (1564–1616) and Andrew Marvell (1621–1678) for Renaissance Studies. For introductions to the field, see, for example, Ruggiero (2002).
2. Bennett (2006). I draw the formulation "making and knowing" from Smith et al. (2014).
3. For objects of ritual medicine in the early modern Caribbean, see Gómez (2017).
4. The literature on this heterogeneous subject is vast. Key works from across the disciplines include: Grafton et al. (1992); Thornton (1998); Farago (1995); Miller (2015). For collecting and oceanic expansion, see Bleichmar and Mancall (2011); Bleichmar and Martin (2016); Davies (forthcoming).
5. For an overview of artifactual encounters in the early modern world, see Bleichmar and Mancall (2011). For featherwork encounters, see Russo et al. (2015).
6. Norton (2017: 26).
7. OED online, last accessed May 11, 2018. Clearly, even human-made objects begin with natural materials, and the boundary between human labor and nature is not discrete.

8. See, for example, the case of (decomposing) preserved mummies in Heaney (2018). For theoretical approaches to artifacts and to the shifting relations between things, concepts, and humans, see, for example, Latour (1993). For ontological systems (including those of premodern Europe) that do not recognize a nature/culture divide, see Descola (2013).
9. For *mentalités* and the *Annales* school of historical method, see Burke (1990).
10. This section is informed by the word histories approach employed in Kenny (1998).
11. For the rich semantic field of "secret" between the Middle Ages and the eighteenth century, see Eamon (1994: 3–5).
12. *OED*, s.v.
13. The literature on the impact of overseas material culture and technology on Europe is vast. Important recent examples that offer new perspectives on the cultural significance of these interactions include Norton (2008); Bleichmar and Mancall (2011); Gómez (2017); Warsh (2018).
14. Copenhaver in Polydore Vergil, ed. Copenhaver (2002: xi).
15. Thomas Langley/Polydore Vergil, *An Abridgement of the notable work of Polydore Vergile conteinyng the deuisers and first finders out as well of Artes, Ministeries, feactes and ciuil ordinaunces, as of Rites, and Ceremonies, commonly vsed in the churche: and the original begynnyng of the same* (London, 1551), book III, ch. I, f.lxiii.*v.* and title page. This discussion is informed by Copenhaver in Polydore Vergil, ed. Copenhaver (2002: xi–xii).
16. Aristotle, *Politics* 1278a1–5 and 1319a20ff, quoted in Smith (2004: 7) and Summers (1987: 242).
17. Long (2001: 4–5).
18. Aristotle, *Nicomachean Ethics*, 6.4–5, 1140a–1141a. Long (2001: 2); Smith (2004: 17); Ash (2010: 20–1); Cadden (2013: 242–3). For Aristotle in the Renaissance more generally, see, for example, Schmitt (1983).
19. This distinction may be traced to classical antiquity and to the Hippocratic corpus of the late fifth and early fourth centuries BCE; see Bensaude-Vincent and Newman (2007: 10–11) and Von Staden (2007); for the mimetic arts, see Wolf (2007).
20. Bensaude-Vincent and Newman (2007: 6, 3–8).
21. See, for example, the constellation of objects and artifacts in sections denoted "artificial" or "mechanic" in early cabinets of curiosities, discussed later in this chapter.
22. Grafton (2007: 185).
23. For the continuum between the artificial and the natural, see Bensaude-Vincent and Newman (2007: Introduction); Norton (2017).
24. For this point, see Bensaude-Vincent and Newman (2007: 3).
25. Earle (2012); Davies (2016: 25–9).
26. There are two ongoing collaborative projects on the intersections of art, science, and practice are the "Making and Knowing Project: Intersections of Craft Making and Scientific Knowledge" at Columbia University (makingandknowing.org) and "ARTECHNE—Technique in the Arts, 1500–1950" at the University of Utrecht (artechne.wp.hum.uu.nl). These groups have been examining Northern European artisanal knowledge at the intersection of art and knowledge of nature and the writings of artisans on how practices of making things generated knowledge about nature.
27. Pamela H. Smith's formulation of the artisan as someone engaged in manual work for which they have been trained via apprenticeship, rather than through the reading of books (although they may also have read books), is useful here; Smith (2004: 7n7).

28. Smith (2004: 7).
29. For the impact of printing on vernacular how-to manuals, see Eamon (1994: 96–105); Smith (2004: 66). For art primers, see Remond (forthcoming). For vernacular medicine, see especially Leong and Rankin (2011).
30. Long (2001: 2–3); Long (2009: III, 5, 30); Smith (2004).
31. Ash (2010); see also the special issue of *Osiris*, "Expertise: Practical Knowledge and the Early Modern State," in which it appears.
32. Smith (2004: 8).
33. Smith (2004: 21, 66–7). For an early exponent of this point, see Rossi (1970: ch. 1).
34. See especially Smith (2004: *passim*).
35. Smith (2004: 31–2). For an overview of the early historiography on the impact of artisan/practitioners on new sciences during the early modern period, see Long (2001: ch. 1).
36. Remond (forthcoming). I am grateful to Jaya Remond for sharing this with me before publication. For an unusually process-oriented recipe book, see the late medieval French exemplar BnF Ms. 640; for high-definition images, see "The Making and Knowing Project" at Columbia University at www.makingandknowing.org.
37. For books of secrets, see Eamon (1994); Leong and Rankin (2011); and the Early Modern Recipes Online Collective at https://emroc.hypotheses.org.
38. For a bibliography of printed books of secrets, see Ferguson (1959).
39. Smith (2013).
40. Folger Shakespeare Library, Washington, DC, shelfmark 298 copy 2.
41. Ruscelli, ff. 12*r.*, 20.*v.*, 22.*r.*
42. Smith (2013: 174).
43. Theophrastus von Hohenheim (called Paracelsus), *On the Miners' Sickness and Other Miners' Diseases*, in *Four Treatises of Theophrastus von Hohenheim called Paracelsus*, edited by Henry E. Sigerist, translated by George Rosen. Baltimore, MD: Johns Hopkins University Press, 1941: 91, cited in Smith (2013: 174).
44. Smith (2004: 66–7, 82–93, 2013: 174–5).
45. For "trading zones" of learned and artisanal expertise, see Long (2001: ch. 4).
46. See especially the literature on medicine and cartography in imperial and colonial contexts. For manuscript and printed map workshops in the long sixteenth century, see Davies (2016: ch. 2); for Iberian science, see Bleichmar et al. (2009); Portuondo (2009). For colonial expansion and the transmission of medical knowledge across cultures and social groups, see Cook (2007); Gómez (2017).
47. The original formulation of the "Scientific Revolution" has been broken down in multiple ways: for new directions and overviews, see Cañizares-Esguerra (2005); Park and Daston (2006); Sivasunderam (2010).
48. Long (2001: 1).
49. Smith (2004: 66–7).
50. Klein and Spary (2010).
51. For the disparate practical artisans and craftspeople whose methods would become bound up with experimental philosophy and the "new science," see Eamon (1994: 7–8).
52. The foundational work that established the history of collections as a field of study is Schlosser (1908).
53. For overviews of collecting in different parts of Europe, see Impey and MacGregor (1985). The foundational work that established the history of collections as a field of study is Schlosser (1908). The field was reinvigorated by Findlen (1994) and Bredekamp (1995).

54. For collecting by scientific practitioners in Italy, see Findlen (1994). For collecting among princes and wealthy elites, see Markey (2016) for Florence; for Central Europe, see Kaufmann (1993, 1995).
55. Findlen (1994).
56. Natural/artificial is, of course, an artificial binary.
57. For a translation and study of Quiccheberg's *Inscriptiones vel tituli theatri amplissimi, complectentis rerum universitatis singulas materias et imagines eximias* (Munich, 1565), see Meadow (2013).
58. Meadow (2013: 61).
59. In class 2, subsection 7.
60. Meadow (2013: 66). Among gems one would also place those that had been cut and set in jewelry.
61. Meadow (2013: 67).
62. Meadow (2013).
63. For chocolate and tobacco, for example, see Norton (2008); for featherwork, see Russo (2015); for cabinets as epistemic installations, see Davies (forthcoming).
64. See, for example, Dackerman (2011).
65. For the notion of a printing revolution and its impact of scientific practices, see the influential Eisenstein (1979); for a critique of Eisenstein's approach, see Johns (1998). The classic work on the impact of printed images on the Protestant Reformation is Scribner (1981). For print and religious reformations, see also Eisenstein (2011: ch. 2). For the history of reading, see, for example, Cavallo and Chartier (1999). For the late medieval book before print, see, for example, Pettegree (2010: ch. 1). For the technologies of scholarly apparatus such as indexes and commonplace books and their impact on scholarship and reading practices, see Blair (2010). For the impact of print on early modern science, see, for example, Frasca-Spada and Jardine (2000).
66. For the history of books in various national contexts, see Walsby and Kemp (2011: pt. 1).
67. For the technologies of print, see Pettegree (2010: ch. 2, esp. 22–6).
68. For the spread of printing and for the speedier adoption of print in mercantile centers than in university towns, see Pettegree (2010: 32–3). For adjacent technologies such as paper, see Pettegree (2010: 17–19).
69. For the publishing business as a driver of the printing revolution in the Renaissance, see Pettegree (2010: chs. 2, 3). For genres of print in the context of scholarship, see MacLean (2012: ch. 3).
70. For the De Bry family's *India orientalis* and *India occidentalis* (*America*) series, see van Groesen (2008). For new geographical genres more generally, see Davies (2016: ch. 8).
71. Polydore Vergil, *On Discovery*, book II, ch. VII, 245.
72. For an overview of the range of responses to printing and to the widening of audiences in the early decades of the printed book, see Eisenstein (2011: 4–33).
73. Heylyn (1657: 865).
74. The classic anthropological work on gifts is Mauss 1990 (first published: 1950). For gifts in Renaissance France, see Davis (2000). For recent approaches, see Um and Clark (2016). For diplomatic gifts in early modern Eurasia, see Biedermann et al. (2018).
75. For ivory, see Guérin (2010); for automata, see Truitt (2015).
76. Richard Hakluyt, *The Principal Navigations, Voyages and Discoveries of the English Nation*, 8 vols. (Glasgow: Maclehose, 1903–1905), III, 272, cited in Fuller (1995: 6) For illustrated maps in the Renaissance, see Davies (2016).

Chapter 3

1. In the original Dutch: *"Het zijn de details ... welke hier doen bloeien in zijn stillen schijn het mysterie van het alledaagsche, de onmiddellijke aandoening over het wonder van alle dingen, en dat verbeeld"* (Huizinga 1919: ch. XIII).
2. Consider, for example, the *Goldenes Rössl*, the elaborately worked statue of the Virgin and, below her throne, a stunning white horse (hence the name of the statue) that was said to be a new year's gift from Isabeau of Bavaria to her spouse Charles VI. The statue was soon pledged for the pension to be paid to her brother, Count Ludwig. At the expiration of this family line, the statue passed to the count of lower Bavaria and then to the town of Altlötting as part of a peace settlement. Its history is recounted in Eikelmann (2006).
3. Historical archaeologists have also claimed since the 1990s that the study of the post-1500 world is essentially the archaeology of capitalism; among others, see Leone and Knauf (2015) and Johnson (1995).
4. Among his extensive publications, see Miller (1987) and his more recent summary, Miller (2010).
5. The scholarship on "self-fashioning" begins with Steven Greenblatt's (1980) *Renaissance Self-Fashioning*. Patricia Allerston (2007) explores this issue, usefully positioning the struggle to reconcile the desire for luxuries with this project.
6. For a rich discussion of the importance of these goods in Southern Europe during the fourteenth and fifteenth centuries, see Smail (2016). My thanks to Lluís To Figueras for the mention of Ypres cloth in the trousseaus of Catalan peasants.
7. For one example of studies that take account of ordinary people's acquisition and treatment of objects, see Cohn (2012).
8. Among the many excellent studies on the history of spices in medieval culture, Freedman (2008) stands out for its judicious coverage of all aspects of the trade.
9. All price quotations for spices in this paragraph are from an article posted by the late John Munro (2003). Also see Freedman (2005) and the sources he cites for the prices of medicines and for additional information about spice prices. Available data about prices are scattered and taken from a variety of sources and different markets, so only general patterns are clear.
10. On this theme, see Normore (2015).
11. These prices are unadjusted for inflation.
12. In New York, a magnum (the equivalent of two bottles) of a 2005 Petrus (a red Bordeaux from the Pomard commune) can be had for US$11,995 (at Sherry Lehman's, one of New York City's elite retailers of wine and spirits).
13. Albala (2002) provides a full discussion of these shifts; also useful is Gentilcore (2016).
14. Also see Smith (2007).
15. Other prices are from Posthumus (1943).

Chapter 4

1. Febvre and Martin (1958).
2. Melograni (2010: 199).
3. Lyall (1989: 11).

4. Tsuen-Hsuin (1985: 154, 158).
5. See Bloom (2001).
6. Kwakkel (2003: 226); Lyall (1989: 11–29).
7. Kwakkel (2003: 243).
8. Wolfe (2012). I am deeply indebted to Wolfe for sharing with me her pioneering work on the cost of paper, which focuses upon England, but has profound implications for paper prices throughout Renaissance Europe.
9. McKitterick (1992: 286–7).
10. Barrett (2014). Barrett's is the best brief summary of European papermaking. For Barrett actually making paper, see https://www.youtube.com/watch?v=bggttPftmVs.
11. van de Wetering (1997: 47–73). This is an unusual flaw in an otherwise superb book.
12. Bervin and Werner (2013); Stallybrass (2018).
13. "18 *quaderni* of *fogli reali* at 12 soldi and 11 soldi the *quaderno*, obtained by Leonardo da Vinci to make the cartoon in the *sala* … As defined by the Bolognese statutes of 1389, a 'risima' [= ream of 500 sheets] was comprised of 20 'quaternorum,' while a 'quaternus' was comprised of 25 sheets ('foleis'), ordinances repeated nearly verbatim in the statutes of 1454" (Bambach 1999: 119).
14. Wilkins (1951: 107–98); Petrucci (1995: 167–8). And for the "multiple redactions" of Petrarch's letters, see Petrarca (1968).
15. Hirsch (1967: 51).
16. Voet (1972, 2: 166).
17. Terence (1475).
18. Cummings (2002: 73n51).
19. Alemán (1623).
20. Brinsley (1612: 69, 141, 256, 327).
21. Dering (1643).
22. Rouse and Rouse (1989b). See also Brown (1994).
23. Chartier (2007: 1–12, esp. 2–5).
24. Caviness (1998: 29–63). See also Emmerson (2002).
25. Jan Gossart, *Portrait of a Merchant*, Washington, DC, National Gallery of Art. There is another version of this painting in the John G. Johnson Collection, Philadelphia Museum of Art. See Friedländer (1972: plates 57 and 56). See also Hand and Wolff (1986: 103–7). The identity of the subject has been established, in my view convincingly, by Herman T. H. Colenbrander (2010: 82–5).
26. I am deeply indebted to Heather Wolfe's work on filing systems, some of which was presented in her "Note-Taking and Filing," Renaissance Society of America, Cambridge University, April 7, 2005. See also Wolfe and Stallybrass (2018: 179–208).
27. Minsheu (1617); William Sewel (1708).
28. *Calengier:* ¶ *Item men mach hier in scriuen met priemen ghemaect van gout, of van siluer, of van ten, of van koeper, of van laettoen, ende met eene[n] natten vingher machment wt doen.* ¶ *Ende wanneert soe veroudt is, dattet niet meer scriuen en wil, soe salt den seluen Jan Seuers soon parkementmaker om een cleyn ghelt vermaeken, dattet so wel scriuen saloft nieuwe waer.* ¶ *Met vinste te koop in die vermaerde coopstadt van Antwerpen, op di Lombaerde veste: By Jan Seuers soon int gros, in die huyse van Jan Gasten boecke bijnder.* ¶ *Item of den wtwisschers vingher vet waer, soe salmen neme[n] een cleyspongie met wat weyten bloems, en daer salt veter mede wt gaen.* ¶ *Int iaer ons Heeren. 1527,* New York Public Library, Spencer Coll. Neth. 1527, 94–143.

29. For more on erasable notebooks, see Woudhuysen (1996: 21 and 2004); Stallybrass et al. (2004); Stallybrass (2007).

30. These erasable notebooks with woodcuts of coins and multiplication tables were printed from Frank Adams's *Writing Tables, with a Necessarie Calendar for xxv Yeares* (London: Frank Adams, 1577?) to Oliver Ridge's *Writing Tables, with a Calendar for xxiii Yeeres* (London: The Company of Stationers, 1628?). Given the fragmentary state of many of the copies, the number of editions that survive in only one copy, and the disappearance rate of such small notebooks, it is probable that not only most copies, but also most *editions* have been lost. John Barnard notes that "the most forcible way to emphasize the high loss rates among short, small-format publications is that the primer, printed in tens of thousands year by year from 1660 to 1700, is now represented by only a single copy in a single library" (1999: 150).

31. See Schobesberger et al. (2016: 19–63).

32. See Henderson (2007: 141–77).

33. Chartier (1997: 59–111, esp. 59, 63, 65).

34. Newbold (2007: 127–40).

35. Bland (1999: 450–63, esp. 459–61). Bland argues that in England in 1600, 80 percent of all texts were in manuscript as opposed to print. And given the vast quantities of letters, notes, and written ephemera that have not survived, this may well be an underestimation.

36. Blair (2010).

37. Heather Wolfe has pointed this out in relation to the striking quantities of blank paper in the fully digitized letters in the Folger Shakespeare Library's Luna Digital Image Collection: https://luna.folger.edu/luna/servlet/FOLGERCM1~6~6. For further details on unused paper in letters, see Glen and Stallybrass (2011).

38. See, for example, the use of octavo sheets in the correspondence of the Grenville family, especially the letters of George Grenville, 1st Marquis of Buckingham (Grenville).

39. Kapr (1996: 189–90). See Maslen (1993: 141): "If we go back to the cradle of printing we find no … separation [of jobbing work from printing books]. Gutenberg's Indulgences of 1454–5 were necessarily printed and issued while his massive 42-line Bible was still slowly going through the press, not to be completed until 1456. His 30-line *Indulgence* … may claim to be the earliest [surviving] product of the Western printing-press. It has many of the characteristics of its kind, ensuring neglect by librarians and scholars. It has no author as books do. It is a legal form, produced for an institutional customer, and serving an immediate social need. There is no point in keeping it once that need has been satisfied."

40. See Flood (2003: 139–51).

41. Griffin (1988: 52).

42. Blake (1969: 79, 232–3); Painter (1977: 83–4). Lotte Hellinga has shown that Caxton printed the 1476 indulgence while he was already at work on his edition of *The Canterbury Tales* (1982: 81).

43. On Caxton's patrons, see Hellinga (1982) and Hellinga and Trapp (1999: 84–5, 213–14, 270–1).

44. See STC 14077c.26 to 14077c.84a.

45. See STC 14077c.85 to 14077c.123.

46. See Hirsch (1967: 122).

47. Needham (1986: 30, 33).

48. Needham (1986: 31).

49. Griffin (1988: 51).
50. Watts (1991: 141, 259). On newsbooks, she cites Dahl (1952: 22).
51. See Eisermann (2001: 99–128).
52. Pettegree (2000: 109–26, esp. 110–11). See also Edwards (1994).
53. Eisenstein (1979: 178, 368, 375). The quote about Montserrat is from Steinberg (1961: 139). In his article on the Benedictines' use of the press from 1470 to 1550, James Clark gives further evidence that "long before the printing press became a servant of religious radicals in the 1520s, it had already come to occupy an honoured position at the very heart of the clerical establishment" (2004: 71–92, 90). Compare Clark's account with David d'Avray's unsubstantiated claim for the "mass" circulation of manuscripts prior to printing. Since he gives no figures, it is hard to know what he is arguing (d'Avray 2004: 50–70).
54. Tedeschi (1991: 67).
55. Kapr notes that Gutenberg printed at least twenty-four surviving editions of *Donatus*, the most important of all medieval schoolbooks and "the most widely distributed book of the fifteenth-century." These schoolbooks, printed on vellum to stand up to wear and tear, were composed of fourteen leaves or twenty-eight pages and were probably "the first books to be printed from type in Europe." But Kapr argues that the printing of *Donatus* was interrupted to print even shorter items, assured of sale, like calendars (1996: 148, 212). The only surviving copy of Gutenberg's *Türkenkalender* of 1454 is composed of three sheets. See Simon (1988).
56. Voet (1972: 296–7).
57. Clair (1987: 64, 74–5, 83–4).
58. Smit (1570s?). Like many other printed sheets, the broadside has been reused for practice writing, including the phrase "Dearly beloued brethren" and the name "mild may ffane ffanes," just possibly Mildmay Fane, 2nd Earl of Westmoreland (1602–1666).
59. Calvin (1574).
60. See Müller (2014: 26–31).
61. Dummett and Abu-Deeb (1973: 106–28, esp. 112–14).
62. Roberts (2017: 17–44, 37–8).
63. van Buren and Edmunds (1974: 12–30, esp. 24). They are arguing against Hellmut Lehmann-Haupt's thesis (1966) that the Master of the Playing Cards developed copperplate engraving with Gutenberg so as to mechanize the printing of images in the margins of his bible.
64. The Cloisters Playing Cards (southern Netherlands, *c.* 1475–1480), the Cloisters Collection, Metropolitan Museum of Art, Accession Number: 1983.515.1–52. This is the only surviving complete deck of ordinary playing cards from the fifteenth century—but several individual (and cheaper) cards survive from the 1420s on.

Chapter 5

1. Steinberg (2001); King (2012: 271); Marani (2014).
2. Delmarcel (1999: 69–72).
3. Cerretani (1993: 212); Gaurico (1999: 255).
4. Elsner (2010: 10–27).
5. Yonan (2011: 232–48); Coltman (2015: 17–31).

6. Kuo and Andrews (2006: 219); Jordanova (2012: 33).
7. Cohn (2012: 987).
8. Didi-Huberman (2005: 15); Lucas-Fiorato and Dubus (2016).
9. Gahtan (2017: 9–12).
10. Rubin (1995); Barriault et al. (2005).
11. Nelson (2000: 414–34).
12. Vasari (1963, 1: 405).
13. Vasari (1963, 2: 205).
14. Edgerton (2009: 126–32).
15. Vasari (1963, 3: 152).
16. Burke (2012a: 1–23).
17. Vasari (1963, 1: 208–9).
18. Rubin (1995); Barriault et al. (2005); Lucas-Fiorato and Dubus (2016).
19. Williams (2017: 2–6).
20. Kristeller (1951: 508–9).
21. Staley (1967: 228–30).
22. Nash (2008b: 51–3).
23. Goldstein (1996); Barzman (2000).
24. Kristeller (1951: 504); Summers (1987).
25. Gill (2005: 177–82).
26. Panofsky (1968: 40–1).
27. Savonarola (1528: CXVIIv).
28. Kessler (2006: 151–2).
29. Didi-Huberman (2005: 24–8).
30. Baxandall (1986: 51–9); Petrarca (1991: 126–30).
31. Petrarca (1991: 130).
32. Ames-Lewis (2000); Rosand (2002); Chapman and Faietti (2010).
33. Maginnis (1995: 40–3); Messling (2011: 95–6).
34. McGee (2004: 73–5).
35. Chapman and Faietti (2010).
36. Bambach (2003: 5).
37. Porras (2012: 245–59).
38. Hernad (1990).
39. Karet (1998: 31–51).
40. Baxandall (1986); Petrarca (1991).
41. Baxandall (1986: 67–72).
42. Emison (2004: 83).
43. Ficino (1975: 10, 52).
44. McHam (2013).
45. Barkan (1999); Bober and Rubinstein (2010).
46. Barkan (1999).
47. Squire (2013: 444–64).
48. Land (2005: 6–9).
49. Baxandall (1986: 51).
50. Kristeller (1952: 17–46).
51. Petrarca (1991: 127).
52. Weisinger (1943: 163–4).
53. Baxandall (1986: 18).
54. Barolsky (1994).

55. Kristeller (1951: 513–4); Lancilotti (1976: 13).
56. Smith (2004); Cennini (2015).
57. Alberti (2011).
58. Wright (1984: 54–5).
59. Baxandall (1986: 59).
60. Burke (1995).
61. Castiglione (2004: 53–6).
62. Chambers (1971); San Juan (1991); Campbell, Stephen (2004).
63. Summers (1987: 3).
64. Kessler (2004: 19–44).
65. Kyle (2010).
66. Husband (2008).
67. Nash (2008a: 724–41); Nash (2010: 357–81).
68. Perkinson (2002).
69. Buettner (1996); Boccaccio (2001: 250, 274–5).
70. Baxandall (1986: 15–17).
71. Borchert (2011: 19).
72. Nash (2008b: 29); Borchert (2011: 31).
73. Savoy (2017).
74. Stowell (2014).
75. Summers (1987: 313–14).
76. Harbison (1985); Williamson (2013).
77. Delcorno (2015: 167–8).
78. Nagel (2011: 28).
79. Burke (2012b: 252–63).
80. Dyrness (2004: 54).
81. Eire (1989: 55–73).
82. Eire (1989); Michalski (1993); Heal (2017).
83. Arnade (2008: 93).
84. Nash (2008b: 27–36); Koerner (2017: 454–5).
85. Koerner (2008); Moxey (2013: 126–30).
86. Belting (1994); Koerner (2008); Nagel (2011); Heal (2017).
87. Metzger (2011: 105).
88. Gaurico (1999: 224–5).
89. Quiviger (2008: 56).
90. Nash (2008b: 27).
91. Campbell (2002: 598); Parshall (2013: 396); Cennini (2015: 25).
92. Campbell (2002: 596–7); Lancilotti (1976: 15–16).
93. Campbell (2002: 596–7).
94. Moxey (2013: 15).
95. della Mirandola (2012: 117).
96. Kren et al. (2018: 209–11).
97. Jacobs (1997); Nagel (2011); Turner (2017); Burke (2018).
98. Simons (2011).
99. Pollock (2003: 2).
100. Loh (2014/2015).
101. Landau and Parshall (1996); Zorach (2005).
102. Gregory and Vasari (2012).
103. da Vinci (2008: 185).

Chapter 6

1. The construction expenses for the Escorial totaled about 5.2 million ducados between 1563 and 1584 (Kubler 1982: 33). The cost of St. Peter's between 1506 and 1620 is estimated to be around 2.5 million ducats, close to 70 percent of which came from the Spanish monarchy (Dandelet 2008: 198).
2. Mathes Roriczer's *Büchlein von der Fielen Gerechtigkeit* (Booklet Concerning Pinnacle Correctitude) was printed in Regensberg in 1486. Hanns Schmuttermayer published his *Fialenbüchlein* (Booklet on Pinnacles) likely in Nuremberg sometime between 1487 and 1488 (Shelby 1977: 31–9).
3. These treatises, which took inspiration from the publications of Hans Blum and Wendel Dietterlin, include those by Hans Jacob Ebelmann, Jakob Guckeisen, Rutger Kasemann, and Gabriel Krammer (Irmscher 2004).
4. Serlio's sixth book is known through a preparatory manuscript on paper (New York, Columbia University, Avery Architectural and Fine Arts Library, AA520 Se619 F), a presentation copy on vellum (Munich, Bayerische Staatsbibliothek, Cod. Icon. 189), and a set of printer's proofs (Vienna, Nationalbibliothek, 72.P.20). On the treatise, see Rosenfeld (1978). On the issue of stylistic pluralism, see recently Nagelsmit (2011).
5. Italianate architecture was referred to as *"ao bom romano"* in Portuguese, *"a lo Romano"* in Spanish, *"à l'antique"* in French, *"anticse wercken"* in Dutch, and *"antique"* or *"Romagne worke"* in English (Thomson 1993: 101).
6. Examples include: Montreal, Canadian Centre for Architecture, DR1982:0020:019; Florence, Uffizi, Gabinetto dei Disegni e delle Stampe, 689A; Chatsworth, Duke of Devonshire Collection, Vol. 36, fols. 8, 13; Stockholm, Nationalmuseum, Cronstedt Collection, 1335; Vienna, Albertina, inv. Egger no. 274; Windsor, Royal Collection, RL 10363v. On these drawings, see Ian Campbell (2004, 3: 881–95, esp. 892).
7. On the Du Cerceau etchings, see Rosenfeld (1989). This Montano drawing in an album in Paris (Bibliothèque Nationale, Hb-22-4, fol. 80) was later posthumously published along with his other drawings of ancient temples (Montano 1624: 9).
8. Early examples include: London, Sir John Soane's Museum, vol. 115 (Codex Coner); New York, Morgan Library & Museum, 1978.44 (Mellon Codex); Berlin, Kunstbibliothek, HDZ 4151 (Codex Destailleur D); and Rome, Gabinetto Nazionale delle Stampe, vol. 2510.

Chapter 7

1. For materiality and selfhood, see, for example, Hillman (1997).
2. For the face as new locus of identity, see Wilson (2005), and also Loh (2009).
3. I thank Lane Eagles for this observation.
4. The clothing terminology of this chapter is very loose, relying on recognizable generic terms like gown and bodice rather than houppelande, kirtle, etc. For reasons of space, it is likewise impossible to discuss specific local trends.

5. On Hamlet's visual shift from the armored noble warrior to courtly pageantry, see especially Richardson (2011: 72–8).
6. For the relative importance of men's clothing, see McCall (2013).
7. Vianello hypothesizes that Venetian women's relative control over their own dowries but overall lack of financial freedom may have prompted this continued display (2006: 93).
8. According to Payne, knitted hose were known, although not common, by as early as the ninth century in Europe (1992: 199).
9. Ringgaard suggests Florence and Spain as the origin points of knitted stockings (2017: 296). Belfanti (2003: 590), however, argues that it is impossible to attribute the fashion for knitted stockings to any one source.
10. Scholarly consensus is that women's drawers were often associated with the transgressive sexuality of prostitutes.
11. On the impending effeminacy of men's fashions during the very late 1500s, see Squire (1974: 55–8).
12. For the specifics of women's and men's undershirts, as well as their functional interchangeability, see Vincent (2003: 51–5).
13. Jane Ashelford pinpoints 1564 as the year that starch made from wheat was introduced to Britain by a Dutch woman (1996: 33).
14. Lace was first produced in Venice and Flanders in the early sixteenth century (Payne 1992: 308). For the availability of lace and its use as a social marker, see Richardson (2011: 62–9).
15. For Said's orientalism as a problematic and insufficient model for this period, see Joswig (2012).
16. See the autobiographical account of this long-lived custom in D'Aulnoy (2005: 216).
17. Levi-Pisetzky (1964–1969, 2: 413–16, 3: 217–23). For black versus colored and gold clothing, see McCall (2013).
18. On this passage, see Richardson (2011: 85).
19. This dichotomy of the self between moral essence and social construction is borrowed from Van den Berg (2000: 12).

BIBLIOGRAPHY

Acciarino, Damiano. 2018. "*De re vestiaria*: Renaissance Discovery of Ancient Clothing." *La Rivista di Engramma*, 154: 111–40.

Ackerman, James. 1949. "'Ars Sine Scientia Nihil Est': Gothic Theory of Architecture at the Cathedral of Milan." *The Art Bulletin*, 31(2): 84–111.

Adams, Nicholas and Simon Pepper. 1986. *Firearms and Fortifications: Military Architecture and Siege Warfare in Sixteenth-Century Siena*. Chicago, IL: University of Chicago Press.

Adams, Nicholas and Simon Pepper. 1994. "The Fortification Drawings." In Christoph Frommel (ed.), *The Architectural Drawings of Antonio da Sangallo the Younger and his Circle*. 2 vols. Cambridge, MA: MIT Press.

Ago, Renata. 2006. *Il gusto delle cose: Una storia degli oggetti nella Roma del Seicento*. Rome: Donzelli Editore.

Agustín y Albanell, Antonio. [1587] 1987. *Diálogos de las medallas, inscripciones y otras antigüedades*. Madrid: Jano.

Ait, Ivana and Manuel Vaquero Piñeiro. 2000. *Dai casali alla fabbrica di San Pietro: i Leni: uomini d'affari del Rinascimento*. Rome: Ministero per i Beni e le Attività Culturali.

Ajmar-Wollheim, Marta and Luca Molà. 2011. "The Global Renaissance: Cross-cultural objects in the early modern period." In Glenn Adamson, Giorgio Riello and Sarah Teasley (eds.), *Global Design History*. London and New York: Routledge, Taylor & Francis.

Ajmar-Wollheim, Marta, Flora Dennis and Ann Matchette. 2006. "Approaching the Italian Renaissance interior: sources, methodologies, debates." *Renaissance Studies*, 20(5): 623–8.

Ajmar-Wollheim, Marta, Flora Dennis and Ann Matchette. 2007. *Approaching the Italian Renaissance Interior: Sources, Methodologies, Debates*. Hoboken, NJ: Wiley-Blackwell.

Ajmar-Wollheim, Marta, Flora Dennis, and Elizabeth Miller (eds.). 2006. *At Home in Renaissance Italy*. London: Victoria & Albert Museum.

Albala, Ken. 2002. *Eating Right in the Renaissance*. Berkeley and Los Angeles: University of California Press.

Albala, Ken. 2016. *A Cultural History of Food in the Renaissance*. London, Oxford, New York, New Delhi, Sydney: Bloomsbury Academic.

Alberti, Leon Battista. [*c.* 1452] 1999. *On the Art of Building in Ten Books*. Cambridge, MA: MIT Press.

Alberti, Leon Battista. 2011. *Leon Battista Alberti: On Painting: A New Translation and Critical Edition*. Edited by Rocco Sinisgalli. Cambridge: Cambridge University Press.

Albertson, David. 2010. "Mystical Philosophy in the Fifteenth Century: New Directions in Research on Nicholas of Cusa." *Religion Compass*, 4(8): 471–85.

Alemán, Mateo. 1623. *The Rogue: Or The life of Guzman de Alfarach*. London: Printed [by Eliot's Court Press and George Eld] for Edward Blount, 1623, sig. *6–*6v.

Alfter, Dieter. 1985. *Die Geschichte des Augsburger Kabinettschranks*. Historischer Verein für Schwaben. Augsburg: Johannes Wach.

Allen, Michael J. B. and Valery Rees (eds.). 2002. *Marsilio Ficino: His Theology, His Philosophy, His Legacy*. Leiden: Brill.

Allerston, Patricia. 1999. "Reconstructing the Second-Hand Clothes Trade in Sixteenth- and Seventeenth-Century Venice." *Costume*, 33: 46–56.

Allerston, Patricia. 2007. "Consuming Problems: Worldly Goods in Renaissance Venice." In Michelle O'Malley and Evelyn Welch (eds.), *The Material Renaissance*. Manchester: Manchester University Press.

Alves, André A. and José M. Moreira. 2010. *The Salamanca School*. New York and London: Bloomsbury Academic.

Ames-Lewis, Francis. 2000. *Drawing in Early Renaissance Italy*. 2nd edition. New Haven, CT: Yale University Press.

Andersen, Michael, Brigitte B. Johannsen and Hugo Johannsen (eds.). 2011. *Reframing the Danish Renaissance: Problems and Prospects in a European Perspective*. Publications from the National Museum, Studies in Archaeology & History, vol. 16. Copenhagen: University Press of South Denmark.

Appadurai, Arjun (ed.). 1986. *The Social Life of Things: Commodities in Cultural Perspective*. Cambridge: Cambridge University Press.

Arikha, Noga. 2007. *Passions and Tempers: A History of the Humours*. New York: Ecco.

Aristotle. 1926. *The Nicomachean Ethics*. Translated by H. Rackham. London: Harvard University Press.

Aristotle. 1932. *Politics*. Translated by H. Rackham. Cambridge, MA: Harvard University Press.

Arnade, Peter J. 2008. *Beggars, Iconoclasts, and Civic Patriots: The Political Culture of the Dutch Revolt*. Ithaca, NY: Cornell University Press.

Ash, Eric H. 2010. "Introduction: Expertise and the Early Modern State." *Osiris*, 25: 1–24.

Ashelford, Jane. 1996. *The Art of Dress: Clothes and Society 1500–1914*. London: The National Trust.

Auden, Wystan Hough. 1998. "Musée des Beaux Arts." In William Harmon (ed.), *The Classic Hundred Poems: All-time Favorites*. New York: Columbia University Press.

Bambach, Carmen C. 1999. "The Purchases of Cartoon Paper for Leonardo's *Battle of Anghiari* and Michelangelo's *Battle of Cascina*." *I Tatti Studies in the Italian Renaissance*, 8: 105–33.

Bambach, Carmen C. 2003. "Introduction to Leonardo and His Drawings." In Carmen C. Bambach (ed.), *Leonardo da Vinci: Master Draftsman*. New York: Metropolitan Museum of Art.

Barkan, Leonard. 1999. *Unearthing the Past: Archaeology and Aesthetics in the Making of Renaissance Culture*. New Haven, CT, and London: Yale University Press.

Barnard, John. 1999. "The Survival and Loss Rates of Psalms, ABCs, Psalters, and Primers from the Stationers' Stock, 1660–1700," *Library* 6th ser. 21: 148–50.

Barolsky, Paul. 1994. *The Faun in the Garden: Michelangelo and the Poetic Origins of Italian Renaissance Art*. University Park: Penn State University Press.

Barozzi da Vignola, Giacomo. [1562] 1999. *Canon of the Five Orders of Architecture*. Translated by Branko Mitrovic. New York: Acanthus Press.

Barrett, Timothy. 2014 [last modified]. "European Papermaking Techniques 1300–1800." In *Paper through Time: Nondestructive Analysis of 14th-through 19th-Century Papers*. The University of Iowa. Available online: http://paper.lib.uiowa.edu/european.php (accessed May 19, 2018).

Barriault, Anne B., Andrew T. Ladis, Norman E. Land and Jeryldene M. Wood (eds.). 2005. *Reading Vasari*. London: Philip Wilson Publishers/Georgia Museum of Art.

Bartoli, Daniello. 1677. *De' simboli trasportati al morale dal padre Daniello Bartoli della Compagnia di Giesù. Libro primo, e secondo*. Rome: Gioseffo Longhi.

Barzman, Karen-edis. 2000. *The Florentine Academy and the Early Modern State: The Discipline of Disegno*. Cambridge: Cambridge University Press.

Bass, Laura and Amanda Wunder. 2009. "The Veiled Ladies of the Early Modern Spanish World: Seduction and Scandal in Seville, Madrid and Lima." *Hispanic Review*, 77(1): 97–144.

Battisti, Eugenio. 1959. "I Comaschi a Roma nel primo Rinascimento." In Edoardo Arslan (ed.), *Arte e artisti dei laghi Lombardi*. Como: A. Noseda.

Baxandall, Michael. 1972. *Painting and Experience in Fifteenth-Century Italy*. Oxford: Oxford University Press.

Baxandall, Michael. 1980. *The Limewood Sculptors of Renaissance Germany*. New Haven, CT: Yale University Press.

Baxandall, Michael. 1986. *Giotto and the Orators*. Oxford: Oxford University Press.

Beckmann, Johan. 1817. *A History of Inventions and Discoveries*. Translated by William Johnston. London: Longman et al.

Bedaux, Jan Baptist. 1986. "The Reality of Symbols: The Question of Disguised Symbolism in Jan van Eyck's 'Arnolfini Portrait'." *Simiolus: Netherlands Quarterly for the History of Art*, 16(1): 5–28.

Belfanti, Carlo Marco. 2003. "Maglie e calze." In Carlo Marco Belfanti and Fabio Giusberti (eds.), *La moda*. Storia d'Italia: Annali, vol. 19. Turin: Einaudi.

Belli, Gianluca. 2008. "Notes sur le transport et le soulèvement des colonnes dans l'architecture des XVᵉ et XVIᵉ siècles." In Roberto Gargiani (ed.), *La colonne: Nouvelle histoire de la construction*, Lausanne: Presses polytechniques universitaires romandes.

Bellitto, Christopher M., Thomas M. Izbicki and Gerald Christianson (eds.). 2004. *Introducing Nicholas of Cusa: A Guide to a Renaissance Man*. New York: Paulist Press.

Belluzzi, Giovan Battista. 1598. *Nuova inventione di fabricar fortezze …* Venice: Tomaso Baglioni.

Belozerskaya, Marina. 2002. *Rethinking the Renaissance. Burgundian Arts across Europe*. Cambridge: Cambridge University Press.

Belozerskaya, Marina. 2009. *To Wake the Dead: A Renaissance Merchant and the Birth of Archaeology*. New York and London: W.W. Norton & Company.

Belting, Hans. 1994. *Likeness and Presence: A History of the Image before the Era of Art*. Chicago, IL: University of Chicago Press.

Benjamin, Walter. 1998. *The Origin of German Tragic Drama*. Translated by John Osbourne. London: Verso.

Bennett, James. 2006. "The Mechanical Arts." In Lorraine Daston and Katharine Park (eds.), *The Cambridge History of Science: Volume 3: Early Modern Science*. Cambridge: Cambridge University Press.

Bennett, Jane. 2010. *Vibrant Matter: A Political Ecology of Things*. Durham, NC: Duke University Press.

Bensaude-Vincent, Bernadette and William R. Newman (eds.). 2007. *The Artificial and the Natural: An Evolving Polarity*. Cambridge, MA, and London: MIT Press.

Bernardi, Philippe and Manuel Vaquero Piñeiro. 2007. "I cantieri edili: idea e realtà." In Philippe Braunstein and Luca Molà (eds.), *Il Rinascimento Italiano e l'Europa, Vol. 3: Produzione e tecniche*. Treviso: Fondazione Cassamarca.

Bervin, Jen and Marta Werner. 2013. *The Gorgeous Nothings: Emily Dickinson's Envelope Poems*. New York: New Directions.

Biedermann, Zoltán et al. (eds.). 2018. *Global Gifts: The Material Culture of Diplomacy in Early Modern Eurasia*. Cambridge: Cambridge University Press.

Biondo, Flavio. 1510. *De Roma instaurata*. Venice. Available online: http://reader. digitale-sammlungen.de/resolve/display/bsb10151922.html.

Biondo, Flavio. 2005. *Italy Illuminated 1*. Translated by Jeffrey A. White. Cambridge, MA: Harvard University Press.

Biondo, Flavio. 2016. *Italy Illuminated 2*. Translated by Jeffrey A. White. Cambridge, MA: Harvard University Press.

Biow, Douglas. 2015. *On the Importance of Being an Individual in Renaissance Italy: Men, Their Professions, and Their Beards*. Philadelphia: University of Pennsylvania Press.

Blair, Ann. 2010. "The rise of note-taking in Early Modern Europe." *Intellectual History Review*, 20(3): 303–16.

Blake, Norman F. 1969. *Caxton and His World*. New York: London House and Maxwell.

Bland, Mark. 1999. "The London Book Trade in 1600." In David Scott Kastan (ed.), *A Companion to Shakespeare*. Oxford: Blackwells.

Bleichmar, Daniela and Meredith Martin (eds.). 2016. *Objects in Motion in the Early Modern World*. Chichester: Wiley-Blackwell.

Bleichmar, Daniela and Peter Mancall (eds.). 2011. *Collecting across Cultures: Material Exchanges in the Early Modern Atlantic World*. Philadelphia: University of Pennsylvania Press.

Bleichmar, Daniela et al. (eds.). 2009. *Science in the Spanish and Portuguese Empires, 1500–1800*. Palo Alto, CA: Stanford University Press.

Blondé, Bruno and Wouter Ryckbosch. 2015. "In 'splendid isolation'. A comparative perspective on the historiographies of the 'material renaissance' and the 'consumer revolution'." *History of Retailing and Consumption*, 1(2): 105–24.

Bloom, Jonathan M. 2001. *Paper Before Print: The History of Impact of Paper in the Islamic World*. New Haven, CT: Yale University Press.

Bober, Phyllis Pray and Ruth O. Rubinstein. 2010. *Renaissance Artists and Antique Sculpture: A Handbook of Sources*. London and Turnhout: Harvey Miller Publishers.

Bobinger, Maximilian. 1954. *Christoph Schissler der Ältere und Jüngere*, Schwäbische Geschichtsquellen und Forschungen, 5. Augsburg: Verlag Die Brigg.

Bodnar, Edward W. 1960. *Cyriacus of Ancona and Athens*. Brussels: Latomus.

Borchert, Till-Holger. 2011. "The Reinvention of Painting: Notes on Panel Painting at the Time of the Van Eyck Brothers." In Till-Holger Borchert (ed.), *Van Eyck to Dürer: The Influence of Early Netherlandish Painting on European Art, 1430–1530*. London: Thames & Hudson.

Borromeo, Federico. [*c.* 1628] 1986. "Sul trasporto delle colonne colossali." In Gruppo Editoriale Zaccaria (ed.), *Le colonne per la facciata del duomo*. Milan: Libri Scheiwiller.

Bovilsky, Lara. 2016. "Shakespeare's Mineral Emotions." In Joseph Campana and Scott Maisano (eds.), *Renaissance Posthumanism*. New York: Fordham University Press.

Boyer-Xambeu, Marie-Thérèse, Ghislain Deleplace and Lucien Gillard. 1994. *Private Money & Public Currencies: The 16th Century Challenge*. Armonk and London: M. E. Sharpe.

Braidotti, Rosi. 2013. *The Posthuman*. London: Polity.

Braudel, Fernand. 1949. *The Mediterranean and the Mediterranean World in the Age of Philip II*, 2 vols. Translated by Siân Reynolds, 1972–1973. New York: Harper & Row.

Braudel, Fernand. 1992. *The Wheels of Commerce*. Translated by Siân Reynolds. Berkeley: University of California Press.

Bredekamp, Horst. [1993] 1995. *The Lure of Antiquity and the Cult of the Machine*. First published as *Antikensehnsucht und Maschinenalauben: Die Geschichte der Kunstkammer und die Zukunft der Kunstaeschichte*. Translated by Allison Brown. Princeton, NJ: Princeton University Press.

Brewer, John and Roy Porter (eds.). 1993. *Consumption and the World of Goods*. London and New York: Routledge.

Brinsley, John. 1612. *Ludus Literarius: or, the grammar schoole shewing how to proceede from the first entrance into learning, to the highest perfection required in the grammar schooles, with ease, certainty and delight both to masters and schollars*. London: [Humphrey Lownes] for Thomas Man.

Brothers, Cammy. 2017. "What drawings did in Renaissance Italy." In Alina Payne (ed.), *Companion to Early Modern Architecture*. Vol. I: Renaissance and Baroque Architecture. Malden, MA: Blackwell Press.

Brotton, Jerry. 2002. *The Renaissance Bazar: From the Silk Road to Michelangelo*. Oxford: Oxford University Press.

Brown, Michelle P. 1994. "The Role of the Wax Tablet in Medieval Literacy: A Reconsideration in Light of a Recent Find from York." *The British Library Journal*, 20(1): 1–16.

Brown, Patricia F. 2004. *Private Lives in Renaissance Venice: Art, Architecture, and the Family*. New Haven, CT: Yale University Press.

Brue, Stanley L. and Randy R. Grant. 2007. *The Evolution of Economic Thought*. 7th edition. Fort Worth, TX: Dryden Press.

Bruno, Giordano. [1584] 1977. *On the Infinite Universe and Worlds*. Translated by Dorothea Waley Singer. New York: Greenwood Press.

Bruno, Giordano. [1584] 1995. *The Ash Wednesday Supper*. Translated by Edward A. Gosselin and Lawrence S. Lerner. Toronto: University of Toronto Press.

Bruno, Giordano. [1584] 1998. *Cause, Principle, and Unity*. Translated by Robert de Lucca. Cambridge and New York: Cambridge University Press.

Buettner, Brigitte. 1996. *Boccaccio's Des Cleres et Nobles Femmes: Systems of Signification in an Illuminated Manuscript*. Seattle: College Art Association in association with University of Washington Press.

Buonocore, Marco. 2015. "Epigraphic Research from Its Inception: The Contribution of Manuscripts." In Christer Bruun and Jonathan Edmondson (eds.), *The Oxford Handbook of Roman Epigraphy*. Oxford: Oxford University Press.

Burckhardt, Jacob. [1860] 1990. *The Civilization of the Renaissance in Italy*. Translated by Samuel George C. Middlemore. London: Penguin.

Burckhardt, Jacob. 1878. *The Civilization of the Renaissance in Italy*. London: C. K. Paul & Co.

Burghartz, Susanna. 2015. "Covered Women? Veiling in Early Modern Europe." Translated by Jane Caplan. *History Workshop Journal*, 80(1): 1–32.

Burgon, John W. 1839. *The Life and Times of Sir Thomas Grisham*. 2 vols. London: Jennings.

Burke, Jill. 2012a. "Inventing the High Renaissance from Winckelmann to Wikipedia: An Introductory Essay." In Jill Burke (ed.), *Rethinking the High Renaissance*. Farnham: Ashgate.

Burke, Jill. 2012b. "Republican Florence and the Arts, 1494–1513." In Francis Ames-Lewis (ed.), *Florence*. Artistic Centers of the Italian Renaissance. Cambridge: Cambridge University Press.

Burke, Jill. 2018. *The Italian Renaissance Nude*. New Haven, CT, and London: Yale University Press.

Burke, Peter. 1990. *The French Historical Revolution: The Annales School, 1929–1989*. Palo Alto, CA: Stanford University Press.

Burke, Peter. 1995. *The Fortunes of the Courtier: The European Reception of Castiglione's Cortegiano*. Cambridge: Polity.

Burke, Peter. 1998. *The European Renaissance: Centres and Peripheries*. Oxford: Blackwell Publishers.

Burke, Peter. 2009. "Jack Goody and the Comparative History of Renaissances." *Theory, Culture & Society*, 26(7–8): 16–31.

Buylaert, Frederik, Wim De Clercq and Jan Dumolyn. 2011. "Sumptuary Legislation, Material Culture and the Semiotics of 'vivre noblement' in the County of Flanders (14th–16th centuries)." *Journal of Society History*, 36(4): 393–417.

Bynum, Caroline Walker. 2011. *Christian Materiality: An Essay on Religion in Late Medieval Europe*. New York: Zone Books.

Bynum, Caroline Walker. 2016. "Are Things 'Indifferent'? How Objects Change Our Understanding of Religious History." *German History*, 34(1): 88–112.

Cadden, Joan. 2013. "The Organization of Knowledge: Disciplines and Practices." In David C. Lindberg and Michael H. Shank (eds.), *The Cambridge History of Science: Volume 2: Medieval Science*. Cambridge: Cambridge University Press.

Calvin, John. 1574. *Sermons of John Calvin vpon the Book of Iob*. Translated by Arthur Golding. London: Henry Binneman for Lucas Harrison and George Bishop. Beinecke Library, Yale University, Me45 C136 J5 +g574b.

Campana, Joseph and Scott Maisano (eds.). 2016. *Renaissance Posthumanism*. New York: Fordham University Press.

Campbell, Bruce M. S. 2016. *The Great Transition: Climate, Disease and Society in the Late-Medieval World*. Cambridge: Cambridge University Press.

Campbell, Ian. 2004. *Ancient Roman Topography and Architecture*. 3 vols. London: Harvey Miller.

Campbell, Stephen J. 2002. "'Fare una cosa morta parer viva': Michelangelo, Rosso, and the (Un)Divinity of Art." *The Art Bulletin*, 84(4): 596–620.

Campbell, Stephen J. 2004. *The Cabinet of Eros: Renaissance Mythological Painting and the Studiolo of Isabella d'Este*. New Haven, CT: Yale University Press.

Cañizares-Esguerra, Jorge. 2005. "Iberian Colonial Science." *Isis*, 96(1): 64–70.

Carelli, Peter. 2001. *En kapitalistisk anda: Kulturella förändringar i 1100-talets Danmark*. Stockholm: Almqvist & Wiksell International.

Carroll, Margaret D. 1993. "'In the Name of God and Profit': Jan van Eyck's Arnolfini Portrait." *Representations*, 44: 96–132.

Castiglione, Baldesar. 2004. *The Book of the Courtier*. London: Penguin.

Cavallo, Guglielmo and Roger Chartier (eds.). 1999. *A History of Reading in the West*. Amherst: University of Massachusetts Press.

Cavallo, Sandra. 2006. "Health, Beauty, and Hygiene." In Marta Ajmar-Wollheim and Flora Dennis (eds.), *At Home in Renaissance Italy*. London: V&A Publications.

Cavallo, Sandra. 2007. *Artisans of the Body in Early Modern Italy: Identities, Families, and Masculinities*. Manchester: Manchester University Press.

Cavallo, Sandra. 2016. "Health, Air, and Material Culture in the Early Modern Italian Domestic Environment." *Social History of Medicine*, 29(4): 695–716.

Cavallo, Sandra and Tessa Storey. 2013. *Healthy Living in Late Renaissance Italy*. Oxford: Oxford University Press.

Caviness, Madeline. 1998. "Hildegard as Designer of the Illustrations to Her Works." In Charles Burnett and Peter Dronke (eds.), *Hildegard of Bingen: The Context of Her Thought and Art*. London: Warburg Institute.

Cazzola, Piero. 1976. "I 'Mastri frjazy' a Mosca sullo scorcio del quindicesimo secolo (dalle Cronache russe e da documenti di Archivi italiani)." *Arte Lombarda*, 44/45: 157–72.

Cennini, Cennino. 2015. *Cennino Cennini's Il Libro Dell'arte: A New English Translation and Commentary with Italian Transcription*. Edited by Lara Broecke. London: Archetype Publications Ltd.

Cerretani, Bartolomeo. 1993. *Ricordi*. Edited by Giuliana Berti, Studi e testi/Istituto nazionale di studi sul Rinascimento, 29. Florence: Olschki.

Chafuen, Alejandro. 2003. *Faith and Liberty: The Economic Thought of the Late Scholastics*. Lanham, MD: Lexington.

Chambers, David Sanderson. 1971. *Patrons and Artists in the Italian Renaissance*. Columbia: University of South Carolina Press.

Chapman, Hugo, and Marzia Faietti. 2010. *Fra Angelico to Leonardo: Italian Renaissance Drawings*. London: British Museum Press.

Chartier, Roger. 1997. "Sécretaires for the People? Model Letters of the Ancien Régime: Between Court Literature and Popular Chapbook." In Roger Chartier, Alain Boureau and Cécile Dauphin (eds.), *Correspondence: Models of Letter-Writing from the Middle Ages to the Nineteenth Century*. Translated by Christopher Woodall. Princeton, NJ: Princeton University Press.

Chartier, Roger. 2007. "Wax and Parchment: The Poems of Baudri de Borgeuil." In Roger Chartier (ed.), *Inscription and Erasure: Literature and Written Culture from the Eleventh to the Eighteenth Century*. Translated by Arthur Goldhammer. Philadelphia: University of Pennsylvania Press.

Chastel, André. 1953. "Marquetrie et perspective au XVe Siecle." *Revue des Arts*, 5(3): 141–54.

Chatenet, Monique. 2001. *Chambord*. Paris: Monum.

Chipps Smith, Jeffrey. 2004. *The Northern Renaissance*. New York: Phaidon Press.

Clair, Colin. 1987. *Christopher Plantin*. London: Plantin Paperbacks.

Clark, James G. 2004. "Print and Pre-Reformation Religion: The Benedictines and the Press, *c.* 1470–*c.* 1550." In Julia Crick and Alexandra Walsham (eds.), *The Uses of Script and Print, 1300–1700*. Cambridge: Cambridge University Press.

Clarke, Georgia. 2003. *Roman House—Renaissance Palaces: Inventing Antiquity in Fifteenth Century Italy*. Cambridge: Cambridge University Press.

Clarke, Tim H. 1986. *The Rhinoceros from Dürer to Stubbs: 1515–1799*. London: Sotheby's Publications.

Cohn, Jr., Samuel K. 1997. *The Cult of Remembrance and the Black Death: Six Renaissance Cities in Central Italy*. Baltimore, MD: John Hopkins University Press.

Cohn, Jr., Samuel K. 2002. *The Black Death Transformed: Disease and Culture in Early Renaissance Europe*. London: John Arnold.

Cohn, Jr., Samuel K. 2012. "Renaissance Attachment to Things: Material Culture in Last Wills and Testaments." *Economic History Review*, 65(3): 984–1004.

Colenbrander, Herman T. H. 2010. "The Sitter in Jan Gossaert's *Portrait of a Merchant* in the National Gallery of Art, Washington: Jan Snoeck (*c.*1510–85)." *The Burlington Magazine*, 152(1283): 82–5.

Coltman, Victoria. 2015. "Material Culture and the History of Art(Efacts)." In Giorgio Riello and Anne Gerritsen (eds.), *Writing Material Culture History*. London: Bloomsbury.

Comenius, Joannes Amos. 1672. *Orbis Sensualium Pictus*. Translated by Charles Hoole. London: Samuel Mearne.

Conrad, Lawrence I., Michael Neve, Vivian Nutton, Roy Porter and Andrew Wear. 1995. *The Western Medical Tradition: 800 BC to AD 1800*. Cambridge: Cambridge University Press.

Contreni, John G. 1984. "The Carolingian Renaissance." In Warren T. Treadgold (ed.), *Renaissances Before the Renaissance: Cultural Revivals of Late Antiquity and the Middle Ages*. Palo Alto, CA: Stanford University Press.

Cook, Harold. 2007. *Matters of Exchange: Commerce, Medicine, and Science in the Dutch Golden Age*. New Haven, CT, and London: Yale University Press.

Coole, Diana and Samantha Frost. 2010. *New Materialisms. Ontology, Agency and Politics*. Durham, NC, and London: Duke University Press.

Copenhaver, Brian P. 1984. "Scholastic Philosophy and Renaissance Magic in the *De vita* of Marsilio Ficino." *Renaissance Quarterly*, 37(4): 523–54.

Copernicus, Nicolaus. 1992a. *Minor Works*. Translated by Edward Rosen. Baltimore, MD: Johns Hopkins University Press.

Copernicus, Nicolaus. 1992b. *On the Revolutions*. Translated by Edward Rosen. Baltimore, MD: Johns Hopkins University Press.

Criminisi, Antonio, Martin Kemp and Sing B. Kang. 2004. "Reflections of reality in Jan van Eyck and Robert Campin." *Historical Methods: A Journal of Quantitative and Interdisciplinary History*, 37(3): 109–22.

Cummings, Brian. 2002. *The Literary Culture of the Reformation: Grammar and Grace*. Oxford: Oxford University Press.

Currie, Elizabeth. 2006. *Inside the Renaissance House*. London: Victoria & Albert Museum.

Cuss, T. P. Camerer. 1952. *The Story of Watches*. London: MacGibbon & Kee Ltd.

D'Aulnoy, Madame. 2005. *Relation du voyage d'Espagne*. Edited by Maria Susana Seguin. Paris: Éditions Desjonquères.

d'Avray, David. 2004. "Printing, Mass Communication, and Religious Reformation: The Middle Ages and After." In Julia Crick and Alexandra Walsham (eds.), *The Uses of Script and Print*. Cambridge: Cambridge University Press.

da Vinci, Leonardo. 2008. *Notebooks*, New edition. Oxford: Oxford University Press.

Dackerman, Susan (ed.). 2011. *Prints and the Pursuit of Knowledge in Early Modern Europe*. Cambridge, MA, New Haven, CT, and London: Harvard Art Museums & Yale University Press.

DaCosta Kaufmann, Thomas. 1995. *Court, Cloister & City*. Chicago, IL: University of Chicago Press.

DaCosta Kaufmann, Thomas. 2004. *Toward a Geography of Art*. Chicago, IL: University of Chicago Press.

Dahl, Folke. 1952. *A Bibliography of English Corantos and Periodical Newsbooks 1620–1642*. London: Bibliographical Society.

Dandelet, Thomas. 2008. "Searching for the New Constantine: Early Modern Spanish Imperial City." In Gary Cohen and Franz Szabo (eds.), *Embodiments of Power: Building Baroque Cities in Europe*. New York: Berghahn Books.

Daston, Lorraine and Katharine Park. 1998. *Wonders and the Order of Nature, 1150–1750*. New York: Zone Books.

Davies, Surekha. 2016. *Renaissance Ethnography and the Invention of the Human: New Worlds, Maps and Monsters*. Cambridge: Cambridge University Press.

Davies, Surekha. Forthcoming. "Catalogical Encounters: Worldmaking in Early Modern Cabinets of Curiosities". In Paula Findlen (ed.), *Early Modern Things: Objects and their Histories, 1500–1800*. 2nd edition. New York and London: Routledge.

Davis, Natalie Zemon. 2000. *The Gift in Sixteenth-Century France*. Oxford: Oxford University Press.

de Azpilcueta Navarro, Martín. [1565] 2006. *Comentario resolutorio de usuras*. Madrid: Ministerio de Cultura. Available online: http://bvpb.mcu.es/es/catalogo_imagenes/grupo.cmd?path=11000181.

de Baïf, Lazare. 1536. *De re vestiaria*. Leiden: Gryphius. Available online: http://reader.digitale-sammlungen.de/resolve/display/bsb11096259.html.

de Champeaux, Alfred. 1885. *Le Meuble*, vol. II. Paris.

de Grazia, Margareta, Maureen Quilligan and Peter Stallybrass (eds.). 1996. *Subject and Object in Renaissance Culture*. Cambridge: Cambridge University Press.

de Grazia, Margreta, Maureen Quilligan and Peter Stallybrass. 1998. "Introduction." In Margreta de Grazia, Maureen Quilligan and Peter Stallybrass (eds.), *Subject and Object in Renaissance Culture*. Cambridge: Cambridge University Press.

De l'Orme, Philibert. 1567. *Premier tome de l'architecture*. Paris: Frédéric Morel.

de Langhe, Kaatje, Bart Vekemans, Wim de Clercq, Laszlo Vincze and Peter Vandenabeele. 2015. "Heating the house. An archaeological and archaeometrical investigation into the tile-stoves of late-medieval Flanders, Belgium (14–17th centuries)." *Post-Medieval Archaeology*, 49(2): 291–312.

De Vries, Jan. 2002. "Luxury in the Dutch Golden Ages in Theory and in Practice." In Maxine Berg and Elizabeth Eger (eds.), *Luxury in the Eighteenth Century: Debates, Desires and Delectable Goods*. London: Palgrave Macmillan.

De Vries, Jan. 2008. *The Industrious Revolution: Consumer Behavior and the Household Economy, 1650 to the Present*. Cambridge: Cambridge University Press.

Dear, Peter. 2001. *Revolutionizing the Science: European Knowledge and Its Ambitions, 1500–1700*. Basingstoke: Palgrave Macmillan.

Del Soldato, Eva. 2016. "Natural Philosophy in the Renaissance." In Edward N. Zalta (ed.), *The Stanford Encyclopedia of Philosophy*. Palo Alto, CA: Stanford University. Available online: https://plato.stanford.edu/archives/fall2016/entries/natphil-ren/.

Delcorno, Pietro. 2015. "'Quomodo discet sine docente?' Observant Efforts Towards Education and Pastoral Care." In James Mixson and Bert Roest (eds.), *A Companion to Observant Reform in the Late Middle Ages and Beyond*. Brill's companions to the Christian Tradition, vol. 59. Boston, MA: Brill.

della Mirandola, Pico. 2012. *Oration on the Dignity of Man: A New Translation and Commentary*. Edited by Francesco Borghesi, Michael Papio and Massimo Riva. Cambridge: Cambridge University Press.

della Porta, Giambattista. 1586. *De humana physiognomonia*. Vico Equense: Giuseppe Cacchi. Available online: http://atena.beic.it/webclient/DeliveryManager?pid=1285 865&custom_att_2=simple_viewer.

Delmarcel, Guy. 1999. *Flemish Tapestry from the 15th to the 18th Century*. Tielt: Lannoo Uitgeverij.

Der Mensch um 1500. Werke aus Kirchen und Kunstkammern. 1977. Skulpturensammlung, Staatlichen Museen Preussischer Kulturbesitz.

Dering, Sir Edward. 1643. "The Dering Book of Expenses," Kent Archives Office, U350 E4, ff. 70, 71; "A Bill of money expended by me Henry Linch for necessaries &c for the Comittee at Cambden howse Dec 21th 1643," National Archives, Kew, SP 28/212.

Descola, Philippe. 2013. *Beyond Nature and Culture*. Translated by Janet Lloyd, foreword by Marshall Sahlins. Chicago, IL: University of Chicago Press.

Deserps, François. 1562. *Receuil de la diuersité des habits*. Paris: Richard Breton.

Deswarte-Rosa, Sylvie (ed.). 2004. *Sebastiano Serlio à Lyon: architecture et imprimerie*. Lyon: Mémoire Active.

Didi-Huberman, Georges. 2005. *Confronting Images: Questioning the Ends of a Certain History of Art*. University Park: Penn State University Press.

Dillenberger, John. 1999. *Images and Relics: Theological Perception and Visual Images in Sixteenth-Century Europe*. New York and London: Oxford University Press.

Douglas, Mary and Baron Isherwood. 1979. *The World of Goods*. New York: Basic Books, Inc.

Dummett, Michael, and Kamal Abu-Deeb. 1973. "Some Remarks on Mamluk Playing Cards." *Journal of the Warburg and Courtauld Institutes*, 36: 106–28.

Dyer, Christopher. 2001. *An Age of Transition? Economy and Society in England in the Later Middle Ages*. Oxford: Oxford University Press.

Dyrness, William A. 2004. *Reformed Theology and Visual Culture: The Protestant Imagination from Calvin to Edwards*. Cambridge: Cambridge University Press.

Eamon, William. 1994. *Science and the Secrets of Nature: Books of Secrets in Medieval and Early Modern Culture*. Princeton, NJ: Princeton University Press.

Earle, Rebecca. 2012. *The Body of the Conquistador: Food, Race and the Colonial Experience in Spanish America*. Cambridge: Cambridge University Press.

Edgerton, Samuel Y. 2009. *The Mirror, the Window, and the Telescope: How Renaissance Linear Perspective Changed Our Vision of the Universe*. Ithaca, NY, and London: Cornell University Press.

Edwards, Mark U. 1994. *Printing, Propaganda, and Martin Luther*. Berkeley: University of California Press.

Eikelmann, Renate. 2006. *Von Paris nach Bayern: Das Goldene Rössl und Meisterwerke der französischen Hofkunst um 1400*. Munich: Bayerisches Nationalmuseum.

Eire, Carlos M. N. 1989. *War Against the Idols: The Reformation of Worship from Erasmus to Calvin*. Cambridge: Cambridge University Press.

Eisenstein, Elizabeth L. 1979. *The Printing Press as an Agent of Change: Communications and Cultural Transformations in Early-Modern Europe*. Cambridge: Cambridge University Press.

Eisenstein, Elizabeth L. 2011. *Divine Art, Infernal Machine: The Reception of Printing in the West from First Impressions to the Sense of an Ending*. Philadelphia and Oxford: University of Pennsylvania Press.

Eisermann, Falk. 2001. "Der Ablaß als Medienereignis. Kommunikationswandel durch Einblattdrucke im 15. Jahrhundert. Mit einer Auswahlbibliographie." In Rudolf Suntrup and Jan R. Veenstra (eds.), *Tradition and Innovation in an Era of Change/ Tradition und Innovation im Übergang zur Frühen Neuzeit*. Medieval to Early Modern Culture/Kultureller Wandel vom Mittelalter zur Frühen Neuzeit, vol. 1. Frankfurt: Peter Lang.

Elkins, James. 1994. *The Poetics of Perspective*. Ithaca, NY: Cornell University Press.

Elsner, Jaś. 2010. "Art History as Ekphrasis." *Art History*, 33(1): 10–27.

Emison, Patricia A. 2004. *Creating the "Divine" Artist: From Dante to Michelangelo*. Leiden and Boston, MA: Brill.

Emmerson, Richard K. 2002. "The Representation of Antichrist in Hildegard of Bingen's *Scivias*: Image, Word, Commentary, and Visionary Experience." *Gesta*, 41(2): 95–110.

Fairchilds, Cissie. 1993. "The Production and Marketing of Populuxe Goods in Eighteenth-Century Paris." In John Brewer and Roy Porter (eds.), *Consumption and the World of Goods*. London: Routledge.

Fanelli, Giovanni and Michele Fanelli. 2004. *Brunelleschi's Cupola: Past and Present of an Architectural Masterpiece*. Florence: Mandragora.

Farago, Claire J. (ed.). 1995. *Reframing the Renaissance: Visual Culture in Europe and Latin America, 1450–1650*. New Haven, CT: Yale University Press.

Febvre, Lucien and Henri-Jean Martin. 1958. *L'Apparition du Livre*. Paris: A. Michel. Translated by David Gerard. 1976. *The Coming of the Book: The Impact of Printing, 1450–1800*. London: NLB.

Feerick, Jean E. and Vin Nardizzi (eds.). 2012. *The Indistinct Human in the Renaissance*. New York: Palgrave MacMillan.

Feest, Christian F. 2007. "John White's New World." In Kim Sloan (ed.), *A New World: England's First View of America*. London: British Museum Press.

Ferguson, John K. 1959. *Bibliographical Notes on Histories of Inventions and Books of Secrets*. 2 vols. London: Holland Press.

Fergusson, Wallace K. 1948. *The Renaissance in Historical Thought. Five Centuries of Interpretation*. Cambridge, MA: Houghton Mifflin.

Ficino, Marsilio. [1471] 2014. *Das Corpus Hermeticum durch Marsilius Ficinus*. Translated by M. P. Steiner. Basel: Edition Oriflamme.

Ficino, Marsilio. [1482] 2001–2006. *Platonic Theology*. Translated by Michael J. B. Allen and John Warden. Cambridge, MA: Harvard University Press.

Filarete [1464] 1965. *Treatise on Architecture*. Translated by John R. Spencer. 2 vols. New Haven, CT: Yale University Press.

Findlen, Paula. 1994. *Possessing Nature: Museums, Collecting, and Scientific Culture in Early Modern Italy*. Berkeley: University of California Press.

Findlen, Paula. 1998. "Possessing the past: the material world of the Italian Renaissance." *The American Historical Review*, 103(1): 83–114.

Findlen, Paula (ed.). 2013. *Early Modern Things: Objects and their Histories, 1500– 1800*. London and New York: Routledge.

Findlen, Paula (ed.). 2013 and 2021, 2nd (expanded edition). *Early Modern Things: Objects and their Histories, 1500–1800*. 2nd (expanded) edition. New York and London: Routledge.

Fisher, Will. 2011. "'Had it a codpiece, 'twere a man indeed': The Codpiece as Constitutive Accessory in Early Modern English Culture." In Bella Mirabella (ed.), *Ornamentalism: The Art of Renaissance Accessories*. Ann Arbor: University of Michigan Press.

Fleming, Donald and Bernard Bailyn (eds.). 1969. *The Intellectual Migration: Europe and America, 1930–1960*. Cambridge, MA: Harvard University Press.

Flood, John L. 2003. "'Volentes Sibi Comparare Infrascriptos Libros Impressos …': Printed Books as a Commercial Commodity in the Fifteenth-Century." In Kristian Jensen (ed.), *Incunabula and their Readers: Printing, Selling and Using Books in the Fifteenth Century*. London: The British Library.

Fontana, Domenico. 1590. *Della trasportazione dell'Obelisco Vaticano …* Rome: Domenico Basa.

Foucault, Michel. 1970. *The Order of Things: An Archaeology of the Human Sciences*. New York: Pantheon Books.

Foucault, Michel. 2002. *Archaeology of Knowledge*. London and New York: Routledge.

Frasca-Spada, Marina and Nicholas Jardine (eds.). 2000. *Books and the Sciences in History*. New York: Cambridge University Press.

Freedman, Paul. 2005. "Spices and Late-Medieval European Ideas of Scarcity and Value." *Speculum*, 20: 1209–27.

Freedman, Paul. 2008. *Out of the East: Spices and the Medieval Imagination*. New Haven, CT: Yale University Press.

Frick, Carole Collier. 2002. *Dressing Renaissance Florence: Families, Fortunes, and Fine Clothing*. Baltimore, MD: Johns Hopkins University Press.

Friedländer, Max J. 1972. *Jan Gossart and Bernart van Orley*. Translated by Heinz Norden, *Early Netherlandish Painting*, vol. 8. New York: Praeger.

Friedman, John Block. 2008. "The Art of the Exotic: Robinet Testard's Turbans and Turban-Like Coiffure." In Robin Netherton and Gale Owen-Crocker (eds.), *Medieval Clothing and Textiles*, 4. Woodbridge: Boydell.

Frommel, Sabine. 2003. *Sebastiano Serlio Architect*. Milan: Electa.

Fuller, Mary C. 1995. *Voyages in Print: English Travel to America, 1576–1624*. Cambridge: Cambridge University Press.

Fulton, Rachel. 2004. "The Virgin in the Garden, or Why Flowers Make Better Prayers." *Spiritus: A Journal of Christian Spirituality*, 4(1): 1–23.

Fumerton, Patricia and Simon Hunt (eds.). 1999. *Renaissance Culture and the Everyday*. Philadelphia: University of Pennsylvania Press.

Gage, Frances. 2016. *Painting as Medicine in Early Modern Rome. Giulio Mancini and the Efficacy of Art*. University Park: Penn State University Press.

Gahtan, Maia Wellington. 2017. "Introduction: Giorgio Vasari and the Birth of the Museum." In Maia Wellington Gahtan (ed.), *Giorgio Vasari and the Birth of the Museum*. London and New York: Routledge.

Gaimster, David. 1994. "The Archaeology of Post-medieval Society, c. 1450–1750: Material Culture Studies in Britain Since the War." In Blaise Vyner (ed.), *Building on the Past. Papers Celebrating 150 Years of the Royal Archaeological Institute*. London: Royal Archaeological Institute.

Gaimster, David. 1997. *German Stoneware 1200–1900: Archaeology and Cultural History*. London: British Museum, Victoria and Albert Museum, and Museum of London.

Gaimster, David. 1999. "The Post Medieval Ceramic Revolution in Southern Britain
c. 1450–1650." In Geoff Egan and Ronald L. Michael (eds.). *Old and New Worlds:
Historical/Post Medieval Archaeology Papers from the Societies' Joint Conferences at
Williamsburg and London*. Oxford: Oxbow.

Gaimster, David and Beverly Nenk. 1997. "English Households in Transition c.
1450–1550: the ceramic evidence." In David Gaimster and Paul Stamper (eds.), *The
Age of Transition: The Archaeology of English Culture 1400, 1600*. The Society of
Medieval Archaeology Monograph 15. Oxford: Oxbow Monograph 98.

Gaimster, David and Paul Stamper (eds.) 1997. *The Age of Transition: The Archaeology
of English Culture 1400–1600*. Oxford: Oxbow.

Galassi, Giuseppe. 1996. "Pacioli, Luca (c. 1445–c. 1517)." In Michael Chatfield
and Richard Vangermeersch (eds.), *History of Accounting: An International
Encyclopaedia*. New York: Garland Publishing.

Galileo, Galilei. 1970. *Scritti letterari*. Edited by Alberto Chiari. Florence: Le Monnier.

Galletti, Sara. 2018. "From Stone to Paper: Philibert de L'Orme, the *Premier tome
de l'architecture* (1567), and the Birth of Stereotomic Theory." *Aedificare:
International Journal of Construction History*, 2(2): 143–62.

Garber, Peter M. 1989. "Tulipmania." *The Journal of Political Economy*, 97(3):
535–60.

Gaurico, Pomponio. 1999. *De Sculptura*. Translated by Paolo Cutolo. Naples: Edizioni
scientifiche italiane.

Geertz, Clifford. 1973. *The Interpretation of Cultures*. New York: Basic Books.

Gentilcore, David. 2016. *Food and Health in Early Modern Europe: Diet, Medicine and
Society, 1450–1800*. London: Bloomsbury Academic.

Georgius Agricola. [1546] 1955. *De natura fossilium: Textbook of mineralogy*.
Translated by Mark Chance Bandy and Jean A. Bandy. New York: Geological
Society of America.

Georgius Agricola. [1556] 1950. *De re metallica*. Translated by Herbert Hoover and
Lou Henry Hoover. New York: Dover Publications.

Gerritsen, Anne and Giorgio Riello (eds.). 2015. *The Global Lives of Things: The
Material Culture of Connections in the Early Modern World*. London and New
York: Routledge.

Gilbert, Jack. 2006. "Failing and flying." In *Refusing Heaven*. New York: Knopf.

Gilbert, William. [1600] 1958. *On the Magnet*. Translated by Silvanus Phillips
Thompson. New York: Basic Books.

Giles of Viterbo. [c. 1513–1517] 1898. "Historia viginiti saeculorum." In Ludwig
von Pastor. *The History of the Popes from the Close of the Middle Ages*. Vol. 6.
Translated by Dom Ernest Graf. London: J. Hodges.

Gill, Meredith Jane. 2005. *Augustine in the Italian Renaissance*. Cambridge:
Cambridge University Press.

Gill, Rebecca. 2016. "Conception and Construction: Galeazzo Alessi and the Use of
Drawings in Sixteenth-Century Architectural Practice." *Architectural History*, 59:
181–219.

Giovanni Boccaccio. 2001. *Famous Women*, I Tatti Renaissance Library, 1. Cambridge,
MA, and London: Harvard University Press.

Girouard, Mark. 1983. *Robert Smythson & the Elizabethan Country House*. New
Haven, CT: Yale University Press.

Glassie, Henry. 1999. *Material Culture*. Bloomington: Indiana University Press.

Glen, Robbie and Peter Stallybrass. 2011. "What Is a Letter?" Huntington Library
Distinguished Lecture, Huntington Library, San Marino, December 11, 2011.

Goldgar, Anne. 2007. *Tulipmania: Money, Honor, and Knowledge in the Dutch Golden Age*. Chicago, IL: University of Chicago Press.

Goldstein, Karl. 1996. *Teaching Art: Academies and Schools from Vasari to Albers*. Cambridge and New York: Cambridge University Press.

Goldthwaite, Richard A. 1982. *The Building of Renaissance Florence: An Economic and Social History*. Baltimore, MD: John Hopkins University Press.

Goldthwaite, Richard A. 1985. "The Renaissance Economy: The Preconditions for Luxury Consumption." In *Aspetti della Firenze-Pisa-Prato, 10–14 marzo 1984*. Florence: Instituto Datini.

Goldthwaite, Richard A. 1993. *Wealth and the Demand for Art in Italy: 1300–1600*. Baltimore, MD, and London: Johns Hopkins University Press.

Gombrich, Ernst H. 1969. *In Search of Cultural History*. Oxford: Clarendon Press.

Gombrich, Ernst H. 1974. "The Renaissance: Period or Movement?" In Joseph B. Trapp (ed.), *Background to the English Renaissance: Introductory Lectures*. London: Gray-Mills Publishing.

Gómez, Pablo F. 2017. *The Experiential Caribbean: Creating Knowledge and Healing in the Early Modern Atlantic*. Chapel Hill: University of North Carolina Press.

Goody, Jack. 2006. *The Theft of History*. Cambridge: Cambridge University Press.

Goody, Jack. 2010. *Renaissances: The One or the Many?* Cambridge: Cambridge University Press.

Grafton, Anthony. 2007. "Renaissance Histories of Art and Nature." In Bernadette Bensaude-Vincent and William R. Newman (eds.), *The Artificial and the Natural: An Evolving Polarity*. Cambridge, MA, and London: The MIT Press.

Grafton, Anthony et al. 1992. *New Worlds, Ancient Texts: The Power of Tradition and the Shock of Discovery*. Cambridge, MA, etc.: The Belknap Press of Harvard University Press.

Greenblatt, Stephen. 1980. *Renaissance Self-Fashioning: From More to Shakespeare*. Chicago, IL: University of Chicago Press.

Greenblatt, Stephen. 2011. *The Swerve: How the World Became Modern*. New York and London: W.W. Norton & Company.

Greene, Thomas M. 2001. "Labyrinth Dances in the French and English Renaissance." *Renaissance Quarterly*, 54(4): 1403–66.

Gregory, Sharon. 2012. *Vasari and the Renaissance Print*. Farnham: Ashgate.

Grell, Ole Peter (ed.). 1998. *Paracelsus: The Man and His Reputation, His Ideas and Their Transformation*. Leiden and Boston, MA: Brill.

Grice-Hutchinson, Marjorie. 1952. *The School of Salamanca: Readings in Spanish Monetary Theory, 1544–1605*. Oxford: Clarendon.

Griffin, Clive. 1988. *The Crombergers of Seville: The History of a Printing and Merchant Dynasty*. Oxford: Clarendon Press.

Gritsch, Eric W. 2017. "Luther on Humour." In Timothy J. Wengert (ed.), *The Pastoral Luther: Essays on Martin Luther's Practical Theology*. Minneapolis, MN: Fortress Press.

Guérin, Sarah M. 2010. "Avorio d'ogni Ragione: The Supply of Elephant Ivory to Northern Europe in the Gothic Era." *Journal of Medieval History*, 36: 156–74.

Gurevich, Aaron. 1995. *The Origins of European Individualism*. Oxford and Cambridge, MA: Blackwell.

Hakluyt, Richard. 1903–1905. *The Principal Navigations, Voyages and Discoveries of the English Nation*, 8 vols. Glasgow: Maclehose.

Haggrén, Georg. 2009. "En tid av transition: Förändringar i den materialla kulturen under 1500- och 1600-talen." *Finskt Museum*, 115(2008): 75–93.

Hall, Marie B. 1962. *Scientific Renaissance, 1450–1630*. New York: Harper Brothers.

Hallyn, Fernand. 1993. *The Poetic Structure of the World. Copernicus and Kepler*. Translated by Donald M. Leslie. New York: Zone Books.

Hamann, Byron Ellsworth. 2010. "The Mirrors of *Las Meninas*: Cochineal, Silver, and Clay." *The Art Bulletin*, 92(1–2): 6–35.

Hamling, Tara and Catherine Richardson (eds.). 2010. *Everyday Objects: Medieval and Early Modern Material Culture and its Meanings*. Farnham: Ashgate.

Hand, John Oliver and Martha Wolff. 1986. *Early Netherlandish Painting*. Washington, DC: National Gallery of Art.

Harbison, Craig. 1985. "Visions and Meditations in Early Flemish Painting." *Simiolus: Netherlands Quarterly for the History of Art*, 15(2): 87–118.

Harley, J. B., and David Woodward (eds.). 1987. *The History of Cartography*. Chicago, IL: University of Chicago Press.

Harvey, Karen. 2009. *History and Material Culture: A Student's Guide to Approaching Alternative Sources*. London and New York: Routledge.

Haskins, Charles H. 1927. *The Renaissance of the Twelfth Century*. Cambridge, MA: Harvard University Press.

Heal, Bridget. 2017. "Introduction: Art and Religious Reform in Early Modern Europe." *Art History*, 40(2): 246–55.

Healy, Margaret. 2014. "Why Me? Why Now? How? The Body in Health and Disease." In Linda Kalof and William Bynum (eds.), *A Cultural History of the Human Body in the Renaissance*. New York: Bloomsbury.

Heaney, Christopher. 2018. "How to Make an Inca Mummy: Andean Embalming, Peruvian Science, and the Collection of Empire." *Isis*, 109(1): 1–27.

Hellinga, Lotte. 1982. *Caxton in Focus: The Beginning of Printing in England*. London: British Library.

Hellinga, Lotte and J. B. Trapp (eds.) 1999. *The Cambridge History of the Book in Britain*, vol. 3, 1400–1557. Cambridge: Cambridge University Press.

Henderson, John. 2006. *The Renaissance Hospital. Healing the Body and Healing the Soul*. New Haven, CT: Yale University Press.

Henderson, Judith Rise. 2007. "Erasmus's *Opus de Conscribendis Epistolis* in Sixteenth-Century Schools." In Carol Poster and Linda C. Mitchell (eds.), *Letter-Writing Manuals and Instruction from Antiquity to the Present: Historical and Bibliographic Studies*. Columbia: University of South Carolina Press.

Herbrechter, Stefan and Ivan Callus (eds.). 2012. *Posthumanist Shakespeares*. London: Palgrave Macmillan.

Hermes Trismegistus. 2002. *Hermetica: The Greek Corpus Hermeticum and the Latin Asclepius*. Translated by Brian P. Copenhaver. Cambridge: Cambridge University Press.

Hernad, Béatrice (ed.). 1990. *Die Graphiksammlung des Humanisten Hartmann Schedel*. Munich: Prestel.

Heuer, Christopher P. 2009. *The City Rehearsed: Object, Architecture, and Print in the Worlds of Hans Vredeman de Vries*. London: Routledge.

Heylyn, Peter. 1657. *Cosmographie in four books containing the Chorographie and Historie of the whole World*. London: printed for Henry Seile.

Hilliges, Marion. 2011. *Das Stadt- und Festungstor. Fortezza und sicurezza—semantische Aufrüstung im 16. Jahrhundert*. Berlin: Gebr. Mann.

Hillman, David. 1997. "Visceral Knowledge." In David Hillman and Carla Mazzio
(eds.), *The Body in Parts: Fantasies of Corporeality in Early Modern Europe*. New
York: Routledge.

Hillman, David and Carla Mazzio. 1997. "Introduction: Individual Parts." In David
Hillman and Carla Mazzio (eds.), *The Body in Parts: Fantasies of Corporeality in
Early Modern Europe*. New York: Routledge.

Hirsch, Rudolf. 1967. *Printing, Selling and Reading*. Wiesbaden: Otto Harrassowitz.

Hodder, Ian and Clive Orton. 1976. *Spatial Analysis in Archaeology*. Cambridge:
Cambridge University Press.

Hohti, Paula. 2007. "The Inn-keeper's Goods: The Use and Acquisition of Household
Property in Sixteenth-Century Siena." In Michelle O'Malley and Evelyn Welch
(eds.), *The Material Renaissance*. Manchester: Manchester University Press.

Hohti, Paula. 2010. "'Conspicuous' consumption and popular consumers: material
culture and social status in sixteenth-century Siena." *Renaissance Studies*, 24(5):
654–70.

Hopkins, Jasper. 2001. *Complete Philosophical and Theological Treatises of Nicholas
of Cusa*. Minneapolis, MN: Banning.

Hopkins, Jasper. 2002. "Nicholas of Cusa (1401–1464): First Modern Philosopher?"
Renaissance and Early Modern Philosophy, 26: 13–29.

Howell, Martha C. 2010. *Commerce before Capitalism in Europe 1300–1600*.
Cambridge: Cambridge University Press.

Huetz de Lemps, Alain. 1999. "Colonial Beverages and the Consumption of Sugar."
In Albert Sonnenfeld (ed.), *Food: A Culinary History from Antiquity to the Present*.
New York: Columbia University Press.

Huizinga, Johan. 1919. *Herfsttij der Middeleeuwen. Project Gutenberg*. Available
online: http://www.gutenberg.org/ebooks/16829 (accessed February 2018).

Huizinga, Johan. [1919] 1972. *The Waning of the Middle Ages*. Translated by F.
Hopman in 1924, reprint. Harmondsworth: Penguin Books.

Huizinga, Johan. 1924. *The Waning of the Middle Ages*. Harmondsworth: Penguin
Books.

Huizinga, Johan. 1996. *Autumn of the Middle Ages*. Translated by Rodney J. Payton
and Ulrich Mammitzsch. Chicago, IL: University of Chicago Press.

Hüme, Ivor N. 1978. "Material culture with the dirt on it: a Virginia perspective."
In Ian M. Quimby and Ivor N. Hüme (eds.), *Material Culture and the Study of
American Life*. New York: Winterthur.

Husband, Timothy. 1981. *The Wild Man: Medieval Myth and Symbolism*. New York:
The Metropolitan Museum of Art.

Husband, Timothy. 2008. *The Art of Illumination: The Limbourg Brothers and the
Belles Heures of Jean de France, Duc de Berry*. New York: Metropolitan Museum of
Art, New Haven, CT and London: Yale University Press.

Ilardi, Vincent. 2007. *Renaissance Vision from Spectacles to Telescopes*. Philadelphia,
PA: American Philosophical Society.

Impey, Oliver and Arthur MacGregor (eds.). 1985. *The Origins of Museums: The
Cabinet of Curiosities in Sixteenth- and Seventeeth-Century Europe*. Oxford:
Clarendon Press.

Irmscher, Günter. 2004. *Kölner Architektur- und Säulenbücher um 1600*. Bonn: Bouvier.

Jacobs, Fredrika H. 1997. *Defining the Renaissance Virtuosa: Women Artists and the
Language of Art History and Criticism*. Cambridge: Cambridge University Press.

Jamnitzer, Wenzel. 1568. *Perspectiva Corpora Regularium. Das ist ein fleissige Furweisung, Wie die Fuenf Regulierten Koerpere, darvon Plato und Timaeo, und Euclides inn sein Elemetis Schreibt* ... Nuremberg.

Jardine, Lisa. 1996. *Worldly Goods: A New History of the Renaissance*. London: Macmillan Publishers Ltd.

Jirousek, Charlotte. 1995. "More than Oriental Splendor: European and Ottoman Headgear, 1380–1580." *Dress: The Journal of the Costume Society of America*, 22(1): 22–33.

Johns, Adrian. 1998. *The Nature of the Book: Print and Knowledge in the Making*. Chicago, IL: University of Chicago Press.

Johnson, Christine R. 2008. *The German Discovery of the World: Renaissance Encounters with the Strange and Marvelous*. Charlottesville: University of Virginia Press.

Johnson, Matthew. 1995. *An Archaeology of Capitalism*. Oxford: Blackwell.

Jolly, Karen Louise. 2002. "Medieval Magic: Definitions, Beliefs, Practices." In Bengt Ankarloo and Stuart Clark (eds.), *Witchcraft and Magic in Europe: The Middle Ages*. London: The Athlone Press.

Jones, Ann R. and Peter Stallybrass. 2000. *Renaissance Clothing and the Materials of Memory*. Cambridge: Cambridge University Press.

Jones, Ann Rosalind and Peter Stallybrass. 2001. "Fetishizing the Glove in Renaissance Europe." *Critical Inquiry*, 28(1): 114–32.

Jones, Ann Rosalind and Peter Stallybrass. 2011. "Busks, Bodices, Bodies." In Bella Mirabella (ed.), *Ornamentalism: The Art of Renaissance Accessories*. Ann Arbor: University of Michigan Press.

Jordanova, Ludmilla J. 2012. *The Look of the Past: Visual and Material Evidence in Historical Practice*. Cambridge: Cambridge University Press.

Joswig, Wibke. 2012. "Painting the 'Orient'? Dosso Dossi's *Melissa*." In Sabine Schülting, Sabina Lucia Müller and Ralf Hertel (eds.), *Early Modern Encounters with the Islamic East: Performing Cultures*. Farnham: Ashgate.

Juan, Rose Marie San. 1991. "The Court Lady's Dilemma: Isabella d'Este and Art Collecting in the Renaissance." *Oxford Art Journal*, 14(1): 67–78.

Kalina, Pavel. 2009. "European Diplomacy, Family Strategies, and the Origins of Renaissance Architecture in Central and Eastern Europe." *Artibus et Historiae*, 30: 173–90.

Kalof, Linda and William Bynum. 2014. *A Cultural History of the Human Body in the Renaissance*. The Cultural History Series. London, Oxford, New York, New Delhi, Sydney: Bloomsbury Academic.

Kapr, Albert. 1996. *Johann Gutenberg: The Man and His Invention*. Translated by Douglas Martin. Aldershot: Scolar Press.

Karet, Evelyn. 1998. "Stefano Da Verona, Felice Feliciano and the First Renaissance Collection of Drawings." *Arte Lombarda*, 124(3): 31–51.

Kaufmann, Thomas DaCosta. 1993. *The Mastery of Nature: Aspects of Art, Science, and Humanism in the Renaissance*. Princeton, NJ: Princeton University Press.

Kaufmann, Thomas DaCosta. 1995. *Court, Cloister & City: The Art and Culture of Central Europe 1450–1800*. London: Weidenfeld & Nicolson.

Kaufmann, Thomas D. and Elizabeth Pilliod (eds.). 2005. *Time and Place: The Geohistory of Art*. Farnham: Ashgate.

Kelly-Gadol, Joan. 1977. "Did Women Have a Renaissance?" In Renate Blumenthal and Claudia Koonz (eds.), *Becoming Visible: Women in European History*. Boston, MA: Houghton Mifflin.

Kenny, Neil. 1998. *Curiosity in Early Modern Europe: Word Histories*. Wiesbaden: Wolfenbütteler Forschungen.

Kent, F. W. 1987. "Palaces, Politics and Society in Fifteenth-Century Florence." *I Tatti Studies in the Italian Renaissance*, 2: 41–70.

Kepler, Johannes. [1596] 1999. *The Secret of the Universe*. Translated by Aiton M. Duncan. Norwalk, CT: Abaris Books.

Kepler, Johannes. [1610] 2010. *On the Six-Sided Snowflake. A New Year's Gift*. Translated by Jacques Bromberg. Philadelphia, PA: Paul Dry Books, Inc.

Kepler, Johannes. 1938 et seq. *Gesammelte Werke*. Edited by W. von Dyck, M. Caspar et al. Munich: Beck.

Kerrigan, William and Gordon Braden. 1991. *The Idea of the Renaissance*. Baltimore, MD: Johns Hopkins University Press.

Kessler, Eckhard. 1998. "Zabarella, Jacopo (1533–1589)." In Edward Craig (ed.), *Routledge Encyclopedia of Philosophy 9: Sociology of Knowledge to Zoroastrianism*. London and New York: Routledge.

Kessler, Herbert L. 2004. *Seeing Medieval Art*. Rethinking the Middle Ages, 1. Ontario: Broadview Press.

Kessler, Herbert L. 2006. "Gregory the Great and Image Theory in Northern Europe during the Twelfth and Thirteenth Centuries." In Conrad Rudolph (ed.), *A Companion to Medieval Art Romanesque and Gothic in Northern Europe*, Blackwell Companions to Art History. Oxford: Blackwell.

Kik, Oliver. 2014. "From lodge to studio: transmissions of architectural knowledge in the Low Countries 1480–1530." In Piet Lombaerde (ed.), *Notion of the Painter–Architect in Italy and the Southern Low Countries*. Turnhout: Brepols.

Kim, David. 2014. *The Traveling Artist in the Italian Renaissance: Geography, Mobility, and Style*. New Haven, CT: Yale University Press.

King, Ross. 2012. *Leonardo and the Last Supper*. London: A&C Black.

Kirn, Paul von. 1925. "Friedrich der Weise und Jacopo de' Barbari." *Jahrbuch der Preussischen Kunstsammlungen*, 46: 130–34.

Klein, Ursula and Emma C. Spary (eds.). 2010. *Materials and Expertise in Early Modern Europe: Between Market and Laboratory*. Chicago, IL: University of Chicago Press.

Knox, Dilwyn. 2013. "Bruno: Immanence and Transcendence in De la causa, principio et uno, Dialogue ii." *Bruniana e Campanelliana*, 19(2): 463–82.

Kocieszewska, Ewa. 2012. "War and Seduction in Cybele's Garden: Contextualizing the Ballet des Polonais." *Renaissance Quarterly*, 65(3): 809–63.

Koerner, Joseph Leo. 2008. *The Reformation of the Image*. Chicago, IL: University of Chicago Press.

Koerner, Joseph Leo. 2017. "Afterword." *Art History*, 40(2): 450–55.

Koeppe, Wolfram (ed.). 2008. *Art of the Royal Court: Treasures in Pietre Dure from the Palaces of Europe*. New Haven, CT: Yale University Press.

Koeppe, Wolfram and Anna Maria Giusti (eds.). 2008. *Art of the Royal Court: Treasures in Pietre Dure from the Palaces of Europe*. New Haven, CT: Yale University Press.

Kopytoff, Igor. 1986. "The Cultural Biography of Things: Commoditization as Process." In Arjun Appadurai (ed.), *The Social Life of Things: Commodities in Cultural Perspective*. Cambridge: Cambridge University Press.

Koster, Margaret L. 2003. "The Arnolfini double portrait: a simple solution." *Apollo*, 158(499): 3–16.

Kren, Thomas, Jill Burke and Stephen Campbell (eds.) 2018. *The Renaissance Nude*. New Haven, CT: Yale University Press.

Kretzmann, Norman, Antony Kenny and Jan Pinborg (eds.) 1982. *The Cambridge History of Later Medieval Philosophy from the Rediscovery of Aristotle to the Disintegration of Scholasticism, 1100–1600*. Cambridge and New York: Cambridge University Press.

Kristeller, Paul Oskar. 1951. "The Modern System of the Arts: A Study in the History of Aesthetics Part I." *Journal of the History of Ideas*, 12(4): 496–527.

Kristeller, Paul Oskar. 1952. "The Modern System of the Arts: A Study in the History of Aesthetics (II)." *Journal of the History of Ideas*, 13(1): 17–46.

Kristeller, Paul Oskar. 1980. *Renaissance Thought and the Arts: Collected Essays*. Princeton, NJ: Princeton University Press.

Kristeller, Paul Oskar and Michael Mooney. 1979. *Renaissance Thought and Its Sources*. New York: Columbia University Press.

Krull, Ebba and Susanne Netzer. 1981. *Welt im Umbruch. Augsburg zwischen Renaissance und Barok*. 3 vols. Augsburg: Augsburger Druck- und Verlagshaus.

Kubler, George. 1982. *Building the Escorial*. Princeton NJ: Princeton University Press.

Kuhn, Heinrich. 2018. "Aristotelianism in the Renaissance." In Edward N. Zalta (ed.), *The Stanford Encyclopedia of Philosophy*. Palo Alto, CA: Stanford University. Available online: https://plato.stanford.edu/archives/spr2018/entries/aristotelianism-renaissance/.

Kuo, Jason C. and Julia Frances Andrews. 2006. *Discovering Chinese Painting: Dialogues with Art Historians*. Dubuque, IA: Kendall Hunt Publishing Company.

Kwakkel, Erik. 2003. "A New Type of Book for a New Type of Reader: The Emergence of Paper in Vernacular Book Production." *The Library*, 4(3): 219–48.

Kyle, Sarah Rozalja. 2010. "The 'Carrara Herbal' in Context: Imitation, Exemplarity, and Invention in Late Fourteenth-Century Padua." PhD thesis, Emory University.

Lamberini, Daniela. 1991. "Il cantiere delle fortificazioni nelle Toscana del Cinquecento." In Jean Guillaume (ed.), *Les chantiers de la Renaissance*. Paris: Picard.

Lamberini, Daniela. 2003. "Machines in Perspective: Technical Drawings in Unpublished Treatises and Notebooks of the Italian Renaissance." *Studies in the History of Art*, 59: 212–33.

Lancilotti, Francesco. 1976. *Tractato di pictura (Roma, 1509)*. Edited by Hessel Miedema. Amsterdam: Kunsthistorisch Instituut van de Universiteit van Amsterdam.

Land, Norman E. 2005. "Giotto as Apelles." *Source: Notes in the History of Art*, 24(3): 6–9.

Landau, David, and Peter Parshall. 1996. *The Renaissance Print: 1470–1550*. New Haven, CT: Yale University Press.

Latour, Bruno. 1993. *We Have Never Been Modern*. Translated by Catherine Porter. Cambridge, MA: Harvard University Press.

Latour, Bruno. 2005. *Reassembling the Social: An Introduction to Actor-Network-Theory*. Oxford: Oxford University Press.

Laughran, Michelle A. and Andrea Vianello. 2011. "'*Grandissima gratia*': The Power of Italian Renaissance Shoes as Intimate Wear." In Bella Mirabella (ed.), *Ornamentalism: The Art of Renaissance Accessories*. Ann Arbor: University of Michigan Press.

Lehmann-Haupt, Hellmut. 1966. *Gutenberg and the Master of the Playing Cards*. New Haven, CT, and London: Yale University Press.

Leijenhorst, Cees. 2010. "Bernardino Telesio (1509–1588): New Fundamental Principles of Nature." In Paul Blum (ed.), *Philosophers of the Renaissance*. Washington, DC: The Catholic University of America Press.

Lemire, Beverly. 2018. *Global Trade and the Transformation of Consumer Cultures: The Material World Remade, c. 1500–1820*. Cambridge: Cambridge University Press.

Leone, Mark P. and Jocelyn E. Knauf (eds.) 2015. *Historical Archaeologies of Capitalism*. Springer. Available online: https://link-springer-com.ezproxy.cul. columbia.edu/book/10.1007%2F978-3-319-12760-6 (accessed March 2018).

Leong, Elaine and Alisha Rankin (eds.). 2011. *Secrets and Knowledge in Medicine and Science, 1500–1800*. Farnham and Burlington, VA: Ashgate.

Leonhard, Karin. 2011. "Painted poison: Venomous beasts, herbs, gems, and Baroque color theory." *Nederlands Kunsthistorisch Jaarboek*, 61(1): 114–47.

Levi-Pisetzky, Rita. 1964–1969. *Storia del costume in Italia*. 3 vols. Milan: Istituto Editoriale Italiano.

Levy, Evonne. 2017. "Jesuit Architecture Worldwide: A Culture of Corporate Invention." In Alina Payne (ed.), *The Companions to the History of Architecture, Volume I, Renaissance and Baroque Architecture*. Hoboken, NJ: Wiley Blackwell.

Lewis, Flora. 1986. "The Veronica: Image, Legend and Viewer." In W. M. Ormrod (ed.), *England in the Thirteenth Century: Proceedings of the 1984 Harlaxton Symposium*. Woodbridge: Boydell.

Lingo, Stuart. 2016. "Agnolo Bronzino's *Pygmalion* and the Statue and the Dawn of Art." *Art History*, 39(5): 868–95.

Lleó Cañal, Vicente (ed.). 1998. *La Casa de Pilatos*. Madrid: Electa.

Llewellyn, Nigel. 1977. "Two Notes on Diego da Sagredo." *Journal of the Warburg and Courtauld Institutes*, 40: 292–300.

Loh, Maria H. 2009. "Renaissance Faciality." *Oxford Art Journal*, 32(3): 341–63.

Loh, Maria H. 2014/2015. "'Cross My Heart, Hope to Die, Stick a Needle in My Eye': Friendship, Survival, and the Pathos of Portraiture." *Res: Anthropology and Aesthetics*, 65–6: 375–86.

Lomazzo, Giovanni. 1584. *Trattato dell'arte della pittura, scultura, et architettura*. Milan: Pontio.

Long, Pamela O. 2001. *Openness, Secrecy, Authorship: Technical Arts and the Culture of Knowledge from Antiquity to the Renaissance*. Baltimore, MD: Johns Hopkins University Press.

Long, Pamela O. 2009. "Introduction: The World of Michael of Rhodes." In Pamela O. Long et al. (eds.), *The Book of Michael of Rhodes: A Fifteenth-Century Maritime Manuscript*. 3 vols. London and Cambridge, MA: MIT Press.

Long, Pamela O. 2011. *Artisan/Practitioners and the Rise of the New Sciences, 1400–1600*. Cornvallis: Oregan State University Press.

Lopez, Robert S. 1953. "Hard times and investment in culture." In *The Renaissance: A Symposium*. New York: Metropolitan Museum of Art.

Lucas-Fiorato, Corinne and Pascale Dubus (eds.). 2016. *La réception des Vite di Giorgio Vasari: dans l'Europe des XVIe-XVIIIe siècles*, Cahiers d'Humanisme et Renaissance. Paris: Droz.

Lüthy, Cristoph H., John E. Murdoch and William R. Newman (eds.). 2001. *Late Medieval and Early Modern Corpuscular Matter Theories*. Leiden, Boston, MA, and Cologne: Brill.

Lüttenberg, Thomas. 2005. "The Cod-Piece—A Renaissance Fashion between Sign and Artefact." *The Medieval History Journal*, 8(1): 49–81.

Lyall, Roderick J. 1989. "Materials: The Paper Revolution." In Jeremy Griffiths and Derek Pearsall (eds.), *Book-Production and Publishing in Britain, 1375–1475*. Cambridge and New York: Cambridge University Press.

MacGregor, Arthur. 2007. *Curiosity and Enlightenment: Collectors and Collections from the Sixteenth to the Nineteenth Century*. New Haven, CT, and London: Yale University Press.

MacKay, Charles. [1841] 2003. *Extraordinary Popular Delusions and the Madness of Crowds*. Petersfield: Harriman House.

MacLean, Gerald. 2005. "Introduction: Re-Orienting the Renaissance." In Gerald MacLean (ed.), *Re-Orienting the Renaissance: Cultural Exchanges with the East*. New York: Palgrave Macmillan.

MacLean, Ian. 1998. "Foucault's Renaissance Episteme Reassessed: An Aristotelian Counterblast." *Journal of the History of Ideas*, 59(1): 149–66.

MacLean, Ian. 2002. *Logic, Signs and Nature in the Renaissance*. Cambridge: Cambridge University Press.

MacLean, Ian. 2012. *Scholarship, Commerce, Religion: The Learned Book in the Age of Convessions, 1560–1630*. Cambridge, MA: Harvard University Press.

Maginnis, Hayden B. J. 1995. "The Craftsman's Genius: Painters, Patrons and Drawings in Trecento Siena." In Andrew T. Ladis and Carolyn Wood (eds.), *The Craft of Art: Originality and Industry in the Italian Renaissance and Baroque Workshop*. Athens and London: University of Georgia Press.

Manning, Gideon (ed.). 2012. *Matter and Form in Early Modern Science and Philosophy*. Leiden: Brill.

Marani, Pietro C. 2014. *Leonardo's "Last Supper": Technique of Execution and Conservation Thirteen Years after Its Restoration*. Milan: SKIRA.

Marías, Fernando. 1990. "Sobre el Castillo de La Calahorra y el Codex Escurialensis." *Anuario del Departamento de Historia y Teoría del Arte. Universidad Autónoma de Madrid* 2: 117–29.

Markey, Lia. 2016. *Imagining the Americas in Medici Florence*. University Park: The Pennsylvania State University Press.

Marschalk, Nicolaus. [1521] 2016. *Annalium Herulorum ac Vandalorum*. Rostock: Rostock Universitätsbibliothek. Available online: http://rosdok.uni-rostock.de/resolve/id/rosdok_document_0000012052.

Marsilio Ficino. 1975. *The Letters of Marsilio Ficino*. London: Shepheard-Walwyn.

Martin, Craig. 2006. "Experience of the New World and Aristotelian Revisions of the Earth's Climates during the Renaissance." *History of Meteorology*, 3: 1–15.

Martin, John. 1997. "Inventing Sincerity, Refashioning Prudence: The Discovery of the Individual in Renaissance Europe." *The American Historical Review*, 102(5): 1309–42.

Martin, John J. 2003. *The Renaissance: Italy and Abroad*. London and New York: Routledge.

Martines, Lauro. 1998. "The Renaissance and the Birth of Consumer Society." *Renaissance Quarterly*, 51(1): 193–203.

Martini, Francesco di Giorgio. [c. 1478–1481] 1967. "Trattato di architettura I." In *Trattati di architettura ingegneria e arte militare*. Edited by Corrado Maltese. 2 vols. Milan: Il Polifilo.

Martini, Francesco di Giorgio. [c. 1487–1500] 1967. "Trattato di architettura II." In *Trattati di architettura ingegneria e arte militare*. Edited by Corrado Maltese. 2 vols. Milan: Il Polifilo.

Maslen, Keith. 1993. "Jobbing Printing and the Bibliographer: New Evidence from the Bowyer Ledgers." In Keith Maslen (ed.), *An Early London Printing House at Work: Studies in the Bowyer Ledgers*. New York: Bibliographical Society of America.

Matchette, Ann. 2007. "Credit and credibility: used goods and social relations in sixteenth-century Florence." In Michelle O'Malley and Evelyn Welch (eds.), *The Material Renaissance*. Manchester: Manchester University Press.

Mauss, Marcel. [1950] 1990. *The Gift: The Form and Reason for Exchange in Archaic Societies*. First published as *Essai sur le don*. Translated by Wilfred D. Halls. London and New York: Routledge.

McCall, Timothy. 2013. "Brilliant Bodies: Material Culture and the Adornment of Men in North Italy's Quattrocento Courts." *I Tatti Studies: Essays in the Renaissance*, 16(1): 445–90.

McDermott, James. 2001. *Martin Frobisher: Elizabethan Privateer*. New Haven: Yale University Press.

McGee, David. 2004. "The Origins of Early Modern Machine Design." In Wolfgang Lefèvre (ed.), *Picturing Machines 1400–1700*, Cambridge, MA: MIT Press.

McHam, Sarah Blake. 2013. *Pliny and the Artistic Culture of the Italian Renaissance: The Legacy of the Natural History*. New Haven, CT, and London: Yale University Press.

McIver, Katherine A. 2014. *Cooking and Eating in Renaissance Italy: From Kitchen to Table*. Lanham, MD: Rowman & Littlefield.

McKendrick, Neil, John Brewer and John H. Plumb. 1982. *The Birth of a Consumer Society: The Commercialization of Eighteenth-Century England*. Bloomington: Indiana University Press.

McKitterick, David. 1992. *A History of Cambridge University Press*, vol. 1, "Printing and the Book Trade in Cambridge 1534–1698." Cambridge: Cambridge University Press.

McLean, Gerald. 2005. "Introduction." In Gerald McLean (ed.), *Re-Orienting the Renaissance*. London: Palgrave MacMillan.

Meadow, Mark A. 2002. "Merchants and marvels: Hans Jacob Fugger and the origins of the Wunderkammer." In Pamela H. Smith and Paula Findlen (eds.), *Merchants and Marvels: Commerce, Science, and Art in Early Modern Europe*. New York and London: Routledge.

Meadow, Mark A. (ed.). 2013. *The First Treatise on Museums: Samuel Quiccheberg's "Inscriptiones" 1565*. Edited and translated by Mark A. Meadow and Bruce Robertson. Los Angeles, CA: Getty Research Institute.

Meier, Hans-Rudolf. 2013. "The Medieval and Early Modern World and the Material Past." In Alain Schnapp (ed.), *World Antiquarianism: Comparative Perspectives*. Los Angeles, CA: Getty Research Institute.

Meisterlin, Sigismund. 1998. *Cronographia Augustensium*. Edited by Hans Gröchenig. Klagenfurt: Armarium.

Melograni, Anna. 2010. "Manuscript Materials: Cost and the Market for Parchment in Renaissance Italy." In Jo Kirby, Susie Nash and Joanna Cannon (eds.), *Trade in Artists' Materials: Markets and Commerce in Europe to 1700*. London: Archetype.

Merrill, Elizabeth. 2017. "The *Professione* di Architetto in Renaissance Italy." *Journal of the Society of Architectural Historians* 76(1): 13–35.

Messling, Guido. 2011. "Drawing in Germany from Van Eyck to Dürer." In Till-Holger Borchert (ed.), *Van Eyck to Dürer: The Influence of Early Netherlandish Painting on European Art, 1430–1530*. London: Thames & Hudson.

Metzger, Christof. 2011. "When Pictures Began to Travel: The Role of Prints in the Transmission of Images." In Till-Holger Borchert (ed.), *Van Eyck to Dürer: The Influence of Early Netherlandish Painting on European Art, 1430–1530*. London: Thames & Hudson.

Michelet, Jules. 1855. *Histoire de France au seizième siècle: Renaissance*. Paris: Chamerot.

Mikkeli, Heikki. 1992. *An Aristotelian Response to Renaissance Humanism: Jacopo Zabarella on the Nature of Arts and Sciences*. Helsinki: Finnish Historical Society.

Mikkeli, Heikki. 2010. "Jacopo Zabarella (1533–1589): The Structure and Method of Scientific Knowledge." In Paul Richard Blum (ed.), *Philosophers of the Renaissance*. Washington, DC: The Catholic University of America Press.

Miller, Clyde Lee. 2017. "Cusanus, Nicolaus [Nicolas of Cusa]." In Edward N. Zalta (ed.), *The Stanford Encyclopedia of Philosophy*. Palo Alto, CA: Stanford University. Available online: https://plato.stanford.edu/archives/sum2017/entries/cusanus/.

Miller, Daniel. 1987. *Material Culture and Mass Consumption*. Oxford: Basil Blackwell.

Miller, Daniel. 2010. *Stuff*. Cambridge: Polity Press.

Miller, Joseph C. 2015. *The Princeton Companion to Atlantic History*. Princeton, NJ: Princeton University Press.

Miller, Peter N. 2013. "A Tentative Morphology of European Antiquarianism, 1500–2000." In Alain Schnapp (ed.), *World Antiquarianism: Comparative Perspectives*. Los Angeles, CA: Getty Research Institute.

Miller, Peter N. 2017. *History & Its Objects: Antiquarianism and Material Culture since 1500*. Ithaca, NY, and London: Cornell University Press.

Milligan, Gerry. 2017. "Literary Representations." In Elizabeth Currie (ed.), *A Cultural History of Dress and Fashion in the Renaissance*. London: Bloomsbury.

Minsheu, John. 1617. *Ductor in Linguas, The Guide into Tongues*. London: John Brown.

Mirabella, Bella. 2011a. "Embellishing Herself with a Cloth: The Contradictory Life of the Handkerchief." In Bella Mirabella (ed.), *Ornamentalism: The Art of Renaissance Accessories*. Ann Arbor: University of Michigan Press.

Mirabella, Bella. 2011b. "Introduction." In Bella Mirabella (ed.), *Ornamentalism: The Art of Renaissance Accessories*. Ann Arbor: University of Michigan Press.

Möller, Lieselotte. 1956. *Der Wrangelschrank und die Verwandten Suddeutschen Intarsiamoebel des 16. Jahrhunderts*. Berlin: Deutsche Verein fur Kunstwissenschaft.

Montano, Giovanni Battista. 1624. *Scielta di varii tempietti antichi*. Rome: Giovanni Battista Soria.

Moore, Kathryn Blair. 2009. "Seeing through Text: The visualization of Holy Land architecture in Niccolò da Poggibonsi's Libro d'oltramare, 14th–15th centuries." *Word & Image*, 25(4): 402–15.

Moran, Bruce T. 2005. *Distilling Knowledge: Alchemy, Chemistry, and the Scientific Revolution*. Cambridge, MA: Harvard University Press.

Moreira, Rafael (ed.). 1994. *A arquitectura militar na expansão portuguesa*. Lisbon: Comissão Nacional para as Comemorações dos Descobrimentos Portugueses.

Moxey, Keith. 2011. "Do we still need a Renaissance?" In Michael Anderson, Birgitte Bøggild Johannsen and Hugo Johannsen (eds.), *Reframing the Danish Renaissance. Problems and Prospects in a European Perspective*. Publications from the National Museum, Studies in Archaeology & History, vol. 16. Copenhagen: University Press of South Denmark.

Moxey, Keith. 2013. *Visual Time: The Image in History*. Durham, NC: Duke University Press.

Müller, Lothar. 2014. "Paper, Scholars, and Playing Cards." In Lothar Müller (ed.), *White Magic: The Age of Paper*. Translated by Jessica Spengler. Cambridge: Polity Press.

Mundt, Barbara. 2009. *Der Pommersche Kunstschrank des Augsburger Unternehmers Philipp Hainhofer für den gelehrten Herzog Philipp II. von Pommern*. Munich: Hirmer Verlag.

Munro, John H. 2003. "The Economic History of Later Medieval and Early Modern Europe." Available online: https://www.economics.utoronto.ca/munro5/lecnot201.htm (accessed July 16, 2017).

Munro, John H. 2009. "Review of Paul Freedman, *Out of the East: Spices and the Medieval Imagination*." *American Historical Review*, 114(2): 407–11.

Mussolin, Mauro. 2017. "Michelangelo architetto militare: progettazione e strategia comunicativa nei disegni di fortificazione per Firenze," In Alessandro Cecchi (ed.), *Michelangelo e l'assedio di Firenze*. Florence: Edizioni Polistampa.

Muzzarelli, Maria Giuseppina. 2006. "Sumptuous Shoes: Making and Wearing in Medieval Italy." In Giorgio Riello and Peter McNeil (eds.), *Shoes: A History from Sandals to Sneakers*. Oxford: Berg.

Nagel, Alexander. 2011. *The Controversy of Renaissance Art*. Chicago, IL: University of Chicago Press.

Nagelsmit, Eelco. 2011. "Visualizing Vitruvius: Stylistic Pluralism in Serlio's *Sixth Book on Architecture*." In Joost Keizer and Todd Richardson (eds.), *Transformation of Vernacular Expression in Early Modern Arts*. Leiden: Brill.

Nash, Susie. 2008a. "Claus Sluter's 'Well of Moses' for the Chartreuse de Champmol Reconsidered: Part III." *The Burlington Magazine*, 150: 724–41.

Nash, Susie. 2008b. *Northern Renaissance Art*. Oxford: Oxford University Press.

Nash, Susie. 2010. "'The Lord's Crucifix of Costly Workmanship': Colour, Collaboration and the Making of Meaning on the Well of Moses." In Vinzenz Brinkmann, Oliver Primavesi and Max Hollein (eds.), *Circumlitio: The Polychromy of Antique and Mediaeval Sculpture*. Munich: Hirmer.

Needham, Paul. 1986. *The Printer and the Pardoner: An Unrecorded Indulgence Printed by William Caxton for the Hospital of St. Mary Rounceval, Charing Cross*. Washington, DC: Library of Congress.

Nelson, Robert S. 2000. "The Slide Lecture, or the Work of Art 'History' in the Age of Mechanical Reproduction." *Critical Inquiry*, 26(3): 414–34.

Nesselrath, Arnold. 2014. *Der Zeichner und sein Buch: Die Darstellung der antiken Architektur im 15. und 16. Jahrhundert*. Mainz: Franz Philipp Rutzen.

Neudörffer, Johannes. 1547. *Des Johann Neudoerffer Schreib- und Rechenmeisters zu Nuernberg Nachrichten von Kuenstlern und Werkleuten daselbst aus dem Jahre 1547: nebst der Fortsetzung des Andreas Gulden: nach den Handschriften und mit Anmerkungen*. Edited by G. W. K. Lochner, Wien: Baumueller, 1875. Quellenschriften fur Kunstgeschichte und Kunsttecknik des Mittelalters und der Renaissance, Bd 10.

Newbold, W. Webster. 2007. "Letter-Writing and Vernacular Literacy in Sixteenth-Century England." In Carol Poster and Linda C. Mitchell (eds.), *Letter-Writing Manuals and Instruction from Antiquity to the Present: Historical and Bibliographic Studies*. Columbia: University of South Carolina Press.

Newman, William. 1989. "Technology and the Alchemical Debate in the Late Middle Ages." *Isis*, 80(3): 423–45.

Ng, Morgan. 2017. "Toward a Cultural Ecology of Architectural Glass in Early Modern Northern Europe." *Art History*, 40(3): 496–525.

Nocks, Lisa. 2008. *The Robot: The Life Story of a Technology*. Baltimore, MD: John Hopkins University Press.

Normore, Christina. 2015. *A Feast for the Eyes: Art, Performance, and the Late Medieval Banquet*. Chicago, IL: University of Chicago Press.

Norton, Marcy. 2008. *Sacred Gifts, Profane Pleasures: A History of Tobacco and Chocolate in the Atlantic World*. Ithaca, NY: Cornell University Press.

Norton, Marcy. 2017. "Subaltern Technologies and Early Modernity in the Atlantic World." *Colonial Latin American Review*, 26(1): 18–38.

Nurmi, Risto. 2011. *Development of the Urban Mind: An Object Biographical Approach: The Case Study of the Town of Tornio, Northern Finland*. Oulu: Risto Nurmi.

O'Brien, Denis P. 2000. "Bodin's Analysis of Inflation." *History of Political Economy*, 32(2): 267–92.

O'Malley, Michelle. 2010. "A Pair of Little Gilded Shoes: Commission, Cost, and Meaning in Renaissance Footwear." *Renaissance Quarterly*, 63(1): 45–83.

O'Malley, Michelle and Evelyn Welch. 2007. *The Material Renaissance*. Manchester: Manchester University Press.

Oechslin, Werner. 1976. "La fama di Aristotele Fioravanti ingegnere e architetto." *Arte lombarda*, 44/45: 102–20.

Olaus Magnus. [1555] 1972. *Historia de gentibus septentrionalibus: Romae 1555*. Copenhagen: Rosenkilde and Bagger.

Olson, Roberta J. M., Patricia L. Reilly and Rupert Shepherd (eds.). 2006. *The Biography of the Object in Late Medieval and Renaissance Italy*. Oxford: Blackwell Publishing.

Orsi Landini, Roberta. 2003. "La seta." In Carlo Marco Belfanti and Fabio Giusberti (eds.), *La moda*. Storia d'Italia: Annali, vol. 19. Turin: Einaudi.

Orsi Landini, Roberta. 2005. "I singoli capi di abbigliamento." In Roberta Orsi Landini and Bruna Niccoli (eds.), *Moda a Firenze 1540–1580: Lo stile di Eleonora di Toledo e la sua influenza*. Florence: Pagliai Polistampa.

Ottenheym, Konrad (ed.). 2014. *Architects Without Borders Migration of Architects and Architectural Ideas in Europe, 1400–1700*. Mantua: Il Rio Artes.

Painter, George D. 1977. *William Caxton: A Biography*. New York: G. P. Putnam.

Palladio, Andrea. 1570. *I quattro libri dell'architettura*. Venice: Dominico de' Franceschi.

Panofsky, Erwin. 1934. "Jan van Eyck's Arnolfini portrait." *The Burlington Magazine for Connoisseurs* 64(372): 117–27.

Panofsky, Erwin. 1939. *Studies in Iconology: Humanistic Themes in the Art of the Renaissance*. Oxford: Oxford University Press.

Panofsky, Erwin. 1944. "Renaissance and Renascences." *The Kenyon Review* 6: 201–36.

Panofsky, Erwin. 1953. *Early Netherlandish Painting, Its Origins and Character*. Volume 1. Cambridge, MA: Harvard University Press.

Panofsky, Erwin. 1955. "Iconology and iconography: An introduction to the study of Renaissance Art." In *Meaning in the Visual Arts: Papers in and on Art History*. Garden City, NY: Doubleday.

Panofsky, Erwin. 1968. *Idea: A Concept in Art Theory*. Columbia: University of South Carolina Press.

Park, Katharine and Lorraine Daston (eds.). 2006. *The Cambridge History of Science: Volume 3: Early Modern Science*. New York: Cambridge University Press.

Parshall, Peter. 2013. "Graphic Knowledge: Albrecht Dürer and the Imagination." *The Art Bulletin*, 95(3): 393–410.

Paters, Walter. [1893] 1980. *The Renaissance: Studies in Art and Poetry*. Berkeley: University of California Press.

Paulicelli, Eugenia. 2011. "From the Sacred to the Secular: The Gendered Geography of Veils in Italian Cinquecento Fashion." In Bella Mirabella (ed.), *Ornamentalism: The Art of Renaissance Accessories*. Ann Arbor: University of Michigan Press.

Payne, Blanche, Geitel Winakor and Jane Farrell-Beck (eds.) 1992. *The History of Costume: From Ancient Mesopotamia through the Twentieth Century*. 2nd edition. New York: HarperCollins.

Pedretti, Carlo. 1972. *Leonardo da Vinci: The Royal Palace at Romorantin*. Cambridge, MA: Harvard University Press.

Pendergast, Sara and Tom Pendergast (eds.) 2003. *Fashion, Costume, and Culture: Clothing, Headwear, Body Decorations, and Footwear through the Ages*, vol. 3. Detroit, MI: UXL.

Perkinson, Stephen. 2002. "Engin and Artifice: Describing Creative Agency at the Court of France, *ca.* 1400." *Gesta*, 41(1): 51–67.

Pérouse de Montclos, Jean-Marie. 2000. *Philibert de l'Orme, architecte du roi, 1514–1570*. Paris: Mengès.

Petegree, Andrew. 2010. *The Book in the Renaissance*. New Haven, CT, and London: Yale University Press.

Petrarca, Francesco. 1968. *Epistole Autografe*. Edited by Armando Petrucci. Padua: Antenore.

Petrarca, Francesco. 1991. *Petrarch's Remedies for Fortune Fair and Foul: Book I*. Translated by Conrad H. Rawski. Bloomington and Indianapolis: Indiana University Press.

Petrucci, Armando. 1995. *Writers and Readers in Medieval Italy: Studies in the History of Written Culture*. Edited and translated by Charles M. Radding. New Haven, CT and London: Yale University Press.

Pettegree, Andrew. 2000. "Books, Pamphlets and Polemics." In Andrew Pettegree (ed.), *The Reformation World*. London: Routledge.

Pfaff, Dorothea. 1996. *Lorentz Stoer, "Geometria et Perspectiva"*. Master's thesis, University of Munich.

Phillippy, Patricia. 2006. *Painting Women. Cosmetics, Canvases, and Early Modern Culture*. Baltimore, MD: Johns Hopkins University Press.

Pieper, Josef. 2001. *Scholasticism: Personalities and Problems of Medieval Philosophy*. 2nd edition. South Bend, IN: St. Augustine's Press.

Pirenne, Henri. 1936. *Economic and Social History of Medieval Europe*. Translated by I. E. Clegg. London: K. Paul, Trench, Trubner & Co.

Plumb, John H. (ed.). 1982. *The Pelican Book of the Renaissance*. Harmondsworth: Penguin.

Pollock, Griselda. 2003. *Vision and Difference: Feminism, Femininity and the Histories of Art*. London and New York: Routledge.

Polydore Vergil, ed. Brian Copenhaver. 2002. *On Discovery*. Cambridge, MA: Harvard University Press.

Pomponazzi, Pietro. [1556] 2011. *De incantationibus*. Edited by Vittoria Perrone Compagni. Florence: L. S. Olschki.

Popplow, Marcus. 2004. "Why draw pictures of machines?: The social contexts of early modern machine drawings." In Wolfgang Lefèvre (ed.), *Picturing Machines 1400–1700*, Cambridge, MA: MIT Press.

Porras, Stephanie. 2012. "'Ein Freie Hant': Autonomy, Drawing and the Young Dürer." In Daniel Hess and Thomas Eser (eds.), *The Early Dürer*. Nuremberg: Germanisches Nationalmuseum.

Porter, Roy. 2006. "Medical Science." In Roy Porter (ed.), *The Cambridge Illustrated History of Medicine*. Cambridge: Cambridge University Press.

Porter, Roy and John Brewer (eds.). 1993. *Consumption and the World of Goods*. London: Routledge.

Portuondo, María M. 2009. *Secret Science: Spanish Cosmography and the New World*. Chicago, IL, and London: Chicago University Press.

Posthumus, Nicholaas Wilhelmus. 1943. *Nederlandsche Prijsgeschiedenis*. Leiden: Brill. Reproduced in *Medieval and Early Modern Data Bank at Rutgers University*. Available online: http://www2.scc.rutgers.edu/memdb/and from http://www.iisg.nl/hpw/data.php#netherlands.

Praz, Mario. 1964. *Studies in Seventeenth-Century Imagery*, 2nd edition. London: Warburg Institute.

Quiviger, François. 2008. "Renaissance Art Theories." In Paul Smith and Carolyn Wilde (eds.), *A Companion to Art Theory*. Oxford: Wiley-Blackwell.

Raphael. [c. 1519] 1962. "A Letter to Pope Leo X on the Architecture of Ancient Rome." In Carlo Pedretti. *A Chronology of Leonardo da Vinci's architectural studies after 1500*. Geneva: E. Droz.

Remond, Jaya. Forthcoming. "The Art of Instruction: Pictorializing and Printing Artistic Knowledge in Early Modern Germany after Dürer." *Word & Image*.

Repishti, Francesco. 2004. "La facciata del Duomo di Milano (1537–1657)." In Francesco Repishti and Richard Schofield. *Architettura e controriforma: i dibattiti per la facciata del Duomo di Milano, 1582–1682*. Milan: Electa.

Richardson, Catherine. 2011. *Shakespeare and Material Culture*. Oxford: Oxford University Press.

Richardson, Catherine, Tara Hamling and David Gaimster (eds.). 2016. *The Routledge Handbook of Material Culture in Early Modern Europe*. London and New York: Taylor & Francis.

Ringgaard, Maj. 2017. "Framing Early Modern Knitting." In Evelyn Welch (ed.), *Fashioning the Early Modern. Dress, Textiles, and Innovation in Europe, 1500–1800*. Oxford: Oxford University Press.

Ripollés, Carmen. 2016. "Fictions of Abundance in Early Modern Madrid: Hospitality, Consumption, and Artistic Identity in the Work of Juan van der Hamen y León." *Renaissance Quarterly*, 69(1): 155–99.

Ripollés, Carmen. 2017. "Still-Life Painting, Material Culture, and Gendered Space in Early Modern Spain." Paper presented at the Pacific Northwest Renaissance Society Conference, Portland, OR, October 21, 2017.

Rivius, Gualterius Hermenius. [1547] 1981. *Der furembsten notwendigsten der gantzen Architectur angehörien mathematischen und mechanischen Künst eygentlicher Bericht*. Nürnberg: Johan Petreius. Facsimile edition, Hildesheim: Georg Olms.

Roberts, Lissa L., Simon Schaffer and Peter Dear. 2007. *The Mindful Hand. Inquiry and Invention from the Late Renaissance to Early Industrialisation.* History of Science and Scholarship in The Netherlands, 9. Amsterdam: Koninklijke Nederlandse Akademie van de Wetenschappen.

Roberts, Sean. 2017. "A Global Florence and Its Blind Spots." In Daniel Savoy (ed.), *The Globalization of Renaissance Art: A Critical Review.* Leiden: Brill.

Roche, Daniel. 1994. *The Culture of Clothing: Dress and Fashion in the "Ancien Régime".* Translated by Jean Birrell. Cambridge: Cambridge University Press.

Roodenburg, Herman (ed.). 2014. *A Cultural History of the Senses in the Renaissance.* London, Oxford, New York, New Delhi, Sydney: Bloomsbury Academic.

Roper, Lyndal. 2015. "Luther Relics." In Jennifer Spinks and Dagmar Eichenberger (eds.), *Religion, the Supernatural and Visual Culture in Early Modern Europe: An Album Amicorum for Charles Zika.* Leiden: Brill.

Rosand, David. 2002. *Drawing Acts: Studies in Graphic Expression and Representation.* Cambridge: Cambridge University Press.

Rosenfeld, Myra Nan. 1978. *Sebastiano Serlio on Domestic Architecture.* New York: Architectural History Foundation.

Rosenfeld, Myra Nan. 1989. "From Drawn to Printed Model Book: Jacques Androuet Du Cerceau and the Transmission of Ideas from Designer to Patron, Master Mason and Architect in the Renaissance." *RACAR: revue d'art canadienne* 16(2): 131–45, 219–50.

Rossi, Marco. 1982. "Giovanni Nexemperger di Graz e il tiburio del Duomo di Milano." *Arte Lombarda,* 61(1): 5–12.

Rossi, Paolo. 1970. *Philosophy, Technology and the Arts in the Early Modern Era.* Edited by Benjamin Nelson. Translated by Salvator Attanasio. New York: Harper & Row.

Rouse, Richard H. and Mary A. Rouse. 1989a. "The Vocabulary of Wax Tablets." In Olga Weijers (ed.), *Vocabulaire du Livre et de l'Écriture au Moyen Age: actes de la table ronde, Paris 24–26 septembre 1987.* Turnhout: Brepols.

Rouse, Richard H. and Mary A. Rouse. 1989b. "Wax Tablets." *Language and Communication,* 9: 175–91.

Rubin, Patricia Lee. 1995. *Giorgio Vasari: Art and History.* New Haven, CT, and London: Yale University Press.

Rublack, Ulinka. 2010a. "Grapho-Relics: Lutheranism and the Materialization of the Word." *Past & Present,* 206: 144–66.

Rublack, Ulinka. 2010b. *Dressing Up: Cultural Identity in Renaissance Europe.* Oxford: Oxford University Press.

Rublack, Ulinka. 2013. "Matter in the Material Renaissance." *Past & Present,* 219(1): 41–85.

Ruggiero, Guido (ed.). 2002. *A Companion to the Worlds of the Renaissance.* Oxford: Blackwell.

Rupprich, Hans (ed.). 1956–1969. *Dürer: Schriftlicher Nachlass.* 3 vols. Berlin: Deutscher Verein für Kunstwissenschaft, 1: 101–2.

Ruscelli, Girolamo. 1558. *The secretes of the reuerende Maister Alexis of Piemount…* Translated by Wyllyam Warde. London: Iohn Kingstone for Nicolas Inglande.

Russo, Alessandra et al. (eds.). 2015. *Images Take Flight: Feather Art in Mexico and Europe, 1400–1700.* Munich: Hirmer.

Sankovitch, Anne-Marie. 2001. "The Myth of the 'Myth of the Medieval': Gothic Architecture in Vasari's Rinascita and Panofsky's Renaissance." *RES: Anthropology and Aesthetics,* 40: 29–50.

Sansovino, Francesco. [1581] 1683. *Venetia città nobilissima et singolare descritta in XIII libri*. With an addendum by Giustianiano Martinioni. Venetia: Appresso Steffano Curti.

Savonarola, Girolamo. 1528. *Prediche nuovamente venute in luce … sopra il Salmo Quam bonus Israel Deus*. Translated by Girolamo Giannoti. Venice: Zanni.

Savoy, Daniel. 2017. *The Globalization of Renaissance Art: A Critical Review*. Leiden and Boston, MA: Brill.

Scamozzi, Vincenzo. [1615] 2003. *The Idea of Universal Architecture. Vol. 3, Villas and Country Estates*. Amsterdam: Architectura & Natura.

Schama, Simon. 1987. *The Embarrassment of Riches: An interpretation of Dutch culture in the Golden Age*. New York: Alfred A. Kopff.

Schlimme, Hermann, Dagmar Holste and Jens Niebaum. 2014. "Bauwissen im Italien der Frühen Neuzeit." In Jürgen Renn, Wilhelm Osthues and Hermann Schlimme (eds.), *Wissensgeschichte der Architektur. Vol. 3: Vom Mittelalter bis zur Frühen Neuzeit*. Berlin: Edition Open Access.

Schlosser, Julius von. 1908. *Kunst und Wunderkammern der Spätrenaissance*. Leipzig: Klinkhardt & Biermann.

Schmitt, Charles B. 1983. *Aristotle and the Renaissance*. Cambridge, MA: Harvard University Press.

Schnapp, Alain. 1997. *The Discovery of the Past*. New York: Harry N. Abrams.

Schobesberger, Nikolaus, Paul Arblaster, Mario Infelise, André Belo, Noah Moxham, Carmen Espejo and Joad Raymond. 2016. "European Postal Networks." In Joad Raymond and Noah Moxham (eds.), *News Networks in Early Modern Europe*. Leiden: Brill.

Schofield, Richard and Giulia Ceriani Sebregondi. 2006–2007. "Bartolomeo Bon, Filarete e le case di Francesco Sforza a Venezia." *Annali di architettura*, 18/19: 9–51.

Schummer, Joachim. 2008. "Aristotelian Physics." In Lee K. Lerner and Brenda W. Lerner (eds.), *Scientific Thought in Context 2*. Detroit, IL: Gale.

Schwyzer, Philip. 2007. *Archaeologies of English Renaissance Literature*. Oxford: Oxford University Press.

Scott, Margaret. 1980. *Late Gothic Europe, 1400–1500*. The History of Dress Series. Edited by Aileen Ribeiro. London: Mills & Boon Ltd.

Screpanti, Ernesto, and Stefano Zamagni. 2005. *An Outline of the History of Economic Thought*, 2nd edition. Oxford: Oxford University Press.

Scribner, Robert W. 1981. *For the Sake of Simple Folk: Popular Propaganda for the German Reformation*. Cambridge: Cambridge University Press.

Sergiusz, Michalski. 1993. *The Reformation and the Visual Arts: The Protestant Image Question in Western and Eastern Europe*, Christianity and Society in the Modern World. London: Routledge.

Serlio, Sebastiano. [1537] 1996. "Book IV: On the Five Styles of Building." Vaughan Hart and Peter Hicks (eds. and trans.), *Sebastiano Serlio on Architecture*. Vol. 1. New Haven, CT: Yale University Press.

Serlio, Sebastiano. [1540] 1996. "Book III: On Antiquities." In Vaughan Hart and Peter Hicks (eds. and trans.), *Sebastiano Serlio on Architecture*. Vol. 1. New Haven, CT: Yale University Press.

Serlio, Sebastiano. [c. 1550] 2001. "Book VI: On Habitations." In Vaughan Hart and Peter Hicks (eds. and trans.), *Sebastiano Serlio on Architecture*. Vol. 2. New Haven, CT: Yale University Press.

Serlio, Sebastiano. [1575] 2001. "Book VII: On Situations." In Vaughan Hart and
 Peter Hicks (eds. and trans.), *Sebastiano Serlio on Architecture*. Vol. 2. New Haven,
 CT: Yale University Press.
Seseña, Natacha. 1991. "El búcaro de *Las Meninas*." In *Velázquez y el arte de su
 tiempo: V Jornadas de Arte*. Madrid: Centro de Estudios Históricos.
Sewel, William. 1708. *A Large Dictionary English and Dutch*. Amsterdam: Steven
 Swart.
Seymour, Charles Jr. 1967. *Michelangelo's David: A Search for Identity*. Pittsburgh:
 University of Pittsburgh Press.
Shapin, Steven. 1996. *The Scientific Revolution*. Chicago, IL: University of Chicago Press.
Shelby, Lon R. (ed. and trans.). 1977. *Gothic Design Techniques: The Fifteenth-
 Century Design Booklets of Mathes Roriczer and Hanns Schmuttermayer*.
 Carbondale: Southern Illinois University Press.
Shields, Christopher. 2014. *Aristotle*. London and New York: Routledge.
Shields, Christopher. 2016. "Aristotle." In Edward N. Zalta (ed.), *The Stanford
 Encyclopedia of Philosophy*. Palo Alto, CA: Stanford University. Available online:
 https://plato.stanford.edu/archives/win2016/entries/aristotle/.
Shuger, Debora. 1999. "The 'I' of the Beholder: Renaissance Mirrors." In Patricia
 Fumerton and Simon Hunt (eds.), *Renaissance Culture and the Everyday*.
 Philadelphia: University of Pennsylvania Press.
Shute, John. 1563. *The first and chief groundes of architecture*. London: Thomas Marshe.
Simon, Eckehard. 1988. *The Türkenkalender (1454) Attributed to Gutenberg and the
 Strasbourg Lunation Tracts*. Cambridge, MA: The Medieval Academy of America.
Simons, Patricia. 2011. *The Sex of Men in Premodern Europe: A Cultural History*.
 Cambridge: Cambridge University Press.
Sivasunderam, Sujit. 2010. "Sciences and the Global: On Methods, Questions, and
 Theory." *Isis*, 101(1): 146–58.
Smail, Daniel Lord. 2016. *Legal Plunder: Households and Debt Collection in Late
 Medieval Europe*. Cambridge, MA: Harvard University Press.
Smit, Hans. 1570s? [*Advertisements of medicines signed by me Hans Smit*] [London],
 Beinecke Library, Yale University, Z96 080.
Smith, Pamela H. 2004. *The Body of the Artisan: Art and Experience in the Scientific
 Revolution*. Chicago, IL: University of Chicago Press.
Smith, Pamela H. 2013. "Making Things: Techniques and Books in Early Modern
 Europe." In Paula Findlen (ed.), *Early Modern Things: Objects and their Histories,
 1500–1800*. London & New York: Routledge.
Smith, Pamela H. (ed.). 2019. *Entangled Itineraries: Materials, Practices, and
 Knowledges across Eurasia*. Pittsburgh: University of Pittsburgh Press.
Smith, Pamela H. and Tonny Beentjes. 2010. "Nature and art, making and knowing:
 Reconstructing sixteenth-century life-casting techniques." *Renaissance Quarterly*,
 63(1): 128–79.
Smith, Pamela and Paula Findlen (eds.). 2013. *Merchants and Marvels: Commerce,
 Science, and Art in Early Modern Europe*. London & New York: Routledge.
Smith, Pamela H. and Benjamin Schmidt (eds.). 2007. *Making Knowledge in Early
 Modern Europe: Practices, Objects, and Texts, 1400–1800*. Chicago, IL: University
 of Chicago Press.
Smith, Pamela H. and The Making and Knowing Project. 2016. "Historians in the
 Laboratory: Reconstruction of Renaissance Art and Technology in the Making and
 Knowing Project." *Art History*, 39(2): 210–33.

Smith, Pamela H., Amy R. W. Meyers and Harold J. Cook (eds.). 2014. *Ways of Making and Knowing: The Material Culture of Empirical Knowledge*. Ann Arbor: University of Michigan Press.

Smith, Stefan Halikowski. 2007. "Demystifying a Change in Taste: Spices, Space, and Social Hierarchy in Europe, 1380–1750." *The International History Review*, 29(2): 237–57.

Smith, Stefan Halikowski. 2008. "'Profits Sprout Like Tropical Plants': A Fresh Look at What Went Wrong with the Eurasian Spice Trade *c*. 1550–1800." *Journal of Global History*, 3: 389–418.

Snyder, James. 1985. *Northern Renaissance Art: Painting, Sculpture, the Graphic Arts from 1350 to 1575*. Englewood Cliffs, NJ: Prentice Hall.

Spiegel, Henry William. 1991. *The Growth of Economic Thought*, 3rd edition. Durham, NC: Duke University Press.

Springer, Carolyn. 2010. *Armor and Masculinity in the Italian Renaissance*. Toronto: University of Toronto Press.

Squire, Geoffrey. 1974. *Dress, Art and Society 1560–1970*. London: Studio Vista.

Squire, Michael. 2013. "'Fantasies so Varied and Bizarre': The Domus Aurea, the Renaissance, and the 'Grotesque'." In Emma Buckley and Martin T. Dinter (eds.), *A Companion to the Neronian Age*, I. Oxford: Blackwell.

Staley, Edgcumbe. 1967. *The Guilds of Florence*. New York: B. Blom.

Stallybrass, Peter. 1997. "Footnotes." In David Hillman and Carla Mazzio (eds.), *The Body in Parts: Fantasies of Corporeality in Early Modern Europe*. New York: Routledge.

Stallybrass, Peter. 2007. "Erasable Notebooks and Writing Technologies 1500–1900." *Gazette of the Grolier Club*, n.s. 58: 5–44.

Stallybrass, Peter. 2018. "Walt Whitman: Manufacturing Manuscript." Workshop in the History of Material Texts, University of Pennsylvania, March 12, 2018.

Stallybrass, Peter, Roger Chartier, Frank Mowery and Heather Wolfe. 2004. "Hamlet's Tables and the Technologies of Writing in Renaissance England." *Shakespeare Quarterly*, 55(4): 379–419.

Steinberg, Leo. 2001. *Leonardo's Incessant Last Supper*. New York: Zone Books.

Steinberg, S. H. 1961. *Five Hundred Years of Printing*. Revised edition. Bristol.

Stetten, Paul von. 1779–1788. *Kunst-, Gewerbe- und Handwerkgeschichte der Reichsstadt Augsburg*, 1, 2 Teile. Augsburg.

Stöer, Lorenz. 1557. *Geometria et Pespectiva. Hierinn Etliche // Zerbrochene Gebew / den Schreinern // in eingelegter Arbeit dienstlich / auch vil andern Liebhabern zusondern // gefalen geordent unnd // gestalt / Durch // Lorenz Stoeer // Maller Burger inn Augspurg*. Augsburg.

Stöer, Lorenz. [1557] 2006. "*Geometria et Perspectiva: Corpora regulate et irregulata*". Introduction by Wolfgang Müller, with essay by Christopher S. Wood. CD-ROM. Erlangen: Harald Fischer Verlag.

Stowell, Steven F. H. 2014. *The Spiritual Language of Art: Medieval Christian Themes in Writings on Art of the Italian Renaissance*. Leiden and Boston, MA: Brill.

Sullivan, Erin and Andrew Wear. 2017. "Materiality, Nature and the Body." In Catherine Richardson, Tara Hamling and David Gaimster (eds.), *The Routledge Handbook of Material Culture in Early Modern Europe*. London: Routledge.

Summers, David. 1987. *The Judgement of Sense: Renaissance Naturalism and the Rise of Aesthetics*. Cambridge: Cambridge University Press.

Tarlow, Sarah. 2015. *The Archaeology of Death in Post-Medieval Europe*. Berlin: Walter de Gruyter.

Tedeschi, Martha. 1991. "Publish and Perish: The Career of Lienhart Holle in Ulm."
 In Sandra Hindman (ed.), *Printing the Written Word: The Social History of Books*, c.
 1450–1520. Ithaca, NY: Cornell University Press.
Terence. 1475. *Comoediae* (Sant'Orso: Giovanni da Reno, 1475), Beinecke Library,
 Yale University, Zi +6936.
Thoenes, Christof. 2005. "Renaissance St. Peter's." In William Tronzo (ed.), *St. Peter's
 in the Vatican*. Cambridge: Cambridge University Press.
Thomas, Keith. 1997. *Religion and the Decline of Magic: Studies in Popular Beliefs in
 Sixteenth and Seventeenth Century England*. New York: Oxford University Press.
Thomas, Nicholas. 1991. *Entangled Objects: Exchange, Material Culture, and
 Colonialism in the Pacific*. Cambridge, MA: Harvard University Press.
Thomson, David. 1993. *Renaissance Architecture: Critics, Patrons, Luxury*.
 Manchester: Manchester University Press.
Thoren, Victor E. and John Robert Christianson. 1990. *The Lord of Uraniborg: A
 Biography of Tycho Brahe*. Cambridge: Cambridge University Press.
Thornton, John. 1998. *Africa and Africans in the Making of the Atlantic World,
 1400–1800*. Cambridge: Cambridge University Press.
Toynbee, Arnold J. 1954. *A Study of History*, vol. 9. Oxford: Oxford University Press.
Trachtenberg, Marvin. 2010. *Building-in-Time: From Giotto to Alberti and Modern
 Oblivion*. New Haven, CT: Yale University Press.
Truitt, Elly R. 2015. *Medieval Robots: Mechanism, Magic, Nature, and Art*.
 Philadelphia, PA: University of Pennsylvania Press.
Tsuen-Hsuin, Tsien. 1985. "Paper and Printing." In Joseph Needham (ed.), *Science and
 Civilization in China*, vol. 5, part 1. Cambridge: Cambridge University Press.
Turner, James. 2017. *Eros Visible: Art, Sexuality and Antiquity in Renaissance Italy*.
 New Haven, CT: Yale University Press.
Ullmann, Walter. 1969. *The Carolingian Renaissance and the Idea of Kingship*. London:
 Methuen.
Um, Nancy and Leah R. Clark. 2016. "Introduction: The Art of Embassy: Situating
 Objects and Images in the Early Modern Diplomatic Encounter." *Journal of Early
 Modern History*, 20(1): 1–18.
Urquhart, Thomas. [1653] 1664. *The Works of the Famous Mr. Francis Rabelais,
 Doctor in Physick Treating of the Lives*, Heroick Deeds, *and* Sayings of Gargantua
 and His Son Pantagruel to Which Is Newly Added the Life of the Author: Written
 Originally in French, and Translated into English by Sr. Thomas Urchard. London:
 Printed for R. B., and are to be sold by John Starkey. Available online: http://name.
 umdl.umich.edu/A57001.0001.001.
van Buren, Anne H. and Sheila Edmunds. 1974. "Playing Cards and Manuscripts: Some
 Widely Disseminated Fifteenth-Century Model Sheets." *Art Bulletin*, 56(1): 12–30.
van de Wetering, Ernst, 1997. *Rembrandt: The Painter at Work*. Amsterdam:
 Amsterdam University Press.
van der Straet, Jan (Johannes Stradanus) (designer) and Theodoor Galle (engraver).
 c. 1580–90. *Nova Reperta*. Antwerp: Philips Galle.
van den Berg, Sarah. 2000. "True relation: the life and career of Ben Jonson." In
 Richard Harper and Stanley Stewart (eds.), *The Cambridge Companion to Ben
 Jonson*. Cambridge: Cambridge University Press.
van Groesen, Michiel. 2008. *The Representations of the Overseas World in the De Bry
 Collection of Voyages (1590–1634)*. Leiden and Boston, MA: Brill.
Vasari, Giorgio. [1550] 1965. *Lives of the Artists*. Translated by George Bull. New
 York: Penguin Books.

Vasari, Giorgio. 1963. *The Lives of the Painters, Sculptors, and Architects*. 4 vols. Translated by Allen Banks Hinds. London: J.M. Dent.

Vasari, Giorgio. 1991. *The Lives of the Artists*. Translated by Julia Conaway Bondanella and Peter Bondanella. Oxford: Oxford University Press.

Vecellio, Cesare. 2008. *Cesare Vecellio's* Habiti Antichi et Moderni. *The Clothing of the Renaissance World*. Edited and translated by Margaret F. Rosenthal and Ann Rosalind Jones. London: Thames and Hudson.

Vène, Magali. 2007. *Bibliographia serliana: catalogue des éditions imprimées des livres du Traité d'architecture de Sebastiano Serlio (1537–1681)*. Paris: Picard.

Ventura, Piero. 2003. "Cuoio e pellicce." In Carlo Marco Belfanti and Fabio Giusberti (eds.), *La moda*. Storia d'Italia: Annali, vol. 19. Turin: Einaudi.

Venturelli, Paola. 1996. *Gioielli e gioiellieri milanesi: Storia, arte, moda (1450–1630)*. Cisinello Balsamo: Silvana Editoriale.

Vianello, Andrea. 2006. "Courtly Lady or Courtesan? The Venetian *Chopine* in the Renaissance." In Giorgio Riello and Peter McNeil (eds.), *Shoes: A History from Sandals to Sneakers*. Oxford: Berg.

Vickers, Nancy J. 1981. "Diana Described: Scattered Woman and Scattered Rhyme." *Critical Inquiry*, 8(2): 265–79.

Viganò, Marino. 1994–1999. *Architetti e ingegneri militari italiani all'estero dal XV al XVIII secolo*. Livorno: Sillabe.

Vigarello, Georges. 2012. "The Skin and White Linen." Translated by Jean Birrell. In Catherine Harper (ed.), *History/Curation*. Textiles: Critical and Primary Sources, vol. 1. London: Berg.

Vincent, Susan. 2003. *Dressing the Elite: Clothes in Early Modern England*. Oxford: Berg.

Vitruvius [*c*. 30 BCE] 1999. *Ten Books on Architecture*. Translated by Ingrid D. Rowland. Cambridge: Cambridge University Press.

Vitruvius Pollio, Marcus. 1914. *The Ten Books of Architecture*. Translated by M. H. Morgan. Cambridge, MA: Harvard University Press.

Voet, Leon. 1972. *The Golden Compasses: A History and Evaluation of the Printing and Publishing Activities of the Officina Plantiniana at Antwerp*, vol. 2. Amsterdam: Vangendt and Co.

Von Staden, Heinrich. 2007. "Physis and Technē in Greek Medicine." In Bernadette Bensaude-Vincent and William R. Newmand (eds.), *The Artificial and the Natural: An Evolving Polarity*. Cambridge, MA, and London: MIT Press.

Vredeman de Vries, Hans. 1577 *Architectura*. Antwerp: Gerard de Jode.

Wade, David. 2012. *Fantastic Geometry. Polyhedra and the Artistic Imagination in the Renaissance*. Glastonbury: The Squeeze Press.

Wake, Christopher H. H. 1979. "The Changing Pattern of Europe's Pepper and Spice Imports, *c*. 1400–1700." *Journal of European Economic History*, 8: 361–403.

Walker Bynum, Carolyn. 2011. *Christian Materiality: An Essay on Religion in Late Medieval Europe*. New York: Zone Books.

Walsby, Malcome and Graeme Kemp (eds.). 2011. *The Book Triumphant: Print in Transition in the Sixteenth and Seventeenth Centuries*. Leiden and Boston, MA: Brill.

Warsh, Molly A. 2018. *American Baroque: Pearls and the Nature of Empire, 1492–1700*. Chapel Hill: University of North Carolina Press.

Waters, Michael. 2012. "A Renaissance without Order: Ornament, Single-Sheet Engravings, and the Mutability of Architectural Prints." *Journal of the Society of Architectural Historians*, 71(4): 488–523.

Watts, Tessa. 1991. *Cheap Print and Popular Piety, 1550–1640*. Cambridge: Cambridge University Press.

Wear, Andrew. 2000. *Knowledge and Practice in English Medicine, 1550–1680*. Cambridge: Cambridge University Press.

Weisinger, Herbert. 1943. "Renaissance Theories of the Revival of the Fine Arts." *Italica*, 20(4): 163–70.

Welch, Evelyn. 2005. *Shopping in the Renaissance. Consumer Cultures in Italy, 1350–1600*. New Haven, CT, and London: Yale University Press.

Welch, Evelyn. 2011. "Scented Buttons and Perfumed Gloves: Smelling Things in Renaissance Italy." In Bella Mirabella (ed.), *Ornamentalism: The Art of Renaissance Accessories*. Ann Arbor: University of Michigan Press.

Welch, Evelyn. 2017. "Presentism and the Renaissance and Early Modern Historian." *Past & Present*, 234(1): 245–53.

Wijsman, Hanno. 2010. "Northern Renaissance? Burgundy and Netherlandish Art in Fifteenth-Century Europe." In Alexander Lee, Harry Schnitker and Pierre Péporté (eds.), *Renaissance? Perceptions of Continuity and Discontinuity in Europe, c. 1300–c. 1550*. Leiden: Brill.

Wilkins, Ernest H. 1951. *The Making of the* Canzoniere *and Other Petrarchan Studies*. Rome: Edizioni di Storia e Letteratura.

Wilkinson, Catherine. 1977. "The New Professionalism in the Renaissance." In Spiro Kostof (ed.), *The Architect: Chapters in the History of the Profession*. Oxford: Oxford University Press.

Wilkinson, Catherine. 1991. "Building from drawings at the Escorial." In Jean Guillaume (ed.), *Les Chantiers de la Renaissance*, Paris: Picard.

Williams, Robert. 2017. *Raphael and the Redefinition of Art in Renaissance Italy*. Cambridge: Cambridge University Press.

Williamson, Beth. 2013. "Sensory Experience in Medieval Devotion: Sound and Vision, Invisibility and Silence." *Speculum*, 88(1): 1–43.

Wilson, Bronwen. 2005. *The World in Venice: Print, the City, and Early Modern Identity*. Toronto: University of Toronto Press.

Wolfe, Cary. 2010. *What is Posthumanism?* Minneapolis: University of Minnesota Press.

Wolfe, Heather. 2012. "How Expensive Was Writing Paper in Early Modern England?" Renaissance Society of America, Washington, DC, March 22, 2012.

Wolfe, Heather and Peter Stallybrass. 2018. "The Material Culture of Record-Keeping in Early Modern England." In Liesbeth Corens, Kate Peters and Alexandra Walsham (eds.), *Archives and Information in the Early Modern World*. London: British Academy.

Wolff, Francis. 2007. "The Three Pleasures of Mimēsis According to Aristotle's *Poetics*." In Bernadette Bensaude-Vincent and William R. Newman (eds.). 2007. *The Artificial and the Natural: An Evolving Polarity*. Cambridge, MA, and London: MIT Press.

Wood, Christopher S. 2003. "The Perspective Treatise in Ruins: Lorenz Stoer, *Geometria et Perspectiva, 1567*." In Lyle Massey (ed.), *Studies in the History of Art*, 59. Center for Advanced Study in the Visual Arts, Symposium Papers, XXXVI. Washington, DC: National Gallery of Art.

Wood, Christopher S. 2005. "Maximilian I as Archaeologist." *Renaissance Quarterly*, 58(4): 1128–74.

Worm, Olaus. 1655. *Museum Wormianum, seu historia rerum rariorum*. Leiden: Elsevir.

Woudhuysen, Henry R. 1996. *Sir Philip Sidney and the Circulation of Manuscripts, 1558–1640*. Oxford: Clarendon Press.

Woudhuysen, Henry R. 2004. "Writing-Tables and Table-Books," *eBLJ*, article 3. Available online: http://www.bl.uk/eblj/2004articles/article3.html (accessed May 20, 2018).

Wright, D. R. Edward. 1984. "Alberti's De Pictura: Its Literary Structure and Purpose." *Journal of the Warburg and Courtauld Institutes*, 47: 52–71.

Wunder, Amanda. 2015. "Women's Fashions and Politics in Seventeenth-Century Spain: The Rise and Fall of the *Guardainfante*." *Renaissance Quarterly*, 68(1): 133–86.

Yates, Frances A. 1964. *Giordano Bruno and the Hermetic Tradition*. Chicago, IL: University of Chicago Press.

Yonan, Michael. 2011. "Toward a Fusion of Art History and Material Culture Studies." *West 86th: A Journal of Decorative Arts, Design History, and Material Culture*, 18(2): 232–48.

Zinner, Ernst. 1990. *Regiomontanus, His life and Work*. Amsterdam and New York: North-Holland.

Zorach, Rebecca. 2005. *Paper Museums: The Reproductive Print in Europe, 1500–1800*. Chicago, IL: David and Alfred Smart Museum of Art, University of Chicago.

NOTES ON CONTRIBUTORS

Jill Burke is Professor of Renaissance Visual and Material Cultures at the University of Edinburgh, Scotland. She is the author of *The Italian Renaissance Nude* (2018) and *Changing Patrons: Social Identity and the Visual Arts in Renaissance Florence* (2004). She is also the editor of *Rethinking the High Renaissance* (2012), coeditor with Michael Bury of *Art and Identity in Early Modern Rome* (2008), and coeditor with Thomas Kren and Stephen J. Campbell of *The Renaissance Nude* (2018).

Surekha Davies is a historian of art, science, and ideas at Utrecht University, The Netherlands. She is the author of the multi-award-winning *Renaissance Ethnography and the Invention of the Human: New Worlds, Maps and Monsters* (Cambridge University Press, 2016), editor of the special issue "Science, New Worlds and the Classical Tradition, 1450–1850" in *Journal of Early Modern History* 1–2 (2014), and coeditor with Neil L. Whitehead of the special issue "Encounters, Ethnography and Ethnology: Continuities and Ruptures" published in *History and Anthropology* 23(2) (2012).

Susan Gaylard is Associate Professor of Italian Studies and Adjunct Associate Professor of Art History at the University of Washington, Seattle. She is the author of *Hollow Men: Writing, Objects, and Public Image in Renaissance Italy* (2013).

Martha C. Howell is the Miriam Champion Professor of History at Columbia University in New York. Her publications include *Commerce before Capitalism in Europe, 1300–1600* (Cambridge, 2010), *From Reliable Sources*, with Walter Prevenier (Cornell, 2001; German ed., Böhlau, 2004), *Uit goede bron*, with Marc Boone and Walter Prevenier (Garant, 2000), *The Marriage Exchange:*

Property, Social Place and Gender in Cities of the Low Countries, 1300–1550 (Chicago, 1998), and *Women, Production, and Patriarchy in Late Medieval Cities* (Chicago, 1986). She is presently working on the culture of credit and commerce in Northern Europe during the late medieval and early modern centuries.

Visa Immonen is Professor of Archaeology at the University of Turku, Finland. He is the author of *Golden Moments: Artefacts of Precious Metals as Products of Luxury Consumption in Finland c. 1200–1600* (2009) and has published several contributions on early modern material culture and luxury in Northern Europe.

Andrew Morrall is Professor of Early Modern Art and Material Culture at the Bard Graduate Center, New York. He has written widely on the arts of early modern Northern Europe, art and the Reformation, early modern collecting, craft and Kunstkammer, intersections of art and science, theories of ornament, and the material culture of the early modern home. He is the author of *Jörg Breu the Elder: Art, Culture and Belief in Reformation Augsburg* (2002; reissued 2018), coeditor with Melinda Watt of *'Twixt Art and Nature: English Embroidery from The Metropolitan Museum of Art, 1580–1700* (2008), and coeditor with Mary Laven and Suzanna Ivanič of *Religious Materiality in the Early Modern World* (2019).

James Symonds is Professor of Historical Archaeology at the University of Amsterdam. His edited and coauthored books include *The Historical Archaeology of the Sheffield Tableware and Cutlery Industries* (BAR, 2002), *South Uist: Archaeology & History* (Tempus, 2004), *Industrial Archaeology: Future Directions* (Springer, 2005), *Interpreting the Early Modern World: Transatlantic Perspectives* (Springer, 2010), *Table Settings: The Material Culture and Social Context of Dining, AD 1700–1900* (Oxbow, 2011), and *Historical Archaeologies of Cognition: Historical Archaeologies of Faith, Hope, and Charity* (Equinox, 2013).

Peter Stallybrass is Annenberg Professor in the Humanities and Professor of English and of Comparative Literature and Literary Theory at the University of Pennsylvania. His work focuses on early modern printing and manuscripts. In 1993, he founded the seminar on the History of Material Texts. Stallybrass co-curated exhibitions on "Material Texts" and "Benjamin Franklin: Writer and Printer" at the Library Company, and "Technologies of Writing in the Renaissance" at the Folger Shakespeare Library. His coauthored books include *The Politics and Poetics of Transgression* (1986), *Staging the Renaissance* (1991), *Renaissance Clothing and the Materials of Memory* (2001), and *Benjamin Franklin, Writer and Printer* (2006).

Michael J. Waters is an Assistant Professor in the Department of Art History and Archaeology at Columbia University. His forthcoming book, *Renaissance Architecture in the Making*, examines how materials, methods of facture, building technology, and practices of reuse shaped the development of fifteenth-century Italian architecture. He has also published articles on the study of antiquity and early modern architectural prints, drawings, and treatises, and in 2011, he co-curated the exhibit "Variety, Archeology, and Ornament: Renaissance Architectural Prints from Column to Cornice" at the University of Virginia Art Museum.

INDEX